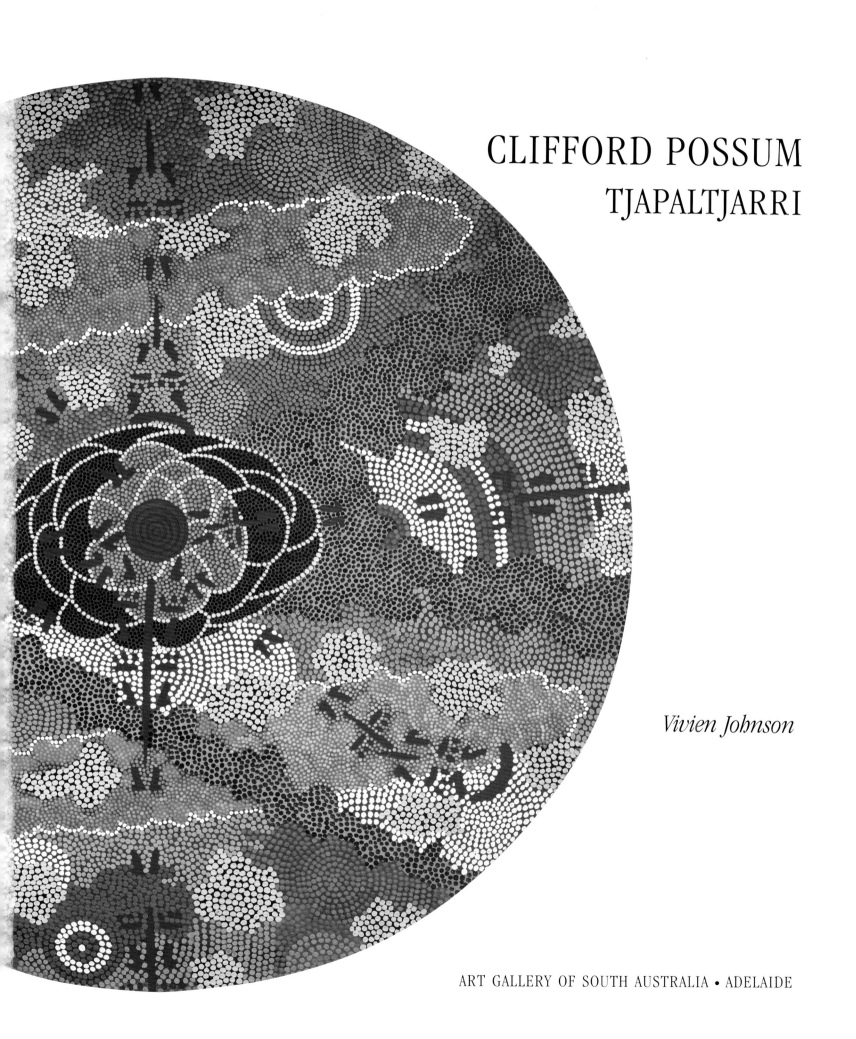

CLIFFORD POSSUM
TJAPALTJARRI

Vivien Johnson

ART GALLERY OF SOUTH AUSTRALIA • ADELAIDE

Exhibition sponsor

Santos

This book was generously supported by the

GORDON DARLING FOUNDATION

Author's acknowledgements

Heartfelt thanks to Clifford Possum Tjapaltjarri for his invaluable support and help in the making of this book, and for his permission to use his name and image in publications connected with his retrospective. Thanks also to his family, in particular his children Gabriella Possum Nungurrayi, Michelle Possum Nungurrayi and Lionel Possum Tjungurrayi for their endorsement of his wishes in this regard. I cannot thank enough my two daughters Tania and Ruby Johnson for their patience and support. Sincere thanks also to Papunya Tula Artists for the annotations of Clifford Possum's paintings and for their long-term support of my research; and to Mem Aziz, Paul Baker, the late Geoffrey Bardon and his wife Dorn, John Brash, Hélène Burns, *The Centralian Advocate*, Belinda Carrington, Jack Cooke, John Corker, Simone Deeb, Hank Ebes, Jon Falkenmire, Peter Fannin, Wendy Gordon, Isobel Hagan, Iris Harvey, Colin Hensche, Chris Hodges, Tim Johnson, John Kean, Richard Kelton, Dick Kimber, Adam Knight, Jeremy Long, Peter Los, Larry May, Elaine Mead, Colin McKinnon, Professor Vincent Megaw, Frank Mosmeri, Andrea Martin Nungarrayi, Emma Nungurrayi, Bergen O'Brien, Pansy Napangati, Dave Richards, Des Rogers, Judith Ryan, Kerry Smallwood, (Steve Strike), Milanka Sullivan, Janis Stanton, the Strehlow Research Centre, Paul Sweeney, Tim Leura Tjapaltjarri, Paddy Stewart Tjapaltjarri, Samson Tjapaltjarri, Anthony Wallis and Daphne Williams for their contributions to this publication. Thanks also to those who lent works to the exhibition.

cover: *Yuelamu (Honey Ant Dreaming)*, (detail), 1980, synthetic polymer paint on canvas, 360.0 x 227.0 cm; South Australian Government Grant 1980. Art Gallery of South Australia, Adelaide

endpapers: *Yuutjutiyungu*, (detail), 1979, synthetic polymer paint on canvas, 231.0 x 365.5 cm; The Kelton Foundation

p. 1: *Kangaroo Story (Mt Denison)*, (detail), 1980–81, synthetic polymer paint on canvas, 122.3 cm diameter; Holmes á Court Collection

p. 3: *Narripi Worm Dreaming*, (detail), 1986, synthetic polymer paint on linen, 121.5 x 91.5 cm; Holmes á Court Collection

Contents

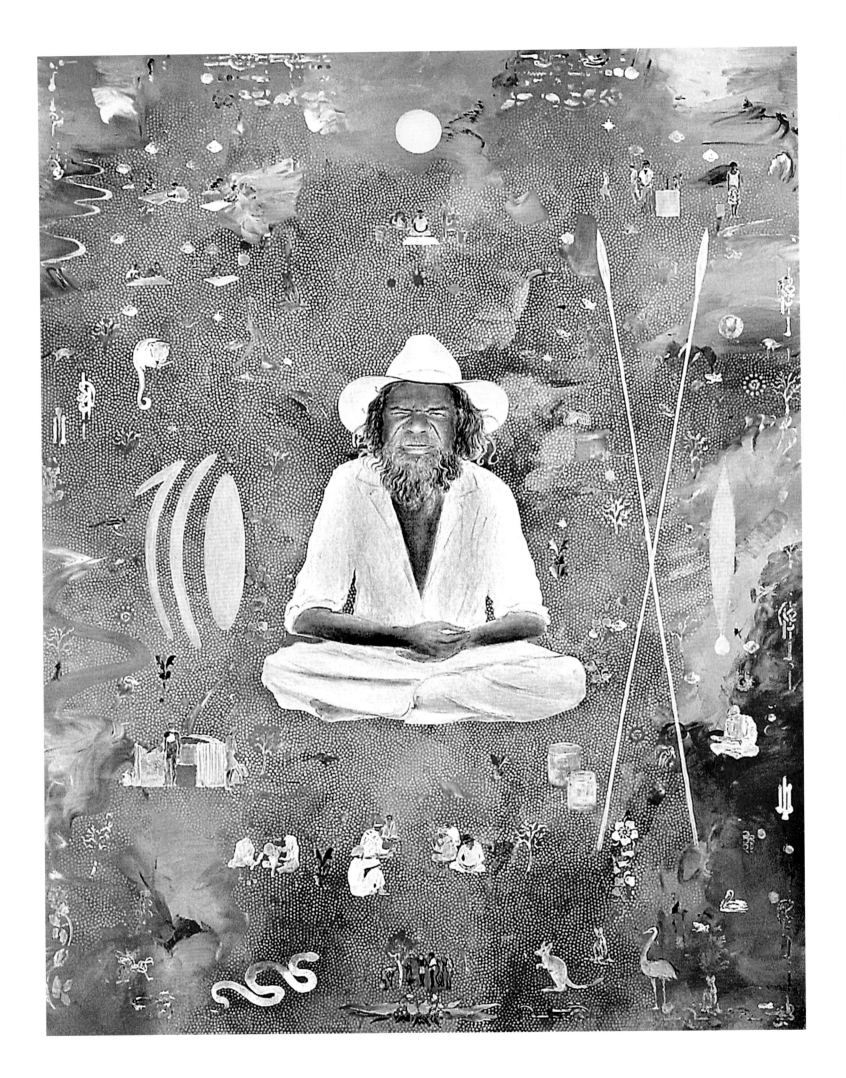

Director's foreword

Ron Radford

Clifford Possum Tjapaltjarri was one of Australia's most distinguished painters of the late twentieth century. A pioneer of dot painting in the Western Desert of central Australia, he soon became a leader of this important movement of Indigenous art. His inherited dreaming stories, embodied in symmetrical designs within cultural 'maps', hold important and potent meaning for his own people but the uninitiated, equally, can feel their power and appreciate their extraordinary pictorial beauty.

The dot-painting movement emerged in 1971–72 at the remote government settlement of Papunya, 250 kilometres north-west of Alice Springs. It was inspired by the local school teacher, Geoffrey Bardon, who encouraged the elder men to transfer ancient ceremonial designs and stories, hitherto drawn in the sand or in natural ochres on their bodies, onto boards painted with professional artists' colours. It was a momentous shift in the history of Australian art, a paradigm shift both within Australian Indigenous art-making and in perceptions from outside.

The passage of cultural knowledge to the younger generations of Western Desert people had been disrupted by European settlement. These paintings were a renewal. They provided a means for appropriate knowledge about the oldest living culture in the world to be shared not only with succeeding generations of Indigenous people but also with the rest of Australia, and the world. The small experimental boards of the early and mid-1970s soon expanded into large and splendid canvases. By the late 1970s Clifford Possum was acknowledged as the artist who could handle with greatest ease and accomplishment the challenging expanded scale. In 1976 he painted one of the very first large canvases of the movement, the unprecedently complex *Warlugulong* story. Some stages of that tour de force of many Dreamings were mapped out with his brother Tim Leura Tjapaltjarri, the first of several collaborative works made with extended family. To the originally imposed 'Aboriginal palette' of yellow and red ochre and black and white, in about 1980 he began to introduce unexpected tertiary hues of pinks, mauves and then blues, the orchestration of which made the big inventive canvases vibrate and sing.

In the first decade of Western Desert painting the art world was either ignorant of or bewildered by the works. In the early 1980s art museums began to take notice, begrudgingly at first, but nevertheless they bought paintings,

Tim Johnson, Australia, born 1947, *Clifford Possum Tjapaltjarri*, 2002, oil and synthetic polymer paint on linen, 152.5 x 115.0 cm; Commissioned with funds from the Basil Bressler Bequest 2003. National Portrait Gallery, Canberra

included them in special exhibitions and then in permanent displays. Many major private collections followed suit. I am glad to record that Adelaide and the Art Gallery of South Australia were leaders in recognising the strength of Clifford Possum's painting and the movement in general.

Clifford Possum was one of the first of these desert artists to be admired by the art world and became their first recognised star. He took justifiable pride in his growing reputation and was the longest serving Chair of the Papunya Tula Artists company incorporated in November 1972 to co-ordinate and market the work of this extraordinary group. He was included in major surveys of Indigenous art and mixed exhibitions of Indigenous and non-Indigenous art and had solo exhibitions in London and New York. He won the Alice Springs Prize in 1983, judged by the then Director of the National Gallery of Victoria, Patrick McCaughey, and many other accolades were to follow. In 1994 Vivien Johnson published a well-researched and well-illustrated monograph on the artist, now out of print. As his reputation grew towards the end of the 1980s he experienced the mixed compliment of a correlation between his growing reputation and the eruption onto the market of a small number of forgeries. This eventually resulted in a very public and, for the artist, stressful court case in 1999. Clifford Possum's final accolade in his lifetime was to be appointed an Officer of the Order of Australia, 'For service as a contributor to and pioneer of the development of the Western Desert art movement, and to the Indigenous community through interpretation of ancient traditions and cultural values'. He was proud to have received this high honour but the very day he was to participate in a vice-regal presentation ceremony in Alice Springs, he died.

This exhibition book accompanies the artist's first comprehensive retrospective and he is the only Papunya Tula artist to be honoured by such an exhibition at a major institution. It is appropriate that Adelaide and the Art Gallery of South Australia should stage the exhibition and publish the most elaborate book so far produced on an Australian Indigenous artist for Adelaide has long collected and promoted Indigenous culture. Adelaide, indeed, has been for over a century the gateway to central and northern Australia where so much Indigenous culture has remained intact. More recently the South Australian Museum, the Flinders University Art Museum and the Adelaide Festival were early supporters of Western Desert art.

However, the appropriateness of staging this retrospective exhibition is more immediate to the Art Gallery of South Australia. When in 1980 the Gallery acquired Clifford Possum's iconic *Man's Love Story*, 1978, it was the first major art museum in the world to purchase a Western Desert dot painting. The acquisition was controversial within the Gallery itself, not least because it was consciously hung in the permanent Australian display in the company of works by major non-Indigenous artists. I was the Curator of Australian and European Paintings and Sculptures at the time and it was difficult to get the purchase approved by the Director and the Art Gallery Board; I was also criticised by colleagues in other public galleries.

The Art Gallery of South Australia has now built a large and extremely comprehensive collection of Western Desert paintings from their emergence to

Man's Love Story, (detail), 1978, synthetic polymer paint on canvas, 214.5 x 257.0 cm; Visual Arts Board, Australian Contemporary Art Acquisitions Program 1980. Art Gallery of South Australia, Adelaide

the present. Clifford Possum's *Man's Love Story* was the first of five major works by him now owned by the Art Gallery; they range in date from 1972 to 1997, and all are included in this retrospective exhibition and book. It is marginally the largest public collection of his art.

The Art Gallery of South Australia was also the first art museum visited by Clifford Possum. As part of the 1984 Adelaide Festival of Arts, artist Tony Bishop had helped organise an exhibition of three Western Desert painters at the Royal South Australian Society of Arts rooms, in the city's historic Institute Building on Kintore Avenue. Clifford Possum and the other two painters made their first trip to Adelaide for the occasion. All the visual arts events for that Festival were formally opened at the Art Gallery of South Australia by the then Governor-General Sir Ninian Stephen. I remember it was my task to introduce the artists to the Governor-General and to the State Premier, John Bannon. When I introduced Clifford to the Premier I stupidly said 'Clifford is known as the Leonardo of the Western Desert', and Clifford scoffed: 'Hah! Who's this Leonardo fellow?'

It was also my privilege to take Clifford and the other artists on a tour around the Australian paintings on display at the Art Gallery of South Australia. Clifford was pleased to see his *Man's Love Story* on view with other Australian paintings, but the only works in which he seemed to show a keen interest, apart from his own, were the landscapes by Fred Williams. At the end of the gallery tour the director of Papunya Tula Artists, Daphne Williams, suggested I send them books on contemporary art, both Australian and international. I did so, including a book on Kandinsky.

In 1983 I curated the Art Gallery of South Australia's large survey exhibition *Recent Australian Painting 1970–83*. It was the first complete survey of contemporary Australian painting held anywhere for many years and the first which included Indigenous art. There were five Western Desert dot painters, including Clifford Possum one of whose two works was *Man's Love Story*. This caused surprise to many people and a number of art critics questioned the wisdom of the inclusion. The reviewer for the exhibition in *Art and Australia*, the most widely circulated art magazine in the country, taunted: 'That one of these Aboriginal works was called *Camp Story* seemed … a comment on the content of many of the 1980s paintings!'

The following year, 1984, the Gallery staged *Aboriginal Dreamings: Paintings from the Western Desert*, the first exhibition of its own small but growing collection of Western Desert paintings, then numbering about thirty works. More significantly, four years later the Art Gallery of South Australia was asked by the Australian Bicentennial Authority to curate and assemble a touring blockbuster, *The Great Australian Art Exhibition*, accompanied by the ground-breaking catalogue *Creating Australia: 200 years of art 1788–1988*. By 1988 Aboriginal art was about to be canonised into Australian art history and the show deliberately included Indigenous art, and of course, Western Desert dot paintings and the work of Clifford Possum.

To coincide with the 1996 Atlanta Olympic Games the High Museum of Art, Atlanta, put together a large exhibition which represented major cultures of the world. It was entitled *Rings: Five Passions in World Art*. Two paintings represented Australia: Eugene von Guérard's dramatic *Bushfire*, 1857, and Clifford Possum's *Honey Ant Dreaming*, 1980, an exceptionally beautiful painting from the Art Gallery of South Australia collection and chosen for the cover of the present book on the artist. Also in 1996, to celebrate the 25th anniversary of the emergence of Western Desert paintings at Papunya the Art Gallery of South Australia staged an exhibition, *Dreamings of the Desert*, of its own by then very large collection of dot paintings, perhaps the most significant such collection in any museum. Vivien Johnson was commissioned to write the major essay in the *Dreamings of the Desert* book, now out of print. Clifford Possum's work was prominently illustrated.

Finally in 2001, thirty years after the emergence of dot painting, Clifford Possum was invited by the Art Gallery of South Australia to stage this retrospective, touring from late 2003 with a new book written by his trusted friend, Vivien Johnson. He gratefully and formally accepted the invitation. Johnson is a long-time scholar of Western Desert dot painting and author of *The Art of Clifford Possum Tjapaltjarri*, 1994. The exhibition tour proceeds from Adelaide to Australia's largest cities Melbourne, Sydney and Brisbane. Alas he did not live to see the realisation of the exhibition and this book, which can be seen as his ultimate, consoling tribute.

We trust that Clifford Possum's family and friends will feel as proud of this major presentation as we do in preparing it.

<p style="text-align:center">★ ★ ★</p>

Such exhibitions as this are the result of much co-operation and the work of many people. First I thank the artist himself, without whose permission and assistance it could not have happened. I also thank the artist's immediate family, his daughters Gabriella and Michelle and his son Lionel, for supporting this project across a difficult time.

Next I thank Vivien Johnson, with whom the Gallery has had a long association. She has shown an unstinting commitment to the scholarship about the artist, his country and his people, and has worked tirelessly to expand and update her work on the life and art of Clifford Possum in this book.

The Gallery must thank the generous lenders to the exhibition. We first acknowledge Janet Holmes à Court who has long supported Aboriginal art and has always been an extremely co-operative lender to exhibitions around Australia. She holds the largest collection of Clifford Possum's major paintings and is the biggest lender to this show. The National Gallery of Australia has also been a generous lender. So too are our colleague Adelaide institutions the South Australian Museum and the Flinders University Art Museum. Other institutional lenders are the Art Gallery of New South Wales, Sydney; the Ballarat Fine Art Gallery, Ballarat, Victoria; The Australian Museum, Sydney; the National Museum of Australia, Canberra; the Araluen Centre for Arts and

Entertainment, Alice Springs, and the National Portrait Gallery, Canberra, which has lent Tim Johnson's sensitive portrait of Clifford Possum.

I would also like to record the Gallery's appreciation for the other private loans: Arnaud Serval, France; Ebes Collection, Melbourne; Gabrielle Pizzi collection, Melbourne; the late Geoffrey Bardon Western Desert Collection; GrantPirrie collection, Sydney; Jinta Desert Art Gallery, Sydney; Mead collection, Melbourne; The Kelton Foundation, Los Angeles; Westpac Corporate Art Collection, Sydney; F. Mosmeri and M.J. Sullivan Collection, Melbourne; Yolette Sullivan Collection, Melbourne; and seven lenders who wish to remain anonymous.

I also acknowledge the work of Tracey Lock-Weir, Associate Curator of Australian Paintings & Sculptures at the Art Gallery of South Australia. She has worked closely with the author Vivien Johnson and myself to help realise this exhibition and book. I must also acknowledge with gratitude the work of Antonietta Itropico who designed this handsome book and saw it through to publication. My thanks also go to Jan Robison, Anne Wright, Georgia Hale and Lindsay Brookes for their assistance at the Art Gallery of South Australia.

Important national touring exhibitions and their accompanying publications cannot take place without major sponsors.

The Kelton Foundation, Los Angeles, has helped with transportation expenses of loans from the United States. The Gordon Darling Foundation has been a substantial sponsor for this book, as it has for so many other major art publications around the nation in recent years; it has enabled the book to be both more elaborately illustrated and more affordable.

Bank SA has long been a sponsor of the Gallery's exhibition program, and Visions Australia has assisted with part of the tour.

However, Santos Ltd is the principal sponsor of the Clifford Possum retrospective. Santos had previously sponsored other exhibitions at the Art Gallery of South Australia and has revisited to sponsor this landmark national touring exhibition from Adelaide to, Melbourne, Sydney and Brisbane. Santos also generously provided a fund to extend the Gallery's rich Aboriginal art collection. One of the purchases it enabled was Clifford Possum's late painting, *Man's Love Story*, 1997, included here. We appreciate Santos's continuing generosity to the Gallery and their interest in Indigenous art.

Ron Radford
Director, Art Gallery of South Australia, Adelaide.

Man's Love Story, (detail), 1997, synthetic polymer paint on canvas, 120.0 x 89.0 cm; Santos Fund for Aboriginal Art 1997. Art Gallery of South Australia, Adelaide

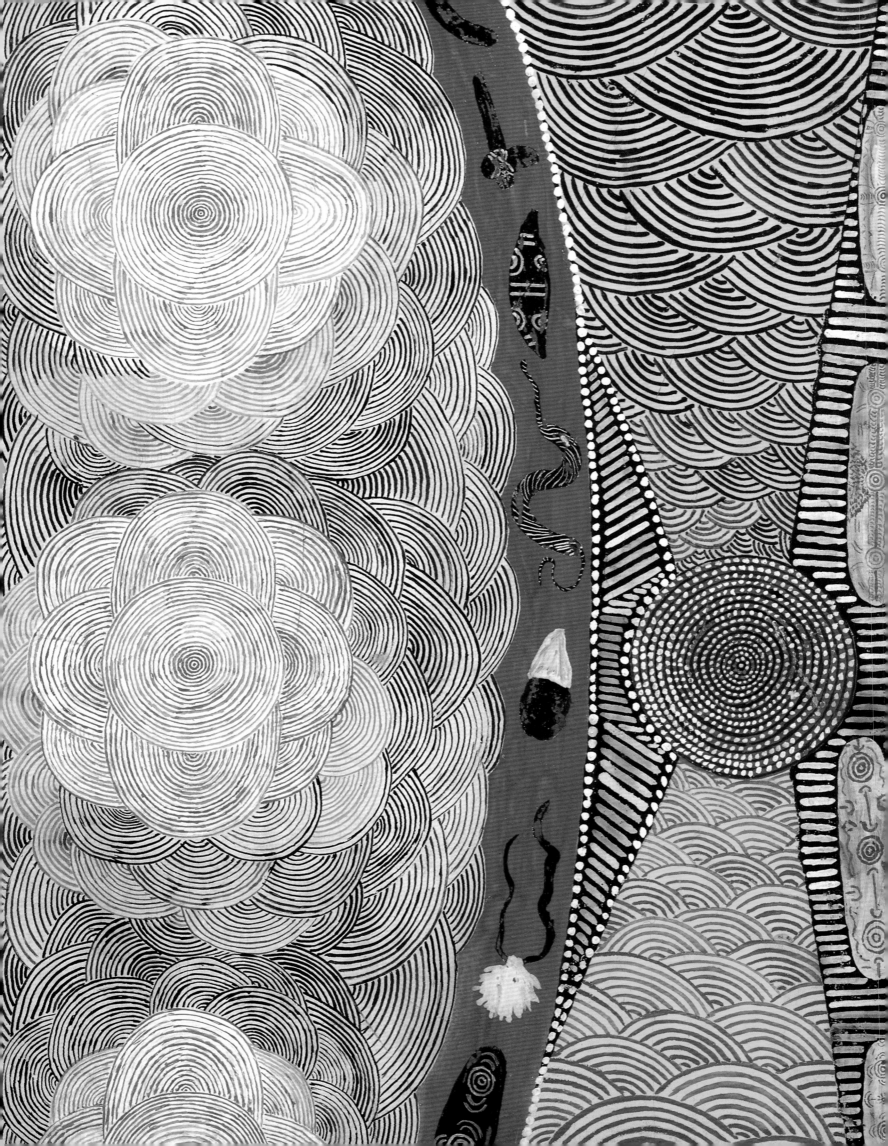

Introduction

Vivien Johnson

Clifford Possum Tjapaltjarri will go down in history as the most famous Aboriginal Australian artist of his generation, but the mystery of who he really was may well have died with him. Perhaps that could be said of all famous people, but the lines between the public and private selves of Clifford Possum Tjapaltjarri – or 'Upambura', to use the name by which many of his Anmatyerre countrymen and women referred to him – were more than usually indecipherable. As this question of names illustrates so perfectly, Clifford Possum was a man of multiple identities, which were not generated out of any desire for self-concealment, but from his determination to express *who he was* within conflicting and conflicted social worlds. Though he became, as his famous predecessor Albert Namatjira was once described, a wanderer between these worlds, he managed to convey to all who knew him a sense of someone totally grounded in life itself and his chosen role as an artist, painting his heritage within one world for consumption by another.

As his story unfolds, the whole history of Aboriginal art in Central Australia, and now on the world stage, will seem to be inscribed in the events of Clifford Possum's personal biography. He began his artistic career as a carver, just as Central Australian Aboriginal art had its beginnings in the trade in carved wooden artefacts started in the 1930s by enterprising Pitjantjatjara tribesmen and women along the newly opened tourist route to Uluru. In the early 1950s, he was offered a place by Albert Namatjira in the lineage of this pioneer Aboriginal artist as a painter of European–style watercolours of the Central Australian landscape, but declined out of a determination to forge his own artistic destiny. Then came Papunya painting, one of the most extraordinary of contemporary art movements, of which Clifford Possum was both a precursor and pioneer. Over three decades of continuous output, he remained a central figure and leading proponent of the painting style which he helped to invent. The hard-won recognition, at first nationally and increasingly on an international level, that the acrylic painters of the Western Desert[1] are *both* bearers of an ancient tribal culture *and* contemporary artists, has been built up by the outstanding achievements of individual artists like Clifford Possum Tjapaltjarri. In time, it may revolutionise the way the art of other indigenous peoples is received by the rest of the world.

But to introduce this narrative at the mundane level of events in the post-colonial history of Aboriginal Central Australia would be to circumscribe too narrowly the sources of Clifford Possum's art:

Honey Ant Ceremony, (detail), 1972, powder paint on composition board, 100.0 x 78.0 cm; Elder Wing Centenary Gift of The Foundation 2001. Art Gallery of South Australia, Adelaide

V.J.: Clifford, where did you get the idea to be an artist?

Like every other Western Desert painter I have asked this sort of question, Clifford Possum seemed oblivious to the invitation it offers to egotistical reminiscence. His answer was:

> That Dreaming been all the time. From our early days, before the European people came up. That Dreaming carry on. Old people carry on this law, business, schooling, for the young people. Grandfather and grandmother, uncle and aunty, mummy and father, all that – they been carry on this, teach 'em all the young boys and girls. They been using the dancing boards, spear, boomerang – all painted. And they been using them on the body different times.

> Kids, I see them all the time – painted. All the young fellas, they go hunting, and the old people there – they do sand painting. They put down all the story, same like I do on the canvas. All the young fellas, they bring 'em back kangaroo. Same all the ladies, they been get all the bush fruit – might be bush onion, bush plum, might be honey ants, might be yala – bush potato – all the kungkas [women] bring them back. Because everybody there, all ready – waiting. Everybody painted. They been using ochres – all the colours from the rock. People use them to paint up. I use paint and canvas – that's not from us, from European people. Business time, we don't use the paint the way I use them – no, we use them from rock, teach 'em all the young fellas.

Clifford Possum reiterates here the original social agenda of the Papunya painting movement: the need for educating the young people about the Dreaming. He stresses the continuity of his art with these ancient traditions of Western Desert society, while noting the distinction between contexts ('business time') in which the visual language of the Dreaming is employed ceremonially, and the European world of 'paint and canvas'. This is not the stuff of conventional artist biographies, but it tells us something about Clifford Possum's concept of himself as an artist which modern social histories simply do not touch upon. Heeding the artist's directions, the starting point of this account will not be modernist biography, but the Western Desert sense of history with which Clifford Possum Tjapaltjarri operated as an initiated Anmatyerre tribesman and custodian of important Dreamings and sites. This is the ground on which the design of his life and art is ultimately inscribed.

History, in the form of geographically based mythologies known as Dreamings, is an integral part of everyday life in Western Desert society and is actively constitutive of the social and personal identity of its individual members. Even the names people go under are decided not by the whim of their parents, but by the laws of the Dreaming. The usual form of address in Western Desert society is by 'skin' name, one of the eight kinship subsection names which everyone bears – in Clifford Possum's case, it was 'Tjapaltjarri'. This name was determined by the skin names of his parents, and in turn determined the skin(s) he should marry and those of his children. His father was a Tjungurrayi, and as Tjungurrayis should, he married a woman of the Nangala skin group, later known to settler[2] culture as Long Rose. Their sons were Tjapaltjarris, who in turn should marry Nakamarra women so their children will be Tjungurrayis (and Nungurrayis) like their paternal grandfathers (and grandmothers), continuing the endless cycle of the generations.

The realisation that Western Desert paintings depict the artists' personal Dreamings and sites, has deepened and clarified non-Aboriginal understandings of the perception which Aboriginal peoples have of their rights in land. The idea that artists paint their Dreaming sites represents an advance on earlier understandings, but does not do justice to the complexity of the relationship of person to country in Western Desert society. The sites with which a particular individual is identified in the network of trails and landmarks that map out the Western Desert for its peoples, depend not only on patrilineal descent but also on a host of interrelated factors. These include the person's birthplace, where they were initiated, where their parents or grandparents were born or initiated, and other areas with which they or their close relatives are associated through extended residence. Rights and responsibilities to country may also be of different kinds depending on whether their inheritance is from the male or female line, and may vary in their significance both to the artist and in the wider scheme of Western Desert society. The focus of this book on the achievements of a single painter produces the desired expansion of the analysis to encompass this kind of detail. It makes possible an understanding of the artist's personal mythological geography as encapsulated in his entire work. Spread through the text is an inventory of Clifford Possum's main sites and their associated Dreamings. These are what inspired Clifford Possum's paintings and, as far he was concerned, were the most important information to be conveyed about his art. However, no attempt has been made here to collect all the information up into some definitive ethnography of the artist's work. This would be to let the discredited idea of 'authenticity' back in through the side door of exposition and explanation. 'Clifford Possum's Dreamings' is not a rigid structure of fact, but a fluid structure of memory, whose rules of operation are mysterious to the scientific gaze. Western Desert society does not detach itself from its past, but keeps it in its collective memory as an ongoing part of a living transforming culture. That is how the Dreaming stories are interwoven in this narrative – as part of a mental landscape which encompasses also contemporary events in the artist's life.

Clifford Possum's concept of himself as an artist might be significantly removed from the mainstream of contemporary art. But to use this difference to deny his right to call himself an artist in a fully contemporary sense would seem a very insidious form of ethnocentrism. Far better to attempt to have the mainstream come to terms with the complex aspirations which the term 'artist' encompasses for the painters of the Western Desert. People may wilfully misinterpret the import of this analysis: the romantic mystification of the artistic vocation in western culture is all the more objectionable when applied to a culture which has been collectively victimised for over two hundred years by far more sinister misrepresentations of its lifeways. But the advantages of an individual artist's point of view on the last half century of Aboriginal art in Central Australia outweigh this disadvantage.

The acceptance – indeed, adoption – of the art enterprise by the Western Desert cultural establishment during the 1980s, has tended to obscure the importance of individuals, particularly in the early development of the painting movement at Papunya. For example, Clifford Possum was one of three or four painters already experimenting with the application of traditional motifs to western

materials, whose presence in Papunya at the beginning of the 1970s, and aspiration to become professional artists, were critical to the emergence of the acrylic painting movement. Clifford Possum's unique experiments in the late 1970s in mapping out the geography of his entire Dreaming country set him apart from other artists of the movement. So did his services as an ambassador for Aboriginal art around the world, which exceeded those of any other artist of his generation. His personal journey showed the world that an Aboriginal artist could be a cosmopolitan world traveller and still maintain his identity as a painter of his Dreamings and a man of his culture. In a social climate which was in its own way as discriminatory and difficult as that faced by Namatjira before him, he never lost his will to 'carry on'. This proud and fiercely independent man overcame vast cultural barriers, doing things his own deeply religious way in accordance with the values of the Anmatyerre people in which he was raised. He held fast to the original vision of the Papunya Tula painters of communicating to the world the custodianship of the Western Desert peoples over their Dreaming narratives and places.

Whatever one may say about the concept of artist, the concept of art making as the creation of meaningful signs is not an alien imposition on traditional Aboriginal cultures. This conceptual congruence was initially overlooked, perhaps because the terms for ancestral designs in Western Desert languages often apply both to the marks left in the country by the ancestral presence *and* to the acrylic paintings depicting these markings. Debate no longer rages about their status as contemporary art – on the contrary, so far has the pendulum now swung in the other direction that it is necessary to remind ourselves that these paintings are 'more than just art'. Both dimensions of the Western Desert concept of mark-making are critical to comprehending their meaning. In the art context for which Clifford Possum produced his paintings, it is vital that the signs continue to be read 'Two Ways'.[3]

This book was originally written in less than six months, although it rested on a much longer involvement with the artist and his work in which research and day-to-day living had become inextricably mingled. The men and women of the Western Desert are in my experience very private people, whose response to the inveterate curiosity of westerners is most often a polite refusal to supply the information they expected to be given just for the asking. In the artist's culture, knowledge is a privilege to be earned by trial of experience, not a right to be demanded. Even the trial of experience must also be earned. I thank Clifford Possum for putting me to the test, and for the knowledge he gave me to impart in this book. I would also like to thank the Art Gallery of South Australia for the honour of curating the retrospective which has provided the occasion for this new book on Clifford Possum. It is a complete revision of my 1994 publication *The Art of Clifford Possum Tjapaltjarri*, and includes the often traumatic final decade of Clifford Possum's life – and corrections of my earlier mistakes and omissions. As the revision process was for me, so I hope this book and exhibition will provide for others – an occasion for a long overdue reappraisal of this great man and his work. He devoted his life to ensuring that his people's traditions would long continue, but we shall not see his like again.

Fire Dreaming, (detail), 1983, synthetic polymer paint on canvas, 120.0 x 152.5 cm; Private collection

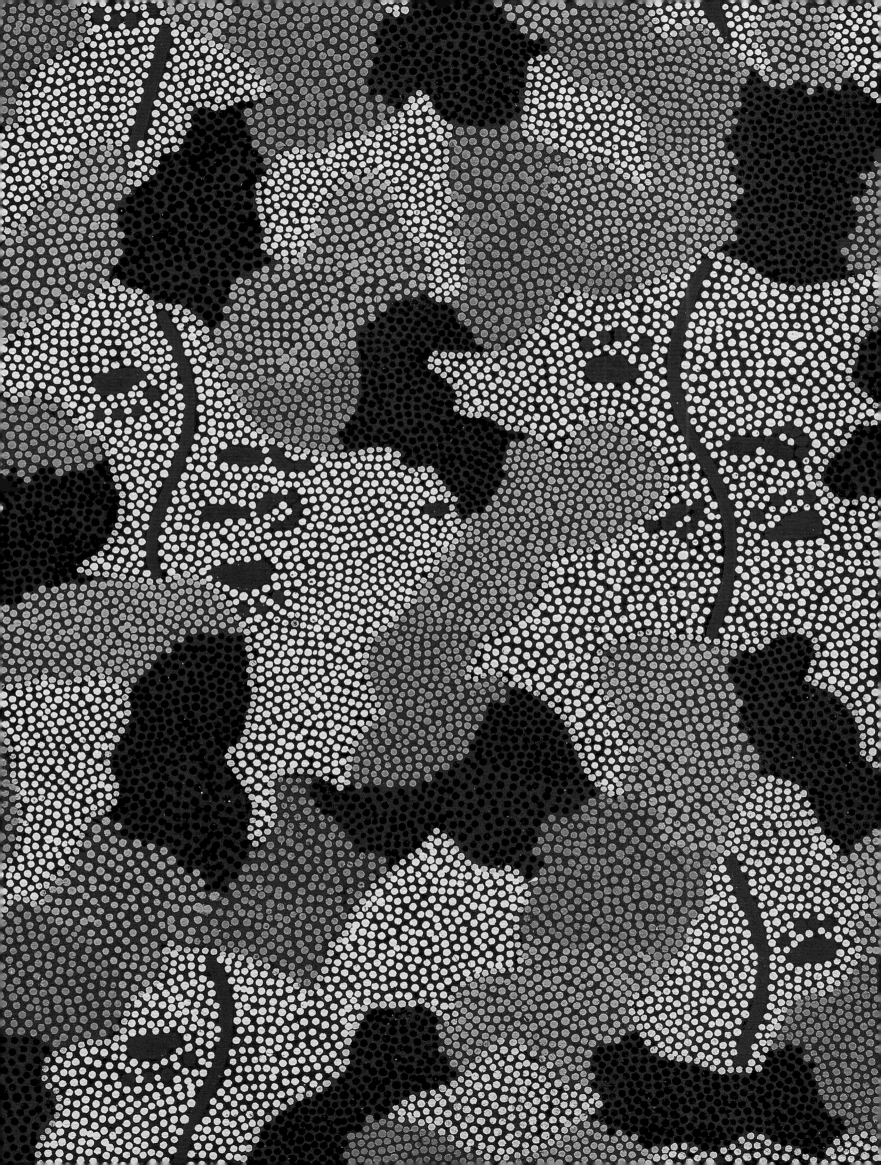

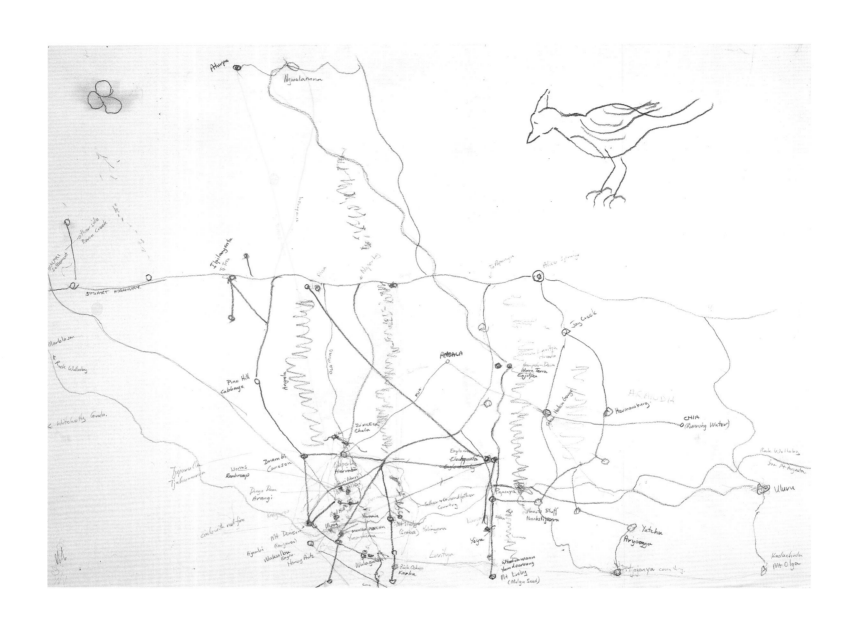

Clifford Possum, *Map of Anmatyerre Country*, 1988, pencil on paper, 56.0 x 76.0 cm; Private collection. Photo: Greg Weight

Corroboree country

Clifford Possum's 'corroboree country' forms a wide arc with a radius of some 100 kilometres centred approximately 200 kilometres north-west of Alice Springs. The sites depicted in his paintings stretch from Watulpunyu, west of Central Mount Wedge in the south, up through Napperby and Mount Allan Stations, north-west as far as the blue hill of Wakulpa just north of Yuendumu, and north-east across Mount Denison and Coniston Stations. To the artist, all this was Anmatyerre country.[1] He acknowledged the congruent claims of other tribal groups now resident within its borders, but his memories went back to the time when,

> From Coniston is one family. Like the old people: they was really proper one in corroboree time – from every soakage before station thought of, before wells and all that. I got all the native names – proper really corroboree countries: from Napperby mob and Coniston and Mount Allan, Mount Denison and Yuendumu and Mount Wedge. Every soakage, from this whole lot. Big corroboree time, we got to show one another this country: this one, this one, this one soakage, this one go past – all that. Because I *know*'m now today.[2]

All the local descent groups were entitled by tradition to use and occupy Anmatyerre lands, though within this expanse, each had custodial rights and responsibilities over their particular 'estate'.

For countless generations, Clifford Possum's fathers and grandfathers[3] had been keeper–owners for Altjupa (Aljupa), a soakage[4] situated halfway down a watercourse which they called Malliera (Maliyarra). As the Anmatyerre name for the river bed suggests, it is a site of post-initiatory or 'malliera' learning, whose secret–sacred significance was glossed by the artist in these terms:

> Flying Snake. From Coniston I can tell you. Them two rainbow snakes, they put all the stories for malliera – native high school. Them two been picking up songs from the country, from every place. All the birds – they might be walking alongside of the river – not river properly, cliff-hang really. They been singing all that bird and bush flowers and everything. All this songs – just like whitefellas make'm song. We sing'm now.
>
> You know what is Yunkurru soakage and Rinkabi soakage? Them two, Rainbow Snakes, put soakages. That is saltwater country, but these rainwater – fresh one. From them two rainbow snakes. They put every soakage.

pp. 22–23: This map of the main sites and Dreamings shown in Clifford Possum's paintings was derived from the author's discussions with the artist in 1992–93 over Lands Department maps of the area in which his country lay. This was a straightforward exercise when locations corresponded to European names on the map, but where they did not, confusions of scale and even direction may have arisen.

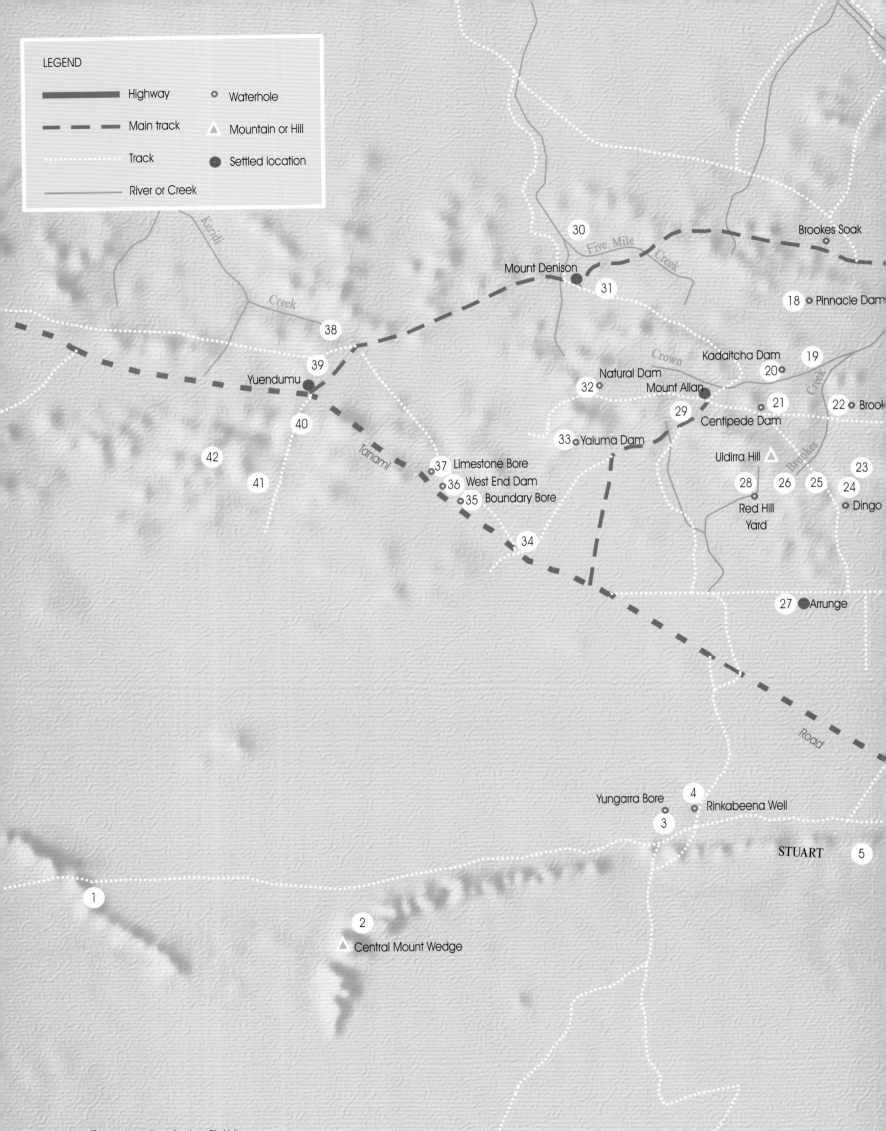

LEGEND

Highway

Main track

Track

River or Creek

Waterhole

Mountain or Hill

Settled location

30

Five Mile Creek

Mount Denison

31

Brookes Soak

18 Pinnacle Dam

Keridi

Creek

38

39

Yuendumu

40

42

41

Tanami

37 Limestone Bore
36 West End Dam
35 Boundary Bore

34

Crown

Natural Dam
32

Mount Allan
29

Centipede Dam

Yaluma Dam
33

Kadaitcha Dam
20

19

21

Brookes Creek

Uldirra Hill

28

Red Hill
Yard

26

25

24

Dingo

22 Brook

23

27 Arrunge

Road

Yungarra Bore

4

Rinkabeena Well

3

STUART

5

1

2

Central Mount Wedge

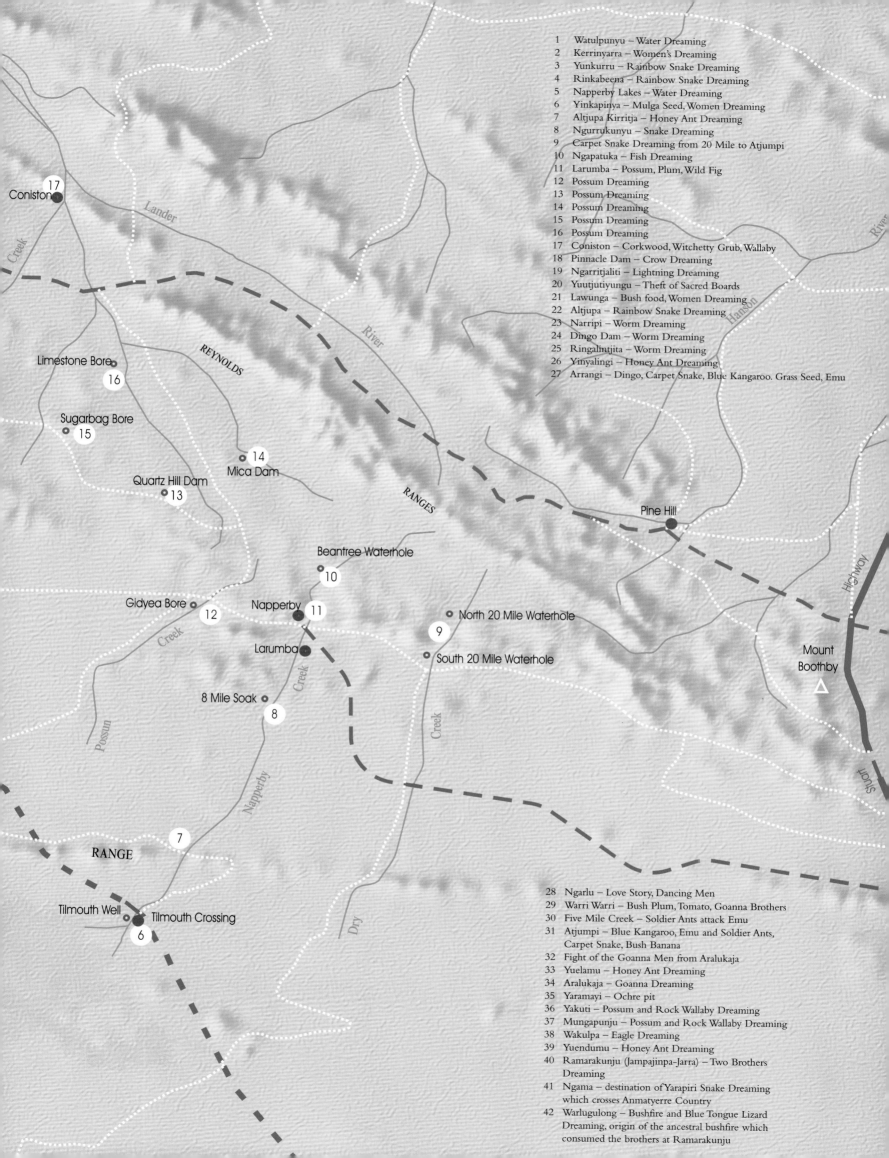

1 Watulpunyu – Water Dreaming
2 Kerrinyarra – Women's Dreaming
3 Yunkurru – Rainbow Snake Dreaming
4 Rinkabeena – Rainbow Snake Dreaming
5 Napperby Lakes – Water Dreaming
6 Yinkapinya – Mulga Seed, Women Dreaming
7 Altjupa Kirritja – Honey Ant Dreaming
8 Ngurrukunyu – Snake Dreaming
9 Carpet Snake Dreaming from 20 Mile to Atjumpi
10 Ngapatuka – Fish Dreaming
11 Larumba – Possum, Plum, Wild Fig
12 Possum Dreaming
13 Possum Dreaming
14 Possum Dreaming
15 Possum Dreaming
16 Possum Dreaming
17 Coniston – Corkwood, Witchetty Grub, Wallaby
18 Pinnacle Dam – Crow Dreaming
19 Ngarritjaliti – Lightning Dreaming
20 Yuutjutiyungu – Theft of Sacred Boards
21 Lawunga – Bush food, Women Dreaming
22 Altjupa – Rainbow Snake Dreaming
23 Narripi – Worm Dreaming
24 Dingo Dam – Worm Dreaming
25 Ringalmtjita – Worm Dreaming
26 Yinyalingi – Honey Ant Dreaming
27 Arrangi – Dingo, Carpet Snake, Blue Kangaroo. Grass Seed, Emu

28 Ngarlu – Love Story, Dancing Men
29 Warri Warri – Bush Plum, Tomato, Goanna Brothers
30 Five Mile Creek – Soldier Ants attack Emu
31 Atjumpi – Blue Kangaroo, Emu and Soldier Ants,
 Carpet Snake, Bush Banana
32 Fight of the Goanna Men from Aralukaja
33 Yuelamu – Honey Ant Dreaming
34 Aralukaja – Goanna Dreaming
35 Yaramayi – Ochre pit
36 Yakuti – Possum and Rock Wallaby Dreaming
37 Mungapunju – Possum and Rock Wallaby Dreaming
38 Wakulpa – Eagle Dreaming
39 Yuendumu – Honey Ant Dreaming
40 Ramarakunju (Jampajinpa-Jarra) – Two Brothers
 Dreaming
41 Ngama – destination of Yarapiri Snake Dreaming
 which crosses Anmatyerre Country
42 Warlugulong – Bushfire and Blue Tongue Lizard
 Dreaming, origin of the ancestral bushfire which
 consumed the brothers at Ramarakunju

Chris Hodges, Sketch of Clifford
Possum's dreaming country.
Photo: Greg Weight

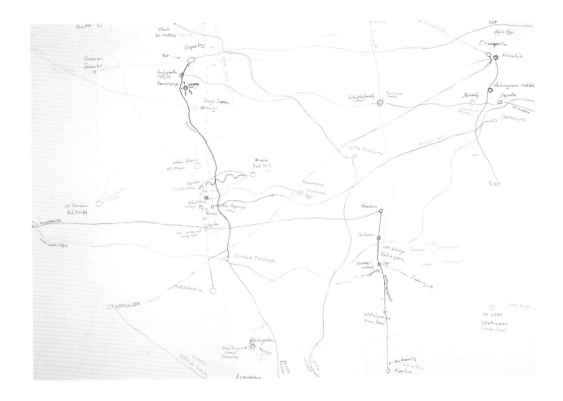

The journey of the Flying Snakes began at Lajamanu on the northern rim
of the Tanami Desert, about 800 kilometres north-west of Altjupa. From
Lajamanu, they 'come up all the way along, from every country, just like a
wandering river', forming rivers and creek beds as they went by blowing air out
through their nostrils. Their journey not only carved out landforms, but also
created freshwater soakages like Altjupa, on which survival depended in this
saltwater country. Between Altjupa and the limestone wells which Clifford
Possum mentions at Yunkurru and Rinkabi down near Mount Wedge Station,
is a fifty kilometre stretch of mulga and witchetty grub country devoid of the
watercourses and soakages which mark the snakes' passage overland. This is
because at Altjupa the snakes took flight, and flew south as far as Rinkabi
(Rinkabeena Well) where they landed and travelled further south, stopping at
Yunkurru (Yungarra Well) to hold more malliera ceremonies before taking flight
again. The knowledge of the locations of these and dozens of other smaller
soakage waters they made is stored in the songs and stories of the Flying Snake
Dreaming. This knowledge enabled the group, spanning several generations of
Tjungurrayis and Tjapaltjarris and their families, to move out freely from Altjupa
in every direction over a huge expanse of country.

> All the families were there, living on the soakage, corroborees all the time.
> Then in the olden time them whitefellas took the well for their cattle. His
> name Brookes that whitefella – that's why everyone call'm Brookes Well.

The only cattle stations to the north-west of Alice Springs in the early part
of the twentieth century were Coniston and Napperby.[5] Their sprawling
unfenced leases encroached on Anmatyerre lands from the north and east, but
despite wandering herds plundering their most vital resource, Clifford Possum's
grandfather's generation had been able to continue their traditional way of life

in the area west of Altjupa undisturbed by any European presence in the region which contained many of their key Dreaming sites and tracks. Competition with the cattle for the waters became a critical factor in the late 1920s, when a severe drought held Central Australia in its grip for seven terrible years. Altjupa was renamed Brookes Well by the settlers, after a prospector called Frederick Brookes, who was murdered at a soakage to the north of Altjupa in 1928. The homicide sparked indiscriminate retaliatory killings of Aboriginal people in the surrounding regions for several years afterwards, now known to Europeans as the Coniston Massacre, and to Clifford Possum and his people as the 'killing times'.

It was not Clifford Possum's family who speared Brookes and stuffed his dismembered body down a rabbit hole. That was reputedly the work of one of the Ngalia Warlpiri groups driven in from their dried-out territories further to the west, with whom the Anmatyerre were obliged to share the precious waters of their soakages during hard times. But the thundering hooves of Constable William Murray and his revenge party would shatter forever their ancient pattern of living. Most of the men were out hunting when Constable Murray galloped into the middle of the camp with his gun raised and shot an old man who was menacing the intruders in a vain attempt to protect the women and children. Many were slain in the mêlée that followed, and soon the air was filled with the frenzied wailing of the survivors. The hunting party returned to a scene of horror. Most plaintive were the cries of the baby of one of the murdered women, who had hidden him in a coolamon beneath some bushes at the sound of the riders' approach. What was left of the group fled south-eastwards to the relative safety of the Napperby pastoral lease. For a generation, Altjupa and the surrounding lands were empty of their original inhabitants.

The drought and the killings had accelerated the exodus of the Anmatyerre from the north-western sector of their territory as more and more families attached themselves to the pastoral properties to gain access to rations and work as stockmen and domestics. Warringi[6] Tjapaltjarri, as Clifford Possum's grandfather was known to his grandchildren, was a senior man of one of the relatively few Anmatyerre groups who continued to live off their lands, but within the area south-east of Altjupa which was part of the Napperby lease. Warringi's fellow tribesmen called the old man Upambura, after the Possum Dreaming site of Yakuti (Yalkuti) to the east of the present site of Yuendumu which was his principal totemic site.[7] He and his Nakamarra wife had two sons and a daughter, who were grown men and women, with wives and husbands and children of their own, at the time of these traumatic events in their family history. The baby who had survived the massacre was adopted into the family of their younger son Jajirdi (Tjatjirti) Tjungurrayi, whose third wife Long Rose Nangala was the sister of the murdered woman. The infant survivor would later be known to the rest of the world as the painter Billy Stockman Tjapaltjarri. He not only survived the Coniston massacre, but outlived almost all the other founding artists of the Papunya school, including his younger 'brother' Clifford Possum, who was Jajirdi and Long Rose's second son.

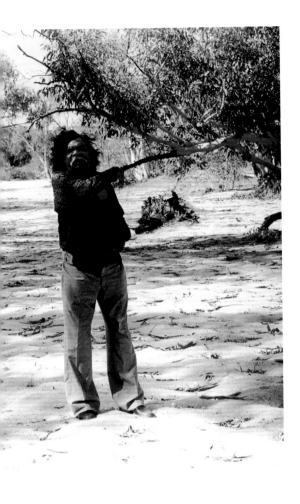

above: Clifford Possum in the bed of Napperby Creek pointing out his birthplace, 1996. Photo: Adam Knight

Possum Country, 1976, synthetic polymer paint on canvas board, 50.5 x 40.3 cm; South Australian Museum, Adelaide

In the world beyond the Western Desert, it was the Great Depression — 1930 was the date originally suggested to me by the artist as the year he was born, although there is no way of knowing for certain.[8] The birth of a baby boy to one of the extended family groups living on Napperby lands was an event to which birth registrars of the day had no access. As he used to say, 'I know only my borning place. I don't know what's the time.' That place was the bed of Napperby Creek, near the safety of the station house, some fifty kilometres south-east of Altjupa. His parents called him Upambura after his paternal grandfather and because the site of his birth was associated with the travels of another Upambura, the old Possum man of Napperby Station. Although he would grow up to travel the world as extensively as his ancestral namesake traversed the length and breadth of Anmatyerre country and well beyond its borders, Clifford Possum's early childhood was spent in the company of his extended family, living off the land on the west side of Napperby Station in the manner of their ancestors.

> After that I grow up in the Napperby, one place. Grandfather, grandmother, my daddy and mother were there first. We been living on only this bush tucker: alyatji and pulapa, nyimaji — and yindrrnga, nguulu, irrditja — mulga seed [to make a sort of cake].[9]

They were not intruders in this space. One of Jajirdi's many connections to Napperby was a waterhole called Ngapatuka — or Beantree, a few kilometres north of the station homestead, which the artist described as a 'secret place':

> Big story — high school. I'm boss today for this corroboree, and my two daughters and my grandchildren.

In this waterhole, several varieties of water creatures, which the local people call fish (though in the artist's diagram they looked more like tadpoles and ticks), appear after heavy storms:

> We call'm, fish. He sleeping on water and wet sand. This kind and another one with a big tail. At Napperby. From the creek. Sometimes, at big storm time, they come out. How come? Really big ones. Just appear from nowhere after storm. We cook'm on the fire.

Once the fish were always in the waterhole, until one day the Magpie Dreaming from Warri Warri (near Mount Allan Station) belonging to the artist's father, flew across to Beantree Waterhole and ordered them out:

> From Mount Allan, that magpie — big black and white bird — we call him Ngurpurlu Ngurpurlu. He came to Napperby, to Beantree Waterhole, and he tell'm all the fish, 'Get outta here! Get out of that you mob!' All the fish get out, go to running water, at Hermannsburg. But when it rains they come back.

A third child was born to Long Rose and Jajirdi, a daughter Lily. The country was still suffering from the effects of the drought, and the young Upambura's training from childhood in the skills required for survival in the arid Anmatyerre homelands was taken at a time when they were honed to their sharpest. Intimate knowledge of terrain, highly tuned senses, and an attitude of self-sufficiency stayed with him for the rest of his life. So did the childhood

memory of his father's death, recounted to the writer within a few months of his own:

> 'He passed away in the sun. No water. I was there. Sitting. Whole lot: mummy and all that, brother.[10] We cry and then we go. We lost him. That's why.'

It is a measure of his intense privacy about the details of his personal life, that I had known Clifford Possum for more than twenty years[11] before he told me this story and the identity of his 'real' father, the man through whom he had inherited the rights to country and Dreamings he had proclaimed in countless paintings. It was an unexpected revelation, which unravelled my previous understanding of his early life. That Sunday afternoon in April 2002 he phoned me from the Alice Springs hospital bed where he lay trapped by his physical weakness, isolated from all the worlds in which he had been such a vivid presence for so long. As we talked on, I raised the subject of his connection to the man so often described as his brother, Tim Leura Tjapaltjarri, whose death in 1984 had marked the end of one of the most inspirational artistic partnerships in Western Desert art. Were they 'really' brothers, I had asked, or 'brothers' in the Western Desert sense of close relatives who have been together in the initiates' camp and share the same skin name? Did they share the same father? No, he said – and professed to know nothing of a man by the name of Barney Turner Tjungurrayi whom Geoffrey Bardon had identified in one of his books as Tim Leura's 'father'.[12] Tim Leura's mother, he told me, was Long Rose's sister Maggie, who was also the mother of Clifford Possum's brother Cassidy. His 'real' siblings – from the same father and mother – were his older brother Immanuel and his 'little sister' Lily. I had thought I already knew who Clifford Possum's father was: we had often discussed the crucial role the man known as One Pound Jim had played in his life. But, he now told me, though he 'grew me up', One Pound Jim was *not* his real father, who had been 'living in Coniston' he said. 'He passed away in the sun – no water'. I asked him this man's name. He had never had a 'European' name, he was 'too rough' – but 'not too much'. What was his father's tribal name? There was a long silence. It seemed he was trying to remember (or perhaps he hesitated to tell me), but finally he said 'Jajirdi. Jajirdi Tjungurrayi'.[13] He had the same reticence about the circumstances in which he lost the sight of his right eye, of which he would say only 'Ah, little one.' – meaning this had happened in his infancy and, 'No. No doctor'.

Following Jajirdi's death, his older brother, Jimmy Tjungurrayi, who had married Long Rose's sister Emily, cared for Long Rose and her family. Both women were from the Fire Dreaming place of Warlugulong (Warlukurlangu) in what were then the most westerly reaches of Anmatyerre country. The group was still living off the land, but moving further south and eastwards and beginning to supplement their traditional diet with the new foods being offered by the European settlers. As part of the official policy at that time of discouraging Aboriginal visits to Alice Springs, Jay Creek and other government ration depots were established at a radius of fifty to 200 kilometres from the township. The depots bought dingo scalps in return for cash and European food and clothing.[14] This practice had the unintended consequence of attracting

Possum and Rainbow Snake, 1976, synthetic polymer paint on canvas board, 50.5 x 40.3 cm; South Australian Museum, Adelaide

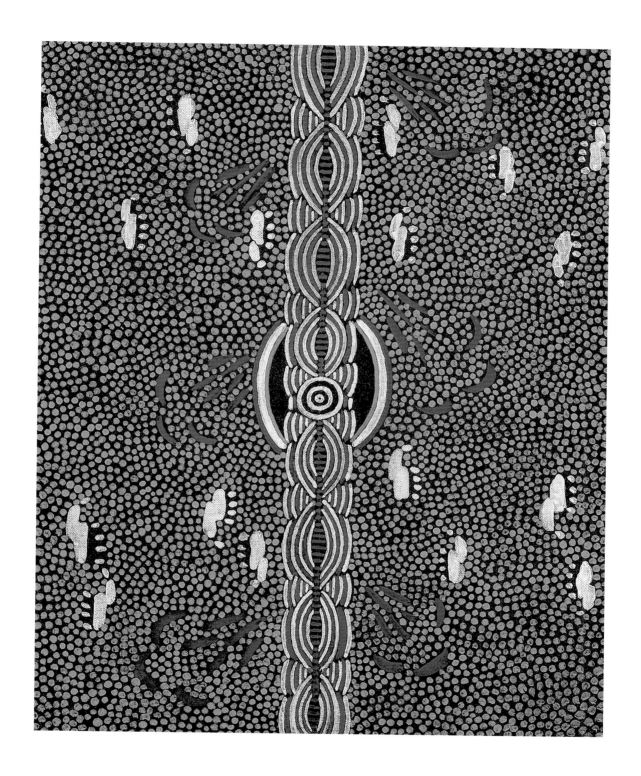

people in from further west, including Warringi's family group:

> Grandfather and mother been selling dingo skins – they been proper really clever – they catch'm with spear and boomerang – catch'm and scalp'm and take scalps – and sell'm and get flour and sugar and all. And catch'm the puppy dog – them little ones – and scalp'm and take'm, sell'm – that's why we come this way, Jay Creek – walk. We bin livin on only this bush tucker – goanna, kangaroo – bush tucker – mana, ipalu and all – and ngamanpurru, pulapa – then we come up and sit down here – we havin' plenty flour in Jay Creek.[15]

'The child who was saved'

The Second World War came to Central Australia in the early 1940s, transforming Alice Springs from an isolated frontier town to a military garrison hosting close to 40,000 Australian and American troops. The *laissez-faire* policies of the ration times came to an abrupt end. The Native Affairs Branch embarked on a program of relocating the Aboriginal population onto government-administered settlements where the men could be recruited for army work gangs. A Northern Territory policeman named Vic Hall, who had played a prominent part in this process, was appointed the new Superintendent of Jay Creek and charged with the task of maintaining the unprecedently large and diverse community of tribesmen and women who were resident there by the end of the war.

> They been mustering all the people. War coming and Native Affairs shifted everybody to Jay Creek. From Stuart Highway, from every station, before the war start. Every station, that Mr Hall was mustering. Walking out or the camel. Big mob, from every soakage, pick 'em up. He was carrying people prisoner, got an old jeep, took everyone. I seen him in Napperby. I've been livin in the Napperby – I been get big there – like Lionel. We shifted out from Napperby. We start walk this way to Jay Creek.

The place had much to recommend itself to Clifford Possum's family after the deprivations they had suffered. Vic Hall had earned the love and respect of the Jay Creek community for his humane treatment: 'he does not beat our folk; he speaks kindly to our community; he also gives out medicines in a friendly way to the sick; he is always well-disposed towards us.'[16]

Perhaps it was the kindly superintendent who drew the attention of Pastor Albrecht, the Lutheran missionary in charge of Hermannsburg, to the signs of severe malnutrition in the young Upambura or 'Possum' as he was then known to settler culture. 'Pastor Albrechta', as he was known to his Indigenous flock, was a regular visitor to the ration depot. He judged the boy's condition serious enough to bring him back to the mission for treatment. There he was given a series of injections which probably saved his life. Pastor Albrecht's daughter Hélène Burns, who told me this story over half a century later, spoke of it as 'one of our Heavenly Father's miracles, that he was the child who was saved'.[17] As soon as he was well enough, Pastor Albrecht took the child back to his mother. Hélène gave me a photograph of the young Clifford Possum from the

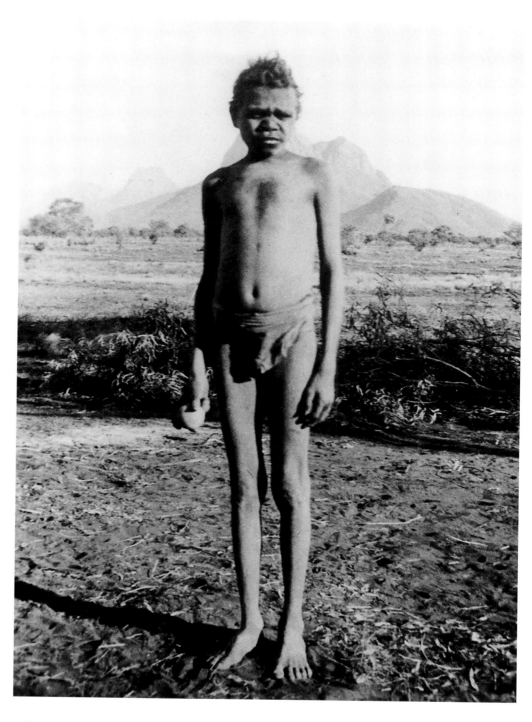

The child who was saved; Hélène Burns'
photo from the Albrecht family album
of the young boy she believed to be
Clifford Possum Tjapaltjarri, who was
brought in for medical treatment to
Hermannsburg by her father.
Rephotographed: Colin Hentschke

Albrecht family album as a memento of the episode. It shows a thin, worried-looking boy, wearing only a loin cloth, holding what looks like an orange in his right hand. Neither of us noticed at the time that the landscape behind the figure was Haasts Bluff – not Jay Creek, or possibly Hermannsburg, as Clifford Possum's account of his life would suggest it should have been.[18] There is no way now of knowing when or even if Clifford Possum was in Haasts Bluff as a child, but for Hélène Burns the photograph was a potent symbol of the lifelong association between the artist's family and her own.[19]

Clifford Possum spoke warmly of the missionary and the powerful effect on him of the doses of Christianity which had been an inseparable part of Pastor Albrecht's ministrations:

He teach me. Teach'm all the Jesus way. I want to be pastor too.

The same desire to be a pastor later gripped Clifford Possum's older brother Immanuel. To achieve it, he learned to read and write in his early twenties, and studied for his ordination with Pastor Albrecht at Hermannsburg. He lived an exemplary life ministering to the Anmatyerre as a Lutheran pastor at Napperby and later Mount Allan Stations until his death in the mid-1980s. Though Clifford Possum's interest (or sense of indebtedness to the Hermannsburg missionary) was initially stronger than his brother's, Pastor Albrecht's younger pupil did not grow up to pursue the ecclesiastic path. However, the instruction (including baptism) he received at Hermannsburg was not forgotten. This story of how Pastor Albrecht saved the artist's life as a young child and taught him about Christianity was unexpectedly revealed by a question about how he decided which Dreaming to paint in his next picture. Without hesitation, this answer came:

> Most of it, God give idea – thinking. Do it this way, that way. Even whitefellas. You got only this. But this Dreaming, that's God for us.

Clifford Possum never saw the inside of a European schoolroom – in his later years he would defiantly call himself 'myall', a derogatory description which the previous generation of settlers had applied to tribesmen and women untutored in European ways. But the Jay Creek school teacher took the time to encourage the young Possum in his experiments with modelling figures in clay – or 'wet sand' as the artist called it. Art historians like to dwell on these sort of vocation–forming childhood experiences, but in this instance the episode may be more illuminating of the artist's wry humour and keen sense of the ridiculous:

> You know, I start from wet sand first – a little boy at Jay Creek. Making men or bullocks. I draw pictures on before I put them in a hot fire. Mix'm up with glue and everything. Put'm under fire and they melt, and be like glass. But he don't come out! But this time, everybody gotta work whitefella work, mix'm all up, but he don't come out. Break'm. [*laughing*] Sometimes I using long wet stick from gum tree, or might be mulga. I also put wet sand – clay. Might be bad people walking out – I hit him. Really! [*hilarious laughter*] Just like bow and arrow, might be shanghai. Yeah! I catch'm.

Losing patience with 'wet sand' as an artistic medium, the boy began his first experiments with carving the figures in wood and was more satisfied with the results, which he remembers proudly showing to 'Pastor Albrechta'.

Clifford Possum's brief stay at Hermannsburg would have overlapped with the early career of Pastor Albrecht's famous artistic protégé, Albert Namatjira. That story began one Saturday afternoon in 1934, when Rex Batterbee and John Gardner mounted an exhibition of their watercolour landscapes of the desert on the whitewashed walls of the Hermannsburg schoolroom:

> Amid all the hubbub, there was one man going around with a serious face and a deeper interest, studying this and that more intently. Finally Albert came up to me, gave me a bit of a dig, and said, 'What do these men get for paintings like this?' When he was told from two to twenty guineas he replied, *I think I can do that too.*[20]

Rock Wallaby Story, 1976, synthetic polymer paint on canvas board, 61.0 x 45.5 cm; National Museum of Australia, Canberra

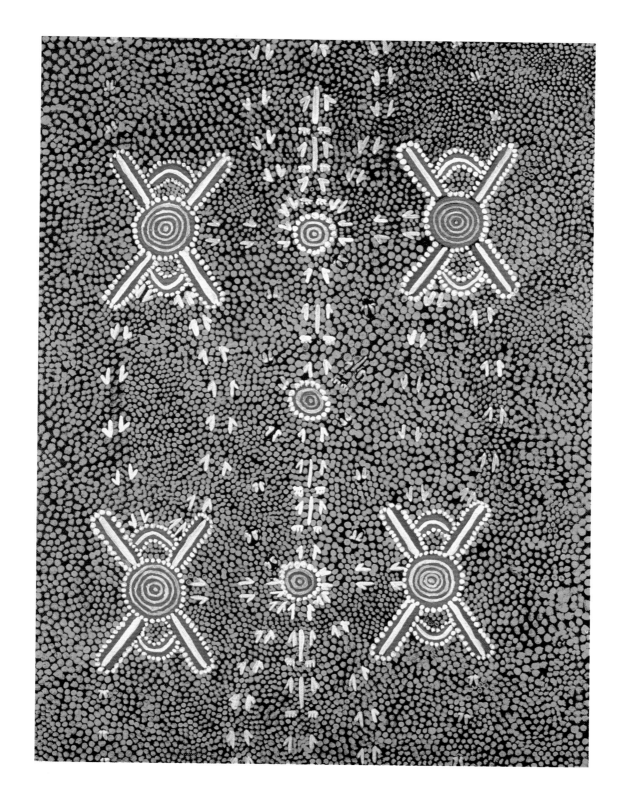

That was the moment of conception, in which Albert Namatjira dared to dream the impossible dream of becoming an artist. Within ten years, he had realised it – beyond the wildest dreams of his white mentors. He had his first solo exhibition in 1938 in Melbourne and was well on the way to becoming a national figure by the time the Second World War reached Central Australia and Clifford Possum's family took up residence at Jay Creek. The lands around the ration depot contain some of the most majestic scenery in Central Australia. Namatjira frequently visited the area on painting trips with his fellow artists, and occasionally called in at the settlement to pay his respects to the superintendent, who dabbled in watercolours himself. (Even in those times, art supplied a meeting ground for the two men, presenting in microcosm its potential as a medium for attitudinal change.)

> I was a boy at that time. I seen him. He was drawing every mountain in Jay Creek.

The boy's curiosity had been aroused by Namatjira's comings and goings, but not for another decade would the paths of these two key figures in Central Australian Aboriginal art actually cross. Another event closer to home would for now touch Clifford Possum's life more deeply. Long Rose married again. Her new husband was a Tjungurrayi man from Mount Doreen in the Ngalia Warlpiri lands which border Anmatyerre territory to the west. He was known to his countrymen and women as Gwoya,[21] though everyone else, including his adoptive son, referred to him as One Pound Jim. Strangely enough, his path had almost crossed with Long Rose's a decade earlier during the 'killing times'. Certainly his life was just as deeply affected by those events:

> 'One Pound Jimmy' is a reminder of a black page in the history of native affairs in Australia, for he escaped from Brooks [sic] Soak in 1928 when the police felt impelled to fire on a tribe of natives, resulting in most of them being wiped out. Afraid to return to his home country, Jimmy remained for some years in the Arltunga district; subsequently his fears were allayed and he went back to the Hamilton Downs–Napperby country, north-west of the centre.[22]

The Coniston massacre was not one scene of death but many, spread over a wide area and a number of years. When questioned about One Pound Jim's experiences of the massacre, Clifford Possum recounted the family's version of this story, which emphasised the courage and cleverness of his new 'father'. In his account, One Pound was actually taken prisoner by Murray and his men:

> They arrest him – he was all chained up. They carry him round to show'm every soakage. They leave him and another old man tied up on a tree, big chain. And after they put leg chain too. They leave him there. Then everybody go out and shoot all the people – family, kids. They come back and see him – nothing! This chain he broke'm with a big rock and he take off. He run through Stuart Highway to mine. Couple of Alyawerre people from that country get him job at mine. That Murray, who shoot'n everyone, he come up to mine place and he see'm. 'Hey! That's the one!' He ask the boss, 'That's the man.' The Alyawerre tell'm 'No, that man, he from this country. He was working here.' That man Murray ask him, 'Get away! Looks like him.' But my father say, 'I don't know'. – *That's the one!* [*hilarious laughter*]

As his name suggests,[23] One Pound Jim also had a keen grasp of the new cash economy. By the time he met Long Rose, he had created a niche for himself as a guide to anthropologists and other Aboriginal enthusiasts of the day (including Ted Strehlow):

> My father was working as a show'm-round-countries: 'You know what this one mean?' – Dreamings, all that. He used to show'm round every soakage, every Dreaming place. People take picture. Around Mount Wedge and everywhere he went. I was at that time a kid.

One Pound Jim's job as a 'show'm round countries' demonstrated to his adoptive son that occupations existed in settler culture in which an Aboriginal person could have the respect of his employer for competence in his own culture. The lesson about the survival value of Aboriginal 'cultural capital' in the rapidly changing circumstances facing the next generation was not lost on his youngest 'son'.

'Grow up in stock camp'

The first few decades of Clifford Possum's life coincide with the heyday of the cattle industry in Central Australia. A twenty-year tax exemption for all primary producers in the Northern Territory was announced in 1934 to encourage pastoral and mining investment. New leases were made available for application, creating a patchwork of stations to the west of Alice Springs around the MacDonnell Ranges. A series of bores were sunk in the early 1940s between the MacDonnell Ranges and Haasts Bluff to provide watering places for travelling stock. This enabled stations along the stock route to undertake crash development of watering places, yards – and the fences which wrought such havoc with the ecological balance on which Western Desert society traditionally rested. But the wandering herds which had displaced his father's generation from their ancestral lands would supply their sons with a new means of subsistence.

The new owners of Hamilton Downs Station, adjoining Jay Creek Aboriginal Lands, were keen to develop the lease. The Aboriginal camps at Jay Creek were an obvious source of supply for the labour involved in the upgrading process. When One Pound Jim took a job as a stockman on Hamilton Downs Station, his new family went with him. Not yet into puberty, Clifford Possum Tjapaltjarri soon found himself recruited:

> I was still a boy – I get job at Hamilton Downs. Everything, do my chore. Mustering all the clean skin cows. Then branding – put mark on ear. Because another mob travelling might come along and pick him up. Not allowed – because that's Hamilton Downs cattle.

Another of his early jobs was watching the cattle to see that none strayed or were stolen. His claim that he never lost one is probably true: if you did lose one, you were fired.

Droving trips to Alice Springs provided Clifford Possum with his first sights of the rapidly growing frontier township of Alice Springs. He recalled excitedly

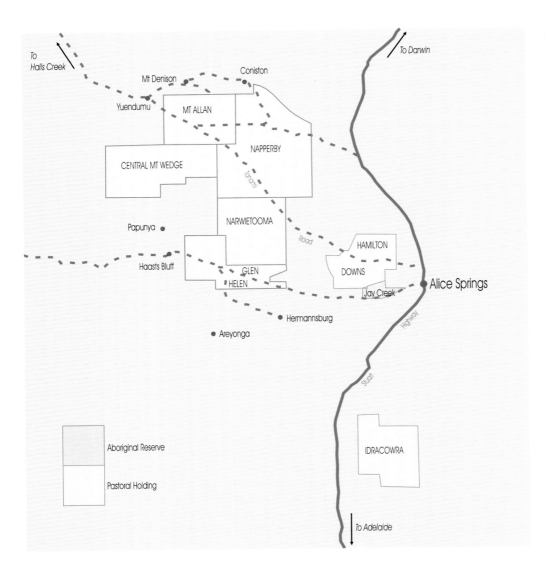

Map of stations where Clifford Possum worked as a stockman *c.*1940–1975.

how they used to drive the cattle 'right up!' to what is now the middle of town. The cowboy culture which went along with stockwork provided youthful Aboriginal workers with a tough image and a measure of personal freedom. However, the reality of their status in Central Australian society would have been brought home to the stockmen every time they took a herd into Alice Springs and were refused the right to stay there. When the artist said he started to 'grow up' in the stock camp at Hamilton Downs, he was not talking about becoming wise in the ways of that world.

> After that, I went to Napperby again – bin get young man [initiated] – I bin there [ceremonial camps of initiates] probably two three months. I bin learn that corroboree – that story – they bin teach me in bush.[24]

An Aboriginal stockman was not thereby cut off from his birthright in the Dreaming. The seasonal character of station work permitted Aboriginal stockmen to fulfill their traditional ritual obligations without interfering with the demands of regular employment – as was the case when Clifford Possum was 'made man'. During his months of seclusion in the bush camp of the initiates, he learnt from his paternal uncles the secret–sacred meanings of many of the stories that he later painted: mala (spinifex wallaby), malu (kangaroo),

sugar ants, warru (wallaby), snake: 'I bin catch'm all them story'.[25] Afterwards, he returned to his job at Hamilton Downs for another four years.

The mobility of the horseman also permitted Aboriginal stockmen greater affinity with more extensive tracts of country than could ever have been possible to 'footwalking' tribesmen in the pre-contact era. Possum's next job took him to Idracowra Station, due south of Alice Springs, a hundred miles from the border with South Australia. This was historically the territory of the Southern Arrente, but its occupiers were now Pitjantjatjara, a group universally feared and respected by surrounding tribes for the strength of their adherence to tribal law. During this time Clifford Possum learned Pitjantjatjara, one of the five Aboriginal languages which he spoke[26] in addition to his first language Anmatyerre. The Idracowra job was mustering wild horses: catching a herd of brumbies near Port Augusta in South Australia and driving them over a thousand kilometres north and into Alice Springs. The whole trip took three months, for which they were each paid thirty pounds – 'small money (tjuku tjuku)' for the dangers and deprivations involved, but far more than they could earn from regular stockwork.

The contacts made while working at Idracowra were underpinned by the artist's connections through the Dreaming to Pitjantjatjara country. The epic journey from Port Augusta had resonance for Clifford Possum with the powerful lessons of the initiates' camp and the father he had lost. The first site he told me about after he said 'I'll give you all these soakages – my daddy's place, everything' was Mungapunju, a soakage about ten miles east of Yuendumu alongside the Tanami Road (also known nowadays as Ten Mile Creek for its distance from the Warlpiri settlement). Mungapunju, he told me, was the site of an ancestral confrontation between the southern rock wallaby men and the northern possum men. The story of these rock wallabies had belonged to Jajirdi: they were Tjungurrayis like him. Their journey, which figured in so many of his son's paintings, also began far to the south at Port Augusta. The rock wallabies travelled in groups, stopping to drink and eat the plentiful grass at various soakages along the way:

> My father's rock wallabies, they had come from Port Augusta right through, through Haasts Bluff Creek, across through Papunya, right through a place called Yulitjulku in the sandhill country – Mount Wedge, that's Kerrinyarra, to Ten Mile Creek, between Mount Allan and Mount Denison.

The possum men were already at Mungapunju, holding 'malliera' for the Possum Dreaming. When the rock wallabies burst in on these ceremonies a fight ensued, in which the possum men used their spears (kulata) and boomerangs (kali) with devastating effect against the rock wallabies, who were armed only with spears.[27] Eventually the opposing sides called out to one another that they had had enough of fighting and were ready to exchange ceremonial knowledge. They established a big corroboree camp at Mungapunju, painting up with red ochres from the ochre pits of nearby Yakuti, which also belongs to the Tjungurrayis and Tjapaltjarris of Clifford Possum's descent group. The artist described the ground at Mungapunju as being levelled from the corroboree

camp, 'just like a grader been working from this possum and rock wallaby mob schooling one another'. After their ceremonies together were over, the rock wallabies continued northwards on their journey, while the possum men stayed at Mungapunju. The whole area was known as good possum country before the settlers arrived, attracting also the old Upambura possum man from Napperby whose journey to Pitjantjatjara country in search of a wife crossed the path of the Flying Snake Dreaming from Altjupa at Mereeni Range, a 'big mountain through Haasts Bluff creek'.

After the malliera ceremonies at Yunkurru, the Flying Snake Dreaming took flight again, landing at another soakage named Ngyatitjangyi on what is now Derwent Station, near Papunya settlement. The two rainbow snakes then continued their journey south, still forming freshwater soakages and watercourses as they went until they reached Mereeni Range, where they encountered old Upambura and his new Pitjantjatjara wife.

> Yep, from Napperby, possum go to Uluru. He called 'lover man', and he going south to get Pitjantjatjara kungka – young woman. He go and pick her up and bring her back to Napperby. Funny one. [*more laughter*]

The ribald humour which the artist indicated in the telling is invoked in his paintings by the ambiguity of the distinctive possum tracks, which show the animal's versatile claw-like foot structure, separated by a sinuous line which is generally said to be made by the possum's dragging tail. Several of the Papunya Tula annotations of Clifford Possum's paintings suggest that as possum ancestors are so often depicted as 'lover boys', there is also a likely reference to the drag marks of the possum's penis in this symbol, enlargement of the sexual organs being one of the common repercussions of too much ancestral philandering.

Accompanied by his Pitjantjatjara 'kungka', the old possum man began the long journey back to Napperby. The couple travelled up through 'Areyonga way', going underground to emerge at Mereeni Range, where they were shocked to discover the two rainbow snakes making a home for themselves under a rock.

> They see'm these two rainbow snakes making place of Mereen. To stop there. That possum came by going to Uluru before the two rainbow snakes put up a home. But now he's coming back and he sees the two snakes. Why two rainbow snakes making place under the rock, like a room – a really big cave them two had made? he thinks. 'Eh! You two not allowed to do'm here in this country. You two from north. You not allowed to stay here!' And those two, they couldn't stay. They went right back to Lajamanu where they came from and stayed there.

Having expelled the intruders, the old possum man and his companion continued on their journey back home to Larumba – as the Napperby area is known to the Anmatyerre.[28]

Young Possum Tjapaltjarri was also making his way back to his ancestral homeland. The stations where Clifford Possum worked in the late 1940s and early 1950s lie on a curving trajectory from Jay Creek back to the country of his father's fathers around what is now Mount Allan station, 200 kilometres to

its north-west (see map pp. 22–23). After Idracowra, he moved north-west to Glen Helen Station, on the western side of Hamilton Downs, then north again to Central Mount Wedge Station, whose northern boundary cuts into the southern edges of Anmatyerre country. The old Mount Wedge homestead actually lay within a few miles of Yunkurru soakage, to which Clifford Possum, as an initiated man whose Dreamings at Altjupa are connected with the Rainbow Serpent initiation ceremonies performed there, also had significant ritual obligations. After Central Mount Wedge, he came to Mount Allan itself. In 1948 a lease had been taken out over the land, on which there was at that time said to be no local population. The lease holder recruited Aboriginal labour with customary responsibilities to the Mount Allan area from Yuendumu and neighbouring stations to re-settle the land and build up the cattle operation. After a season at Mount Allan, Clifford Possum spent some time working at Narwietooma Station, before finally turning his horse towards Napperby to spend a well-earned break with his family.

Nine long years in his own estimate, since he was a boy with 'no whiskers', Clifford Possum had been working as a stockman away from relatives and countrymen for long periods. The experience may have helped form a kind of personal independence: the freedom of the loner accustomed to living without close ties, which is evident in the biographies of many former stockmen turned artists, but nowhere to such a high degree as in the life of Clifford Possum. His stockman's pay, starting at five pounds, had risen after all those years to a princely ten pounds[29] – meagre reward for a year's work! Is it any wonder that the young man's thoughts turned, like Albert Namatjira's a generation before, to the idea that art might offer a better way of making one's living?

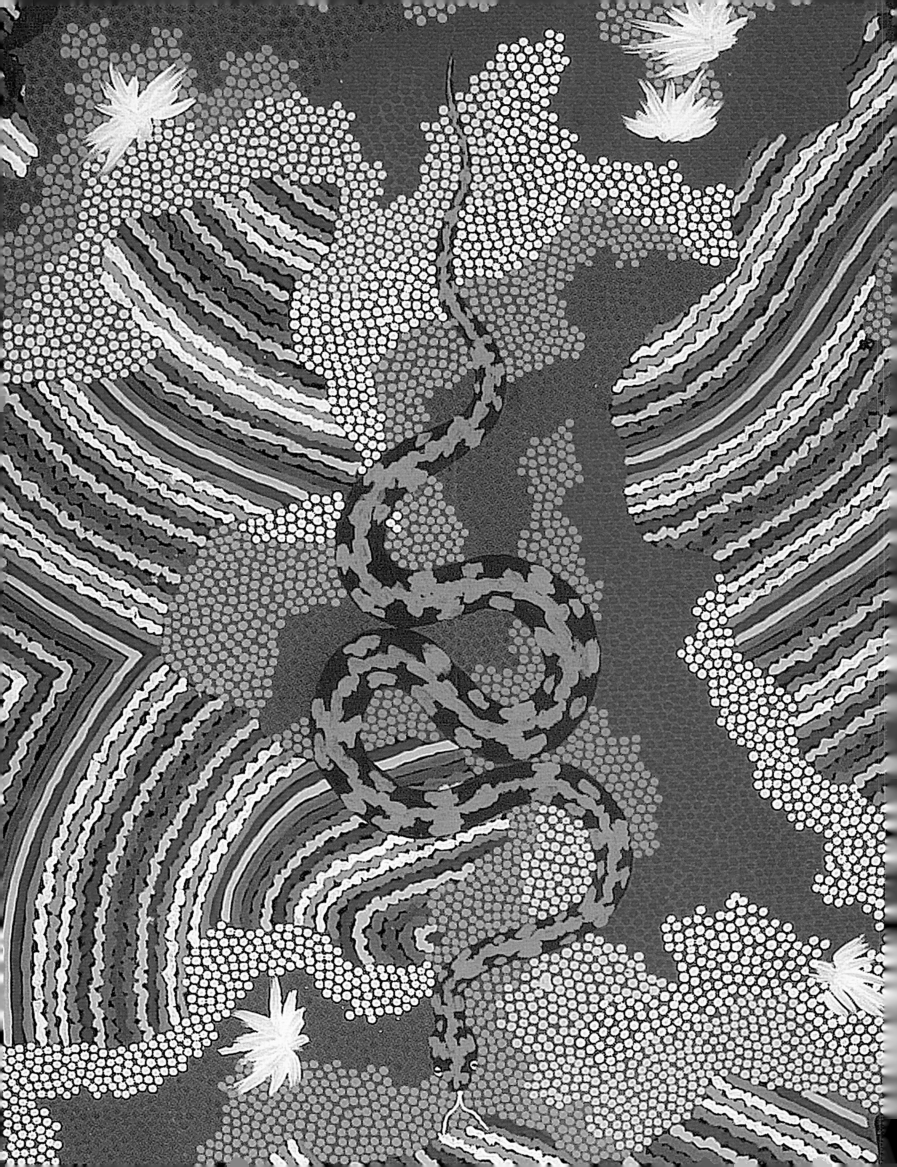

Start from carving

> After that I been go back work Napperby – then we get holiday – at Napperby – and I pick'm out idea! I start from tree like this – I cut'm with the axe and tomahawk – I start make'm saddle first – from wood.[1]

While the precise date is uncertain, Clifford Possum here pinpoints the exact time and place in his personal biography at which he decided to become an artist. He was by his own account 'round about sixteen', as he sat beneath the red river gums that line Napperby Creek, carving away with intense concentration at a tree trunk in which he had seen the sculptural form of his first serious artistic creation. For clearly, Clifford Possum's 'idea' of his vocation as a carver went beyond the expectations of the emerging tourist trade in Aboriginal artefacts. This was no suitcase–sized throwaway knick-knack he was making, but a wooden saddle fashioned from red river gum – fitting monument to the stockman's life whose transcendence it implicitly announced. Ironically, his adoption (after a Lutheran pastor who was at Napperby Station in the early 1950s[2]) of the name 'Clifford' by which he would subsequently be known to the European art world coincided with these first steps in his trajectory towards it.

Clifford Possum did go on to carve hooked boomerangs from mulga wood and coolamons for babies in softer wood, just as his grandfather had before him, as well as various snakes and goannas for the souvenir trade. 'People say in the stock camp – I'm always doing my carving after knock off.' This sort of artefact production was interspersed with more striking and ambitious pieces like the saddle: he remembered particularly a snake standing up ready to strike a rabbit; a baby lying smiling in a coolamon; a camel and its rider, complete with pack saddle and swag. His brothers Tim Leura, Billy Stockman and Immanuel Rutjinama were also skilled carvers, whose example presumably spurred the younger man's ambitions for his own work in this medium.

Declining the mantle of Namatjira

For someone trying to make a living from selling carvings to the tourist trade just beginning to develop in Central Australia, Glen Helen Station was a natural destination. Bordering on Hermannsburg Aboriginal lands in the south, it provides some of the finest scenery in the Centre, including Glen Helen

Carpet Snake Dreaming, (detail), c.1991–92, synthetic polymer paint on canvas, 210.0 x 127.0 cm; Peter Los Collection

Gorge and the Ormiston. In the early 1950s, the station owner built Glen Helen Chalet, one of the first tourist ventures in the Centre, to accommodate a small but growing stream of visitors drawn by the Hermannsburg artists' depictions of the surrounding country. This development in turn expanded the local market for the artists' work. So it was logical that Clifford Possum should head for Glen Helen after he had finished his wooden saddle.

Albert Namatjira was a frequent visitor to the station in the early 1950s, and it was on one of those visits that he and Clifford Possum became acquainted:

> I seen him that Namatjira – drawing all the gum trees. He try teach me watercolour paints that old man Tjungurrayi. I tell him no. I already start work – carving. He been livin' in Glen Helen – that tourist mob – Glen Helen Gorge – I got it from them Namatjira's son – he give me watercolour – I start painting boomerang – and then ukurrukurru [women's dancing board] I start painting – I been doing carving and sell'm. I been getting good money – from tourist people you know – yeah – I been doing watercolour with the boomerang – use'm them kangaroo, them euro, them tjampi, them watia [grass and trees].

Apart from decorating his carvings with these sort of naturalistic images, Clifford Possum denied ever painting in the manner of the Hermannsburg artists. However, he did draw landscapes in this style with coloured pencils:

> No. Only one time. Rest of time pencil. All pencil. All the colours. Might be mountain, might be waterhole there, trees, man might sneak up on kangaroo – all those things.

His fellow artist and friend since childhood, Dick Lechleitner Tjapanangka, backed up this assertion. He remembered that they used to paint dots rather than kangaroos on the boomerangs they carved to sell while working as stockmen at Narwietooma Station, before any painting began at Papunya.[3] Others recall a time, some years later, when Clifford Possum did paint a few 'Namatjira style' landscapes with encouragement and materials supplied by his brother Immanuel at Napperby Station.[4] However, the artist discounted the significance of his excursions in the medium of watercolour (as he did his boyhood experiments with 'wet sand' at Jay Creek) to his later artistic development. Interviewed by CAAMA[5] in the late 1980s, he was emphatic on this point: 'I don't do landscape painting'. As far as he was concerned, carving was his artistic starting point, and he would not be deflected from it. Not even by an offer from the most famous artist in all Central Australia – and indeed all Australia at that time – to follow in his footsteps.

> See – Namatjira asked me, 'You want learn watercolour painting, carry on my work?'. But I said, 'No No. I do it my way. Carving – start from carving'.

When he met Clifford Possum at Glen Helen, Albert Namatjira was about fifty years old,[6] and may well have sought to put his stamp on future developments in Central Australian art in this manner. Perhaps he said similar things to other young would-be artists amongst his tribesmen, although those who knew him well doubt this.[7] As a Tjapaltjarri, Clifford Possum was his

Mt Wedge and Lake Leura (Napperby Lakes), 1988, pencil on paper, 56.0 x 76.0 cm; Private collection

classificatory 'son', an appropriate person on whom to bestow one's lineage.[8] The young man's talent and determination must have particularly impressed the older artist for him to have gone outside the previously closed circle of Arandic watercolourists in this attempt to enlist a protégé. Because of the bonds of co-residence with Arrente people which Clifford Possum's family formed while living at Jay Creek, his tribal affiliation has sometimes been cited as Anmatyerre/Arrente.[9] However, as far as he and his Anmatyerre fellow artists were concerned, they were Anmatyerre, pure and simple. Their territories, unlike those of tribes living further to the west, had firm boundaries – or as Clifford Possum put it, 'We live in shape. We keep in shape – like India or Germany, England, Japan – like that'. Namatjira's offer implicitly opened the school of Hermannsburg – and the vocation of artist – to tribesmen (and women) of other language groups. This was a new idea, ahead of its time. Apart from this offer to Clifford Possum, there is nothing to indicate that membership of the original group of Hermannsburg painters was at that time open to non-Arrente people. On the contrary: Rex Batterbee, travelling these parts with Albert Namatjira on a painting expedition in about 1950, noted that:

> Loritja, Pintupi, Pitjentjara and Ngalia tribes in this area who are still intact but living in a more primitive state than the Arunta people ... are becoming interested in the success of the Arunta men. They too want to be artists. It is to be hoped that they will also have their chance to show any ability or latent talent they may possess. Who knows but that some of these men may show us a new form of art?[10]

Clifford Possum's refusal to limit his own vision for the privilege of one day wearing the older artist's mantle, is the more remarkable for the offer having been made in this way – across the tribal boundaries which he compared to national borders. Even Namatjira, despite his then unrivalled knowledge within Aboriginal society of the ways of the European art world, could not have perceived the inherent limitations of a place within another artist's lineage, and neither would Clifford Possum. His genuine love of carving must have played a part in this: he never dismissed it from his conception of himself as an artist in the way he did clay modelling or painting watercolour landscapes. He would happily have carved again, but as the years went by the soft bean tree wood that he used became too difficult to obtain. Besides, there were too many other carvers: 'I seen them from every country – no chance mine, I got painting job to do'. Nevertheless, as we shall see in later chapters, though he adopted neither Namatjira's medium nor his approach, Clifford Possum did ultimately carry on the tradition of Aboriginal landscape in Central Australia which Namatjira began – but in his own inimitable style.

The image of Aboriginality

Not long after he had invited Clifford Possum to join him painting at Glen Helen, Namatjira took up more or less permanent residence on the outskirts of Alice Springs at a place known as Morris Soak. It was one of the illicit camps established in the early 1950s by the Hermannsburg artists in defiance of official

decrees still excluding Aboriginal people from the town. The camps were sparked by the refusal of Namatjira's application to build his own house on land he had bought in Alice Springs. The lifestyle of the town-based watercolourists, which more and more came to signify social delinquency to authorities in Alice Springs, might be supposed to have exercised some attraction for a teenager accustomed after nine years of stockwork to the idea of living it up while in town. White authorities of the day who described scenes of 'drunkenness and debauchery' at these camps, expressed their concern about the effect of the potent alternative image of outlawry which they offered the next generation of Aboriginal artists.[11]

However, Clifford Possum had other business to attend to than the attractions of this new form of Aboriginal bohemianism. His long lost father, Jajirdi, had a mantle to bestow on his younger son which meant more to him than the one held out by Namatjira. Obeying the strict rules of his Anmatyerre upbringing, Clifford Possum returned from Glen Helen to the lands occupied by his family for generations, to his fathers' and grandfathers' Dreaming place at Altjupa. There he took his place in post-initiatory rituals or 'malliera' for the Flying Snake Dreaming as the Tjupurrula/Tjakamarra custodians handed over responsibility for the Rainbow Snakes' journey to the next generation of Tjungurrayi/Tjapaltjarri custodians.[12]

> First of all Tjupurrula and Tjakamarra – that's for them mob. If they want to get ready, we got to help them, shift him round, go get water, bring him up. That's the law. I gotta work for this man.
>
> They keep following, singing corroborees – Two Rainbow Snakes. That snake place called Ilyndita – really wide rock – north from Altjupa. Tjakamarra and Tjupurrula, they hand him over for me and my daddy, or me and my son – Tjapaltjarri and Tjungurrayi. We boss right through from Brookes Well. Then they got to get all ready, doing job. Might be doing sand painting, take the shirt off me. [*laughing*]

Tjungurrayi/Tjapaltjarri are custodians from Altjupa south to Yunkurru near Mount Wedge Station, where the Dreaming is handed on to yet another group of custodians, in the richly interwoven fabric of spiritual ownership which binds together all the peoples of the Western Desert.

One Pound Jim also had a legacy for his adoptive son: his celebrity in the world of settler culture. In the early 1930s, Charles H. Holmes of the Australian Geographical magazine *Walkabout*, met Gwoya Tjungurrayi at the Spotted Tiger mica mine east of Alice Springs. Even then, according to Holmes, 'he rejoiced in the name "One Pound Jimmy"'.[13] Perhaps, in light of One Pound's reasons for being so far from his own country, he preferred to keep his tribal name to himself. Holmes thought him 'as fine a specimen of Aboriginal manhood as you would wish to see. Tall and lithe, with a particularly well-developed torso, broad forehead, strong features and the superb carriage of the unspoiled primitive native'.[14] No wonder he had captured Long Rose's heart! Holmes sent Roy Duncan, a staff photographer, to capture his image for the magazine. The result was an Australian equivalent of the romantic American Indian figure riding

AUSTRALIAN GEOGRAPHICAL

WALKABOUT

MAGAZINE

AUSTRALIA

2/6 ABORIGINE 2/6
POSTAGE

1/6

REGISTERED AT THE GENERAL POST OFFICE, MELBOURNE
FOR TRANSMISSION BY POST AS A PERIODICAL

SEPTEMBER, 1950

bareback across the prairie: the lean hunter standing on a rock with his head tilted up looking out over the vastness of the desert landscape, holding his spear, shield and spear thrower. This image of One Pound Jim, or others based on it — the TAA poster of the naked tribesman looking up at a jet passing overhead is one of the best known — had subsequently appeared on travel posters and journals world wide. If his Western Desert compatriots had seen the image, they might have been amused at the idea of a hunter standing silhouetted against the skyline for all the world (including his prey) to see, but it is unlikely that they, any more than One Pound Jim himself, knew anything of all the publicity.

His fame increased with the use of his profile from this photograph, labelled simply 'Aborigine', on two Australian stamps which came out on 14 August 1950.[15] It was the first and one of the very few times since Federation, that a portrait of an Aboriginal person has appeared on an Australian stamp. *Walkabout* ran One Pound Jim's head and torso from the original photo on the front cover of its September 1950 issue to commemorate the occasion, identifying him as One Pound Jimmy of the Wailbri [sic] tribe. The Australian Post Office archives record that the design of the stamp 'created a good deal of public interest at the time'. An American philatelist contacted *Walkabout* to enlist their assistance in obtaining One Pound Jim's 'mark' on a block of the stamps destined for a National Museum alongside 'members of the Royal families of Europe and other countries, dignitaries of State and other world celebrities'.[16] *Walkabout* succeeded in contacting him and ran a contemporary photograph of him, still ruggedly handsome though he was by then in his mid-fifties,[17] with the following biographical information:

> Here we present 'Jimmy' as he is today, husband of Rosie and father of Ben [Immanuel], Possum and Nellie [Lily]. Nellie is a house-girl on a station in the Northern Territory while the two boys are similarly employed on stations as stockmen.[18]

The stamps were so-called 'definitives' for general postal use, and were in circulation for the next sixteen years. The 2/6d stamp sold a staggering 85,813,200 up to February 1966 when the new decimal currency stamps were issued. Altogether over ninety-nine million copies of this image of One Pound Jim were sold, including a special re-printing for Christmas 1965 when stocks of other £. s. d. 'definitives' began to run low — coincidentally commemorating its subject's death.

> He was just a station hand — but instead of him being known at Mount Wedge or Narwietooma, he was known world wide. He was the positive image — if also totally as he was not. Other people wanted to photograph him. They wanted that noble savage image — they didn't want him in clothing. They wanted the *Walkabout* portrait.[19]

One Pound's local fame was only briefly eclipsed by Albert Namatjira in the mid-to-late 1950s. Even then, he was the other half of the assimilationist dichotomy between (noble) savagery and 'civilisation' that made Namatjira's case so celebrated. He was the mysterious figure of the 'tribal Aborigine', strongly associated with the land in ways that Namatjira never was to his non-Aboriginal

One Pound Jimmy stamp

One Pound Jimmy Tjungurrayi on the cover of *Walkabout,* September 1950. Photo: Roy Dunstan c/– Australian National Publicity Association

public. In that sense, One Pound Jimmy Tjungurrayi remained the leading Aboriginal identity in Alice Springs until his death while 'on walkabout' with his relatives on Narwietooma Station on 28 March 1965.[20] He was accorded the unusual respect of a front page obituary in *The Centralian Advocate*, under the large heading 'ONE POUND JIMMY IS DEAD'.

The obituarist dwelt on his fame, calling him 'the most publicised Aborigine in Australia'[21] and recounted Holmes's difficulties in re-contacting – between fifteen and twenty years later – the subject of the famous photograph. The anecdote is an eloquent commentary on the mixture of respect, affection and mild derision that One Pound Jim must have encountered from settler culture as the world's best known image of Aboriginality. Like his son, who was to become one of the best known makers of Aboriginal images for the next generation, he preferred to avoid the limelight and stay out of trouble:

> It seems that Jimmy heard someone was inquiring about him, and probably suspected that some trouble was afoot. If so, he wanted none of it, and as a result it was thought he had gone bush. He was finally located by L. N. Penhall of the Native Affairs Branch of the Northern Territory Administration on an isolated cattle station.[22]

As with Namatjira, Clifford Possum chose not to exploit One Pound Jim's status as a cultural icon for the West by publicising the connection. For years few people knew of it[23] – to the point where others tried to claim that they were the subject of the famous photo.

Why Papunya?

Papunya Aboriginal settlement was the last of dozens of government outposts established across remote Australia during the assimilationist era. Construction of the settlement had commenced in 1957 after the discovery that the water at nearby Haasts Bluff settlement was unfit for human consumption. The Lutheran missionaries who ran Hermannsburg had established a ration depot at Haasts Bluff in 1941 after the government of the day reluctantly agreed to gazette the area for the continuing use of its original owners. Amongst the tribespeople from surrounding areas who soon took up residence at Haasts Bluff in large numbers was the artist's future wife, Nantakutara Nakamarra, the daughter of a Kukatja tribesman known as Tjanatji to his family and Walter to those who employed him for his tracking skills and local knowledge as a police tracker. Walter Tjanatji Tjupurrula (*c*.1912–1957) and his wife Inyamari Napanangka[24] (1922–1974) had five children of whom Emily, as Nantakutara later became known, was the eldest. The family had originally come in from the Papunya area to be nearer to the missionaries' flour and blankets. Emily was born in about 1943 according to the Register of Wards, and was still a child in the mid-1950s when the size of the Aboriginal population of Haasts Bluff began to put pressure on the water supply. Close to five hundred people were living there according to the 1954 Register of Wards census: 3 Luritja, 24 Arrente, 24 Pitjatjantjara, 67 Kukatja, 117 Warlpiri and 229 Pintupi, including a party of more than thirty men, women and children, who in 1956, had walked nearly

400 kilometres from near the Western Australian border area to join earlier Pintupi arrivals from the west. The government had established a cattle station to provide employment for some of the men and fresh meat for the settlement. Three bores had been sunk in 1948 along the north of the range to enable the extension of cattle grazing onto the eastern fringes of reserve land. The decision was taken to re-locate the population of Haasts Bluff to Papunya at the site of one of these new bores.

The team of Aboriginal workers recruited to work on the building program for the new settlement included Clifford Possum's brother, Tim Leura Tjapaltjarri, who moved to Papunya from Napperby Station with his wife Daisy Nakamarra and their young family at the start of the building program. The first stage of construction was completed in 1959 and the Aboriginal population of Haasts Bluff was moved across in trucks, leaving only a small group to maintain the cattle project. It seems unlikely that Clifford Possum was in Papunya at this time, because he was unaware that Namatjira's notorious three-month sentence for supplying liquor to one of his relatives had been served at Papunya. He denied Namatjira had ever been in Papunya, though his broken-down pick-up truck with the words 'Albert Namatjira Artist' painted on the side door was part of the settlement landscape for years after his death. But Clifford Possum could not read, and Namatjira was under 'house arrest' during his time at the settlement in 1959.

Like many of the former stockmen who later signed up as painters with the Papunya Tula Artists company, Clifford Possum may have come to Papunya looking for a wife.[25] Marriageable women were scarce on the cattle stations where he was still working. He was about thirty years old when he married Emily Nakamarra, who would be the mother of his four children. Now he was 'proper young fellow getting married with my missus'. At the time of One Pound Jim's death, he was in Papunya awaiting the birth of their first child, Daniel Tjungurrayi (1965–1990). After the birth, he returned to stockwork at Mount Allan Station while Emily remained with family at Papunya. He continued to visit Papunya regularly to spend time with family, relatives and countrymen. There were three more children: his oldest daughter Gabriella was born in 1967, then Michelle in 1969, and another son, Lionel in 1971.

The boom years of the cattle industry were now over. After the introduction of award wages for Aboriginal workers in the industry in 1968, opportunities for Aboriginal stockmen were dwindling. Only the best could be certain of continued employment on hard-pressed stations. Pastoralists were turning to technological solutions to their labour problems. Clifford Possum seems to have had no difficulty obtaining work, but the uncertainty of his long-term prospects in the industry would have spurred his ambition to support his family from his art. The tourist industry, on which the income to be earned from carving depended, was growing as fast as the cattle industry was declining. He had been carving for nearly twenty years, and his reputation as a carver extended well beyond Papunya. He was selling all his work for a 'good price' at $20 a piece – $40 for 'really special' ones. He proudly displayed his carvings to the 'school

teacher mob' at Papunya, and they gave him a job teaching the children to carve:

> I was paid teach'm after school, teach'm school mob – you know, snake catch-im rabbit – or must be perentie [lizard] – after that Geoff Bardon bin there!

The precursors

> We three start painting: Tim Leura, Kaapa Tjampitjinpa, Clifford. Before everybody. This is in Papunya – and outside from Papunya. First on art board and on carving.

In the years before Geoffrey Bardon's arrival at Papunya, Clifford Possum Tjapaltjarri was the last surviving member of a group of Anmatyerre artists whose members were experimenting with 'turning traditional art into a commercial form – paintings on flat surfaces'.[26] There may well have been others who were part of this group of precursors,[27] but Clifford Possum named himself, Kaapa Mbitjana Tjampitjinpa (*c*.1926–1989) and Tim Leura Tjapaltjarri (*c*.1934–1984) as the core of the group who were producing paintings at Papunya before Papunya Tula Artists, or even the initial group of 'painting men' established by Bardon in mid-1971, existed to support the activity. Whether or not they would have persisted without Geoffrey Bardon's enthusiasm and the widespread support and participation in the painting movement on the part of so many of the artists' countrymen at Papunya, does not alter the claim of this group of three to be pioneers of what is now known as Western Desert art.

Kaapa, Tim Leura and Clifford Possum were all Anmatyerre tribesmen, sharing a common fate of dispersal from their traditional lands to serve as cheap labour for the cattle industry in Central Australia. They had known each other intimately since childhood. Clifford Possum's mother, Long Rose Nangala, was the sister of Kaapa Tjampitjinpa's father, Kwalapa ('Mad Jack') Tjangala: they were first cousins. All three men were born on Napperby Station and subsequently initiated there. Their paths continued to overlap at the various cattle stations in the area where they had worked since they were boys, and they all came to Papunya in the mid-1950s or early 1960s, married women from the Papunya area and settled there to raise their families. As far as their role in the establishment of a painting movement at Papunya is concerned, one of the most important things shared by these three close relatives and countrymen, whose lives intersected and paralleled each other in so many ways, was the idea of themselves as artists and craftsmen.

Their experiences as stockmen in the area west of Alice Springs in the 1940s and 1950s had brought them into contact with Albert Namatjira's brilliant, trail-blazing career as an artist in the sense that western culture gave to that term. As more and more people embraced the vocation of artist, the term itself increasingly became part of the Western Desert vocabulary also – with the subtly different sense communicated by the following exchange:

> *V. J.: Clifford do you like being an artist? Do you enjoy painting?*
>
> Good job! More better than digging holes for fencing post! [*hilarious laughter*]

Cheeky Snake Carving, 1973, carved bean wood and synthetic polymer paint, 62.8 x 27.0 x 22.0 cm (irreg.); Jinta Desert Art Gallery, Sydney

Kaapa, Tim Leura and Clifford Possum brought from their encounters with the Arrente school of watercolourists a more detailed and practical understanding of the possibilities of Aboriginal art-making in Central Australia than either of the other main players in the Papunya scenario: Geoffrey Bardon or the Pintupi group. Their aspiration to become professional artists like Albert Namatjira was critical to the emergence of Papunya painting. Without it, contemporaneous ventures at other settlements failed.[28] The presence of this cohesive group of determined individuals who were already practising artists was one of the factors which made the situation at Papunya unique.

The concept of depictions of Dreaming and country which lies at the heart of Western Desert painting can also be traced through this group of three to the influence of Albert Namatjira. In his previous career at Hermannsburg as a carver of mulga wood plaques inscribed with biblical sayings, Namatjira had used concentric circles and U-shapes as decorative embellishment. Some of his early paintings included ceremonial boards or tjurungas and images of kangaroos and emus, never seen in his later work. These things dropped out because they angered his countrymen, who questioned his entitlement to represent the secret–sacred in this manner and to paint Dreamings that were not his. Namatjira was an initiated man: he understood the importance of observing the rules of his own culture. However Europeanised the forms of representation in his paintings, the landscapes depicted were almost exclusively places to which he was connected through his own Dreaming heritage. Clifford Possum was probably too young to have been aware of the intra-Aboriginal debates about Namatjira's early work, but he would have understood the site references in his paintings and what they represented: his choice of his own Dreaming subjects. Non-proprietary references were against the rules.

The snakes and lizards which Clifford Possum carved as a young man were likewise drawn from his personal repertoire of ancestral beings. Was he then a carver of his Dreamings before he became a painter of them? The list of his major pieces does suggest otherwise. Secular subjects, the more challenging the better, clearly inspired Clifford Possum's work. He was fascinated with the idea of making his pieces as life-like as possible, a preoccupation which would emerge in different guises in his later paintings. But a man so steeped in his culture would also have been aware of the significance in his Dreaming landscape of these creatures brought into being by his hands. The markings painted on the *Snake Carving* (p. 55) are the same as those on Rainbow Snakes in his Snake Dreaming paintings from two or three decades later.[29] When shown the 1973 *Cheeky Snake Carving* (p. 51), his first response was to begin explaining exactly what kind of snake it was: poisonous, with black, brown and white markings – and then to indicate its ancestral journey line from north of Alice Springs to Napperby Lakes.[30]

At Glen Helen in the 1950s, Clifford Possum would also have been exposed to the direction in which Namatjira's followers, including his own sons, were taking the Hermannsburg style. Their experiments with effects of simplification, schematisation and repetition were dismissed as formulaic by

watercolour landscape enthusiasts of their day, but have since been hailed as a daring counter-appropriation of the traditions of European landscape painting to their own expressive ends. The Papunya painters employed these same strategies in the invention of the painting language of Western Desert art. In some ways, these second-generation Hermannsburg artists portrayed their totemic landscape just as starkly as later generations of Papunya painters would theirs. In the meantime, the works of the 'School of Kaapa', depicting actual ceremonial performances in which the artists' connections to country and Dreamings were celebrated, were taking Central Australian Aboriginal art onto wholly new ground.

Kaapa had established his painting headquarters at Papunya in one of the buildings he probably helped to construct: the old settlement office, long since abandoned by the white administrative staff. In 1971 he could usually be found painting there on any flat, more or less rectangular surface and with whatever paint and brushes he could scavenge from around the settlement. His cousins Tim Leura and Billy Stockman Tjapaltjarri often worked there with him. So did Clifford Possum, whose 'grotesque statues'[31] of branches draped with eerily realistic snakes repelled Jack Cooke, District Welfare Officer from the Northern Territory Welfare Branch, on one of his regular inspections of the settlement when he came for a look at Kaapa's 'studio'. Jack Cooke's reaction may help to explain why so few of Clifford Possum's carvings seem to have survived into the present. They may have been the sort of thing that people bought on impulse because they were so well done, but later discarded because they became disturbing to have around.

It was assumed that none of Kaapa's pre-Bardon artistic experiments had survived either, but one of the last works to be painted in the style of the principal painter of the group of three has been part of the history of Papunya painting all along. That work is *Gulgardi*, 1971, the painting which won Kaapa Tjampitjinpa the Caltex Art Award in August 1971 and galvanised Bardon's 'painting men' into a veritable frenzy of productivity.[32] It was not Bardon who entered the painting in the Art Award but Jack Cooke, who had been so struck by some paintings he saw on display in the Papunya canteen that he sought out the artist responsible. Like the works Cooke had seen at the canteen, *Gulgardi* features the style of exquisitely decorated human figures on plain backgrounds surrounded by the paraphernalia of ritual performance, which has erroneously been identified with the earliest works to come out of the group of painters established around Geoffrey Bardon at Papunya in 1971. In fact, this style of painting, which culminated in *Gulgardi*, was the product of an artistic practice based in Western Desert traditions which existed independently of and prior to the events comprising the now familiar tale of the origins of painting at Papunya. It drew loosely on elements of European figuration carried over from the experiences of Kaapa, Clifford Possum and Tim Leura with the Hermannsburg watercolourists.

By contrast, the first works to come out of Geoffrey Bardon's painting group at Papunya were actually devoid of explicit references to the ceremonial

life.[33] They featured simple designs surrounded by the dotted infilling which in the received account came much later in the sequence of events as an attempt to mask controversial elements. In fact, the dots were there at the very beginning. Their disappearance from slightly later works of painters in the group around Bardon was one of the stylistic repercussions of the presence of the pioneering Anmatyerre painters, most notably Kaapa himself, within the founding group of 'painting men'. So, in all likelihood, was the explicit focus on the ceremonial which rapidly emerged in the other painters' work as their skills in the new medium developed. Kaapa Tjampitjinpa, Tim Leura Tjapaltjarri and Clifford Possum Tjapaltjarri also brought to the painting group superb technical skills. When Clifford Possum began to paint for Geoffrey Bardon in early 1972, he was not taking his first tentative steps as an artist. If his indefatigable will to create in his later years is anything to go by, he had probably carved or painted almost every day for the past twenty years. He was by then in his late thirties, the prime of his life, no longer the young man on the bank of Napperby Creek dreaming of becoming an artist, but a married man with four young children and a wife to support. His art-making was an important source of supplementary income for his family. But when he sat down in front of a flat piece of board and began to paint, he may have surprised even himself.

The extraordinarily accomplished *Emu Corroboree Man* (p. 61) which Clifford Possum produced for Bardon that first day, is more than one of the seminal Papunya boards. As such, it represents the historic beginnings of what would later develop into an internationally significant contemporary art movement. But in Clifford Possum's own life as an artist, this painting was not the beginning. It was an artistic breakthrough, to a new medium in which his decades of experience as a carver and painter of wooden sculptures would all come together. The precision of line and the steadiness of hand, the conjuring with three-dimensional spatial effects, but most of all the ability to visualise the final form of the work even before he had picked up his brush: these were the legacies of Clifford Possum's days as a wood carver.

Snake Carving, *c.*1975, carved bean wood and watercolour, 68.5 x 40.0 cm; The Kelton Foundation

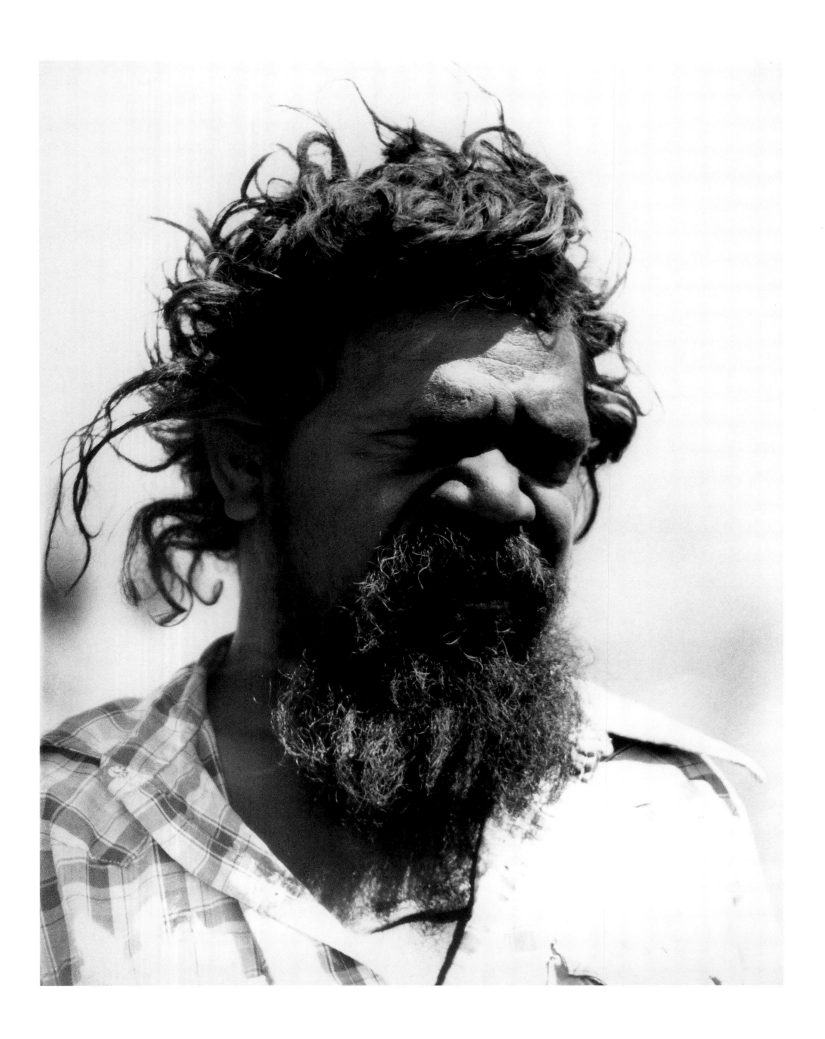

School their eyes

One of the reasons why the role of Tim Leura Tjapaltjarri and Clifford Possum Tjapaltjarri in the beginnings of commercial art production at Papunya has received so little attention is that they were among the last men at Papunya to join Geoffrey Bardon's painting group. Kaapa, the extrovert of the trio, had made his presence felt from the beginning, when he was chosen by the older men for his acknowledged mastery of brushwork to paint the main mural on the Papunya school wall. But neither of the Tjapaltjarri brothers figures in Geoffrey Bardon's narrative of events at Papunya until February 1972, when Tim Leura finally put in an appearance at the 'painting room' which had been established in late 1971 in a corner of the old Papunya Town Hall.[1] Twenty to thirty men had been coming there every day for months to work on their paintings when Tim Leura turned up one morning and asked for the use of a board and some paint. He completed his first painting that day in ten hours' silent concentrated effort.

> A few days later I came to the painting room and saw a dusty, wild-haired man ... whom I'd not seen before ... His name was Clifford Possum Tjapaltjarri ... He had already found a board and was at work. Tim spoke for him: 'This is my brother, Clifford. I can't beat him'.[2]

No doubt Clifford Possum tried to live up to the friendly fraternal rivalry of Tim Leura's introduction. He could still see the painting in his mind's eye more than twenty years later: 'This man, he was really dancing! All painted up – Emu corroboree man.' Geoffrey Bardon's comments on the brothers' paintings on their first days in the painting room make it obvious that both men were already highly accomplished artists – Clifford Possum's for example, 'showed superlative skill'.[3] However, this is not explained by reference to their previous experience as artists. The impression persists that because they were amongst the last to join the painting group; they must also have been among the last people at Papunya to begin painting.

Asked by Bardon why he had not come forward before to paint, Tim Leura's laconic reply was 'I've been watching you'. This comment makes sense against the background of the reception at the settlement of the earlier efforts of the group of three. The level of discouragement can be gauged by Kaapa's dismissal from his job as a school yardman for allegedly stealing paint brushes.[4]

Clifford Possum, Papunya, October 1977. Photo: Jon Falkenmire

Whether or not he took the brushes, the contempt in which his artistic efforts were held by the school and/or settlement authorities who had him sacked for it is painfully evident. This sort of treatment would explain an unwillingness to be made fools of again by joining the group of painters around Geoffrey Bardon. It was their pride, precisely because they did take themselves seriously as artists, that made them hold back. Both Tim Leura and Clifford Possum were, by this time, quite widely known in Central Australia for their carving skills. They were doing well enough on their own to see no necessity of joining what might have looked at first like just another doomed adult education initiative in the authorities' tireless attempts to find employment for the Aboriginal residents of the settlement.[5] Once convinced of the viability of the project, Kaapa and Tim Leura threw their energies behind it and emerge as key figures in Geoffrey Bardon's account of his time at Papunya. Tim Leura became Bardon's closest friend and intermediary with the other artists, and the painting movement was built on Kaapa's energy and indomitable will. Clifford Possum, however, remains a shadowy figure in this narrative.

He had been present at what Bardon called the 'moment of inception'[6] of the art movement. He remembered the painting of the school murals in July 1971: 'They think about it: What about Papunya school? We shoulda put story. That's Yarumpi – Honey Ants'. As a custodian of several major Honey Ant sites on nearby Mount Allan Station, he would have been involved in the intra-Aboriginal discussions leading up to the licensing of the designs for use on the mural. He took no part in the actual painting, perhaps because of his relative youth. His older brothers, Billy Stockman Tjapaltjarri and Paddy Stewart Tjapaltjarri[7] from Yuendumu were part of the team of painters working under Kaapa. Clifford Possum particularly recalled one of the smaller murals which preceded the large Honey Ant design as their work. It had shown the Eagle Dreaming from Wakulpa and their shared Dreamings at Mount Denison.

Bardon knew little of Clifford Possum's earlier life, except that 'he had been a stockman at Napperby but then apparently became unemployed'.[8] He probably assumed this from the artist's unkempt appearance that first morning in the painting room, but Clifford Possum was actually taking a short break from stockwork when Tim Leura brought him in to meet the new champion of their art. He was one of several Papunya residents recruited between 1969 and 1972 as stockmen at Narwietooma Station. Clifford Possum in this period worked at both Mount Wedge and Narwietooma. He described the pattern of his visits to Papunya during the early 1970s in this way:

> I'd come over there and start work, carving and painting, and after about two weeks, go back and work again – to Mount Wedge Station and sometimes Narwietooma. Sometimes work for a year, and then come to Papunya. Doing stockwork.

He was still carving mainly, though increasingly inscribing the results with motifs inspired by the work of the 'painting group', whose membership at this time was predominantly Pintupi. He recalled Geoffrey Bardon offering him a job after he had shown him his carvings:

Geoff Bardon, he was a teacher. I show him all my carving. He think about and he pick up ideas. He leave that government work. He want to turn round and get all the carving. Give me job for this art board – for me and Tim Leura and Kaapa. And everyone come up.

Maybe when he saw that another thirty men had already been offered the same position, Clifford Possum decided to keep his 'day job' as head stockman at Narwietooma Station for a while longer.

Aboriginalisation

I wanted to see indigenous art. That was the size of my mission.[9]

Geoffrey Bardon's writings tell the story of the beginnings of the painting movement in Papunya as he saw it: a defiant and courageous stand by himself and the artists against the policies of assimilation. Bardon had been horrified to discover these policies still being relentlessly pursued by the non-Aboriginal authorities on remote settlements like Papunya, notwithstanding the popular rhetoric of Aboriginal self-determination in the cities of the southern and eastern states. The proponents of assimilation believed Aboriginal culture was doomed: that was why they saw the only hope for the people in becoming like 'ordinary Australians'. That had been the original 'reason' behind the settlements: to train nomadic tribespeople to make this transition. The reigning salvage paradigm in anthropology, which tried to record as much as possible of traditional culture before it disappeared, was motivated by exactly the same conviction. Even judge Jo Caddy, who had awarded equal first prize in the 1971 Caltex Art Award to Kaapa Tjampitjinpa, thereby giving the work of the Papunya painters its first public exposure and recognition, commented that she had chosen works by Aboriginal painters because 'they might not be around in such numbers in years to come'.[10]

Bardon's response to these attitudes was to encourage the artists to make their paintings the strongest possible statements of Aboriginal culture's continuing survival in its pre-contact form. To this end, he tried to outlaw all European forms that crept into the work, discouraging such things as an early tendency to draw borders, on the grounds that: 'That's nothing to do with Aboriginal art'.[11] On the Papunya school mural, he had persuaded the painters to substitute Aboriginal honey ant designs for the representational forms of the ants which they had originally painted. For him, this re-assertion of pure traditional forms was the central meaning of the painting movement for the painters themselves, for the wider Western Desert community, and for the world at large: 'The Aboriginal men saw themselves in their own image on a European building.'[12] He was constantly reiterating the basic message of 'Nothing whitefella. No whitefella colour, no whitefella perspective, no whitefella images'.

On these grounds, Bardon was critical of the elements of European realism in the style which Kaapa and his cousins had evolved in their independent practice: 'Decoration associated with "illustrations" concerning mythology was often not authentic and was not encouraged.'[13] In his 1979 book Bardon wrote,

'I did not want them to be changed'[14] but he did want *Kaapa* to change, or rather 'to come back to his true self'[15] – meaning the use of 'correct Aboriginal design'.[16] Kaapa was as conscious as Bardon that these figurative elements were what made his work saleable in the tourist market. That explains why in the beginning he continued painting in his old style, selling these works through the Papunya canteen or galleries in town, while the works he produced under Geoffrey Bardon's gaze were purged of such 'whitefella' influences.

By the time Clifford Possum arrived in the painting room, the lectures on this theme were less frequent, but only because their message was taken for granted by most of the artists. But Geoffrey Bardon was no less intent on his mission for 'indigenous art'. Clifford Possum's realistic *Emu Corroboree Man* flanked by two emus which look like something off the old dollar note could not fail to have offended Bardon's purist sensibilities. But the painting was so superbly done and such a source of pleasure and pride for Clifford Possum that it is impossible to imagine Bardon's overt response at the time as being anything but positive. The execution of the linework behind the central figure and in the concentric circles that surround the dancing ground is absolutely flawless, reflecting the artist's long previous experience in the exacting art of the wood carver, where one slip of the hand can destroy many hours of painstaking labour. Bardon's comments in a 1988 interview revealed his reservations about the Europeanised forms in Clifford Possum's early work. He cited the cowboy comic and 'the coat of arms on the coins' as among his western influences, remarking somewhat disparagingly that: 'Some of Clifford's early paintings looked like those decorative bark pictures that are coming out of Mexico.'[17]

The idea that the stylistic evolution of one of the founders of Western Desert art might initially have involved the Aboriginalising of his own forms of expression in the sense of censoring all recognisably European elements, may be startlingly unexpected. But the invention of Western Desert art was a far more complex process than the popular conception of it as a simple de-sacralisation of an ancient iconography allows. The complex and multi-layered character of both the artists' experience and its artistic expression is ignored by this radical over-simplification.

The secret–sacred controversy

As the application of tribal visual traditions millenia old to a western art medium, Western Desert painting always was – in intention at least – an 'establishment art', affirming the truths and values of its culture, like the pre-Renaissance religious art of Europe. But when it began, Papunya painting was perceived within most of Central Australian Aboriginal society as profoundly *anti*-establishment in its exposure of these things to the prying eyes of the outside world. In the beginning, the painters working with Geoffrey Bardon were painting primarily for themselves, without thought of an art audience or any other apart from people like Bardon whom they knew and trusted. Bardon drew them out by his boundless admiration for their work, but they kept the

Emu Corroboree Man, 1972, synthetic polymer paint on composition board, 45.8 x 61.5 cm; Collection of Larry and Susan May

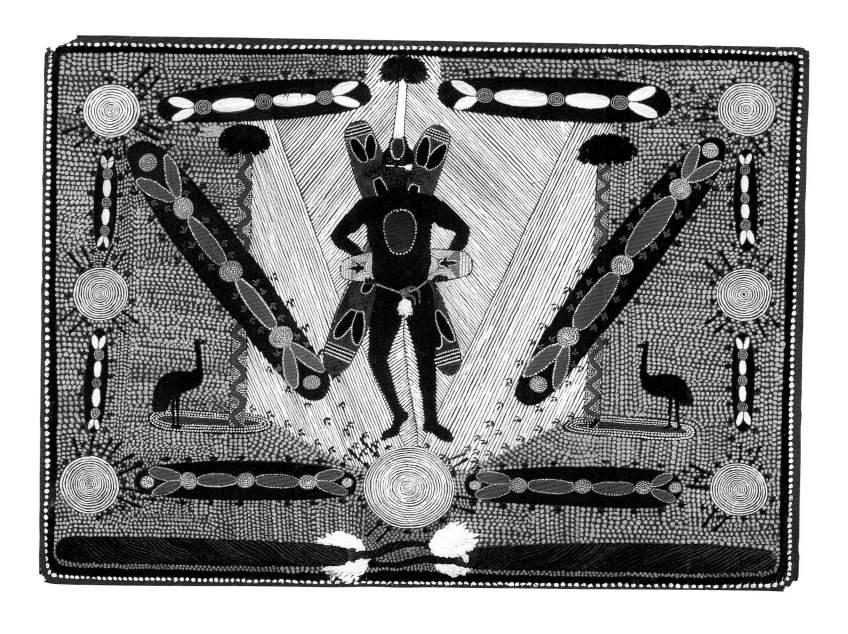

painting boards wrapped carefully in blankets in the men's camps, only unwrapping them to show the Europeans working for Papunya Tula Artists, lest women or unitiated young men be exposed to things of which they were not entitled to know. In these circumstances, they were not deterred from painting something simply because in some more public context it might be considered dangerous.

Even so, some of the Anmatyerre painters, particularly Tim Leura, complained to Bardon about the daring licence being taken by some of the Pintupi with their own culture. *They* might be forgiven, because of their minimal contact with western culture, for not knowing the risk they took in doing this. But anyone not in such a position of ignorance risked severe punishment for an offence of this kind. The Anmatyerre painters had wide experience from an early age of both settler culture and other Aboriginal communities in Central Australia. They would be expected to understand the dangers of improper disclosure – and they did. In 1990 Clifford Possum would be quoted in *The Centralian Advocate* as saying that 'he would not have been able to do his dot paintings in Albert Namatjira's time without being killed':

> 'I would have been speared.'
>
> 'The story is the painting, not the design.'
>
> 'They are stories from my grandparents' family group – the Anmatyerre people of Napperby, Mount Allan and Yuendumu – of Central Australia.'
>
> 'The stories are part of my religion but not the whole story which is out there [in the bush] and in my mind.'
>
> 'I cannot tell you the whole story or you and I would die.'[18]

As soon as the paintings began to be sold outside Papunya, the public display of imagery drawn from the ceremonial context became a focus for the general disquiet amongst the painters' countrymen at neighbouring communities with the step they were taking in committing their Dreamings to western art. But even before the vocal opposition they would later encounter, the painters understood that if they wanted to continue selling their paintings, they would have to tone down this sort of content radically. Under Bardon's watchful eye, they began progressively attentuating the references to the secret–sacred in their work: leaving out the potentially offending images from the ceremonial context, reducing the design elements to essentials and returning to their original device of infilling the backgrounds of their paintings with dots. The result was a new secularised painting language: the 'Papunya' style of dots, circles and lines in variations of which hundreds of painters across the length and breadth of the Western Desert have since painted their Dreamings. This artistic experiment was already well underway by the time Tim Leura and Clifford Possum joined the painting group in early 1972.

In all our discussions of this subject, Clifford Possum insisted that he had *always* strictly avoided offending his countrymen and women by including potentially dangerous material in his paintings:

> I can tell you – no trouble and no run into trouble. That trouble come back through by me and everybody else, but not my trouble. I keep clean. Because

everybody got to be painted. I know. I carry on today. Everybody, all the family got to be painted business time, corroboree time, all got to be in uniform, from little ones and all, got painted.

His insistence on this point is somewhat surprising, in light of the appearance of objects identified by the annotation as tjurungas, ceremonial poles, headdresses, and sand paintings in *Emu Corroboree Man*, *Honey Ant Ceremony* and *Love Story*, 1972. According to Bardon's account, the artists had settled their differences over the inclusion of controversial motifs by the end of the first year, and ceased to paint them. Perhaps Clifford Possum, as a newcomer to the 'painting room' was simply not aware of these proscriptions. And yet it is hard to believe his acute senses would not have noticed this absence in the other painters' work. His quick artist's eye had immediately absorbed the emerging 'dot' style and applied it to the background.

The presence of these restricted elements in his earliest known works for Geoffrey Bardon appears to contradict the artist's protestations of innocence of any culturally inappropriate imagery in his paintings. The apparent paradox could be explained by the fact that, like the nation states to which Clifford Possum compared them, Western Desert language groups had different attitudes to disclosure of the secret–sacred. The Anmatyerre must be about the only language group in Central Australia not to have been subjected to systematic anthropological study and disclosure, placing generalisation about their traditions on shaky ground. Part of the reason for this neglect may lie in their dispersal from their tribal lands to various cattle stations in the surrounding area. The cultural impact of this movement of Anmatyerre peoples in the early part of the century is a further complicating factor. However, their presentation of their own evidence in the Mount Allan land claim hearings of the late 1980s attested to the continuing strength of Anmatyerre traditions.[19] One critical area in which these traditions reportedly differ from many other Western Desert groups is the greater sexual de-segregation of ceremonies from which the women of other tribes are forbidden.[20] Anmatyerre women traditionally made their own ground paintings, whereas amongst some tribes from further west this activity was restricted to the men. 'Same same. They use body paint, sometime in sand painting. We always sand painting. Warlpiri women too, same.' Anmatyerre women, when shown early Papunya paintings by their husbands, do not flinch from what is shown there, as a European observer familiar with the controversy about these works would expect them to:

Some of the early paintings had those exquisite human figures kneeling down, ritual poles standing up, the notion of a ground painting at all odd angles to the theme – fantastic. I showed them to Kaapa – I was really worried about showing them to him, this is going to be dire stuff, and he just sort of laughed, 'Yeah, that's all right' – just talked about it. And then his wife joined him, looked at them – no problems. White people looked at them, and I said 'Nothing wrong with this?' and he said 'No, no, that's all right. That's easy one'.[21]

The creative tension in the work of these Anmatyerre painters derives not from flirting with taboo subjects, but from their fearless exploration of the

unprecedented *artistic* space opened up by the impact of the European presence in Central Australia on the Anmatyerre world view.

The secret–sacred controversy undoubtedly exercised a decisive impact on the development of the secularised painting language of contemporary Western Desert art through the artists' recourse to self-censorship of potentially inappropriate imagery. However, the controversy may have been just the most tangible focus people could find at that time for their apprehensions about what the Papunya artists were doing. For all the furore over this issue, the more fundamental question turned out to be collective rights of ownership in the designs and Dreaming trails depicted in the Papunya painters' work. When these Dreamings pass through another tribe's lands (as when the Flying Snake Dreaming passes out of Warlpiri hands into Anmatyerre at Altjupa), custodianship passes into other hands. By proclaiming only the Papunya painters' rights to these Dreamings, the paintings had inadvertently torn the fabric of Western Desert society. The tear could be mended by the Papunya painters desisting from their art – or the rest of the Western Desert joining them. In time, this latter scenario came to pass, as the Papunya artists' spectacular success in the contemporary art world a decade and a half later finally vindicated their actions to their countrymen. The way was then open for the painters to pursue their ambition to succeed as painters of their Dreamings in the white art world with the support of their society, rather than its implied or expressed disapproval.

Clifford Possum maintained that the corroboree portrayed in *Emu Corroboree Man*, though performed only by men, could be watched by the whole family – albeit from 'across the road'. Bardon remained convinced that its disclosures about the secret–sacred world of initiated men offended against the strict rules of censorship within Western Desert culture.[22] He generously supplied a copy of the image at Clifford Possum's earnest request that it be included in the 1994 monograph on his work.[23] The problem with *Emu Corroboree Man* at the time may have been that it portrayed a Dreaming to which the artist was not directly connected.[24] It was his cousin Kaapa who was the Emu Man – and in all likelihood the work was painted with his knowledge and consent. But the 'out of area' issue may have been enough to make Clifford Possum share Geoffrey Bardon's nervousness about the painting. It was stored away out of sight of the other painters in the staff flat which Bardon shared at Papunya with Peter Fannin. It was here, three or four months later, that the 'American bloke' whom Clifford Possum identified as the painting's owner, first saw *Emu Corroboree Man*. A memorable encounter with Geoffrey Bardon and the Papunya 'painting men' resulted in its disappearance into the vastness of the North American subcontinent for another three decades.[25]

The next painting Clifford Possum produced for Geoffrey Bardon in the 'painting room' at Papunya was *Love Story*, 1972 (p. 65). As with *Emu Corroboree Man*, only the tentativeness of the background dotting betrays the artist's unfamiliarity with the new medium. Already Bardon's passionate advocacy of a return to traditional forms of representation had produced a radical

Love Story, 1972, synthetic polymer paint on composition board, 45.5 x 61.0 cm; Ebes Collection

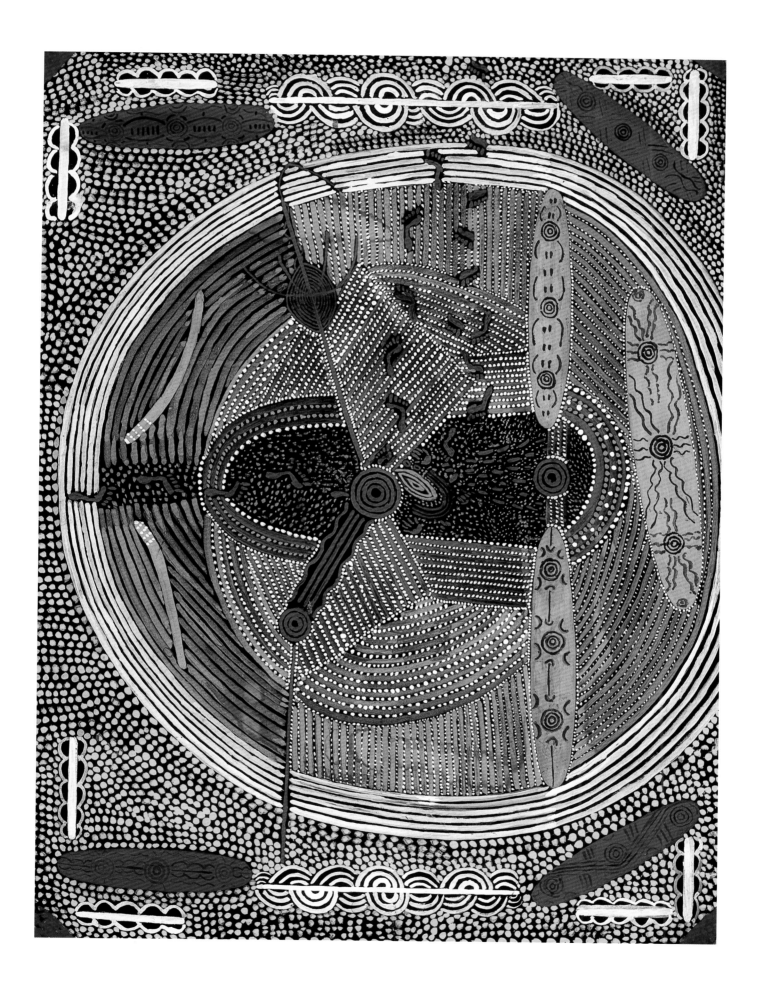

modification of the terms on which Clifford Possum saw his artistic ambitions being realised. Gone is the realistic corroboree man and in his place is a remarkable abstract schematisation of the Ngarlu Love Story, which in time would become one of the artist's core subjects. Gone too are the references to the exclusively male ritual world which had disquieted Bardon about the earlier work. Outside eyes might mistake the three pink and four smaller brown shapes at the base and sides of the painting, and the white designs around the sides, for secret–sacred elements, but according to the artist they are 'ukurrukurru' (women's dancing boards) and women's sand paintings, whose representation would not attract censure. It is surely significant, given the 'out of area' issue, that it is a depiction of Ngarlu, one of the key sites in Clifford Possum's ancestral estate.

About ten kilometres south-east of Mount Allan Station homestead is a large rockhole site known to the Anmatyerre as Ngarlu and to the settlers as Red Hill. The Tjungurrayis and Tjapaltjarris of Clifford Possum's patrilineal descent group are keeper–owners of this place, for which the principal Dreaming is the Love Story:

> Big law this one. Everybody know this place and this story, because this is a love story. Everybody know what this love mean. But everybody don't know. Only me. This because I know the one. This is my country – proper really. I got all the songs for this one. My uncle tell me and my grandfather's daddy: 'That's your father's and fathers'.'

In the first episode of the story, a Tjungurrayi man named Liltipililti sees and falls in love with a woman of the wrong skin group – Napangati, his classificatory mother-in-law, with whom any kind of intercourse, let alone sexual, is strictly forbidden. 'He's a Tjungurrayi. He lover man with his mother-in-law – Napangati. Wrong one. Oh!'

In the part of the story which Clifford Possum usually depicts in his Love Story paintings, the Tjungurrayi man is making love magic. He is spinning hair string for a pubic tassle on a simple cross spindle known as 'wirrakurru', while singing to attract the woman to his camp. Mirages or 'mirrawarri', are also associated with weaving the spell:

> We call'm mirrawarri. Special one. Sometimes sing'm for love – for kungka. And that kungka can sing too. I seen that man come up for mirrawarri – lift him up – even car, he can lift up. I can sing that song now [*singing*]. That's mirage: lift him up. Up in the sky.

The love magic has the desired effect and the woman approaches. The Tjungurrayi becomes so distracted by her approach that he loses concentration on the spinning and the hair is blown away by the wind. During the night, four women of the Nungurrayi skin group approached and kept a vigil by the lovers' campsite under the cover of darkness. The ceremonies for this Dreaming involve the Alyawerre people from far to the east:

> Across the Stuart Highway, a long way – that's Alyawerre country, different language I don't understand some people up there, but Alyawerre people, Three Bore way, all those people is all of my religion. These people come from the country of that Napangati this Tjungurrayi loving.

Honey Ant Ceremony, 1972, powder paint on composition board, 100.0 x 78.0 cm; Elder Wing Centenary Gift of The Foundation 2001. Art Gallery of South Australia, Adelaide

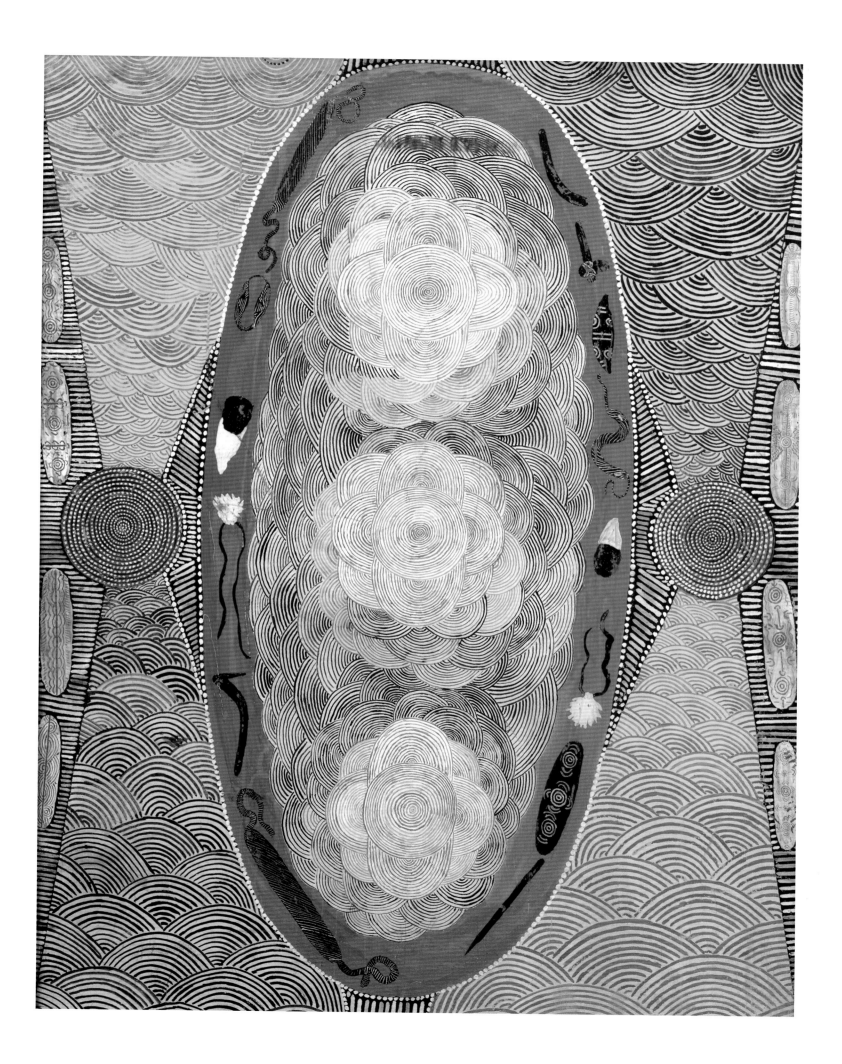

left: *Honey Ant Dreaming*, 1972, from Bardon 1991, p. 14 (image courtesy of Dorn Bardon)

right: *Honey Ant Dreaming*, 1972, (attributed to Tim Leura Tjapaltjarri) synthetic polymer paint on composition board, 65.5 x 48.0 cm; Australian Museum, Sydney

The same reversion to his core repertoire of Dreamings is apparent in *Honey Ant Ceremony* (p. 67), where Clifford Possum depicts the men's and women's ceremonies for the site of Yinyalingi, located in the heart of his ancestral homeland. The only element of the painting which retains the figurative preoccupations of the school of Kaapa is the assortment of delicately painted stone knives, women's necklaces, boomerangs, digging sticks, stone axes, dancing boards, coolamons and pubic belts around the rim of the large oval shape which dominates the composition. The painting was one of a dozen works by various Anmatyerre artists comprising the sixteenth consignment of Papunya paintings to Stuart Art Centre in Alice Springs, delivered sometime in the second quarter of 1972. Its composition and infilling technique are startlingly different from the two earlier works, indicating that one of Clifford Possum's periodic absences from Papunya doing stockwork may have intervened, but also revealing his susceptibility to the influence of the other painters. Both Kaapa and Tim Leura produced a series of works, including several that were included in the sixteenth consignment, employing the same heraldic compositional device of a large central shield to signal a major gathering for ceremonial purposes. Symmetry had already emerged as a characteristic feature of the Anmatyerre artists' Aboriginalised style. The infilling of overlapping yellow arcs on red and black backgrounds, which in *Honey Ant Ceremony* represents 'growth' in the roots of the mulga trees where the Honey Ants live, also drew on a technique that most artists in the painting group were experimenting with at the time this work was painted, though David Corby Tjapaltjarri's name is particularly associated with its use. The technique gave Clifford Possum an opportunity to show off his precision linework, tapering the arcs to create the illusion of looking down into one of the tunnels dug by the ancestral woman searching for honey ants. However, when cultural authorities inside and outside Papunya began criticising these kinds of effects for imitating too closely the patterns incised on sacred objects, the technique abruptly disappeared from Papunya paintings.

Layering the ground

Clifford Possum had not yet mastered the application of the dots which were rapidly becoming the near essential element of Western Desert art.[26] He now faced this technical difficulty head on, producing a group of works whose visual impact relies on the integration of design and background achieved through painterly dotting techniques rather than virtuoso effects carried over from his career as a carver. *Bushfire I* (p. 72) was several decades ahead of its time in the overall development of Papunya painting. Neither European realism nor traditional Western Desert iconography figure. The painting consists entirely of dots. The underlying composition of lines and arcs marked out in bands of dots was said by the artist to represent fallen wood. It is set in a field of predominantly white dots symbolising the ash from the fire over a rhythmic distribution of black and brown areas representing the burnt ground. The overall structure of the painting finds an echo in *Napperby Country* (see adjacent image), a painting from the latter part of 1972 now housed at the Australian Museum, in whose

Napperby Country, 1972, synthetic polymer paint on board, 60.0 x 60.0 cm; Australian Museum

records it is variously ascribed to both Clifford Possum and his brother Tim Leura. Close examination of the painting, however, reveals the presence of two distinct hands in the dotting, suggesting that it may be one of the Tjapaltjarri brothers' very first collaborative efforts. Even more startling is the design of concentric circles and straight and wavy lines completely submerged in the background dotting, a device which appears in several of Tim Leura's other works from the same period.[27]

Clifford Possum's role as his brother's assistant on *Napperby Country* may have prompted a series of works in which glimpses of the underlying design elements appear to emerge from variegated clouds of dotting. The influence of Tim Leura's distinctive atmospheric technique is still evident in *Honey Ant Dreaming* (p. 69), but Clifford Possum's developing mastery of the quintessential mark of Papunya painting is also increasingly apparent. Geoffrey Bardon commented of this aspect of the work: 'Intense dotting unifies the patchy effect caused by irregular shapes and gives the painting an impressive decorative splendour'.[28] Although an image of *Honey Ant Dreaming* appears in both Geoffrey Bardon's 1979 and 1991 books as the work of Clifford Possum, the painting itself disappeared beneath a veil of red paint applied across the whole surface by the artist's brother Tim Leura, who then claimed it as his own. The washover, so distinctive of Tim Leura's early work, led later to its attribution to him alone. Clifford Possum was presumably not around to dispute this early example of the mutability of authorship in Western Desert art.

By contrast, *Love (Sun) Dreaming* (p. 71) is unmistakably the work of Clifford Possum, one of the earliest examples of the sophisticated effects of superimposition and overlaying of Dreaming landscapes which would become an enduring feature of his work. The enlargement of the black dots across the centre of the painting produces a sense of zeroing in on Liltipililti's campsite, clearly discernible through the glowing flagged and dotted overlay signifying variously 'sunlight, cloud, shadow and the earth'.[29] In the later *Bushfire II* (p. 73) the complicated fragments of possum tracks, concentric circles and lines appear not submerged but partially obliterated by the imagery of the fire's passage across the landscape. The artist's awareness of one series of events being laid down on top of another in the Dreaming, sets him apart from the other artists and has a bearing on the prevalence of these effects of superimposition in his work. Events are not temporally discontinuous in his paintings, but linked in a progressive narrative sequence. The great fire seems to have been the last major cataclysm, creating a final overlay of mythological imprints on the land.

Unlike *Bushfire I*, the fire in *Bushfire II* is identified by its Dreaming connections. It is the ancestral bushfire 'which started near Yuendumu and swept over a vast area west and south'[30] that was soon to figure spectacularly in the artist's work. A later, more highly resolved rendering of the same subject is *Bushfire at Irpulku*, 1973 (p. 75) in which dark patches representing ash and charcoal appear superimposed over a simple symmetrical design composed of the foot prints and dragging tail marks of the old possum man Upambura. The locale is the north-west corner of the artist's country, which the great fire from

Love (Sun) Dreaming, 1972, synthetic polymer paint on composition board, 61.0 x 46.0 cm; Private collection

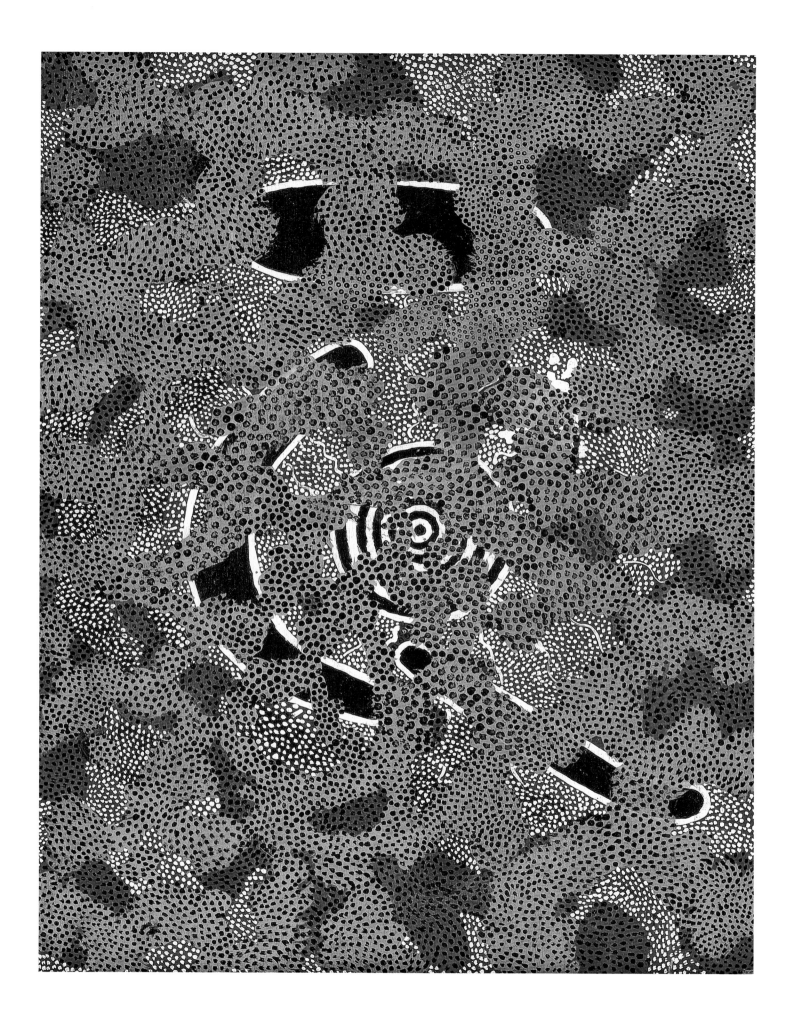

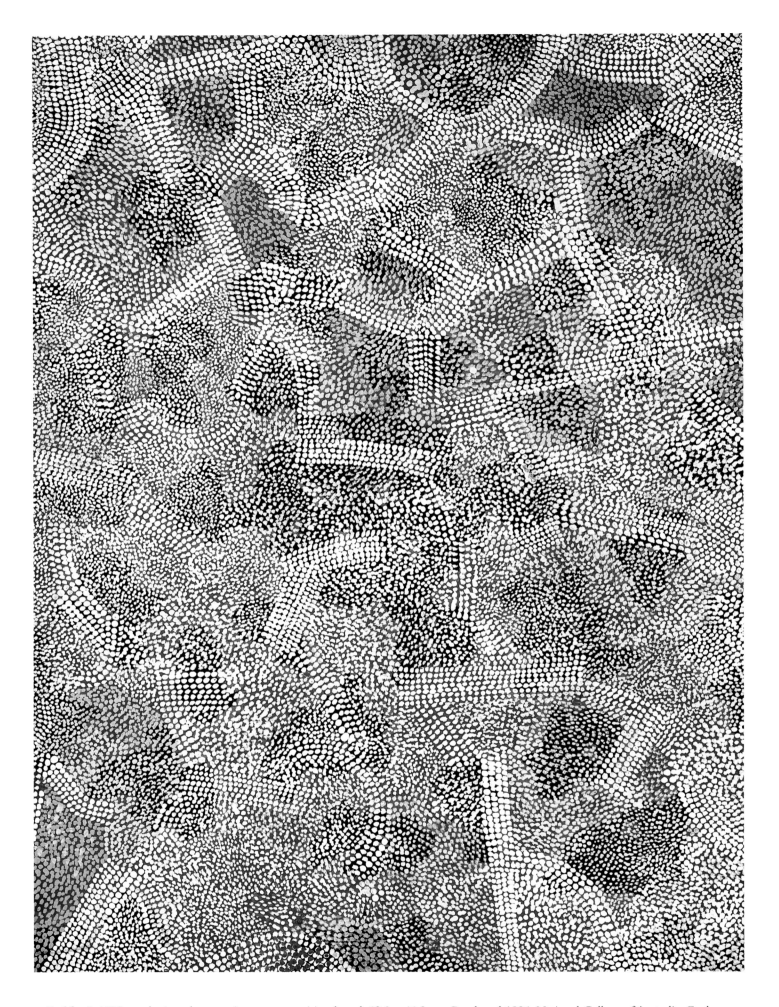

Bushfire I, 1972, synthetic polymer paint on composition board, 62.0 x 46.2 cm; Purchased 1994. National Gallery of Australia, Canberra

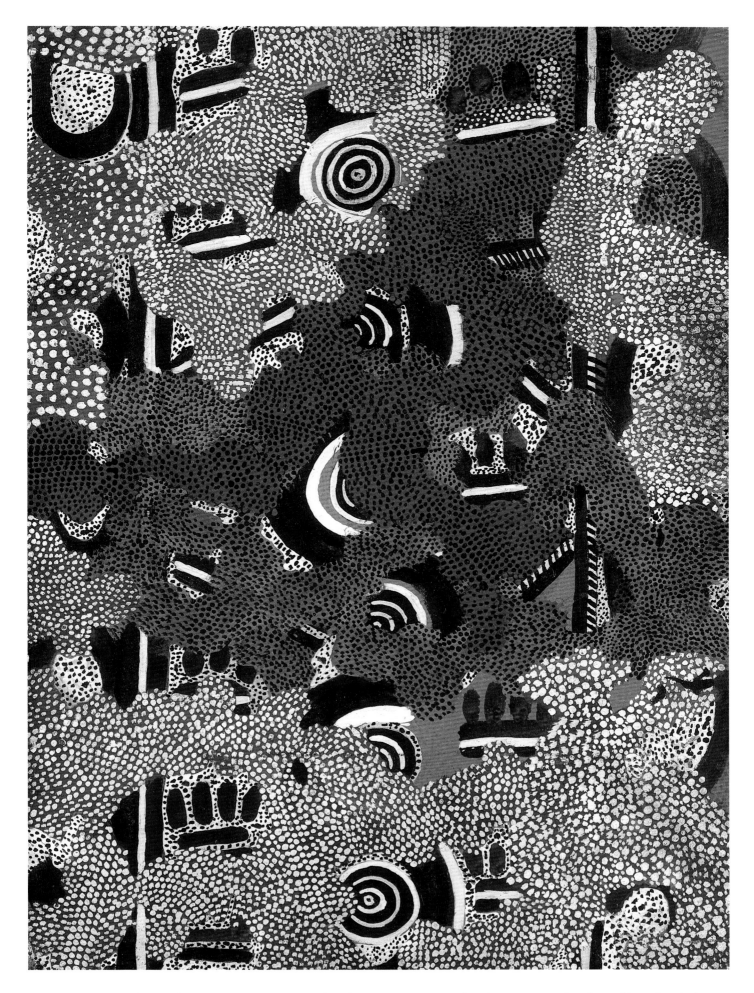

Bushfire II, 1972, synthetic polymer paint on composition board, 61.0 x 43.0 cm; Purchased 1994. National Gallery of Australia, Canberra

Warlugulong swept through in the Dreaming. The yellow daisies and white spinifex grass of the underlying landscape indicate a landscape regenerating after the fire has swept through. The simple device of alternating light and dark tracks implies the perambulations of Upambura continue day and night.

There is a complex development of the basic ground and design stages of the classic Western Desert painting process in all these works. To the standard base coat of red ochre or black, Clifford Possum applied a second layer of brushwork after, but not over the design, which is laid down in the fragmentary state glimpsed through the background dotting to create the illusion that the rest of the design has been covered over by it. The layered grounds of these works provide a striking visual metaphor for the co-existence of strong traditionalism and innovativeness in the artist's mental landscape. Embedding the designs within the ground in this way expresses the traditional idea that the ancestral beings which these marks represent are in the same way embedded within the landscape. The artist's account of why he painted these startlingly original multi-layered backgrounds cited the philosophical sources of the idea in Anmatyerre tradition:

> Under the ground — that's the one. Everybody know about this — some Dreaming go underneath and then come out again here. Oh yes, well. These people, they gotta school their eyes. They gotta think about it. Some Dreaming you can follow: this one, then go to another soakage, then stop, then keep going. And sometime, Dreaming go underground. All the way — just walking right up through and then come out again.

The signature motifs

What Clifford Possum came up with in these extraordinarily polished works was much more than a pared-down vocabulary of traditional symbols or the elimination of the figurative influences of the School of Kaapa. He was learning how to turn the immense aesthetic advantage of an inherited visual language into a foundation upon which to build a personal pictorial code. Alongside these ingenious effects of layered landscape he was also developing a range of striking motifs which represented his Dreaming stories, not with their traditional designs, but with his own set of symbols. One of the most striking examples of this is the spindle motif best known from *Man's Love Story*, 1973 (p. 77) — although the 1972 *Love Story*, in which it is much less prominent, was the first version of this Dreaming.

Man's Love Story, 1973 was painted for Geoffrey Bardon, who was visiting Papunya after an absence of a year. In his notes on the painting Bardon recounts how a rumour circulating around the settlement that he was about to be married produced a rash of paintings on the theme of relations between the sexes. If so, the topic of illicit love which is the subject of the painting was at least a salutary lesson for the western fiance on the importance of finding the right partner. (The story of Liltipilinti and his 'wrong skin' lover ends in their tribal execution under the rigorous marriage laws of Western Desert society.) More importantly for Clifford Possum, *Man's Love Story* presented for the art

Bushfire at Irpulku, 1973, synthetic polymer paint on composition board, 77.4 x 59.8 cm; Holmes á Court Collection

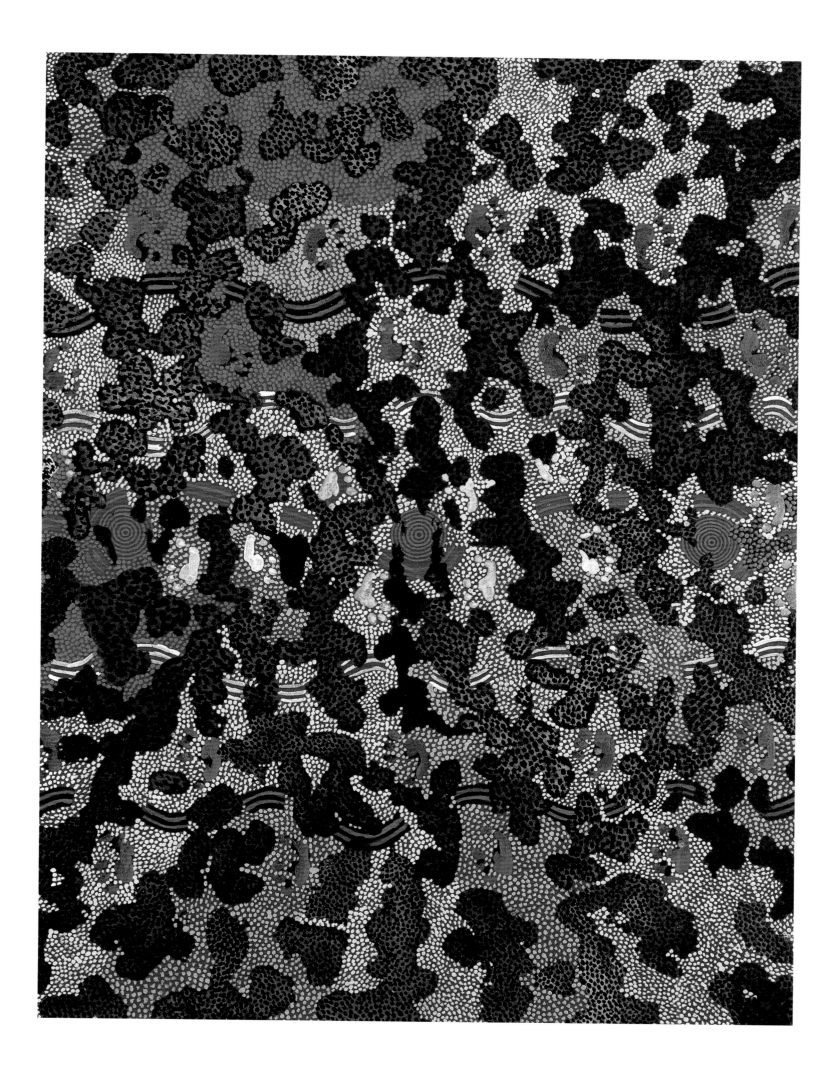

teacher's attention, the first and one of the most striking, of a set of innovative 'signature motifs' which would characterise his work over the next three decades. With the perfecting of the Love Story motif, the painter had dramatically extended the parameters set down for his work by Papunya Tula's founding vision of 'indigenous art'.

In his annotation of the painting in *Papunya Tula: Art of the Western Desert*, Geoffrey Bardon notes approvingly that its iconography was 'immediately identifiable' to 'any Western Desert Aborigine'.[31] This remark would apply only to the depiction of the man's ceremonial body paint. The spindle with which the man spins string as he sings to 'catch' the woman, hovers between the brown haze of 'atmosphere' and an 'earth' made up of angular striped planes. It is clearly a non-traditional motif, yet over time it has been transformed into a component of the artist's telling of the Dreaming story as Clifford Possum's own set of secular symbols comes to symbolise elements of the Ngarlu Love story.[32] A skilful combination of introduced and 'indigenous' influences had generated a decisively different vision of his Dreamings which was clearly both of the past and in the present.

The spindle design functions in *Man's Love Story*, 1973 as a visual key for viewers of the painting to orient themselves spatially to the symbols. It has the effect of positioning the onlooker above the painting, looking down on events at the site with the characteristic aerial perspective arising from Western Desert peoples' traditional reliance for survival on their tracking skills. In an extraordinary twist of the task he had been set of transforming his Europeanised style back into an identifiably 'Aboriginal' one, Clifford Possum showed in this painting that he could employ European visual codes to create illusory three-dimensional effects which evoke a distinctively Western Desert vision of the landscape. Over the remainder of the decade, he would develop his ideas about space and landscape in a series of immense canvases, which form the subject of the next chapter.

The tension between tradition and change existed in Papunya painting from the outset. Not just in the controversy about the secret–sacred: that was, in retrospect, a kind of metaphor for the entire transformation of Western Desert art from its beginnings in 'culture conservation' into its contemporary forms. The same tension existed between the idea of the art movement as a way for the painters to become professional artists, and the idea of it as an act of cultural re-assertion. But despite the tension between them, neither viewpoint was considered to exclude the other. That was the key to Papunya Tula Artists' success: the realisation that the art movement could – indeed *must* – do both these things. Every individual member of Western Desert society at that time faced the same challenge. Clifford Possum had found in painting an accommodation with the new historical reality which still allowed him to be who he was.

Man's Love Story, 1973, synthetic polymer paint on composition board, 58.0 x 43.0 cm; Private collection

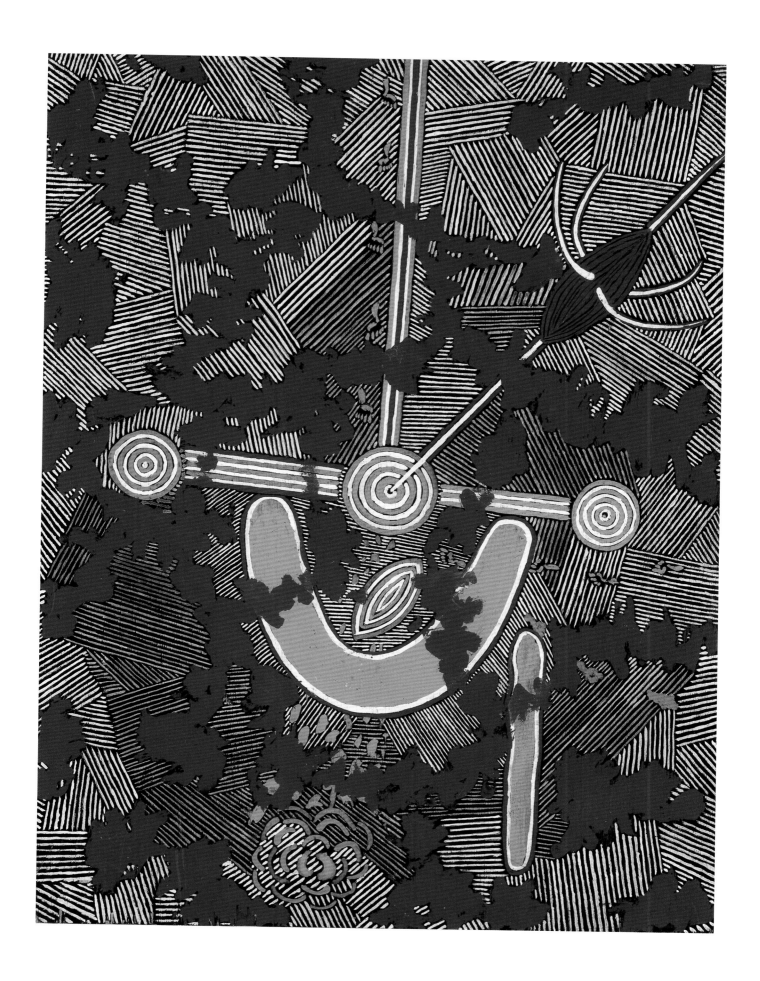

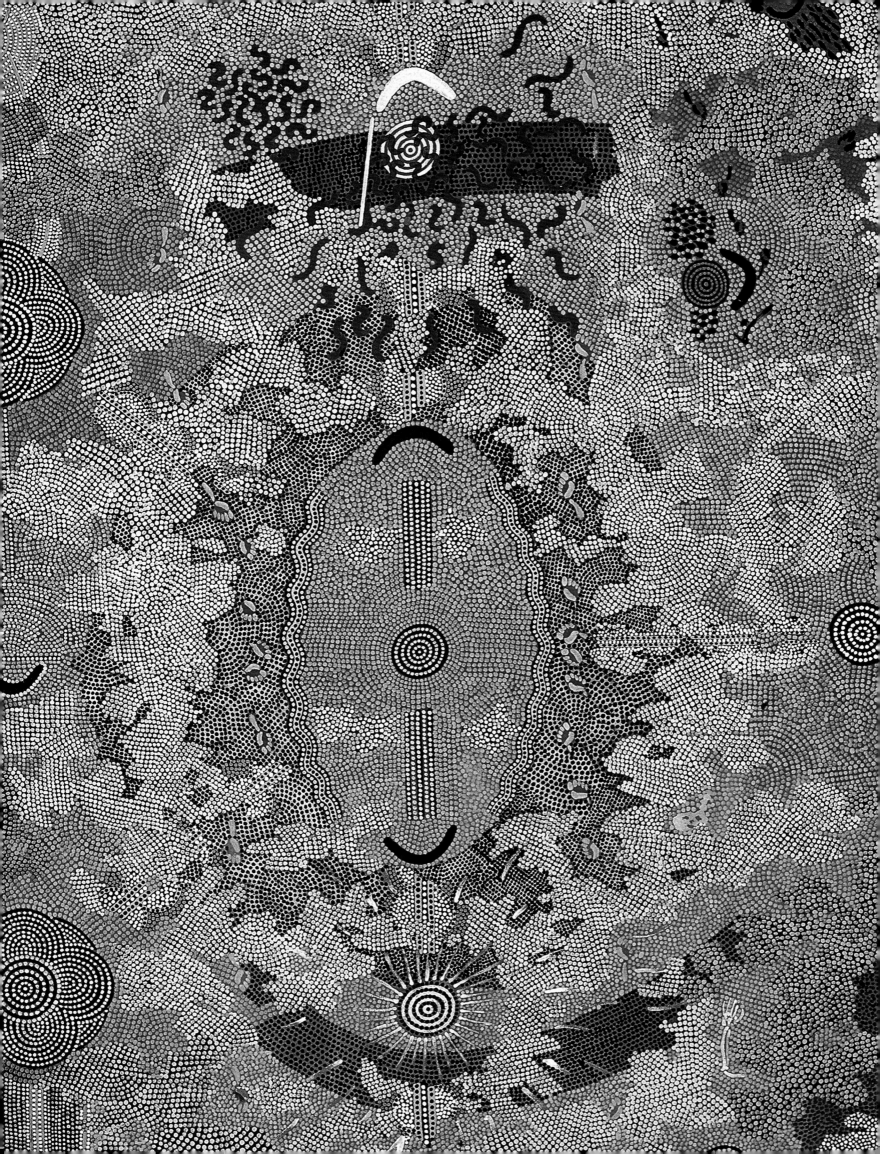

Mapping the Dreaming

V. J.: Clifford, what gave you the idea to put more than one story on the canvas?

Nobody. My idea. I think, I do it this way: make it flash. Well, I got to do all this story now, like old people do'm. They been gather up in the bush, and they been draw'm in the sand first — might be with a stick: 'And all this story bin come this way. And this story go — this one bin come half way. And this one here, he come up here and finish up here. This one from right up there and he bin come right back around and finish up there.' — like you see'm [in] my picture.[1]

Maps, drawn in the sand by the elders to instruct initiates about their Dreamings in preparation for the ceremonies, were an intrinsic part of Western Desert culture. So was the iconography of which the elders' drawings were composed: the circles and journey lines which for twenty-five years were the quintessential design elements of Western Desert painting. The source of this imagery was the sand paintings, constructed of plant and animal down on the ceremonial grounds, which are themselves coded representations of Dreaming places and events.[2] But the series of large and very large canvases mapping his Dreaming country which Clifford Possum produced between October 1976 and July 1979 are without precedent in Western Desert culture — and in the art movement which he helped to establish. Clifford Possum's genius in the great map series was to have perceived the parallel between the abstract diagrams of ancestral passage in these traditional expressive forms of his culture and the maps of the Europeans — and to have realised its artistic potential in the new art form by developing over this series the concept of his paintings as 'maps of country'.

The parallel is not as obvious as his extraordinary achievement in these paintings has made it appear. The peoples of the Western Desert are justly renowned for their uncanny mastery of their terrain and its resources. Their phenomenal skills of site location, tracking and spatial orientation in apparently featureless country almost defy explanation for those dependent on maps to find their way around. Clifford Possum and all his countrymen and women experience their ancestral estates as a 'humanised realm saturated with significations',[3] marking out their passage through the subtlest variations of vegetation and landforms. They do not need to read directions off a map because they know how to read the ground itself. A bush childhood like Clifford

Yuutjutiyungu, (detail), 1979, synthetic polymer paint on canvas, 231.0 x 365.5 cm; The Kelton Foundation

Possum's included countless nights around the family camp fire watching grandparents and older siblings drawing tracks on the smoothed out sand, learning how to copy them and the names of the creatures who made them as a European child learns the alphabet. The uncanny sense of direction and ability to align themselves in space relative to distant points of reference found in all those raised in this culture were inculcated at a very early age by their mothers and grandmothers. On food-gathering expeditions and journeys across country from site to site, they followed the paths of their ancestors, hearing the songs of their exploits as they passed their markers on the landscape. However, the practical skills, so essential to nomadic survival, brought to bear in locating places in actual physical terrain, do not necessarily correlate with being able to represent the knowledge underlying these abilities in pictorial space – much less provide accurate topographical representations of locations in two-dimensional space as on a European map. On the contrary: those who have investigated their skills have remarked upon the extraordinarily abstract character of Western Desert graphic representations of ancestral journeys across known terrain, concluding that the very precision of communal knowledge allows almost total artistic freedom in the manner of its representation.[4]

During the 1970s, only the artist's brother Tim Leura Tjapaltjarri shared with Clifford Possum the idea of combining many Dreaming sites and stories in their geographical relationship to each other on the one canvas.[5] Early exposure to One Pound Jim's work as a guide to anthropologists trying to make maps of country may have influenced the brothers' unusual interest in the geography of their Dreamings. The activities of the anthropologists who descended on Central Australian Aboriginal communities in the wake of the passing of the *Land Rights Act* of 1976, eager to involve traditional owners in drawing up the site maps for a series of land claims under the new legislation, might have re-awakened this interest. It is even possible that they were exposed to the rhetoric of the land rights struggle which preceded the introduction of the act, particularly Tim Leura, whose term on the Aboriginal Arts Board in 1974 would have brought him into contact with the attitudes of what hardened Territorians called the 'southern stirrers'. But other ideas predominated in Tim Leura's work after the mid-1970s. Only Clifford Possum went on to devote the second half of the decade to scaling up their mapping enterprise to produce a series of 'deeds of title' to his home country, whose monumental size, complexity and sheer visual impact would proclaim their cultural authority.

After two decades of dissemination of Western Desert painting into the mainstream, the relationship of art to land encapsulated in this phrase 'deeds of title', serves to unlock the cultural and political significance of its imagery for outside audiences. With the great map series, it is much more than an apt metaphor. Tim Leura used to employ the term 'topographical' to describe this kind of painting,[6] which is exactly the right word. Like western topographic maps, the perfectly realised form of Western Desert topographical painting constitutes a large-scale map of a land area, based on detailed ground surveys, with great attention to accuracy in terms of the positional relationships among the items mapped. Their precision gives them the validity of legal documents:

Dreaming Story at Warlugulong, 1976, synthetic polymer paint on canvas board, 50.0 x 40.0 cm; National Museum of Australia, Canberra

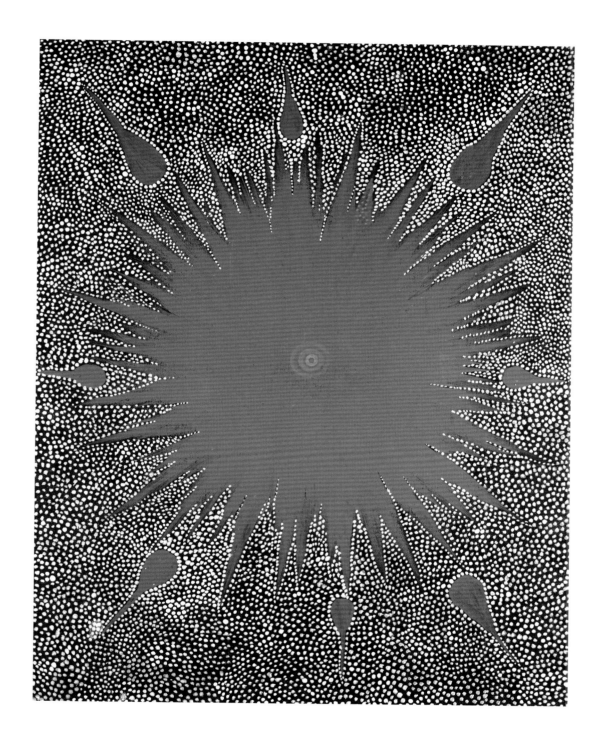

they are indeed the Western Desert graphic equivalent of European land titles. In them, Clifford Possum records the encyclopedic knowledge of his Dreamings which had earned him a place, despite his relative youth, in the original group of 'painting men' at Papunya alongside some of the most learned and venerable men in the community. They make an ideal subject for exploring the relationship between artist and country which is the wellspring of all Western Desert art. Among the pioneering artists of the painting movement, only Clifford Possum was to develop the idea of actually representing this relationship in his own paintings. Many artists since have worked with the idea of depicting a number of different Dreamings on the one surface, but never with the refined cartographic perspective Clifford Possum applies in his map paintings of the late 1970s.

Cartographer of the Dreaming

The earliest annotation for one of Clifford Possum's paintings preserved in Papunya Tula's records shows the artist already engaged in the task of mapping his Dreamings. Dated September 1973, it documents a painting on a 120 x 90 cm compsition board in which nine different Dreamings around Mount Allan Station are depicted: old man, possum, emus, fire, perentie (lizard), dancing woman, kadija (kataitja) man, warru (wallaby), and flying snakes. All of these Dreamings have at various times recurred in Clifford Possum's paintings over the intervening thirty years. Mount Denison and the Warlpiri settlement of Yuendumu to the west of Mount Allan, as well as the sites of 'Ankapiri (old Mount Allan)' and 'Brogas (Brookes) Well (Altjupa)', 'Mount Allan', are marked on a diagram of the painting with the comment that the 'map'[7] was 'probably accurate, although there was some difficulty in placing English names on it. Orientation is north to the top.'

About the same time as this painting was produced, Peter Fannin, who ran Papunya Tula Artists from December 1972 until June 1975, introduced canvas in place of the boards which the artists had used almost exclusively to that point. The change was made for purely practical reasons. By then, the production of art at Papunya was enormous. Many people had expressed verbal support for the painters, but no one was buying their work – not in Alice Springs anyway. There was an obvious need to take the paintings further afield, to the cities on the eastern and southern seaboards, where there was some level of interest. The ever-larger sheets of composition board and masonite on which the painters worked were an expensive nightmare to consign and freight. The initial transition was to cotton duck, which Peter Fannin heard had been found in a remarkably well-preserved state in archeological digs in Europe.[8] The idea appealed to his image of the artists as 'culture conservationists'. At least, that was how he described them in his first submission to the Aboriginal Arts Board on behalf of Papunya Tula Artists late in 1972. The submission was for wages to pay twenty-five of the company's principal painters to continue their work free of the distortions of the marketplace. The Board denied the request (though it continued to fund the company's activities at a lower level of support). Survival

then dictated that the enterprise move in the direction of professionalisation, including the shift to canvas. This decision precipitated the dramatic artistic developments at Papunya in the late 1970s by enabling the artists to work on a much larger scale.

The first large canvas (203 x 173 cm) to be found in Papunya Tula Artists' records was a collaborative work painted in March 1974 by Clifford Possum's 'brothers' Tim Leura and Billy Stockman. Peter Fannin gave it the title *Life at Yuwa* after the hill to the west of Napperby denoted by the large concentric circle at the centre of the canvas. The painting's whereabouts are unknown, and it is possible that it no longer exists, but from the diagram which accompanied Fannin's annotation of the painting it is apparent that, in a compositional sense at least, it is the precursor of the first great map painting, *Warlugulong*, 1976 (pp. 90–91). Like *Warlugulong*, the narrative burden of the painting is arranged around the focal point of Yuwa, set in what Peter Fannin described as a 'movement graph' of tracks and pictograms indicating the lifeways of the extended family who dwelt at Yuwa in the ancestral past. No other painting among the two dozen or more large and very large canvases produced by the Papunya Tula artists in the two-and-a-half years from March 1974 up to October 1976 echoes the complex structure of this painting. Billy Stockman, who was the company's leading artist over this early period, painted numerous other large canvases commissioned by the Aboriginal Arts Board for travelling exhibitions and government offices offshore. Like *Life at Yuwa*, they relate to a single site in the artist's estate, but rarely go beyond abstract allusions to the activities of the ancestral beings associated with that particular location. Nor did Tim Leura pursue the trajectory *Life at Yuwa* had marked out in his other large canvases from this period. Nor had any of the other artists who for the going price of a broken-down secondhand 'motocari', had so far lovingly inscribed their Dreaming heritages on the grand scale of the New York School. Not even *Life at Yuwa* comes close to the multi-layered, multi-directional topographical schemata which Clifford Possum would extract from this prototype when his turn finally came to paint a large canvas.

In May 1976, almost a year after Peter Fannin's departure, Dick Kimber joined Janet Wilson in the running of Papunya Tula Artists. The company was still embattled: sales interest was virtually nil, and there was still widespread antagonism being expressed towards the painting movement within other Western Desert communities, despite the modifications which the artists had made to their painting language in an effort to allay criticism. The arrival of a film crew – a rare event at Papunya in those days – to make a documentary for the BBC about the paintings, represented a chance to break out of this depressing cycle of opposition and indifference and capture an international audience for Papunya art. The 168.5 x 170.5 cm canvas which was prepared for the film was considerably larger than any Clifford Possum had painted before. He was still painting only occasionally for the company, working as head stockman at Narwietooma Station and returning to Papunya on his holidays to visit family and paint. *Life at Yuwa* may have been painted during one of his

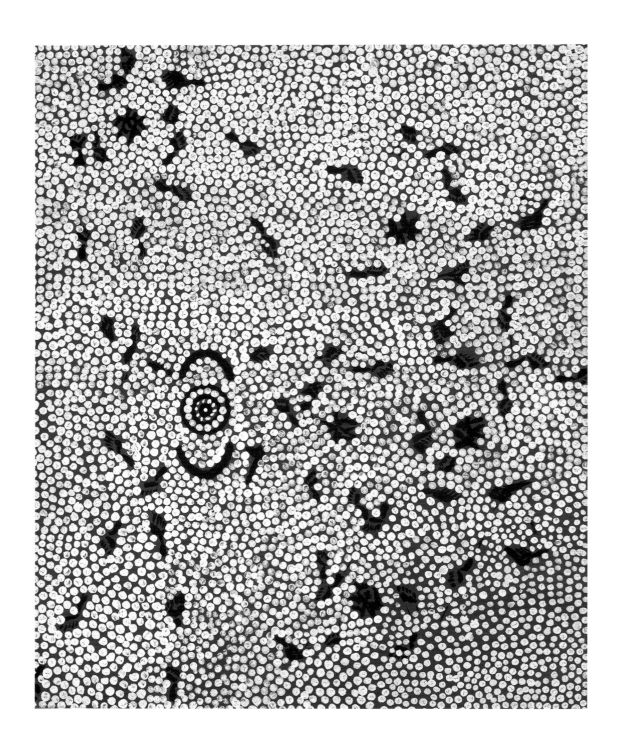

Aralukaja, 1976, synthetic polymer paint on canvas board, 50.5 x 40.3 cm; South Australian Museum, Adelaide

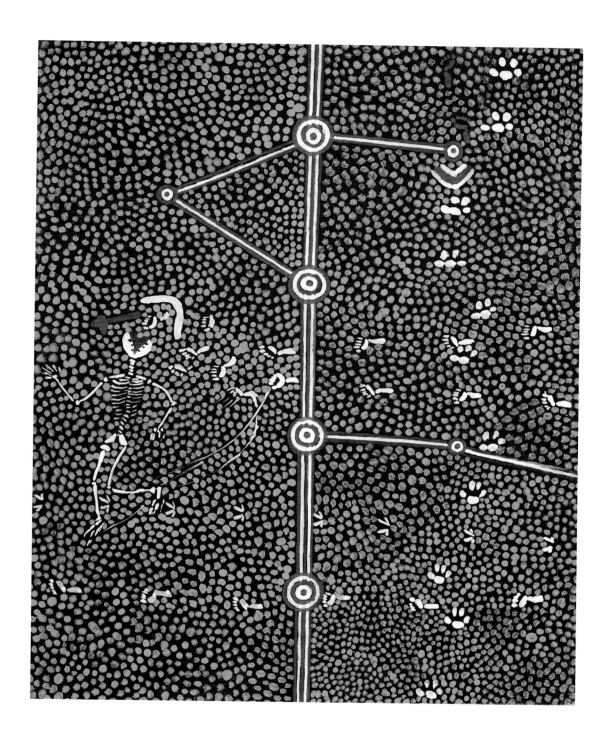

Five Dreamings, 1976, synthetic polymer paint on canvas board, 50.5 x 40.3 cm; South Australian Museum, Adelaide

frequent long absences. But if it was, the influence of this work on the painting which Clifford Possum executed before the cameras of the BBC is so pronounced that the idea of it as Clifford Possum's work alone must be modified to include the contribution of his brother Tim Leura, who was present throughout, assisting on the background – and presumably dispensing compositional advice. *Warlugulong*, 1976 is the endpoint and culmination of the two brothers' mutual experimentation over the early 1970s with the idea of mapping their Dreamings onto canvas.

Five years later, after he had seen some of the other large topographical paintings in the great map series, Dick Kimber revised his original assessment of *Warlugulong*, 1976 as 'the most complex ever created by any of the Papunya Tula Artists' to 'the most complex work created in the entire period 1971–76'.[9] But when it first appeared, this painting was a work of unprecedented narrative complexity in the Papunya Tula style, encyclopedic in its range and detail. Dick Kimber was in as good a position to judge as anyone. He had observed closely the first five years of Papunya painting and, after a year full-time working with Janet Wilson, continued to liaise closely with their successor John Kean, who started in mid-1977 and stayed till the end of 1979. Over the next two-and-a-half years, Dick Kimber and John Kean were between them witnesses to Clifford Possum's production of five canvases based on the idea of his paintings as maps of country which are amongst the most remarkable paintings he, or any other artist of the movement, has ever done.

Their passionate conviction of the importance of these five paintings as cultural witness shows in the range and detail of the annotations they prepared for them. Often five or six typed pages long with background information on the sites and Dreamings depicted and accompanying diagrams, they have been invaluable in constructing this analysis of these archetypal visualisations of the idea of mapping the Dreaming. Apart from some minor editing to avoid repetition, they are reproduced in full, carefully re-checked and corrected by the artist, in the section *Catalogue of works of art*. Their groundwork permits the analysis here to diverge from explanatory ethnography and explore more fully the representation of space in these paintings. Comparisons between the depictions of country in these works and European mapping conventions will shed new light on the artist's approach to compositional questions in these paintings, illuminating issues of aesthetics *and* ethnography.

The title deeds

Warlugulong 1976

In 1971, Clifford Possum had been an onlooker at the Papunya Honey Ant mural, watching his cousin Kaapa Tjampitjinpa, whom the senior men had chosen to paint up the appropriate designs on their behalf. This time Clifford was the chosen one, though it was the Papunya Tula art advisors who made the selection. As with the school mural, his artistic agenda was pre-assigned. The artist was flattered by the confidence in his ability to produce a vivid image on demand for the film crew's cameras, but would later declare that he had agreed

Lungkata's Two Sons at Warlugulong, 1976, synthetic polymer paint on canvas board, 70.5 x 55.0 cm; Mollie Gowing Acquisition Fund for Contemporary Aboriginal Art 1996. Art Gallery of New South Wales, Sydney

to their request that the Warlugulong Bushfire be the subject matter of the painting with some misgiving:

> Because I was at that time really thinking, don't paint this. But they give me the job anyway, and I ask him, uncle and mother: 'Well, you can do him one this because only part' – and all this. I don't touch'm secret today from start.

Warlugulong is the Anmatyerre name for a site 300 kilometres north-west of Alice Springs where Lungkata, the old Blue-Tongue Lizard Man started a great bushfire, the 'ancestor of all bushfires', in which his two sons perished. Clifford Possum stressed that he knows 'only this sandpainting' for Warlugulong and has never been there himself. It lay well to the west of the land of his fathers and grandfathers in the most westerly reaches of Anmatyerre country (for this reason, it was not included in the detailed account of his Dreamings in chapter 1, *Corroboree country.*) However, his mother Long Rose Nangala, and his maternal uncle (Kaapa Tjampitjinpa's father) were both born at Warlugulong, so he had close family connections to the site.

In the months leading up to the painting of *Warlugulong*, Clifford Possum and Tim Leura had both painted small canvas boards to spectacular effect with the image of a bushfire as an explosion of red flame surrounded by tear-shaped sparks and white dots representing swirling ash against the blackened countryside. *Dreaming Story at Warlugulong*, 1976 (p. 81), painted only the month before, was Clifford Possum's first version of this developing motif. He now placed another variant, with the concentric circles marking the site of Warlugulong showing through the red of the fire, in the centre of the large canvas. Over the preceeding months Clifford Possum had also been experimenting with spelling out a Dreaming narrative in detail over a series of small boards (see pp. 84–85). The large canvas now gave him scope to depict several complete stories, including the extensive travels they often involve. He painted in the most complex set of Dreaming tracks and sites ever seen from one of the artists, structured around the bushfire as the focal point. Tim Leura assisted on the richly atmospheric background infilling. The two brothers worked together for twenty hours to complete the painting, which strongly bears the signature of both their painting styles.

The account of the Warlugulong story originally supplied by Dick Kimber[10] can hardly be improved upon for accuracy and detail, except perhaps in one respect. In this, and all subsequent accounts of these events which I have seen in annotations of Clifford Possum's paintings, the reader is left with the impression that Lungkata's two sons suffered their terrible fate for not sharing, or sharing only a rib bone of, the kangaroo they had killed. As Clifford Possum explained, there is more to this story than a father's rage and punishment for his sons' ungenerous and disrespectful action. This was not the worst of their crimes:

> This old man – father – don't like. Might be secret one, that kangaroo man them two been catching. That's why old man don't like. That is wrong one them two cut up. See, them two feeding all the kangaroo meat, not from bush tucker. Only this kangaroo meat they been eating all the time. That old man them two young fellas been feeding all the time. This only once from this one kangaroo man.

The kangaroo they had killed and eaten, which went on and on satisfying their hunger, without any of the vegetables, fruit, small reptiles and animals that are usually the staples of a tribesman's diet, was a sacred kangaroo, and the Law demanded that its killing incur the severest punishment.

The annotated diagram gives a quick indication of the painting's contents. Detailed accounts of the Dreaming stories associated with the sites of Kerrinyarra, Yakuti, Aruakuna, and Wakulpa also depicted in *Warlugulong* are contained in the original Papunya Tula annotation, and at other locations in the text. Here we step back from these narratives to take in the 'topographical' dimension of the painting – its representation of the space in which those Dreaming events are enacted. In the supplementary notes he wrote to *Warlugulong*, Dick Kimber recorded the artist's observation that the geographical location of the site of that name is 'beyond the right hand border' of the canvas. Since all the other Dreaming sites shown on the diagram of the painting are located on a European map to the *east* of Warlugulong, it should follow that if European mapping conventions are observed, the top of the painting is *south*. The viewer is facing in the direction in which the two brothers fled south to escape the flames of the great bushfire. Their white footprints head upwards away from the centre of the fire towards Ernabella in the south.

Like almost all Western Desert paintings, *Warlugulong* was painted flat on the ground. This displaces the European assumption that the top of the painting must, like a western map, be north, with a perspective from which there are only four sides, any of which might be the top depending on which side of the canvas the artist is located at the time. This idea proves useful in deciphering the placement of the other Dreaming sites and trails on the canvas.[11] Over what landscape then, is the Warlugulong bushfire motif superimposed? What is the country somewhere to the east of Warlugulong being mapped in this painting? The southern part of whatever landscape this is should be located at the *top* of the painting. In the left-hand corner, we find the site of Kerrinyarra where it should be by this reckoning, south-east of Warlugulong. To the right across the top of the painting is the next mythological marker on the southern horizon. The diagram indicates where the Rain Dreaming enters Anmatyerre country from the west and is handed over to Tjangala and Tjampitjinpa (artist's maternal uncle and grandfather) custodians for the next stage of its journey. This event occurred in the vicinity of Watulpunyu, about twenty kilometres west-north-west of Kerrinyarra, which is again consistent with the idea of facing south – although inconsistent with its bearings from Warlugulong. Likewise the third Water Dreaming site of Aruakuna, found below the bushfire motif, is correctly located on this alignment to the north of the other two.

However, this set of bearings breaks down when it comes to the path of the Great Snake Yarapiri, who travelled from Winpar'ku south of Mount Wedge many hundreds of miles to the north. Yarapiri's path runs horizontally right across the top of the painting, but the great serpent is said to be travelling *north*. So were the group of rock wallabies whose tracks traverse the lower width of the painting on their way from Port Augusta far to the south, through

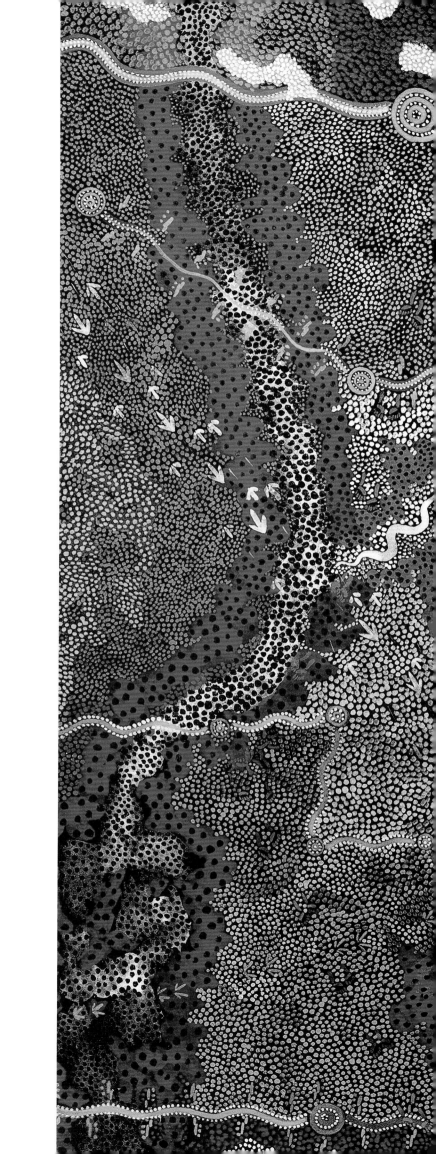

Warlugulong, 1976, synthetic polymer paint on
canvas, 168.5 x 170.5 cm; Purchased 1981.
Art Gallery of New South Wales, Sydney

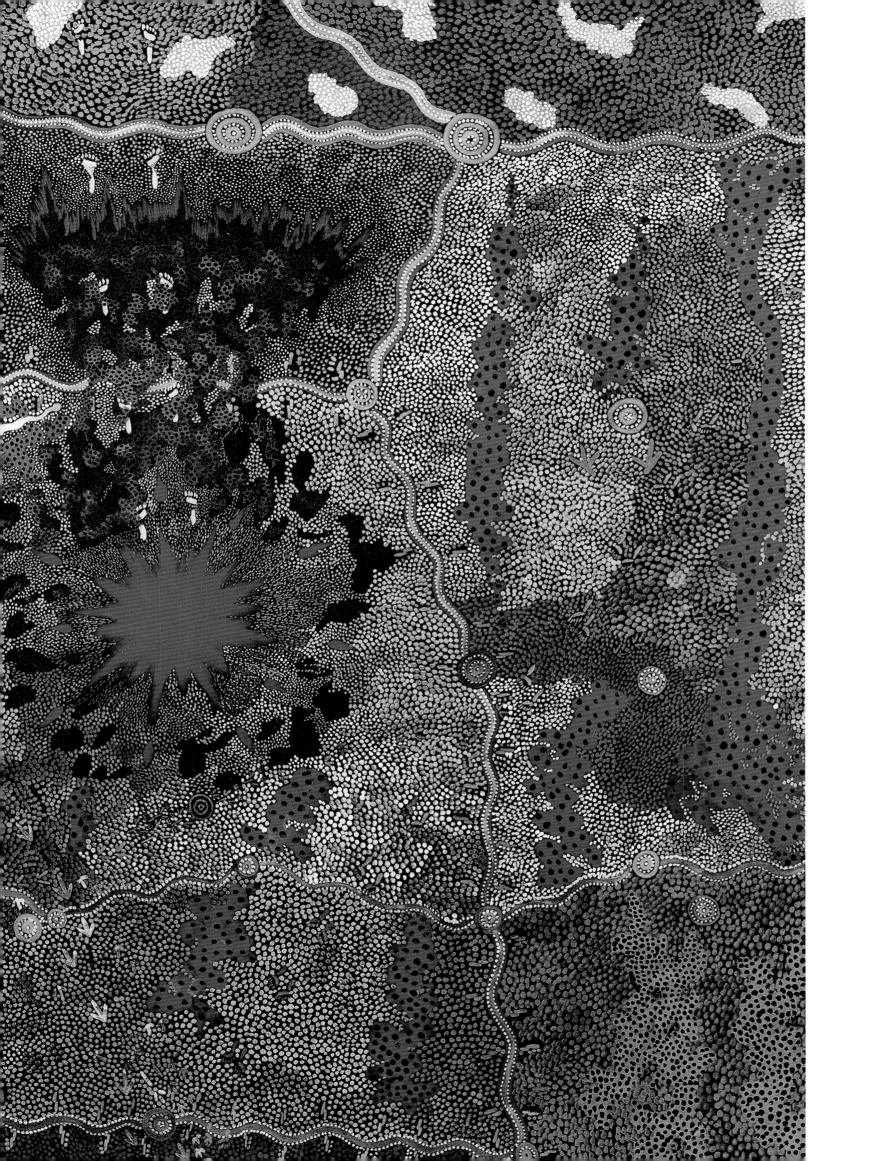

Mungapunju and on to the Top End. Again, the ochre pits at Yakuti to the north of Mungapunju are indicated by an arrow as lying off to the right of the painting. To accommodate these perceptual shifts, just imagine doing what Clifford Possum might have done himself before putting in the Yarapiri and rock wallaby Dreaming trails: turn the painting around and take a new set of bearings based on this new orientation in space. He seems to have done this at least once more in the course of mapping out the designs for this *Warlugulong*, with the top of the canvas now *north*. The footprints of two Napanangka women who travelled from Pikilyi in the north-west, down past Kerrinyarra and further south, lead out the *bottom* of the canvas. The tracks of a second group of women, said to be from 'far in the *east*' near Aileron, come in from the top right of the painting. Their footprints curve downwards in a wide arc which would converge with the path of the Napanangka women from Kerrinyarra somewhere underneath where the painting ends.

Clearly then, the sites and Dreaming trails on *Warlugulong* have *not* been placed on the canvas in their geographical relationship to one another as on a European map – though the painting's annotation leads us to expect this by describing the work as 'in effect a map of a section of country'.[12] By examining in detail the shifting spatial alignments in the painting, we have discovered something much more interesting than a European map. The artist is drawing up the map in stages, taking his bearings from different sides of the canvas. The sites and journey lines relating to each narrative strand are correctly positioned in space with respect to one another, and also to at least one other strand, so that two or more Dreamings tie in with each new directional re-alignment. The painting's Dreaming geography reveals a *systematic* re-orientation of the artist's viewpoint in space. What appears dizzyingly complex to the static, 'mono-directional' gaze of the western observer makes sense in terms of the idea of a different sense of space in Western Desert art. The orientation of the artist–cartographer is constantly changing – like spinning in space above the landscape, just as the tracker continually updates his bearings and alignment in space with each change of direction in the chase. The peoples of the Western Desert can always tell you the direction home whatever direction they happen to be facing. They know, because of a lifetime spent refining their sense of direction – and enhancing it with an internalised navigational device: the knowledge of their Dreamings, which automatically adjusts their bearings for them in country with which they are familiar.[13]

In addition to the Western Desert sense of space which this analysis has disclosed in *Warlugulong*, its annotation identifies another significant factor in its composition: the artist's 'sense of balance, which clearly emerges despite the perceived European desires and resultant need for modifications'. The inclusion and placing of the emu tracks running diagonally across the left-hand corner of the painting are cited as a case in point. Apparently, the Tjapaltjarri brothers perceived 'a need for some further design element to give greater balance to the canvas'. They obtained formal permission to include in the painting the part of the Emu Dreaming for which their cousins Kaapa Tjampitjinpa and Dinny

Nolan Tjampitjinpa were keeper–owners. Unlike other re-orientations we have considered, nothing else corresponds to this as an east-west axis of the painting, giving weight to the suggestion that the positioning of the emu tracks is based on aesthetic rather than geographical considerations. As the map series continues, Clifford Possum works to reconcile European and Anmatyerre senses of direction and balance in his Dreaming cartography.

The BBC documentary, called *Desert Dreamers*, was completed with remarkable speed, and screened in England over Christmas 1976, and in Australia early in the New Year. The film created a small surge of interest – the next day a wealthy private collector of Australian art rang Papunya Tula Artists wanting to buy *Warlugulong*. The offer was unprecedented, but politely declined, on the grounds that the painting was a 'national treasure' and should not belong to a private individual. The painting was actually offered at the time to the National Gallery of Australia, which eventually sent it back to Aboriginal Arts and Crafts Pty Ltd with the excuse that they could not afford the relatively meagre amount of money necessary to buy it. This was probably true of Aboriginal arts budgets in the mid 1970s – it was still unthinkable to buy the work of Aboriginal artists under the category (or in the price range) of 'contemporary Australian art'. *Warlugulong* was shipped off for safe-keeping to the Aboriginal Arts Board in Sydney – and what turned out to be for the time being a destiny of far greater obscurity than the one from which it had been saved. For the next three years, it would lie on the concrete floor of the Grace Bros Furniture Storage Warehouse beside the Pacific Highway in Sydney with the rest of the Board's collection – gathering dust.

Warlugulong 1977

In June 1977, Clifford Possum completed a second 'topographical' painting, considerably larger (201.5 x 338.0 cm) than the first, with the bushfire motif once again the central focus. This time, he worked alone – there is no mention in the annotation or stylistic evidence in the painting of Tim Leura's assistance. The representation of the bushfire is more emblematic than in the first *Warlugulong*, with an outer ring of red sparks placed like the markings on a compass, which stand out against the cloud of luminous white dots replacing the sombre blues and charcoal greys of the first (Tim Leura assisted) painting. In the later version, the effect is of huge black-and-white clouds of smoke billowing out from the fiery explosion at the centre towards the right-hand edge of the painting. The white footprints of Lungkata's fleeing sons, which stood out in the earlier painting against a dark pall of smoke and ash, almost recede into this spectacular image, which dies out, as the fire did, at the place where the two brothers met their death. To complete the image of this Dreaming on the canvas, the artist has painted two large white skeletons (which are anatomically correct bone by bone down to the number of ribs), with the bundles of sticks they used to beat at the flames lying scattered beside them,

pp. 94–95: *Warlugulong*, 1977, synthetic polymer paint on canvas, 201.5 x 338.0 cm; Ebes Collection

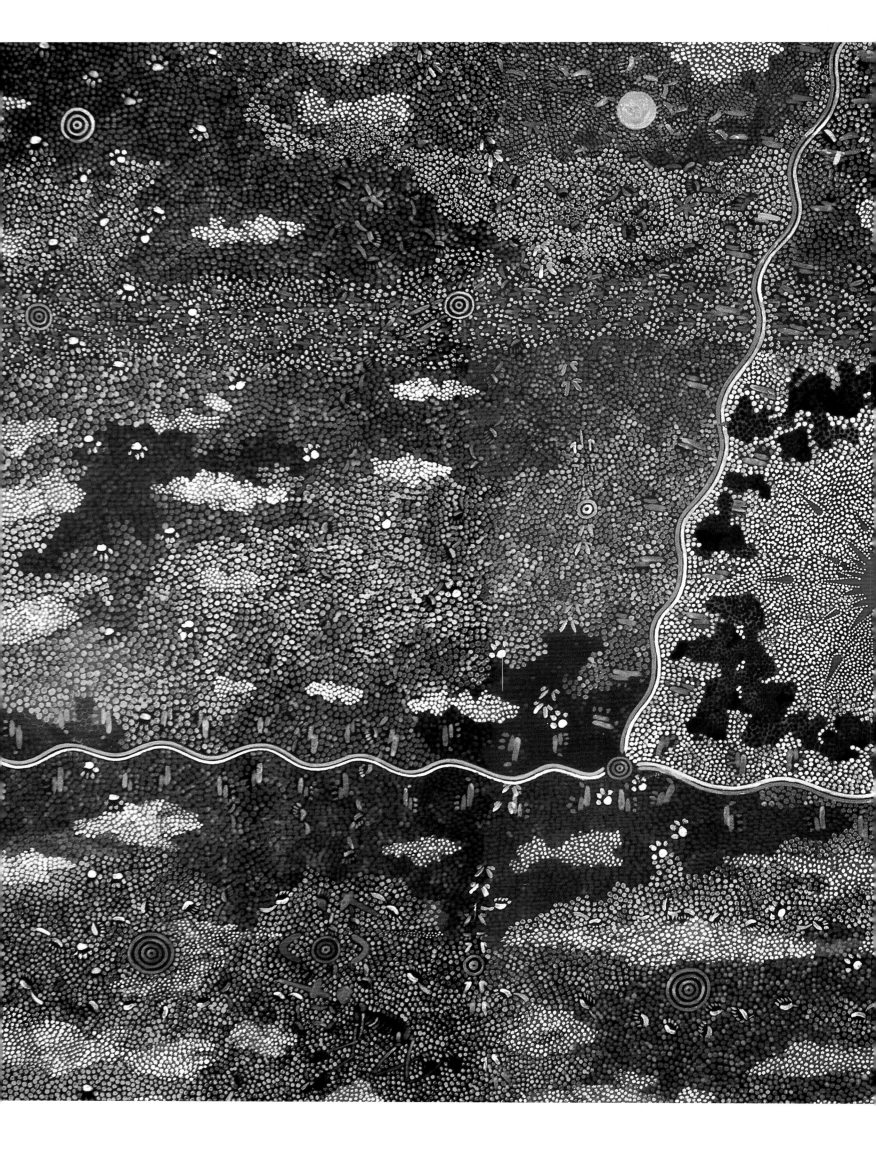

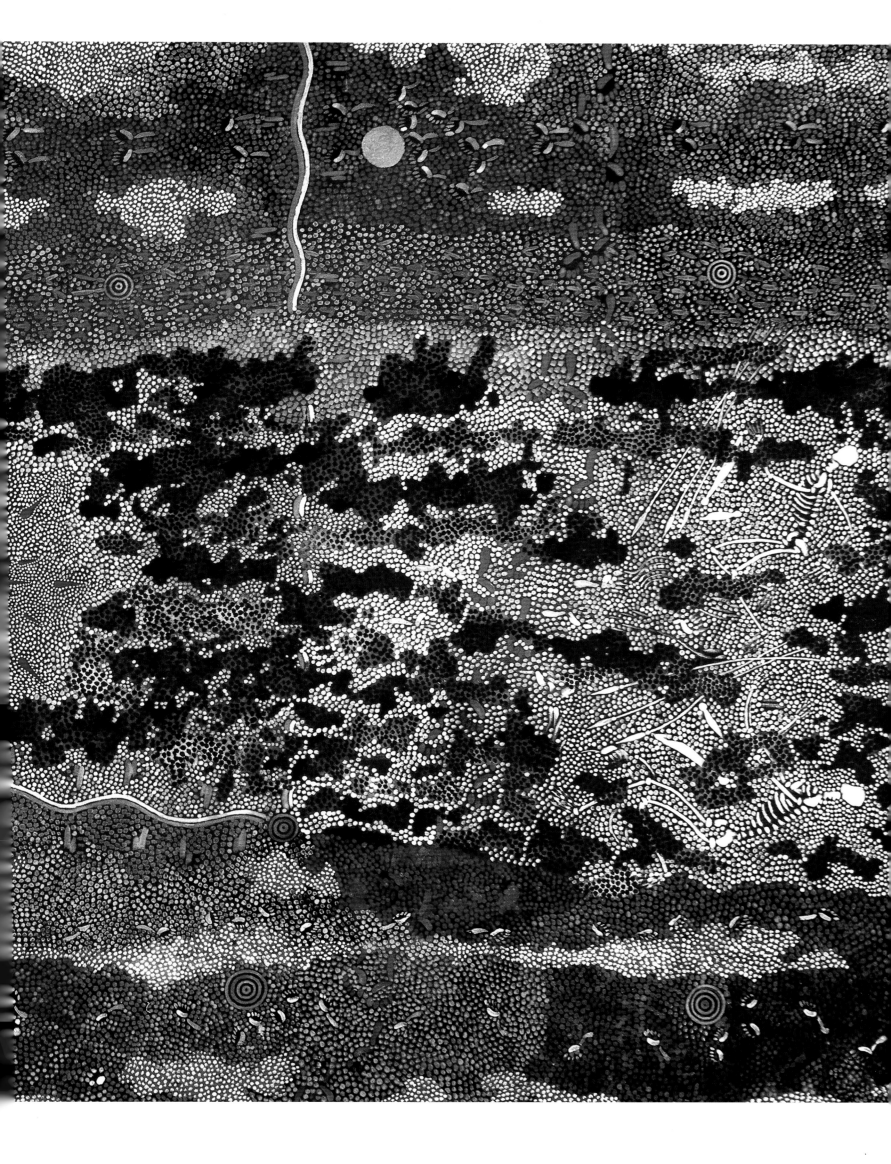

against the right-hand edge of the canvas.

Over what landscape has the bushfire motif been superimposed this time? None of the southern Dreamings from around Kerrinyarra or Watulpunyu shown in the first painting appear in the second, suggesting that *Warlugulong*, 1977 (pp. 94–95) covers a more circumscribed area. All of the Dreamings in common between the two paintings traverse the north and west of the artist's country, around Mount Allan station and west across to Yuendumu.[14] This includes the track of the old possum man Upambura, a prominent visual feature of both *Warlugulong*, 1976 and *Warlugulong*, 1977. When the two paintings are compared, the possum's trail, broken up where it crosses the path of the fire and interwoven with clouds of smoke and ash, is clearly visible. The long meandering U-shape on its side followed by the possum tracks in the first *Warlugulong*, turns into an F-shape on its back in the second painting by the addition of a trail going out the left-hand side of the canvas.[15] The Dreaming trails which only appear on *Warlugulong*, 1977 also all pass through key sites in the Mount Allan–Yuendumu area.[16]

Tracing the painting's orientation in space, we find a far more straightforward picture than emerged in the first *Warlugulong*. The direction of the fire and the brothers' fleeing footprints indicate that, for this Bushfire Dreaming, we are *facing east*, looking across the flame front, which is moving southwards off the right-hand edge. The alignment of the possum tracks and the bushfire front is constant between the two paintings, presumably because the events they depict are part of a chronological sequence in the Dreaming narrative. In *Warlugulong*, 1977, Upambura's tracks lead east out the top of the painting, and come back in further north behind the fire.

All other Dreaming trails which appear on *Warlugulong*, 1977 are placed on the canvas as if the underlying landscape were in a south–north orientation in space, with *south* again at the top of the painting. The single track of the 'boss' emu going west runs out to the right, and the multiple tracks of the returning band going east come back in from this side. The footprints of the family travelling north to Ngama run from the top to the bottom down the right or western side of the painting. The track of the rock wallabies also runs from the top of the canvas right down the the left-hand side, east of these events. Beside it the chase of the goanna men takes them first south then back around to the north. The old Tjangala dingo man travels south-east from Ngama to Arrangi on Mount Allan station, then north to Warrabri with his Nungurrayi dingo woman. The Tjungurrayi's footprints are shown across the bottom of the canvas, moving east through four unnamed sites in search of sacred boards to steal, and then returning to Kunatjarrayi, a site far to the west in Warlpiri country. The easterly path of the dancing women from Aileron, broken by blank circles marking the sites of their joyous ceremonies along the way, runs across the top of the painting from right to left, crossing the path of the Possum Men but not, as in the first *Warlugulong*, that of the Mala Men. The separate narrative strands represented in these paintings may cross over one another on the canvas, but they are unrelated in mythological space.

There is only one directional wildcard in this painting: the placement of the skeletons of the two brothers on the right-hand edge of the painting. The place where they died, known as Tjampitjinpa-Jarra or Ramarakujunu ('red bones'), is actually about twenty-five kilometres to the *north* of Warlugulong just outside Yuendumu. This comparative stability of the spatial orientation of the underlying landscape in *Warlugulong*, 1977 permits a clearer assessment of the degree of geographical displacement of the sites and Dreamings trails on the canvas. On the eastern (left-hand) side of the painting, Arrangi in the top corner is correctly positioned in relation to Aralukaja to the north-west. The Mala tracks following the usual route from Port Augusta go through Mungapunju, which is about ten kilometres west of Yuendumu on the Tanami road. The tracks of the dingo travelling to Arrangi converge backwards on the path of the travelling family from Winpar'ku somewhere below the bottom line of the canvas at the site of Ngama, whose geographical position is further to the north-west. In general, there is a topographic rationale for the order in which the Dreamings appear from left to right (that is, east to west) across the painting. The same can be said of the transverse Dreaming trails, for example, the emu tracks are correctly placed between Arrangi and the paths of the possum and kadaichi (kataitja) man further north.

However, beyond this ordering, the distribution of the painting's cognitive burden across the canvas appears to be as much influenced by considerations of symmetry as by the geographical relationship between the sites from the perspective of western mapping. Symmetry is one of the hallmarks of Anmatyerre painters' styles within Western Desert art. On the evidence available, it is difficult to say whether this is a traditional feature of Anmatyerre culture or the personal influence of the great Anmatyerre artists of the early painting movement like Kaapa, Tim Leura, Clifford Possum and Billy Stockman, all of whom have painted in symmetrical styles. Though there are some clues in Clifford Possum's paintings (for example, mirages) to the significance of reflections, the origins of symmetry in Anmatyerre painting on traditional ceremonial objects must, out of respect for the artist's culture, remain obscure.

The process of checking the alignments in space of the many Dreamings depicted on this vast canvas, discloses the striking balance in the composition of *Warlugulong*, 1977. The placement of the tracks of the Mala down the left-hand side of the painting and the tracks of the travelling family down the right-hand side is precisely symmetrical. The emu and dancing women tracks across the top of the canvas are balanced by the long horizontal possum trail and the footprints of the kataitja man across the base of the picture. By comparison, the first *Warlugulong*'s structure appears completely asymmetrical around the 'central core' of the bushfire motif. The relative calm and order of *Warlugulong*, 1977 may have something to do with the circumstances in which it was produced: an unhurried solo effort with the time to ponder compositional questions.

Alongside the aesthetic and cartographic dimensions already canvased, a third factor bearing on the composition of *Warlugulong*, 1977 is censorship. The following passage from the annotation is a clear reference to the earlier

controversy and a statement of Papunya Tula Artists' position at the time on this issue:

> In its creation the bushfire was centrally placed to give artistic balance, certain of the mythological routes were slightly altered to maintain this balance, and minor imperfections were purposefully made to allow secular viewing. Added to this, only a secular description of events, rather than a secret–sacred, has been given to ensure that offence is not given to other Aboriginal men. This is common for virtually all paintings, the artists having, in general, come to grips with an acceptable way of presenting their art to an audience they recognise as being largely non-Aboriginal.[17]

The second *Warlugulong*'s immediate destiny was anything but obscure. July is show time in Alice Springs and Papunya Tula Artists decided to mount an exhibition at the showground in an effort to promote the art movement locally:

> We had hessian pinned out at the Show, with that painting and another one that was going to France on display. There was a bit in the *Advocate* about this being your only chance to see them. We were terrified that some vandal would do something to them because they'd already been sold – or were committed. There were a lot of people, dust going everywhere, so many people wanted to see it.[18]

As usual, however, no one wanted to buy:

> We also had some very good quality artefacts for sale there, and a lot of paintings. We might've sold one painting and probably one boomerang or

Papunya Tula Artist's display area, Alice Springs show 1977

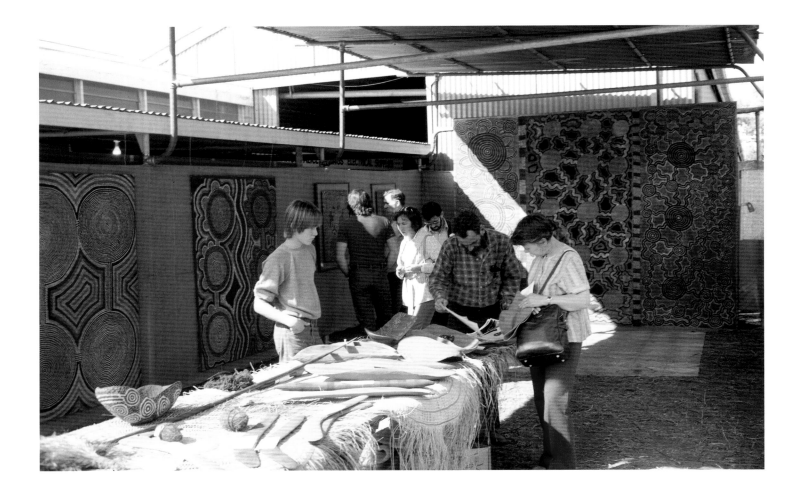

something like that, and that was top quality stuff with maximum exposure in Alice Springs. We were selling them – my memory is from $300 to $1200, I bet I'm not too far out, and that was what we could sell.[19]

The newspaper article was almost right about this being the only chance for the painting to be seen. *Warlugulong*, 1977 was consigned to the Realities Gallery in Melbourne for its pathfinding 1977 exhibition of Papunya Tula Artists. Billed as 'a major exhibition of Pintubi-Walbiri Ground Paintings', the show drew this response from *The Australian*'s art critic:

> We are here given the opportunity to see a stunning collection of works. The painted versions of the desert tribes' sand patterns have a decorative richness which makes them in every way the equivalent in quality of their contemporary Western counterpart.[20]

Despite the glowing review, there was still no interest from public galleries or museums in the art movement. *Warlugulong*, 1977 was bought from the exhibition by a bank who hung their treasure high on the wall of a staff dining room, probably unnoticed by most who sat beneath it for the next fifteen years. It was taken down to be photographed for the first edition of this book to the accompaniment of a wild electrical storm, with torrential rain and rolling thunder, which ceased and turned into a rainbow as the painting was returned to its place on the wall. A few years later, the bank inexplicably de-accessioned what must have been one of the jewels of its collection. Clifford Possum's first very large canvas was unceremoniously sold off through an auction house not noted as a clearing house for 'important Aboriginal art'. An eagle-eyed art dealer spotted it and snapped it up for a bargain price to adorn an upstairs wall of his Melbourne gallery – when it is not on loan for travelling exhibitions.

Kerrinyarra

'Kerrinyarra' means literally 'love song', named for the song which men and women come to a large stone platform on the top of Mount Wedge to sing in order to make themselves irresistible to the objects of their desire. Clifford Possum is, to use his own term, 'boss' for Kerrinyarra, a 'sharp hill' whose sheer face can be climbed only with ropes, some 240 kilometres north-west of Alice Springs and about forty kilometres north of Papunya. Kerrinyarra marks the southern boundary of Anmatyerre territory and the intersection of many Dreamings to which the artist is ceremonially connected. Clifford Possum obtained its Dreamings from his Tjapaltjarri grandfather ('only Napaltjarris and Tjapaltjarris this one').

Kerrinyarra is a Women's Dreaming site, the most important of thirteen ceremonial locations in the extensive travels of a group of Napaltjarri and Napanangka women around the Mount Wedge area depicted in the painting *Kerrinyarra* (pp. 100–101). Their tracks traverse almost every part of the canvas, before moving to Napperby Lakes, where they danced more ceremonies. Kerrinyarra is located in the top right of the canvas by a women's ceremonial sand painting. Well camouflaged by the background dotting, it does not stand out from the surface of the painting – unlike what the annotation identifies in

pp. 100–101: *Kerrinyarra*, 1977, synthetic polymer paint on canvas, 238.0 x 365.5 cm; Westpac Corporate Art Collection

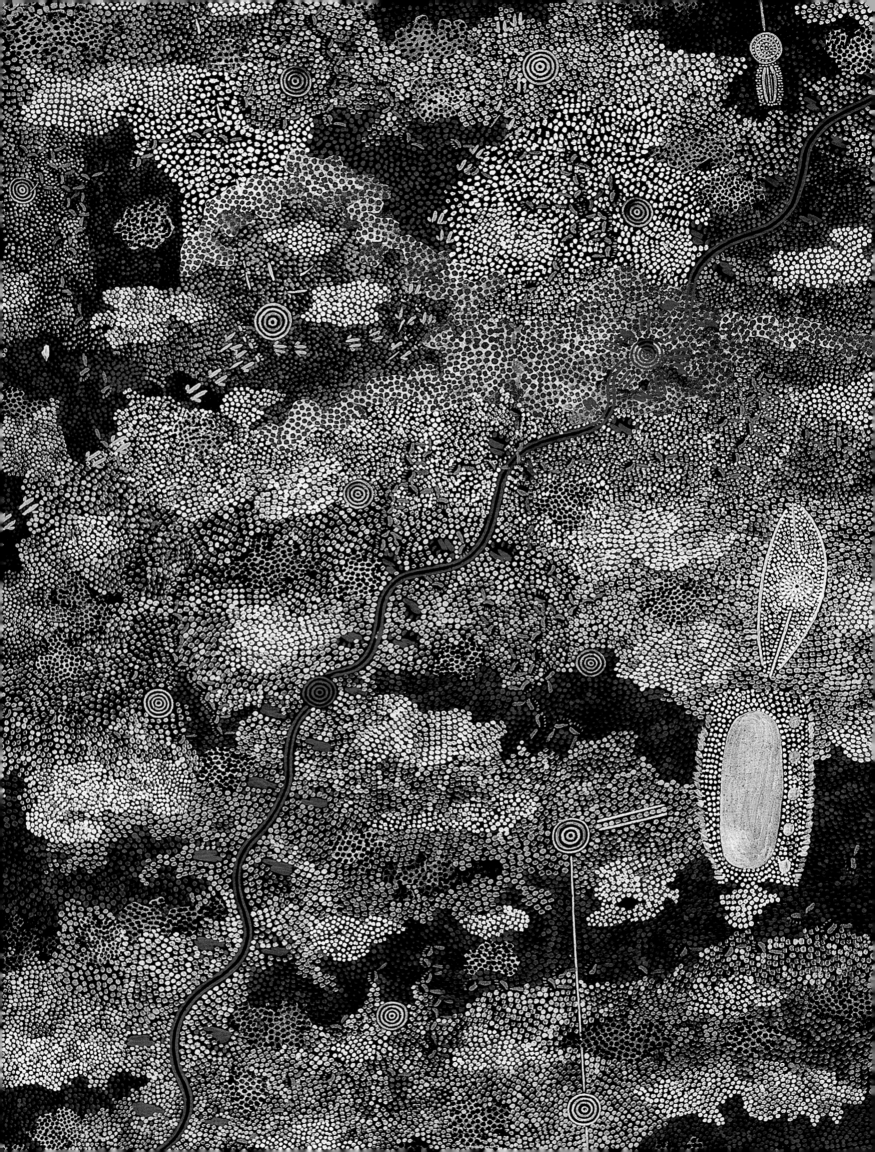

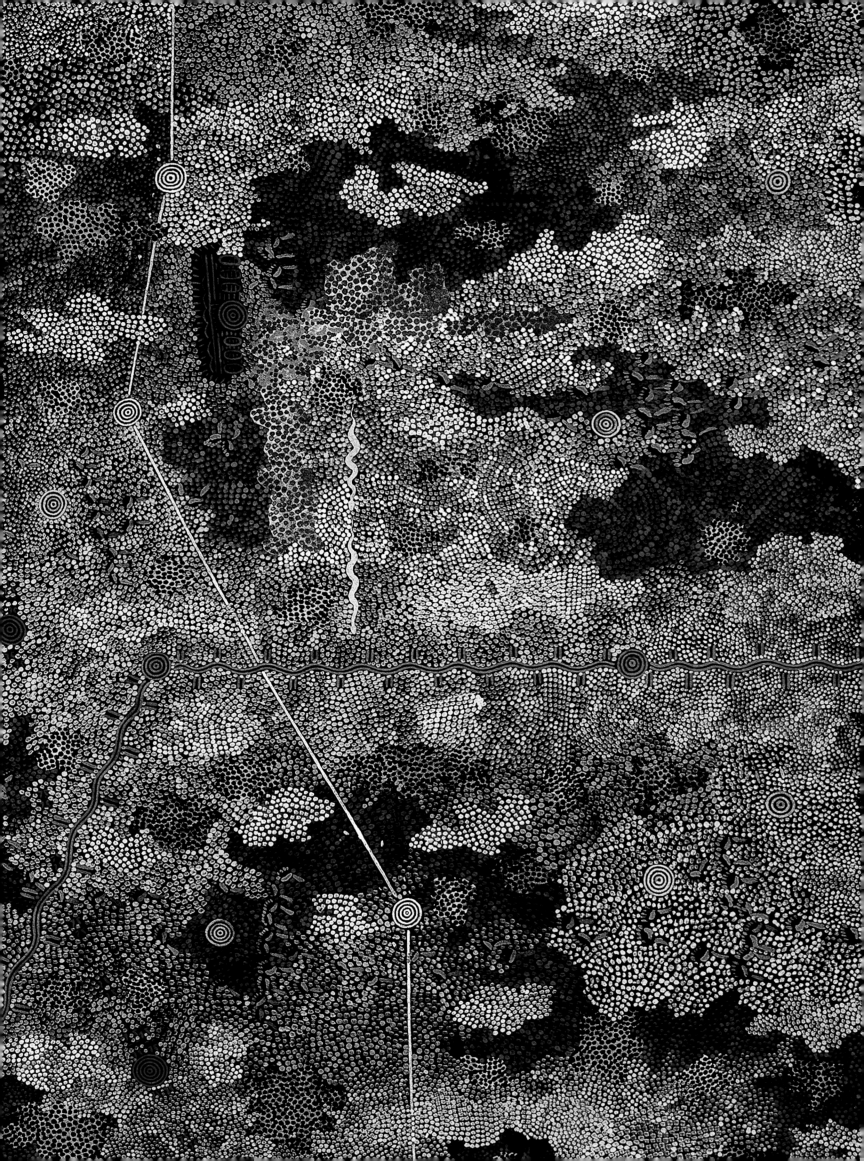

the lower left of centre of the painting as an 'explicit ground plan' of the main
malliera ceremonies for the Rainbow Snakes from Altjupa held at the site of
Yunkurru. The ground painting at Yunkurru and an associated ceremonial
object situated at the top of the picture are both covered with white dotting,
just as in the ceremonial context, the designs on ritual objects are covered in
white plant or bird down until the initiates have been prepared for the sight of
them. The white overdotting makes these elements stand out in the painting's
composition, while their exact significance remains opaque. No details of the
ceremonies or of the related mythologies were supplied in the annotation, on
the grounds that they 'belong to the secret–sacred world of the men'.

Kerrinyarra, completed in October 1977, just four months after the
monumental feat of *Warlugulong*, 1977, represents a further transformation of the
artist's approach to mapping the country. In this painting, the spatial orientation
is fixed, with the top of the painting representing the south-easterly part of the
landscape depicted in *Kerrinyarra*. A set of bearings to this effect alongside the
diagram of the painting with the Papunya Tula annotation provides a directional
marker. Everything on the painting is part of a single landscape rather than one
landscape laid on top of another. The area covered by the painting is much more
localised than *Warlugulong*, 1976 or even *Warlugulong*, 1977, allowing for more
precise placement of the Dreamings in their geographical relationship than over
larger expanses of the artist's territory. *Kerrinyarra* is also more like a European
map than the previous two paintings in this series in its detailed depiction of the
physical terrain which contains the sites. The areas of pink and grey dotting
denote saltpans and mulga tree stands, with which the region is covered. The
watery yellow dots which cover the rest of the surface are desert. Against the
black background they give the painting an overall green look.

This look of greenness is related to the presence of the Kalipinypa storm
front, identified by the annotation as the Water Dreaming which connects with
rockhole sites far to the west in Pintupi territory, bringing the lush growth
celebrated in the women's ceremonies. The great storm front from Kalipinypa
comes through into Anmatyerre territory at Watulpunyu, on the southern tip of
the artist's arc of sites. This is the 'ancestor of all storms' for all Western Desert
peoples whose lands lie in its extensive path. The Lightning Dreaming is the
'boss' of the storm, lashing it to a fury as the deluge travels east from Pintupi
country forming rockholes and claypans. The path of the Water Dreaming is
shown by a sinuous line representing the lightning, with short parallel bars
representing the rain clouds associated with the storm. It comes in from the
south-west on the lower right-hand side of the canvas and turns north at
Aruakuna, situated just to the north of Kerrinyarra. The storm front is crossed
by two vertical Dreaming paths, whose presence also relates to the abundance
of life after rain: the zigzagging line of the Centipede Dreaming heading south-
south-east and, further to the left, the path of a rock wallaby stopping to drink
or feed at three sites down the middle of the canvas on its way across Anmatyerre
territory.

Apart from censorship and the geographical relationship between the sites

and Dreamings, the third compositional factor identified in these paintings involves sometimes overt symmetry, sometimes a more diffuse sense of visual balance. Its basis may be in sacred Anmatyerre visual traditions, but the general idea of balance at work in these paintings on close inspection is also one recognisable to students of western principles of formal design. Unlike the two *Warlugulong* paintings, *Kerrinyarra* has no central focus. However, the two ground paintings at the sites of Kerrinyarra and Yunkurru form a diagonal south–north axis around which the placement of other elements in the painting is pivoted. The southward trail of the old possum man in search of his 'kungka' runs diagonally across the left-hand side of the painting, parallel to this axis. The same line is echoed in the adjacent path of the kangaroo and euro heading south through Mutjuku. This is balanced out on the other side of the painting by the Water Dreaming, coming around the bottom right-hand corner directly opposite. The white line of the Centipede Dreaming down the left-hand side of the canvas, seems placed so as to correct the visual imbalance caused by the off-centre placement of the Yunkurru ground painting, the most prominent element in the picture. However, only someone with the artist's close knowledge of the region around Kerrinyarra would be able to work out to what extent this arrangement of sites and Dreaming tracks around the canvas is already pre-determined by the mythological geography of the Mount Wedge area.

This structure of Dreaming trails is visually overwhelmed in *Kerrinyarra* by the highly atmospheric dotting, which evokes the airiness of birds' swooping flight over a verdant landscape after rain. Nguuri, the tawny frogmouth (an owl-like night bird), is indicated by its footprints landing at two sites down the right-hand edge of the painting to feed on the leaves of the bush banana. Alluku-purra, another small nocturnal bird (possibly a brown hawk or a kestrel), swoops down to sieze its prey at the site of Mutjuku in the top left corner of the canvas, off to the east.

The fate of *Kerrinyarra* was to be the most obscure of all the great map series. The painting was commissioned to decorate the premises of another bank. An employee had seen and coveted *Warlugulong*, 1977 in the Realities exhibition. It was the showpiece of the manager's dining room for nearly two decades, until the bank was bought out by a larger competitor and the painting moved to its new owner's Sydney headquarters at the top of Martin Place. It sits in pride of place in the boardroom, high above the city, commanding a panoramic view of the harbour and skyline. Until the 2003 *Clifford Possum* retrospective, it had never been exhibited publicly.

Mt Denison Country

The fourth in the large map series, *Mt Denison Country* (pp. 104–105), was painted the year after *Kerrinyarra*, probably on the same frame used for the original *Warlugulong*. The painting has been exhibited several times now as *Mt Denison Country* and will be referred to in this discussion by that title – though Clifford Possum wanted it on record that 'Atjumpi' is the Anmatyerre name for the Mount Denison area. A complex network of Dreaming trails and sites;

Mt Denison Country, 1978, synthetic
polymer paint on linen, 200.0 x 170.0 cm;
The Kelton Foundation

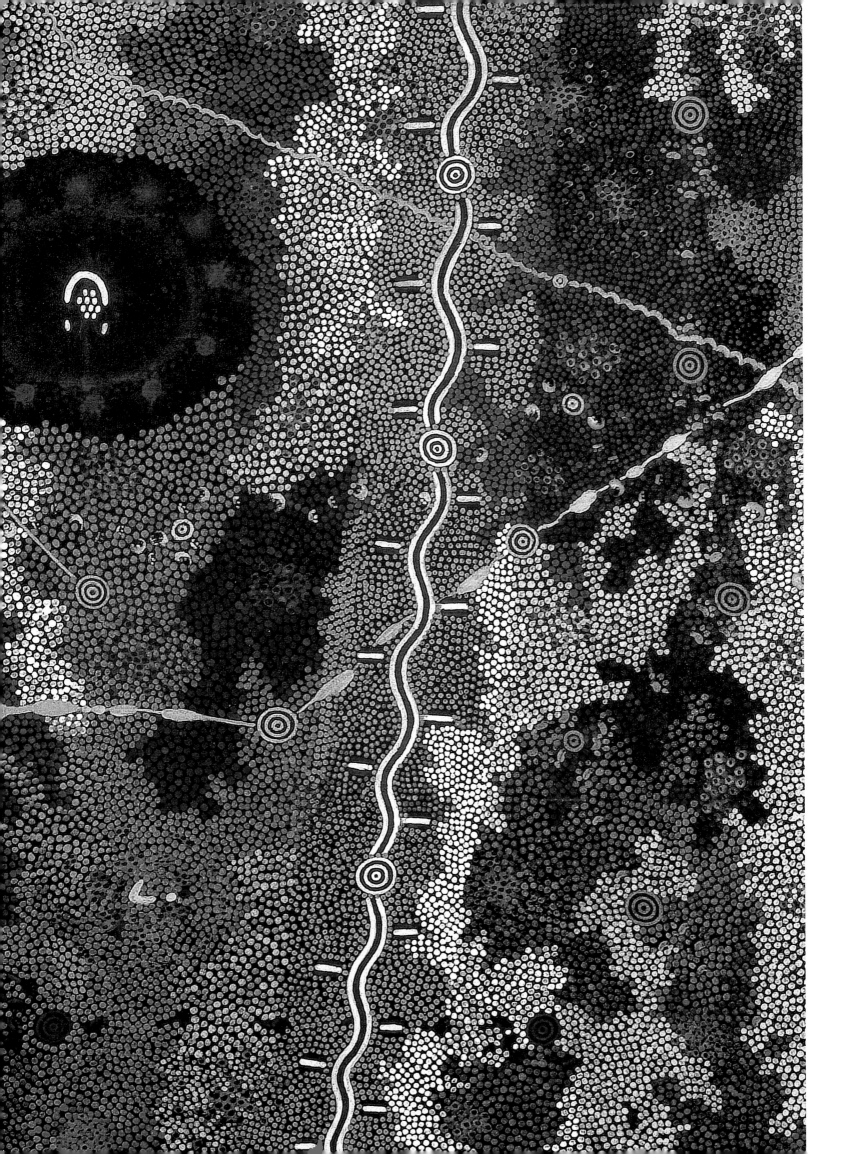

twelve in all, is laid out across a wide area of what is now Mount Denison Station, to the north of Mount Allan. The top of the canvas is designated north on the diagram of the painting – like a European map. According to the annotation, the trails are laid out as they lie across this country, from east to west (Dingo, Rain Dreaming, Ants surrounding an Emu on its eggs, Wallaby Man and Blue Kangaroo) and north to south (Legless Lizard, Echidna, Wild Carrot, Woman grinding Mulga Seed and a Tjungurrayi Man).

It is interesting that, of the five paintings in the large map series, this one should be the closest to an accurate topographical map of the mythological geography represented. The painting was privately commissioned by John Kean, who was Dick Kimber and Janet Wilson's successor in the Papunya Tula manager position. His first assignment when he started working for Papunya Tula Artists in June 1977 had been to drive out from Alice Springs and collect the second *Warlugulong* from the artist. In the course of annotating the painting's encyclopedic contents, the young man fresh from art school in Melbourne received a lesson in Western Desert art he never forgot. His subsequent fascination with Clifford Possum's project of mapping his Dreamings was integral to its success. While John Kean ran Papunya Tula (mid-1977–late 1979) he kept Clifford Possum supplied with large canvases on which to inscribe these visionary landscapes. His interest in the topographical dimension of the paintings is reflected in the close attention to direction and site identification in the copious annotations he prepared for the four large map paintings completed under his tenure. These lines of questioning may have influenced Clifford Possum's approach to the compositional challenges created by the sudden scaling up of his work to the vast dimensions of these canvases. In *Mt Denison Country*, painted especially for John Kean, we see a classic example of the perfected cartographic style which the artist's supporters had been seeing in these paintings all along.

Mt Denison Country shares with *Kerrinyarra* the representational function of the background dotting – signifying the characteristic landforms or vegetation of different parts of the landscape depicted in the painting. For example, the bold sinuous white line of the Rain Dreaming running from south to north up the eastern side of the canvas, follows the line of one of the occasional sand dunes of north-western Anmatyerre country, indicated by a broad stripe of dotting under the lightning. A similar, but more meandering, corridor of dotting undulates up the painting just to the west of centre, following the path of an Old Tjungurrayi Wallaby Man. No other details of what the different background colours represent were given, but the overall effect of this more representational approach is the heightened sense of aerial perspective in this painting – as if flying low over Mount Denison with the artist beside you pointing out the mythological markers within the landscape. The overlaying of ancestral trails on *Mt Denison Country* enhances this sensation. The pink ochre path of the Wild Carrot ancestor crossing the centre of the painting from north-east to south-west, and the underground journey of the Legless Lizard Rrinypa Rrinypa across the north-west corner, appear to pass underneath the Lightning Dreaming.

The Bush Carrot and the Legless Lizard, like most of the Dreamings depicted on this canvas, do not occur elsewhere in the artist's work – perhaps out of deference to the closer association with Mount Denison and its Dreamings of the Yuendumu painter Paddy ('Cookie') Stewart Tjapaltjarri, son of Jajirdi's older brother Jimmy Tjungurrayi:

> Mount Allan is mine – another one, and Napperby and Mount Denison. Tell other mob – big brother Cookie – you know Paddy Stewart? He's painter. He for Mount Denison.

One story on *Mt Denison Country* with which Clifford Possum does have particular associations concerns an old Tjungurrayi 'lover boy' wandering the area 'sending telepathic "telegrams" to women of the Napangati subsection' – the same one whose activities at the site of Ngarlu in the south are the subject of the artist's Love Story paintings. The old Tjungurrayi man's meandering footsteps, through three sites across the south-west corner, roughly parallel the journey of the Legless Lizard across the opposite corner. The artist's continuing concern with issues of symmetry and balance in *Mt Denison Country* is evident from the diagram, although as with *Warlugulong*, 1977 and *Kerrinyarra*, this is far from obvious in a cursory examination of the painting itself.

The focal point of *Mt Denison Country* is the large dark circular shape in the top centre of the painting, with the seated Emu a stark white U-shape on its ten eggs ringed by the fires of the soldier ants. The name of the place was Pingariya – after the ants, which the Anmatyerre call 'pingari'. Clifford Possum indicated that the darkness was not ordinary night time but magical: 'because light everywhere and darkness here'. The bold white vertical blaze of lightning down the right-hand side of the painting is the other striking feature of this canvas, in which Clifford Possum also introduced a new compositional device. Grey patches superimposed with small black dots denoting mulga seed supplies are distributed throughout *Mt Denison Country*. Their ubiquitous presence is attributed by the annotation to the economic importance of the mulga seed as a staple of the Anmatyerre diet, but as a design element, the repeated motif works to unify the surface of the painting – over-and-above the unifying effect of the dotting. Over the next decade, this would become a recurrent element of the artist's style, with pale spinifex tufts substituted for the mulga seed supply motifs.

Yuutjutiyungu

Finally, this journey brings us to the fifth and last in the series of great map paintings from the late 1970s: *Yuutjutiyungu* (pp. 108–109) – the title the artist suggested during our conversation about names for his paintings. However, it is Geoffrey Bardon's exclamation when he first saw a photograph of this painting in 1980 that most sticks in my mind: 'The diamond of the movement!', he called it. Hyperbole perhaps, for the painting movement has many diamonds, but *Yuutjutiyungu* is certainly one of its largest and finest. People who saw it in 1979, when it was brought in to Papunya Tula Artists, speak of it with awe. John Kean, who had the job of taking the painting off its 231.0 x 365.5 cm stretcher and

pp. 108–109: *Yuutjutiyungu*, 1979, synthetic polymer paint on canvas, 231.0 x 365.5 cm; The Kelton Foundation

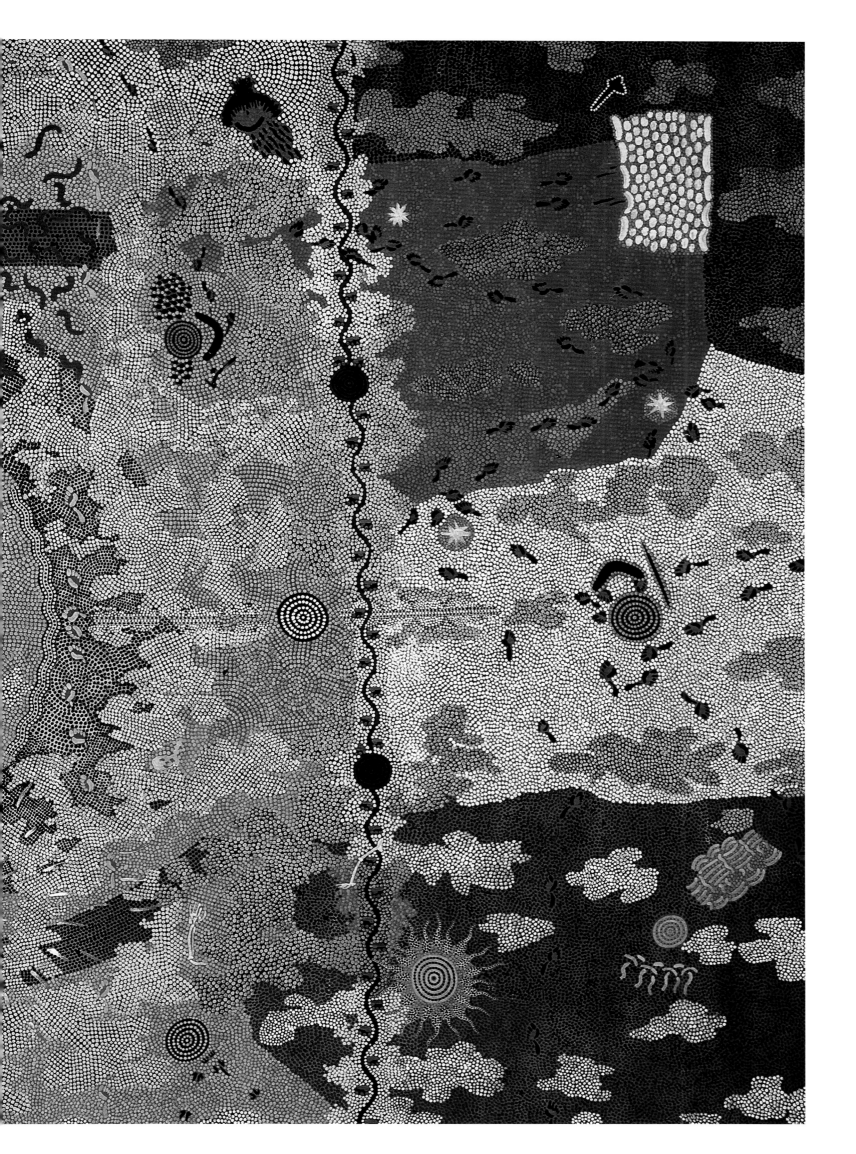

rolling it up to send off for an exhibition, recalls writing an urgent note on the consignment slip to the effect that this painting should not leave the country and should go to the National Gallery.[21] 'Masterpiece' is too poor a word to describe a work which so completely transcends the fetishes of European art history.[22]

The Aboriginal Arts Board had asked Papunya Tula Artists for a group of paintings to form part of an exhibition of Aboriginal art to tour major Australian cities. Perhaps this was why Clifford Possum was again given the very large stretcher on which he had painted *Warlugulong*, 1977 and *Kerrinyarra*, for his next picture. Between October 1978 and the following July when *Yuutjutiyungu* was finished, Clifford Possum painted only three other small canvases for Papunya Tula Artists, so the large work may have occupied him over many months. Few people were around to see it actually painted, and if on account of this it lacks some of the superb theatricality of the first *Warlugulong*, its astonishing complexity may be a product of the intense isolation in which it was produced.

In the latter part of 1978, the Possum family had moved to Mbunghara, on the Narwietooma lease close to the Haasts Bluff Aboriginal Lands and about forty kilometres east of Papunya, on country to which the artist's wife Emily had family connections. Mbunghara continued to be their place of residence, apart from brief spells in Papunya, until the mid-1980s, when they moved into Alice Springs. It had also been Albert Namatjira's home country – a fitting place for Clifford Possum to attempt the last great mapping of his sites, in which he would perfect the cartographic style and move his art into a new trajectory.

Since the early 1970s, at least since 1973, he had been developing and refining the idea of mapping out country in his paintings. *Yuutjutiyungu* was a

left: Clifford Possum and friends engaged in a card game under the trees at Mbunghara, early 1980s. Photo: John Corker

right: Clifford Possum's open air studio at Mbunghara, July 1980. Photo: Tim Johnson

kind of endpoint in this six-year process, the expression of the archetype – as if everything else had been a kind of preparation for the painting which would map his patrilineal descent country around Mount Allan:

> I'm right with that *Yuutjutiyungu*. That's really right one – me for do. Really – like this and this from that country, every soakage be there – I'm happy. Because everybody know'm soakage – which one which one – they know. No problem. I was thinking too much for this two [*Warlugulong*, 1976 and 1977]. Uncles and aunts and maybe daddy's – but I'm not happy. My mind might be thoughtful.

Clifford Possum attributes the resolution of the principles of his artistic cartography in this painting to the rightness of its subject matter, revealing the inseparability in his mind of the various factors separated out in the preceding analysis of these paintings. The passage also contains a fascinating insight into how the artist monitors his own creative process – conscious in retrospect of the mistake of 'thinking too much'.

The central motif of *Yuutjutiyungu* invokes a story about two women of the Nangala skin group who prevented the theft of sacred boards by hiding them in a cave in the side of the rocky outcrop for which the site is named. A ritual assassin or kadaitja man named Yirrinytarrakuku tried to sneak up on the two women, but from where they were sitting on top of the outcrop, they had a view of the entire countryside and saw him coming. They guessed he was after the sacred boards and hid them in a cave in the side of the hill. In Clifford Possum's account of these events, Yirrinytarrakuku came from Kunatjarrayi in the sandhill country out near the Western Australian border, heading towards Alyawerre country to the east of Anmatyerre lands. Disappointed by his failure to steal the Anmatyerre sacred boards, he continued east, and succeeded in stealing some of the Alyawerre's tjurungas, which he concealed in his ceremonial headdress:

> He come up from the west that bloke, and he want to steal secret one. And them two women – kungkas – there, steal'm before him come up – hide them away. In a cave. Standing and looking. He can't see. He keep going – to Alyawerre. After, he coming back from Alyawerre country, with a big mob of boards. He carry'm in his headdress.

Passing Yuutjutiyungu on the other side on his way west, he again tried to sneak up on the two Nangalas, who again foresaw his intentions and successfully concealed their sacred boards. He returned to Kunatjarrayi with only the booty from Alyawerre country.[23]

Kunatjarrayi is Tjungurrayis' and Tjapaltjarris' country, but not the artist's kinsmen – 'Nothing to do with us'. However, Clifford Possum took the attitude that Yirrinytarrakuku's exploits within his ancestral estate were his to depict, in accordance with Anmatyerre ceremonial practice. The artist described how the attempted theft is re-enacted at the site of Yuutjutiyungu:

> Him running around and standing this way through my country. We show'm one another this, because he's really flash, all in 'uniform' [body paint]. I do him when running – all in uniform. We use him, because he is in my country, my grandmother's country. Grandmothers and grandfather's from Tjapangati and Napangati – mummy's mother. We use him sometime, might be

corroboree time – malliera time. That one we use'm too. We use him this man – dress up, paint up, like this man. We gotta show one another this one too. We use'm in sandpainting.

The women's custodianship of the boards is noteworthy in itself, as a further indication of the significantly different attitudes of the Anmatyerre towards women, who are usually excluded from the knowledge of such things amongst Western Desert peoples. The women are depicted in the painting sitting on top of the rock with the boards lying on the ground between them as the kadaitja sneaks around the base of the outcrop. Above and below them on the canvas are two large curved mirages, half submerged in the background dotting. Their significance in the story is not explained, but they are part of the main Yuutjutiyungu motif.

Directly above the outcrop, in about the same position on the canvas as the Emu on its eggs in *Mt Denison Country*, the campfire, digging stick and seated U-shape of an old Tjapangati man stand out in white against the dark brown of the mirage. Above the concentric circles of the campfire float dark worm-like shapes representing the edible green caterpillars found in the country around Yuutjutiyungu after good rains, which the man has collected and eaten. Their size varies to give the effect of them floating upwards across his campfire towards the viewer. Directly below the central motif, and counter-balancing the Tjapangati figure above it, is a design like a catherine wheel, showering sparks outwards to all points of a compass (which it also resembles). White against the dark background of the lower mirage, it is an image of a man's hiding place exploding. It is a new motif – or a re-working of the bushfire motif to represent another subject: the lightning striking the western side of the same outcrop at the site of Ngarritjaliti. Here another man, a Tjungurrayi, barricaded himself in a cave to escape a very strange cloud[24] which magically appeared from the north out of a clear blue sky:

> He seen one cloud come up in a clear sky, from long way – from Lajamanu. He was going around this place and he thinking, 'Oh that one cloud, he got something there. How come from one cloud he come up this only lightning?' This old man, he know.

Old Tjungurrayi hid in a cave in the side of the hill, barricading the entrance with a wall of rocks, but could not save himself. Pieces of Tjungurrayi's body, turned into stone, are strewn across the surrounding country:

> That hill, really proper cave inside this. He went inside and shut the door. Put rocks on the door, more rocks. But that lightning came up in the cloud and blow him up – rocks, all the body and all that all blew up, rock everywhere.

The lightning struck with uncanny accuracy, blowing away the man, his cave hiding place, and his barricade of rocks without leaving a mark on the rest of the hill:

> And today, this flat. It was proper really cave, and today flat everywhere. Just only one part, and never touching Yuutjutiyungu just behind.

Since the first *Warlugulong*, Clifford Possum had been exploring various alternatives to the compositional device of a spectacular central image as the

focal point of the painting. The uneasiness he apparently felt about the Bushfire Dreaming as subject matter, notwithstanding the permission of his mother and uncles to paint about these aspects of it, may be the reason why in the second *Warlugulong*, he shifted the emphasis from the fire itself. The eye is drawn away from the central point of the conflagration by the spectacular pall of smoke pouring out from it over the charred countryside, ending on the right-hand edge of the canvas in the skeletons of the two brothers who died in the fire. In *Kerrinyarra*, he tried a different solution, pivoting the other elements of the painting around a diagonal axis connecting up the two ground paintings. In *Mt Denison Country*, he placed the Emu on its eggs up towards the top centre of the painting with the white slash of lightning running down the right-hand side. In *Yuutjutiyungu*, he returns to the device of a spectacular central image. The rocky outcrop of Yuutjutiyungu is not a geographically displaced fireburst but, as in the 1974 prototype, *Life at Yuwa*, an elevated vantage point from which the artist can survey in his mind's eye the events of the ancestral past occurring over the surrounding country, like the Nangalas in the story of the painting.

Around this focal point, other elements of the painting are arrayed with a keen eye to symmetry. The possum tracks straight up the right-hand side of the painting, in about the same position as the lightning strike on *Mt Denison Country* but in black, show the possum ancestor stopping at two main sites, also recessed in black. The second of these sites, Yuula, is where he saw himself reflected in a rockpool, just as these two possum sites are mirrored in the two principal honey ant sites on the opposite side of the canvas. At opposite diagonals of the painting there is the same balancing out of design elements: the white goannas' eggs in the top right against the striking white symbol in the bottom left corner at a site known as Tjunykurra, which is not explained, though the Papunya Tula diagram indicates it may be part of the main Yuutjutiyungu story. Examples could be multiplied in this complex painting, whose annotation covers six typed pages, and then discusses only the thirteen most prominent Dreamings represented on the canvas. The symmetry and balancing of opposites continues down to minor features, like the three white flashes on the right-hand side denoting blows which the older goanna man directed at his brother before striking him dead with a tomahawk. In the opposite diagonal, just below centre, is its counterpoint: the white feather decoration on the woman's hairstring belt or 'wirripunkanu' lying beside her on the ground.

The designs representing the activities of this woman, shown by the dark U-shape beside her belt as she digs for honey ants in the country around Yuelamu, merge into the background dotting, adding another symbolic dimension. The device of submerged design elements appears to have made its first appearance in this painting, though the over-dotted groundpaintings in *Kerrinyarra* were an important precedent. Here, however, the issue is not censorship, or cultural sensitivity, as it seems to have been in the earlier work. The setting of the honey ant chambers into the background not only signifies their underground location, but also avoids their inclusion disturbing the

balance of the central motif. This allows for a much greater density of cartographic information without the surface appearing too crowded with design elements. The artist pointed out the many concentric circles which emerge in the white dotted area at the centre of the painting as well-known soakages in the Mount Allan area.

In terms of cartography, the series has come full circle. The European mono-directional sense of spatial orientation which predominated in *Mt Denison Country* is overlaid in *Yuutjutiyungu* with the effects of the 'free wheeling' multi-directional and multi-focal Western Desert sense of spatial orientation so evident in *Warlugulong,* 1976. It is noteworthy that the two paintings in the great map series where continual re-alignments in space provide a graphic representation of the uncanny Western Desert sense of direction in actual terrain are those in which the artist was depicting the sections of his country with which he was most familiar. In *Kerrinyarra* and *Mt Denison Country*, which most closely approximate to European maps of country, he was painting areas to which he had legitimate Dreaming ties, but to which other male relatives on his father's side were more intimately connected.

The artist pointed out the top of the painting as east, but while this orientation may hold for the landscape around Yuutjutiyungu, it quickly breaks down beyond this locale. Clifford Possum indicated that the line of the possum tracks was the boundary of the Yuutjutiyungu set of directions. The camp and chase of the goanna men are located to the right of this line, over country which lies well to the *west* of the outcrop. Beyond the central focus, elements appear to be laid out on *Yuutjutiyungu* without much concern for their correct geographic placement – or even sometimes their significance. Clifford Possum remarked of the Bush Potato (Yala) Dreaming that 'For nothing do this one'. In other words, like the emu tracks in the *Warlugulong,* 1976, this motif was added to complete the picture in an artistic rather than an ethnographic sense. The completeness of *Yuutjutiyungu* as an inventory of sites on the one hand, and the symmetry and balance of the composition on the other, were the most important components of Clifford Possum's keen sense of satisfaction with the painting as the culmination of his mapping series. In it, the artist resolved the compositional problems he had been wrestling with since 1976 to accommodate the vast dimensions of his visionary landscape within the boundaries of a rectangular surface.

Yuutjutiyungu was sent off to the Aboriginal Arts Board as the centrepiece of Papunya Tula's contribution to the touring exhibition. The exhibition never happened, and the only public showing of the painting in Australia was in the lobby of the Kings Cross Hilton in Sydney later that year. The painting and many other small and large works by the Papunya artists then found their way from the Aboriginal Arts Board to the Collectors Gallery in the Rocks, part of the Australian Government's marketing operation in Aboriginal art. In early 1980, about a dozen large canvases from the period 1976–79 including *Yuutjutiyungu*, and another twenty smaller works, were sold to an American collector with an enduring passion for Papunya paintings. The loss of

Yuutjutiyungu to the nation about which John Kean had expressed concern in his consignment note was justified at the time by the collector's connection to the Pacific Asia Museum in Los Angeles. At the time, no Australian art gallery or collecting institution outside the Northern Territory (including the National Gallery of Australia, to whom this painting was also offered) had shown any real interest in the art movement.[25] Given the indifference of Australian cultural institutions reflected in the trajectory of the other paintings in this series, this may have been the best that could be hoped for it at the time – and it was in many ways far less obscure a destiny than the fates which have so far befallen most of the other paintings in the great map series. In a sense, *Yuutjutiyungu* slipped through the fingers of the Aboriginal art marketing system at that time, because it was ill-equipped to deal with the elevation of Papunya painting to High Art commodity, in demand on the international collecting circuit, foreshadowed by the individual fate of this painting.

Iconography for the Eighties

Why did the large map series end with *Yuutjutiyungu*? How do we account for Clifford Possum abandoning the cartographic style after the very painting in which he had perfected it? The answer cannot be that he had mapped all his Dreamings in this monumental series of paintings, for he had not. Whole areas of the eastern side of his country around Napperby were still unmapped in this style. However, the areas around Mount Allan, Yuendumu, Mount Wedge and Mount Denison which were the subject of the topographical paintings, do contain most of the artist's most important patrilineal inheritance of sites and Dreamings.

The answer to *Yuutjutiyungu* being the endpoint of the great map series may lie within the paintings themselves. The extensive networks of sites and Dreaming tracks which are the most remarkable feature of these paintings, emerged in the production of *Warlugulong*, 1976 as an effective way of marking out the much larger surface area of these paintings for dotting. The transition from the small-scale works, with only a few centimetres of space left for dotted infilling between the design elements, to the very large canvases, could occur smoothly. With so much already in the painting at the design stage, the distances between the shapes to be dotted around at the infilling stage were of manageable dimensions. However, there was another problem: on the larger scale, the innovative design elements which had given smaller works their structure and potency tended to disappear into the background.

Consider Peter Fannin's comment on the small 1973 mapping work, in which these aspects of the painting take precedence over the generalised totemic landscape idea which dominates the annotations of all the large map paintings: 'It is hard to imagine a more vivid illustration of ancestors and iconographs (stylised diagrams representing the ancestors) than this painting'.[26] During the 1980s, Clifford Possum would turn his attention to refining and developing the iconographic qualities of his work, just as in the 1970s he had concentrated on its cartographic qualities. *Yuutjutiyungu*, in which he had achieved an astonishing

pp. 116–117: *Man's Love Story*, 1978, synthetic polymer paint on canvas, 214.5 x 257.0 cm; Visual Arts Board, Australian Contemporary Art Acquisitions Program 1980. Art Gallery of South Australia, Adelaide

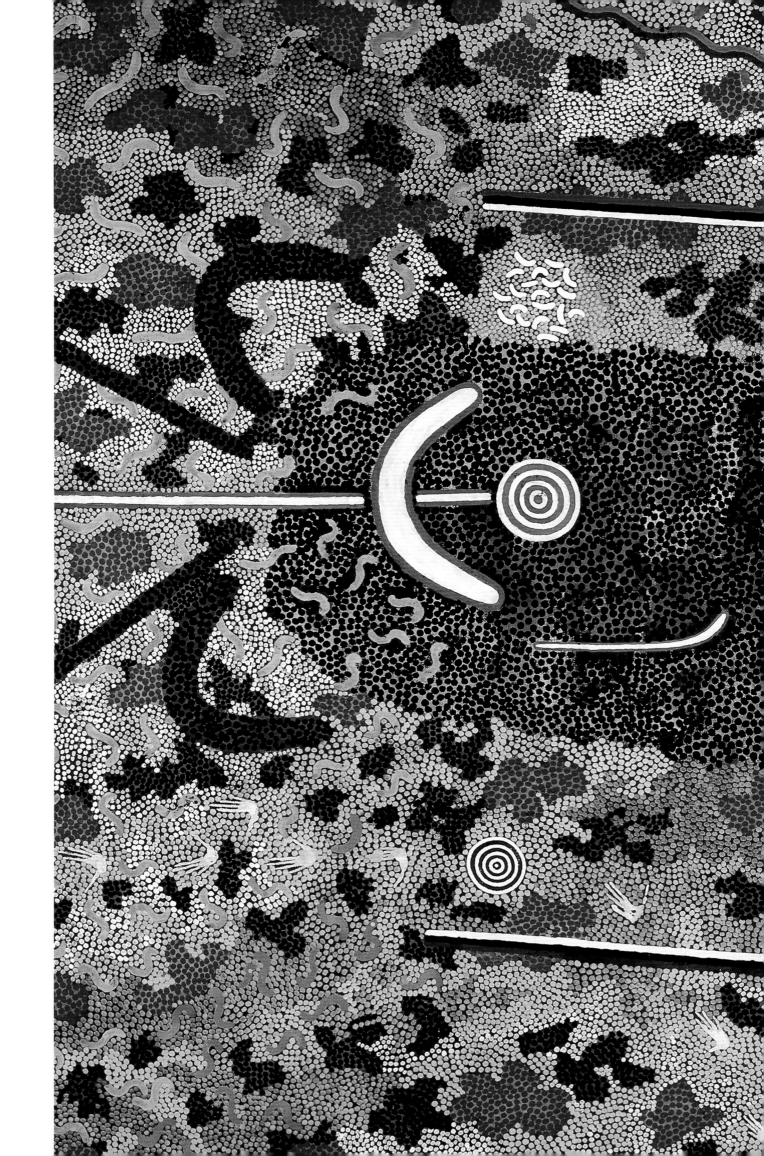

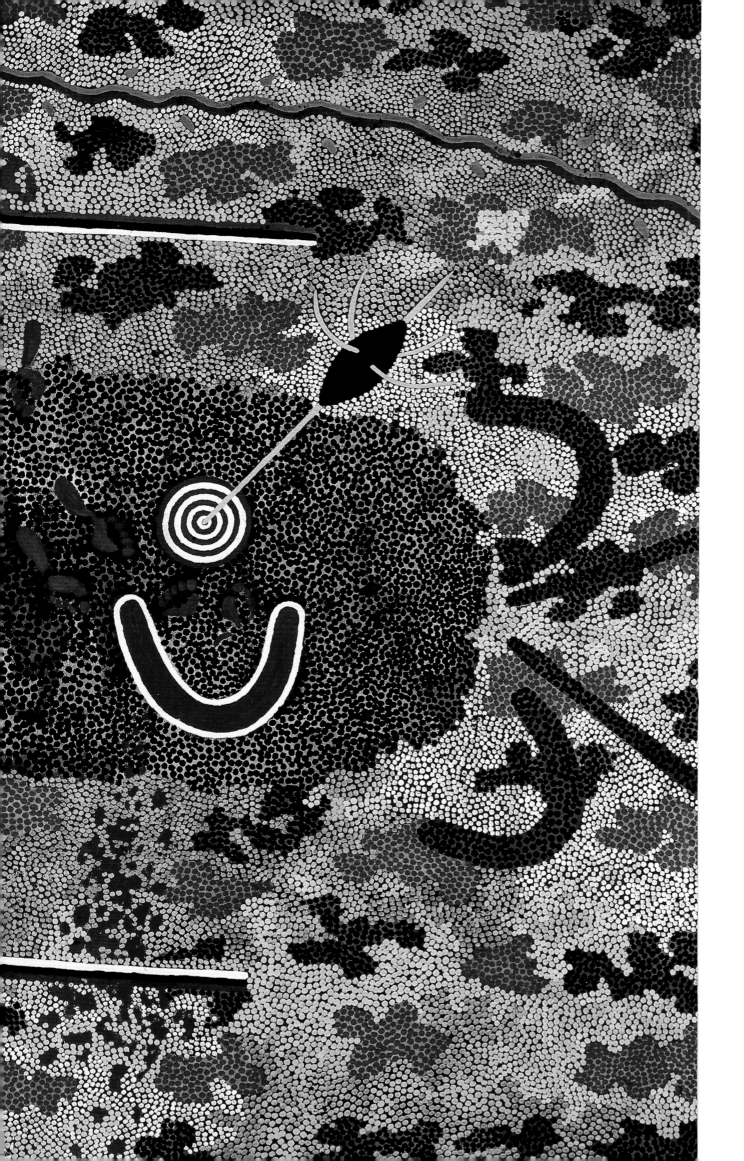

synthesis of both these elements, while taking the infilling itself to a new level of significance, marked both an endpoint – and a new beginning.

A handful of paintings which the artist completed between the landmarks of the large map series also took significant steps in this new direction. The painting known as *Man's Love Story* (pp. 116–17), completed in January 1978 between *Warlugulong*, 1977 and *Kerrinyarra*, is perhaps the most critical work of transition. A number of Dreamings are depicted on the 214.5 x 257.0 cm canvas, but visually the painting is dominated by the striking image at its centre. A large oval-shaped area of black dots signifying the 'kanala' or initiates' teaching area marks out the ceremonial ground. On this dark shape, the white concentric circles marking the sites of Yinyalingi and Ngarlu stand out boldly. On the left at Yinyalingi, the journey line and seated white U-shape with digging stick represent a Nungurrayi woman who dug for honey ants at the site. The sticky white substance called 'Lurrka' which she had found at the foot of a mulga stand, indicating the ants' presence, appears directly above the site. On the right, at Ngarlu, the seated U-shape of a Tjungurrayi man is shown beside a hair string spindle sending out messages to the 'wrong skin' woman. These two iconographs are framed above and below by the long black and white bars of the mirages associated with this love magic. At each end of the dark oval shape sit the Nangala ('right skin') women with their fighting sticks, singing to break the lovers' spell.

Other Dreamings are scattered around the edges of the canvas – goanna and green caterpillars, even mulga and witchetty seeds embedded in the background dotting, but compositionally, the painting relies on the impact of this central set of motifs. In this work, Clifford Possum presented the discovery that the amazing facility with scale displayed in his monumental canvases of the late 1970s could also be applied to the design elements to create stunning abstract-looking images with instant acceptability as contemporary art. In less than two years, he was vindicated in this new direction: in 1980 the Art Gallery of South Australia made *Man's Love Story* its first major purchase of a Papunya work (the first by any of the southern galleries) – and hung it in its display of contemporary Australian art. By this simple act of imaginative curating, the ethnocentrism which had allowed Australian art experts to operate as though High Art and Aboriginal Art were mutually exclusive categories was exposed.

Two Men Fighting (p. 119) was also painted in 1978, between *Mt Denison Country* and *Yuutjutiyungu*. The dotted areas infilled with parallel bands of dotting represent simultaneously the lake and saltbush country around Mount Allan and the two giant figures of the Goanna brothers in the Aralukaja story, fighting one another with spears, boomerangs, stone knives and 'waddies'. Clifford Possum would later revive the motif of the warring brothers, who are represented in his later works by larger-than-life-sized skeletons with their weapons strewn beside them. *Possum Dreaming at Napperby* (p. 121) was the first painting he completed after *Yuutjutiyungu*, and it is as simple as its predecessor was complex. The perambulations of the ancestral Upambura up and down the area known as Tjuirri on Napperby Station dominate the painting through the

Two Men Fighting, 1978, synthetic polymer paint on canvas, 170.0 x 200.0 cm; Private collection

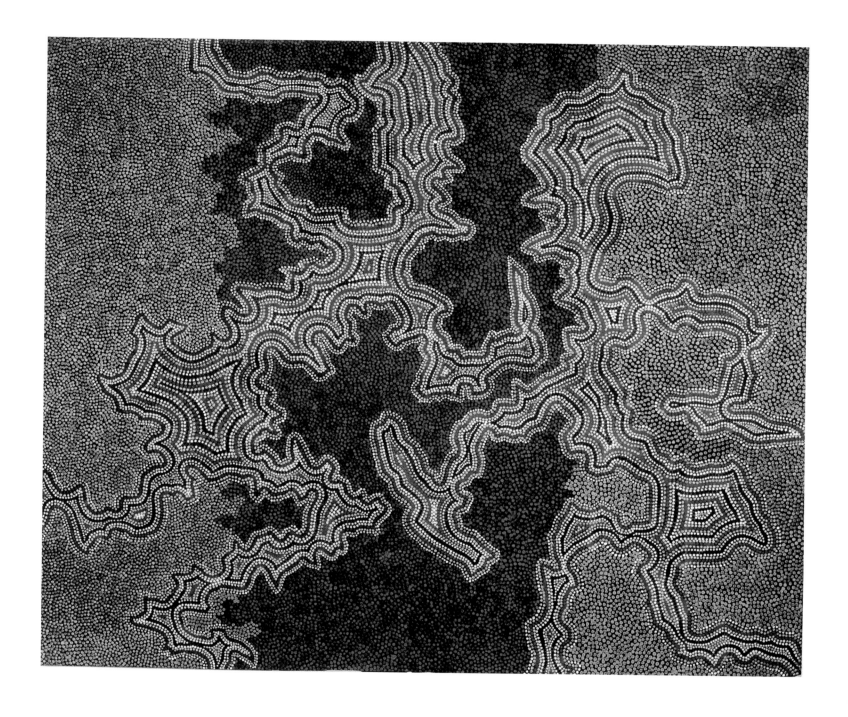

bold enlargement of the possum tracks and the ritual body paint design for the associated possum ceremonies. The background dotting has also been scaled up, and is applied with a virtuosity reflecting the prolonged labour of *Yuutjutiyungu* which preceded it, heralding an era in which immaculate craftsmanship would become one of the hallmarks of Clifford Possum's style.

The market for Western Desert canvases generally proved far more receptive to this bold modernist-looking art than it had to the alien and encyclopedic complexity of the map paintings. However, while satisfying the dictates of the marketplace, this new direction in Clifford Possum's art may also be understood as a continuation of the 'deeds of title' theme of the earlier works onto terrain which, until then, had been 'too hot to handle'. The ancestral beings laid their claim to a site by leaving their marks on it in the landforms and water sources, plant, insect and animal life of the place. So the members of Western Desert society legitimate their contemporary claims to sites — by performing ceremonies in which they invoke the ancestral presence by producing graphic designs which are pictures of these ancestral marks on the landscape. The analogy with the paintings is obvious. What really upset the rest of the Western Desert society about Papunya paintings was that the artists were effectively stating their claim to the Dreamings they painted without due recognition of others' joint rights of ownership.[27] Clifford Possum's map series may be interpreted as a contribution to this debate. By mapping out the artist's Dreamings over his own country, these paintings actually resolve the problem of disputed custodial rights. They localise the artist's presumptive claims to Dreamings which also pass through others' countries by de-limiting these claims to an identifiable area of country — his ancestral estate — over which they are indisputable. From this perspective, the map paintings can be seen as as a kind of prolegomena to the iconographic works of the 1980s, which continue the treatise on his Dreaming designs commenced in the early 1970s.

Possum Dreaming at Napperby, 1979, synthetic polymer paint on canvas, 154.0 x 186.0 cm; Private collection

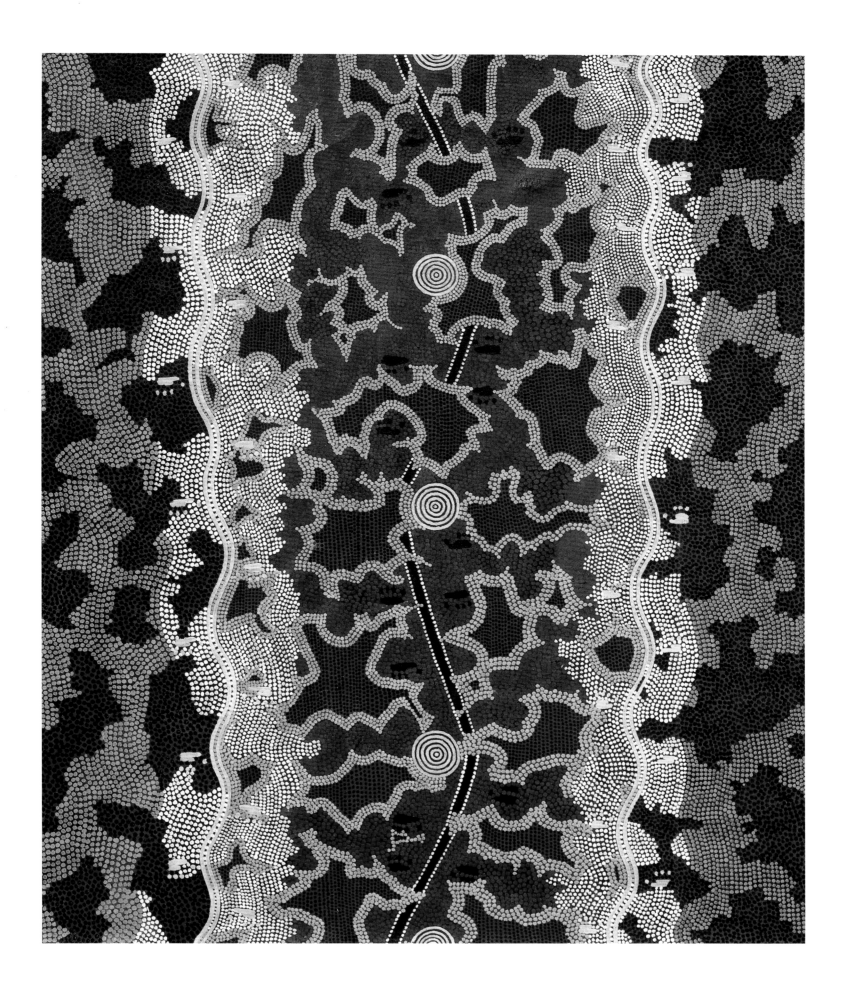

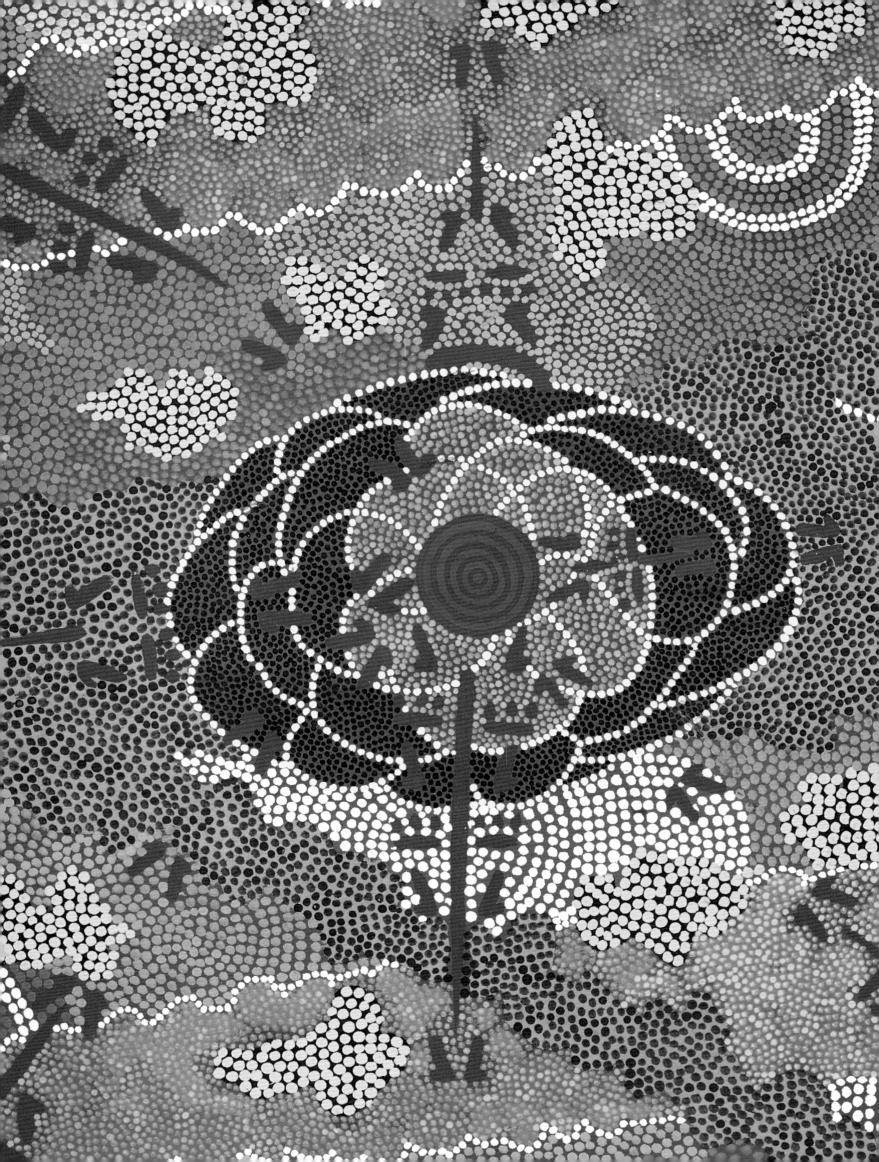

More better than everything

The first time I saw Clifford Possum Tjapaltjarri, he was standing beside his disabled car somewhere along the dusty road that runs between the Gunbarrel Highway and Papunya settlement, waving frantically. When we pulled over, the first thing he said, drawing himself up proudly as he said it, was 'I am Clifford Possum' – as if he expected us to recognise the name. He was obviously delighted that we did – the more so when we agreed to give him a lift into Alice Springs to get a new gearbox: he had been waiting there for three days. It was 1980, and his vehicle, like most Aboriginal-owned cars in Central Australia at that time, looked as though it was ready for the wrecking yard. In earlier encounters along the road, his countrymen had performed miracles of ingenuity to get their cars back in motion, and he must have performed another with the parts obtained in town, for his car was gone the next time we drove by.

Not the way you might expect to meet the newly elected Chairman of Papunya Tula Artists – unless you knew that his predecessor in the position, David Corby Tjapaltjarri (1940–80) had recently drowned trying to drive his beaten up car across a flooded creek on the way back to Papunya.[1] Like Clifford Possum, David Corby had been one of the youngest of the pioneer artists who started painting in Papunya at the beginning of the seventies. Both men were coming into their prime as artists as the first decade of the painting movement drew to a close. Many of the older artists from the founding group had begun to scale down their involvement in painting and concentrate on encouraging younger painters coming through. Some of the senior artists, like Uta Uta Tjangala, pressed on and became elder statesmen figures in the wider movement of Western Desert artists, producing some of their finest works in the early eighties. But in mid-1980 when this roadside encounter took place, Clifford Possum was Papunya Tula's rising star, the first of its artists whose name had begun to evoke recognition in Australian art circles. Not that this appeared to intrude on the artist's consciousness out there on the Papunya Road – except as an assurance of ready assistance from the occupants of the Papunya Tula Artists' vehicle in which we were travelling. For a man who had just been stranded by the side of the road for several days he appeared remarkably carefree: it was no hardship for him to live off the land for such a brief interval. His 'supermarket', he used to call it. The sound of that hilarious laughter of his, which seemed to express both a love of life and a philosophical delight in its absurdities, lingered

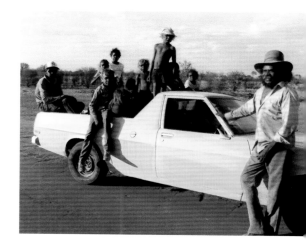

Clifford Possum on the Papunya Road, early 1980s. Photo: John Corker

Kangaroo Story (Mt Denison), (detail), 1980–81, synthetic polymer paint on canvas, 122.3 cm diameter; Holmes á Court Collection

in the car after that first meeting. Over the next decade, it would accompany Clifford Possum's brilliant progress through the Australian and international art worlds, meeting challenges for which his own society offered no cultural precedents.

The departure of John Kean at the end of 1979, and his replacement in the job of company supervisor by Andrew Crocker, marked a turning point not only in the development of Papunya Tula Artists but also in the career of Clifford Possum Tjapaltjarri. To this day, Kean regards *Yuutjutiyungu* as the best painting ever painted by one of the Papunya Tula Artists.[2] He held Clifford Possum in the highest esteem as an artist, and throughout his two-and-a-half years with the company kept him supplied with materials on a grand scale and paid him generously for his work. The arrival of John Kean's successor in the role of 'Company Secretary/Art Supervisor' (as Crocker preferred to describe himself) of a flamboyant Englishman with aristocratic connections and not much enthusiasm for driving out over rough roads to Mbunghara to witness the progress of Clifford Possum's latest masterpiece, might have been something of a disappointment.

The new management had a different attitude towards the paintings from all previous incumbents in the Papunya Tula job. This succinct declaration of Andrew Crocker's position on ethnographic documentation is taken from a statement which he displayed at every exhibition he mounted for Papunya Tula Artists:

> I think that for the purposes of this exhibition the paintings should be allowed to exercise their own aesthetic appeal and that explanations of content and symbolism be best kept to a minimum.[3]

Crocker's insistence that the paintings be seen as contemporary art rather than ethnographic artefacts had undoubted effectiveness as a promotional strategy in attracting the art world's attention to works it had previously thought of only in a museum context. But to the artists it meant that the person with the company cheque book, the man who gave out the canvases, no longer gave the same priority to the work of cultural conservation exemplified in such high degree by Clifford Possum's large map series. They responded accordingly: as the painters came and went from the artists' house at Papunya in those years, the most frequently used words of approval for one another's work in their 'Western Desert English' vocabulary were 'flash one!'.

Andrew Crocker was also a man with a mission: to save Papunya Tula Artists, which the auditors had declared a financial disaster area. If the enterprise was to survive another ten years, it must begin to attain self-sufficiency — by scaling down production (the company storeroom was overflowing with unsold paintings, though none of them were Clifford Possum's) and producing more saleable work that would help balance the company's books. From the artists' point of view, the new regime meant they were reduced to a single canvas per month by the company supervisor. The artists responded positively to the higher quality of the materials (artist quality paint and Belgian linen instead of student quality and cotton duck) that Crocker made available to them, and to the

Dreamings of Napperby Station, 1980, synthetic polymer paint on canvas, 182.0 x 182.0 cm; Holmes á Court Collection

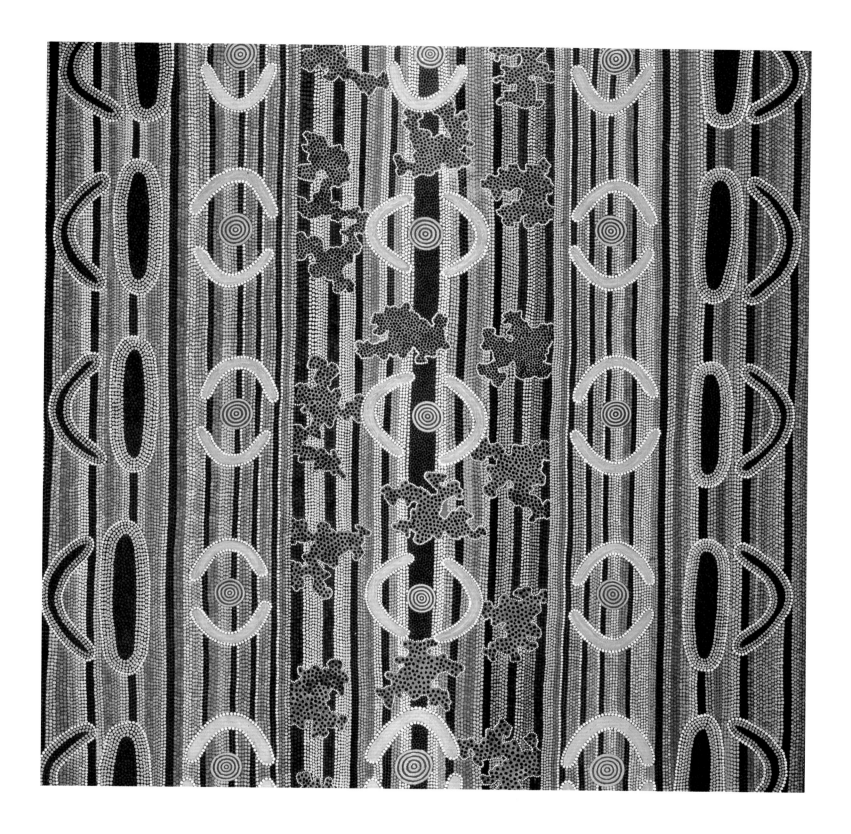

shortness of their supply, by putting more work into each canvas. This was exactly the outcome Andrew Crocker had hoped to achieve. His strategy was to secure a niche for Papunya painting in the collectors' market for 'museum quality' art from the 'Fourth World'. He also drove a much harder bargain with the painters over what prices the company could afford to pay them for their finished paintings without operating at a loss. The more outspoken, like Kaapa Tjampitjinpa, used to mutter darkly about the meagre prices they were being paid by the company for their work. Clifford Possum voted with his feet.

On the map

The first painting Clifford Possum did after Andrew Crocker took over the running of Papunya Tula Artists in February 1980 sounds remarkably like the first picture he did for Geoffrey Bardon in the 'painting room' at Papunya eight years earlier. Because of Andrew Crocker's sudden death in Africa in 1987, the painting's fate may never be known – although given the story of *Emu Corroboree Man*, the possibility of its reappearance cannot be entirely discounted. However, from the description and sketch Crocker left of it in his field notes, there were three 'anthropomorphic figures' in ceremonial hats with the added touch of realistic possums painted on their torsos. Even the usually sceptical Crocker was moved by the drama and potency of the image (just as Geoffrey Bardon had been by *Emu Corroboree Man* in 1972) to assume they must belong to the secret–sacred world of the men. Clifford Possum himself made no such assertion. Crocker's notes on the painting concluded:

> Despite this tribal group's long acquaintance with white people, largely through stock work, they remain imbued with strong traditional views. Through acquaintance with the new artistic mediums, however, some of the artists have had the courage and curiosity to develop their art. Clifford is among the most innovative. Thus his inspiration and many of his motifs are traditional while many elements are very much his own.[4]

But Crocker's admiration for his work did not translate into the steady income to which the artist had become accustomed in John Kean's time. The restricted supply of painting materials under the new regime, combined with the lower prices being paid for each canvas, significantly diminished the artist's ability to provide for his family. When the owners of Napperby station suggested paying him a regular wage to come and paint for them, Clifford Possum took them up on the offer. *Dreamings of Napperby Station*, 1980 (p. 125), was one of the outcomes of this arrangement.

No doubt disturbed at the prospect of losing Papunya Tula's highest profile artist, whose every canvas found an instant buyer, Crocker made the trip over to Napperby where he pointedly delivered a 'company canvas' and some paint. Clifford Possum's response was the masterful *Anardeli Kangaroo Dreaming* (p. 127) in which he extrapolated from the idea of enlarging the basic design elements by adding an enlargement of the distinctive tracks of the Anardeli Kangaroo ancestor to his vocabulary of signature motifs. Though they do not necessarily figure in the ceremonial context, tracks are in some ways the archetypal ancestral

Anardeli Kangaroo Story, 1980, synthetic polymer paint on canvas, 122.5 x 76.0 cm; Holmes á Court Collection

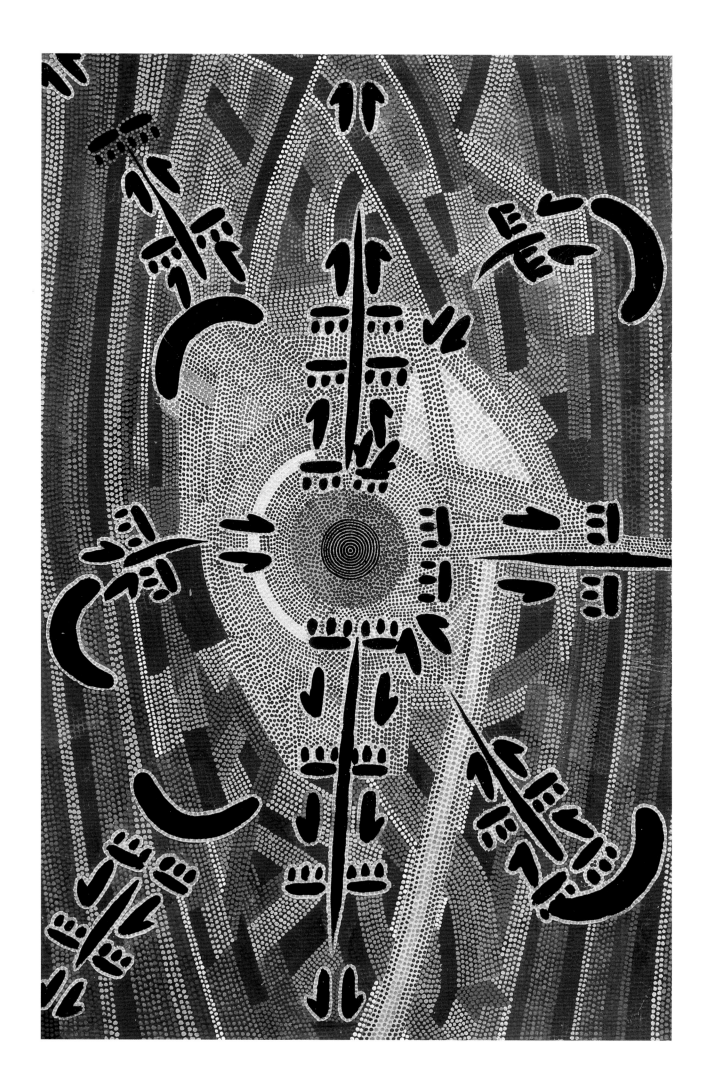

designs, a kind of 'controlling metaphor' for the relation between the ceremonial designs and their ancestral referents. They are the marks left on the ground which signify the presence of the ancestor or species that they identify. Tracks enable the tracker to find the creature who made them, just as access to the ancestral presence in the ritual context is through their designs, which are depictions of the ancestral marks. In time, Clifford Possum would develop his own distinctive vocabulary of symbols for each ancestral being's journey line, highly stylised and iconic like the Kangaroo prints on *Anardeli Kangaroo Dreaming*, but also reflecting the artist's acute observational powers, developed in his childhood as a tracker of these animals. The striking set of markings in black outlined in white dots accurately render the activities of the Kangaroo Men stopping to drink, lying down and so on around the central waterhole. Back in Papunya, Crocker put the painting aside for a special company collection of 'museum quality' paintings he had started to build and waited anxiously for the artist's return.

Meanwhile, Clifford Possum had been joined at Napperby by his brother Tim Leura, another of Papunya Tula's leading artists at the time. During this interval spent together on their shared country, the brothers briefly resumed their artistic partnership to work on a very large canvas, the largest either of them had ever painted. It was a private commission from Geoffrey Bardon who,

Tim Leura Tjapaltjarri assisted by Clifford Possum Tjapaltjarri, *Napperby Death Spirit Dreaming*, 1980, synthetic polymer paint on cotton duck, 207.7 x 670.8 cm; Felton Bequest 1988. National Gallery of Victoria, Melbourne

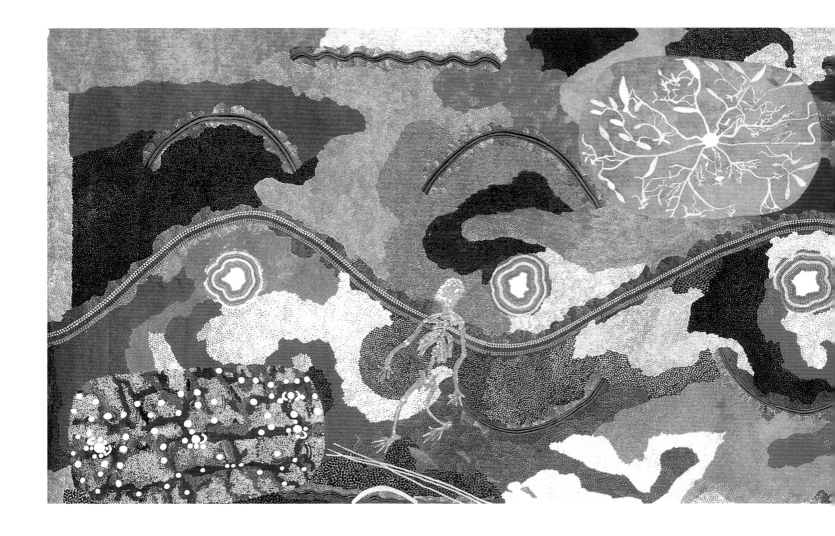

as soon as he was shown the photograph of *Yuutjutiyungu*, had gone out and bought paints and a seven metre roll of cotton duck to send to Papunya with the request that Clifford Possum paint him another one like it. He planned to use it in his next – never to be completed – film on the art movement. Crocker dutifully delivered the materials to Napperby, but perhaps he neglected to convey Bardon's request for a re-painting of the 'diamond of the movement'. The resulting work was so unlike what Bardon had expected, that he asked for another one. This time, the result was the magnificent epic to which Bardon ultimately gave the title *Napperby Death Spirit Dreaming* (pp. 128-29).

The painting was, again, so unlike *Yuutjutiyungu,* that Geoffrey Bardon assumed it must be primarily the work of Tim Leura, to whom it has been attributed 'with assistance from his brother Clifford Possum'. The annotation Bardon wrote for the painting nominates the possum's line of travel through six sites across the centre of the painting as Clifford Possum's only contribution. However, close inspection reveals that much of the background is also his work. Clifford Possum's precise, even dotting is clearly distinguishable from Tim Leura's characteristic blurred dotting on a still-wet ground. According to Clifford Possum, he painted in the main design first, just as he had on *Warlugulong,* 1976: the possum's journey through the middle, but also the outline of the wavy lines along the top and bottom denoting running water, and the

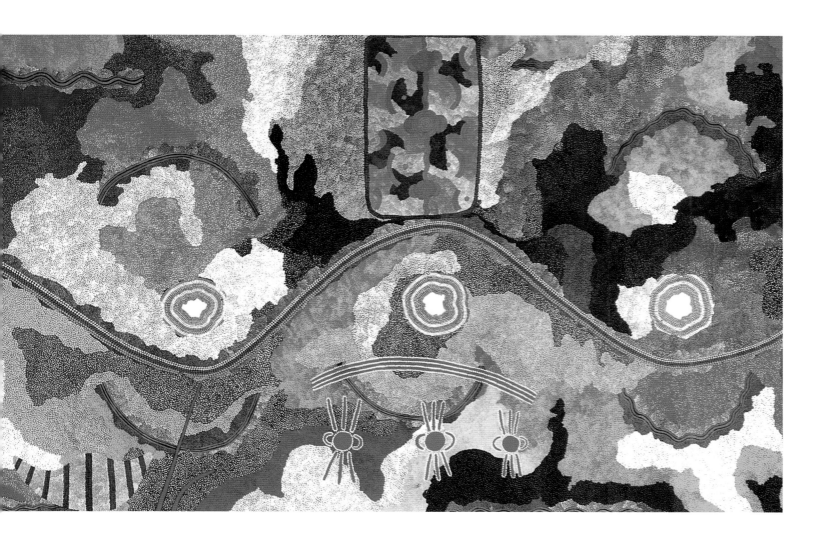

large curving windbreaks on either side of the central design. Then Tim Leura came in to assist *him*, dotting these design elements to 'bring'm up', but also adding many new design elements of his own, which make the end result a real collaboration of the two artists, rather than the more unequal partnership implied by its current attribution.[5]

One of Andrew Crocker's projects for expanding the market base for Papunya paintings was an arrangement he made to supply Mary Maha, a Perth art dealer, with a total of ten 240 x 360 cm canvases over the next few years. Maha planned to re-sell them as a group to a major corporation in Western Australia, thereby opening up the business sector to Papunya Tula art. As soon as Clifford Possum returned to Mbunghara, Andrew Crocker stretched a 240 x 360 cm canvas and took it over to him. *Yuelamu (Honey Ant Dreaming)* (pp. 132–33) was completed in June 1980 after a month of 'proper really hard work'. Its dimensions are the same as the three largest paintings in the map series, but Clifford Possum's approach retained little in common with his major works of the late 1970s. Compared to the absorbing vastness of the networks of sites and trails spread out across those canvases, this painting converges on a single site and explores its underground spaces.

The picture is a view of the interior of an ants' nest at Yuelamu, the top of which has been washed away by large rains to reveal the chambers of the Honey Ant ancestors. These ants, whose globular honey-filled abdomens were one of the few sources of sugar in the traditional diet, live in large colonies deep underground. The vast ancestral chambers are said to have created natural soakages, found throughout the mulga country with which the ants are associated. Though the name Yuelamu is nowadays associated with the Mount Allan community, the site of Yuelamu is a soakage about fifteen kilometres south-west of the settlement. Clifford Possum described Yuelamu as his grandmother's country. This important soakage water was the meeting place in the Dreaming of ancestral Honey Ants from Pine Hill, Papunya (Warumpi) and another site on Mount Doreen Station. The particular Honey Ant Dreaming with which the artist is connected continues east from Yuelamu, through a claypan site known as Altjupa Kirritja about ten kilometres north of Tilmouth Well, and then north-east to Pine Hill station, which marks the eastern boundary of Anmatyerre jurisdiction over this Dreaming. From here the Honey Ants travelled on to a site in Alyawerre country known as Ngwalanunga, where the other group from Papunya also 'finished up' after passing through Hamilton Downs station. But the painting is more a lesson in entomology or food gathering than in mythological geography. The sugar-laden abdomens of the ants are shown clinging to the sides of the nest. Their larvae or 'lurrka' are clustered around the nine nest centres or 'nakala' – valuable information when digging out their colonies several feet down in the rock hard ground to collect the highly prized food. The twelve large, brown, irregularly edged U-shapes around the six outer circles represent the custodians of the site and people looking for honey ants, using the special curved 'tjipwala' (to use the Anmatyerre term) sticks to probe for the ants.

An intriguing aspect of Clifford Possum's development of his 'stripe' style in the early eighties is the close stylistic connection between sections of the complex striated background of *Yuelamu* and Tim Leura Tjapaltjarri's well-known work *Kooralia (Seven Sisters)*,[6] which was also painted during the brothers' time together at Napperby in 1980. The same influence is evident in *Anardeli (Kangaroo Dreaming)*. Like the previous period of collaboration, when the painting of *Warlugulong*, 1976 ushered in the three-year creative outpouring of the large map series, the time spent painting with his brother at Napperby in 1980 had a strong impact on Clifford Possum. Living in isolation from the other painters at Mbunghara, he had missed out in recent years on this sort of artistic exchange, which had been such an important part of the amazing dynamism of the painting movement in the early years at Papunya. Exposed again to the influence of other artists, Clifford Possum's work underwent a radical stylistic transformation, which drew on many sources of inspiration.[7] The severe, overt symmetry which characterised his new style, down to the rain-exposed black rocks scattered across the surface of *Yuelamu*, suggests that traditional Anmatyerre requirements for reflective balance were also exerting some sway. Striping is also characteristic of much sand and body painting in a ceremonial context. But perhaps the most striking component of the new style is Clifford Possum's rediscovery of elements of his own much earlier style. The effects of superimposition and the complex background striping of *Yuelamu* recall seminal works like *Emu Corroboree Man*, 1972 and *Man's Love Story*, 1973.[8]

As it happened, the 1973 *Love Story* painting had just become the first of Clifford Possum's works to be reproduced – in Geoffrey Bardon's first book about the early Papunya painters, *Aboriginal Art of the Western Desert*, published by Rigby in late 1979. Ironically, given the focus in that book on the primary importance of the artists' 'haptic' sensibility,[9] its publication presented the Papunya painters with their first opportunity to study a sequence of the visual images they themselves had created. Prior to this, they had only their own memories of past work from which to make copies – and the noticeboard in the artists' house at Papunya, which used to draw artists to its worn and curling assortment of photos like a magnet when they came to collect their canvases and paint. The absence of readily available images of their paintings explains why at that time everyone who asked for a copy of an earlier work had the same experience as Geoffrey Bardon when he asked for another *Yuutjutiyungu*: some idea content in common, but little if any visual similarity. To that point, the designs and the concepts they symbolise had been the painters' only 'formulae'. It is no coincidence that *Napperby Death Spirit Dreaming*, painted in the wake of the book's publication, included precise visual copies of the two paintings by Tim Leura which are reproduced in it. These 'autobiographical' references, in conjunction with the title bestowed on it, effectively transform the painting's significance for contemporary art audiences. Clifford Possum's straightforward depiction of the Possum ancestor's travels has become the journey of Tim Leura's own possum-identified spirit through his major Dreaming sites. The skeletal figure in the bottom right-hand corner representing the artist's grandfather evokes the spirit of death as the artist nears the end of his life's journey.[10]

Clifford Possum at Mbunghara with *Yuelamu (Honey Ant Dreaming)*, 1980. Photo: Vincent Megaw

pp. 132–33: *Yuelamu (Honey Ant Dreaming)*, 1980, synthetic polymer paint on canvas, 360.0 x 227.0 cm; South Australian Government Grant 1980. Art Gallery of South Australia, Adelaide

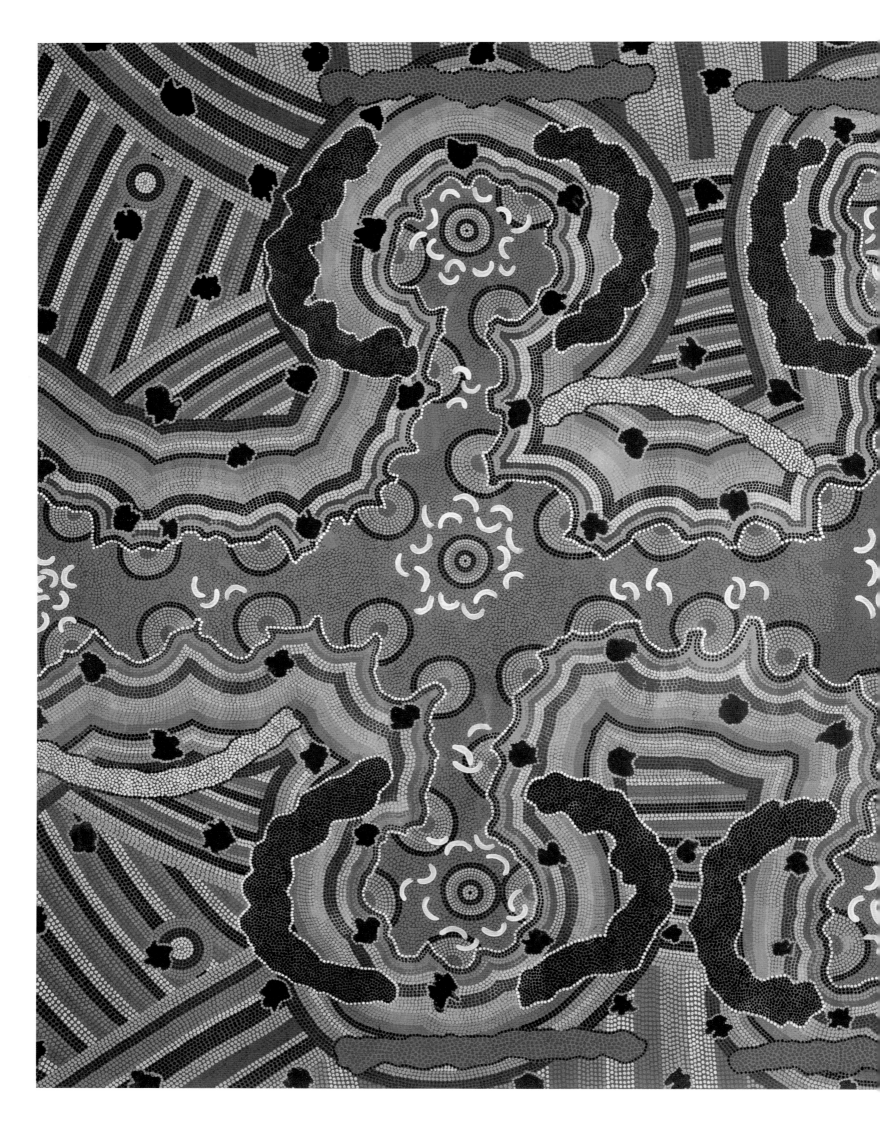

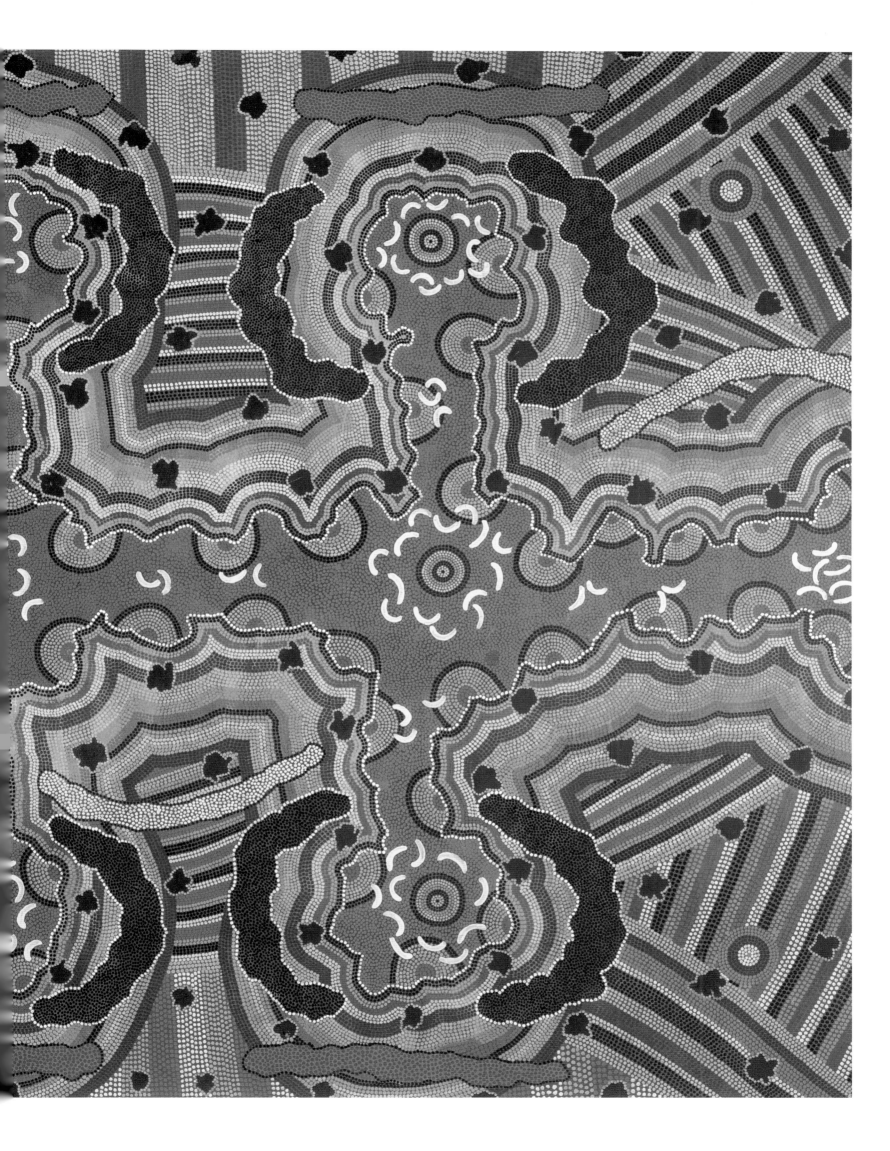

So fast were events now starting to move with the art movement, that by March 1981, *Napperby Death Spirit Dreaming* was hanging in the Art Gallery of New South Wales as part of the prestigious exhibition *Australian Perspecta*. It was the first time Aboriginal art had ever been included in this biennial survey of contemporary Australian art. Just when the occasion demanded it, a stunning group of Papunya paintings became available in Sydney. After years lying forgotten in a dank furniture warehouse, *Warlugulong*, 1976 was unexpectedly uncovered in a long overdue stocktake of the Aboriginal Arts Board collection made in the summer of 1981. *Perspecta '81* was imminent and its curator Bernice Murphy provided the occasion for the painting's first public exhibition – more than four-and-a-half years after it was painted.[11] Papunya Tula's *Perspecta* display also included a recent 240 x 360 cm painting by Charlie Tjapangati, assisted by Freddy West Tjakamarra, John Tjakamarra and Yala Yala Tjungurrayi, a superb example of the Pintupi's mastery of the vast collaborative canvas. *Napperby Death Spirit Dreaming* completed an extraordinary display. The critical response was guarded, not so much to the paintings themselves as to the 'cultural dislocation' of their implied inclusion in contemporary Australian art. The *Sydney Morning Herald*'s reviewer said the paintings looked 'suspiciously sophisticated, tasteful, opulent, expansive – like murals for a luxury liner. They were virtually indistinguishable from abstract paintings'.[12] On the contrary, the juxtaposition made undeniable the previously inconceivable: here were paintings so meticulous in their execution, so powerful in their visual impact, that they not only stood up amongst the work of their non-Aboriginal contemporaries, they stood out – and overnight put Papunya painting 'on the map' of Australian art.

Star turns

Clifford Possum may have been unhappy with the payment he had received for *Yuelamu (Honey Ant Dreaming)*, or perhaps he was still smarting from Geoffrey Bardon's having made out the cheque for *Napperby Death Spirit Dreaming* to Tim Leura alone, but he seemed to have lost interest in painting, especially for Papunya Tula. In an effort to stimulate his painterly imagination, Andrew Crocker devised a circular canvas for him, using the end of a bail of fencing wire as a stretcher. It was the first circular painting in the history of the company, and Clifford Possum responded with the virtuoso *Kangaroo Story (Mt Denison)*, 1980–81 (p. 135), to complete Crocker's special company collection of 'museum quality' paintings. In mid-1981, accompanied by artists Billy Stockman Tjapaltjarri and Charlie Tjapangati, Crocker took twenty-six paintings to America for the first exhibition Papunya Tula Artists itself had mounted overseas.[13] Crocker gave the exhibition catalogue the very unethnographic title of *Mr Sandman Bring Me a Dream*.

One of Crocker's instructions to Tim Johnson, who was acting art supervisor for Papunya Tula during his absence overseas, had been to 'get Clifford painting again'. Johnson, who was a painter himself and a great admirer and avid collector of the artist's work, was only too happy to try. He personally commissioned Clifford Possum to paint him a Love Story like the one in

Kangaroo Story (Mt Denison), 1980–81, synthetic polymer paint on canvas, 122.3 cm diameter; Holmes á Court Collection

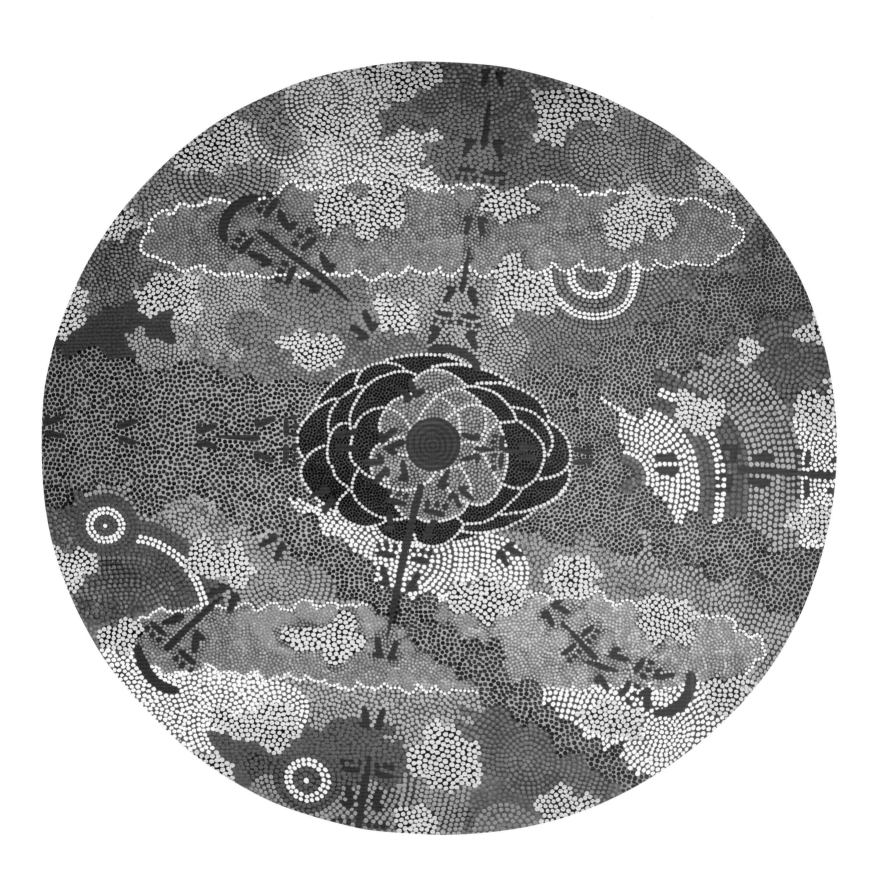

Geoffrey Bardon's book. *Love Story*, 1981 (p. 137) was the result:

> I was only there for a month in the middle of 1981. At the time, Clifford wasn't painting for the company because of friction with the art advisor. I coaxed him back – I kept making visits and giving him canvases. I gave him a big canvas first and he didn't do anything on that. I gave him a little one and when I went back he hadn't painted it. That was on the last day – I was on my way back to Sydney and he said 'Look, I'll paint it now'. And he sat down and painted it. He did the Love Story with the spindle in it – a famous painting now, it was in the *Dreamings* show. It took him nearly two hours, the first painting he'd done for Papunya Tula all year. After that, he started off painting again.[14]

The only other painting Clifford Possum did for Papunya Tula Artists in the period 1980–81 was a second very large commission for Perth, *Yakuti (Possum Dreaming Site)* which he completed in December 1981, presumably on the large stretcher Johnson had delivered to him in July.

Tim Johnson had given the artist an assortment of different colours including blue and bright yellow as part of his efforts to revive his interest in painting. This may have sparked off the experimentation with tone and 'whitefella' colour which is apparent in these two works and other privately commissioned ones from around the same time. But the artist's interest in colour dated from the earliest years of the painting movement:

> I give it all this fellas idea – [other artists] all them dot, yellows and red everything – first put in circle, circle'n Dreaming – [as all the artists were doing to represent] body paint or might be ground paint – [of a particular Dreaming]. And after that one, you put in different, different colour. That's my idea. I give everybody idea. Not them white men colour. No – them native colour – them red one, them white one, black one. I start yulpa, karrku, nguntju nguntu, kantawarra – that's what I been thinking idea: from four paint, red one, and a yellow, black one white one, from four paint – I mix'm. 'Nother four more – I mix'm from white 'nother four more. From my idea they all got it. I give'm different different colour. Like the old people they been using – in the ground, in the body. I seen'm in the plane – same colour. See, I put story first and [then] different different patch of colour. You can see'm in the board – or might be canvas – same as you see'm from the plane – munda – karru – [earth, creek] and all red one, yellow one. I seen-im, I seen-im, proper good colour too.[15]

The palette of red ochre, yellow ochre, black and white for which the first two-and-a-half decades of Papunya painting are famous is not the artistic invention to which Clifford Possum lays claim in this statement. That idea was the product of the collective genius of the art movement in those first years – and the colour range made available to the painters by Geoffrey Bardon and his successors at Papunya Tula Artists. Painting in what were perceived as 'Aboriginal' colours was an integral component of Papunya Tula's founding concept of an 'indigenous art'. According to Peter Fannin, the colours given out to the artists for the first five years (1971–75) of the art movement were burnt sienna, burnt umber, white, black, two yellows and an orange.[16] 'Whitefella' colours, such as blue, were not supplied and not encouraged. Later art advisors

Love Story, 1981, synthetic polymer paint on linen, 51.3 x 41.5 cm; Private collection

further restricted the painters' range of primary pigments to the four basic colours to which the artist is referring in the passage quoted, which were standard Papunya Tula issue for two decades.[17]

Clifford Possum's innovation, which can be understood as a response to these conditions, was about *mixing* other colours from this basic palette. This idea may not sound particularly original in a western art context, but few Western Desert artists actually mix their own colours. A glance through Geoffrey Bardon's *Papunya Tula: Art of the Western Desert* with a knowledge of the colours that were being given out to the artists at the time will confirm the lack of colour mixing in the early years of painting at Papunya (with, of course, some significant exceptions). What appear at first glance to be examples of colour mixing in Papunya Tula paintings of the 1970s and 1980s often turn out to be ingenious combinations of the basic 'Papunya' palette to achieve colour effects without physically having to mix pigments: watery yellow ochre on black for green, grey on red ochre for blue, red ochre on black for purple. Even today it is surprisingly relevant as a general observation about the whole art movement – the 'rainbow palettes' of many of the newer painting communities notwithstanding.

In the late 1970s Clifford Possum had applied the idea of mixing colour to the achievement of effects of topographical verisimilitude. The annotations of the large map paintings indicate the artist's keen awareness of the colours in his backgrounds as an integral part of the portrayal of his Dreaming subject – usually the vegetation or landforms associated with the particular area of country. He was striving for realistic effects in the colours used to represent different terrains: areas of pink dots for mulga tree stands or limestone ridges, grey for claypans, yellow ochre for dry lakes, paler yellow for the desert, spinifex, red dots for open country and so on. Like the mapping concept (and the idea of painting itself), this was not an idea for which Clifford Possum claimed personal credit. In the spirit of Anmatyerre traditionalism, he traced the idea of colour mixing to its source in the Dreaming, to the ground and body painting of the 'old people'. His insistence that his background colour effects are 'Same as you see'm from the plane', shows his continuing interest in the cartographic dimensions of his art, but his paintings reveal a strong fascination with chromatic effects.

Changes at Papunya

Back in Papunya, crucible of the painting movement, dramatic changes were in train. The re-settlement of tribal homelands, which Europeans call the 'outstation movement' was gathering momentum, with radical implications for settlements like Papunya where large populations had assembled under the old policy of centralisation. The Pintupi spearheaded the movement back to tribal lands, establishing a bridgehead in their home country at Kintore, 350 kilometres west of Papunya and twenty kilometres inside the Western Australian border, late in 1981. This eventually depleted the population of Papunya by about half, and precipitated further depopulation as people moved out to newly

Bushfire Dreaming, 1982, synthetic polymer paint on canvas, 81.0 x 100.8 cm; Elder Bequest Fund 1984. Art Gallery of South Australia, Adelaide

established communities like Mount Liebig and Mount Allan, or into Alice Springs. The artistic community which had sustained the first decade of Papunya Tula art was disbanding.

For Clifford Possum, living thirty kilometres away with his family at Mbunghara, the impact of these developments was felt indirectly, in increased access to the resources of the painting company. The Pintupi were pre-occupied with the work of establishing a new Aboriginal-initiated settlement at Kintore and re-establishing their connections to country. Their exodus from Papunya came at the very time when the work of Papunya Tula Artists was beginning to be noticed in the art marketplace. When Daphne Williams took over the job of running the painting company at the end of 1981, sales were picking up to a level which permitted cautious expansion of its operations. Papunya Tula Artists was altering its modus operandi to accommodate the new developments, shifting its base into Alice Springs. By the end of the 1980s, Papunya would be just another stopover on a field trip lasting a month all round and taking in about 1,500 kilometres on dirt and sand tracks. But in the meantime, the Warlpiri and Anmatyerre artists who lived closer in towards Alice Springs were the beneficiaries of the company's increased resources.

Papunya Tula Artists knew it could sell as many Clifford Possum canvases as the artist could paint. There was a large unmet demand for his work. The artist's star was rising steadily through events like *Perspecta '81* and the publication of Geoffrey Bardon's book, but not a single Clifford Possum painting had been available on the open market for nearly two years. The company could also afford to pay more generous returns to the artist. A slow but steady stream of meticulously painted small-to-medium-sized canvases began to flow from Mbunghara. In these Clifford Possum returned to the uncanny precision and control of his earliest works. His paintings were featured in Papunya Tula Artists' exhibitions in Melbourne (Georges Gallery 1982, Roar Studios 1983) and Sydney (Mori Gallery 1983). *Bushfire Dreaming*, 1982 (p. 139), showing the skeletons of the two brothers who perished in the great bushfire, was originally exhibited in Brisbane in 1983. It was acquired by the Art Gallery of South Australia in 1984, and included in the *Dreamings* exhibition which toured the United States of America in 1988–89. The pale exhausted bones of *Warlugulong*, 1977 have returned as dancers striking dynamic poses in this strongly emblematic composition. The symmetry of the painting encompasses even their poses, but is alleviated by subtle deviations and the three white threads identified as smoke in the annotation, which meander across the painting around and above the figures. These skeletons would continue to dance, in wilder and wilder postures, through Clifford Possum's last works.

The Australian National Gallery had reserved in advance the next large Clifford Possum canvas, and in May 1983, *Yinyalingi (Honey Ant Dreaming Story)* (p. 141) was ready for consignment. It was the artist's third 240 x 360 cm canvas since the large map series – and only his second painting of a Honey Ant subject since *Yuelamu (Honey Ant Dreaming)* three years before. There are profound differences between these two paintings' depictions of their closely related

Yinyalingi (Honey Ant Dreaming Story), 1983, synthetic polymer paint on canvas, 244.0 x 366.0 cm; Purchased from National Gallery admission charges 1984. National Gallery of Australia, Canberra

Dreaming subjects. In contrast to the almost naturalistic detail of *Yuelamu*, all the design work on the later canvas is highly stylised and laid out with almost mathematical precision, creating a strong repeat effect, like a length of material cut from a larger cloth. The annotation gives a general description of the painting's contents as 'body and ground designs used in both men's and women's ceremonies for the Honey Ant Dreaming at Yinyalingi', again confirming the supposition of cooperation amongst Anmatyerre men and women in the ritual sphere. The painting appears to be strictly symmetrical on either side of the central line of women with digging sticks and young ants, this structure being emphasised by the broad stripes of the background dotting working out from the centre. The alternating alignments of the men's ceremonial camps between the black and white circles of the women's subtly complicate the composition. The pattern of caterpillars framing the ceremonial designs echoes the smaller forms of the Honey Ant larvae to give viewers a sense of looking down into a valley. Some have noticed the lyrical effect of the artist's use of the colours of sunrise to suggest the fog rising from between the hills as daylight breaks over the end of the ceremonies.[18]

Even before it went on show in Canberra, *Yinyalingi* had featured alongside Uta Uta Tjangala's *Yumari,* 1981 and seven smaller Papunya works at the *XVIIth Sao Paulo Biennale* in October–December 1983. The Australian representation at the Biennale, curated by Bernice Murphy, also included the bark paintings by David Malangi and photographs by his son Jimmy Barnabu which had been shown in *Australian Perspecta '83.* Amazingly, Sao Paulo remained for more than a decade the only occasion on which Papunya Tula artists had represented Australia in a major international contemporary art exhibition of this kind. A National Gallery of Australia postcard and a double page colour plate in *Windows of the Dreaming* dominating the section on the Gallery's collection of Western Desert art, increased *Yinyalingi's* recognisability. This did not prevent unauthorised reproductions (illegally drawn from these sources) on a variety of merchandise, including the jumper worn by the artist in the adjacent photo.[19]

While *Yinyalingi (Honey Ant Dreaming Story)* was in Brazil, Clifford Possum had won the annual Alice Springs Art Prize[20] with his most recent work, *Mulga Seed Dreaming,* 1983 (pp. 144–45) whose swirling striped background almost submerges the pared-back designs. He was the first Aboriginal artist to take out the prize in its thirteen-year history. It was another local milestone for the painting movement, and a moment of rare happiness for Clifford Possum – not just for his first (and as it turned out, his only) art prize, but also because his sixteen-year-old daughter Gabriella Possum Nungurrayi also received a Highly Commended from the judges. In an interview at Mbunghara for the *Centralian Advocate* he told reporter Dave Richards that he enjoyed his work 'more better than everything',[21] and was confident the artistic tradition of the Papunya artists would be carried on by future generations of his people. Gabriella Possum was at that time studying at Yirara College in Alice Springs, which provides live-in accommodation for students from remote communities who want to extend their education beyond the primary school level provided on the settlements.

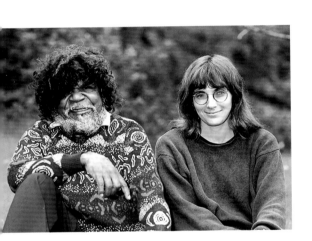

Clifford Possum Tjapaltjarri and
Vivien Johnson, Melbourne 1993.
Photo: John Brash

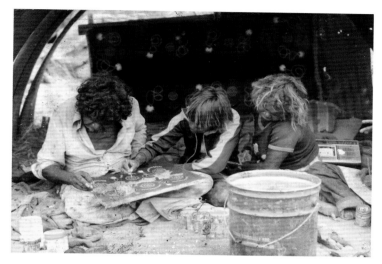

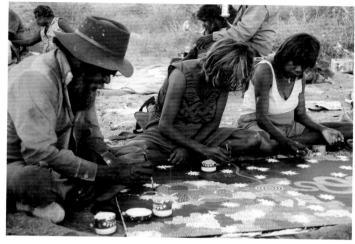

left: Clifford Possum teaching his younger daughter Michelle Possum Nungurrayi (centre) to paint, watched by Emily Possum Nakamarra, Mbunghara, 1983. Photo: Tim Johnson

right: Six years later, Clifford Possum's daughters Gabriella (centre) and Michelle (right) assist their father on the background dotting of one of his canvases, Eight Mile on the outskirts of Alice Springs, 1989. Photo: Peter Los

The rest of the family was still at Mbunghara, on the banks of Dashwood Creek, where the *Advocate*'s reporter found the artist hard at work on a group of canvases for a three-man exhibition at the Adelaide Arts Festival the following February:

> As we were about to leave the studio of this year's Alice Prize winner, we had a unique glimpse of the difficulties of his working conditions. A sudden gust of the searing southerly wind that had been blowing all day caught the edge of the tarpaulin on which his near-completed latest work lay and knocked a can of paint all over it. The artist leapt to his feet, upended the painting and poured a can of water over its acrylic surface. He saved the painting in the nick of time.[22]

Dave Richards' last word on the artist's open air 'studio', as 'a moveable feast of earth, air, sky and colour', shows a photographer's insight into the significance of the unique lighting and weather conditions under which Clifford Possum was working at this time. Where red earth meets blue sky, the light and heat of a late Spring day in Central Australia is mirage-like in its intensity.

In February 1984, Clifford Possum took one of his first trips out of Central Australia since his days as a stockman droving brumbies up from Port Augusta in the late 1940s. The occasion was the opening of *Painters of the Western Desert: Clifford Possum Tjapaltjarri, Paddy Carroll Tjungurrayi and Uta Uta Tjangala* at the aptly named Kintore Gallery in Adelaide. The exhibition, held under the auspices of the Royal South Australian Society of Arts, was the first time Aboriginal art had been a featured event at the Adelaide Arts Festival. There were twenty-three works in all, mostly 150 x 180 cm canvases, with Uta Uta Tjangala's magnificent 240 x 360 cm *Old Man Dreaming at Yumari*, 1983, the largest work in the exhibition. The opening night was resplendent with the art conscious of Adelaide high society and the Festival crowd. Assorted Papunya

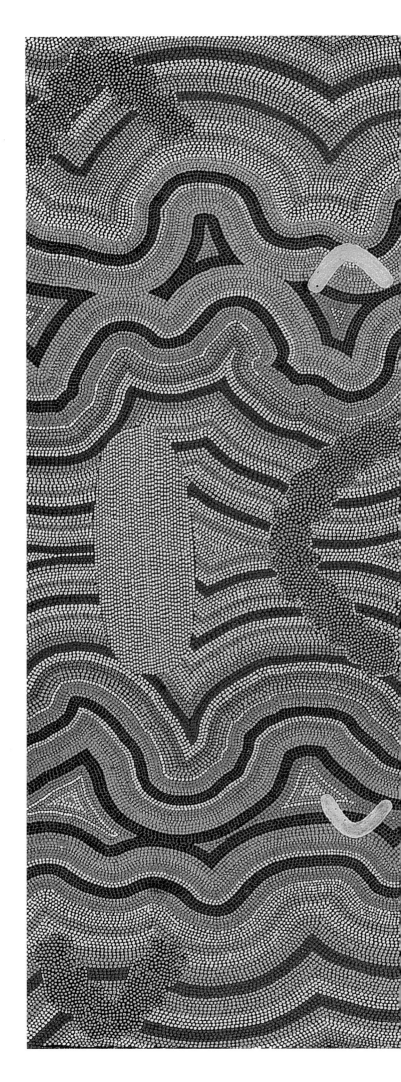

Patrick McCaughey, who judged the 1983 Alice Springs Prize with Clifford Possum's winning entry *Mulga Seed Dreaming*. Photo: Courtesy *The Centralian Advocate*.

Mulga Seed Dreaming, 1983, synthetic polymer paint on linen, 152.5 x 182.5 cm; Acquired by the Alice Springs Art Foundation as winner of the Alice Prize 1983. The Araluen Centre, Alice Springs

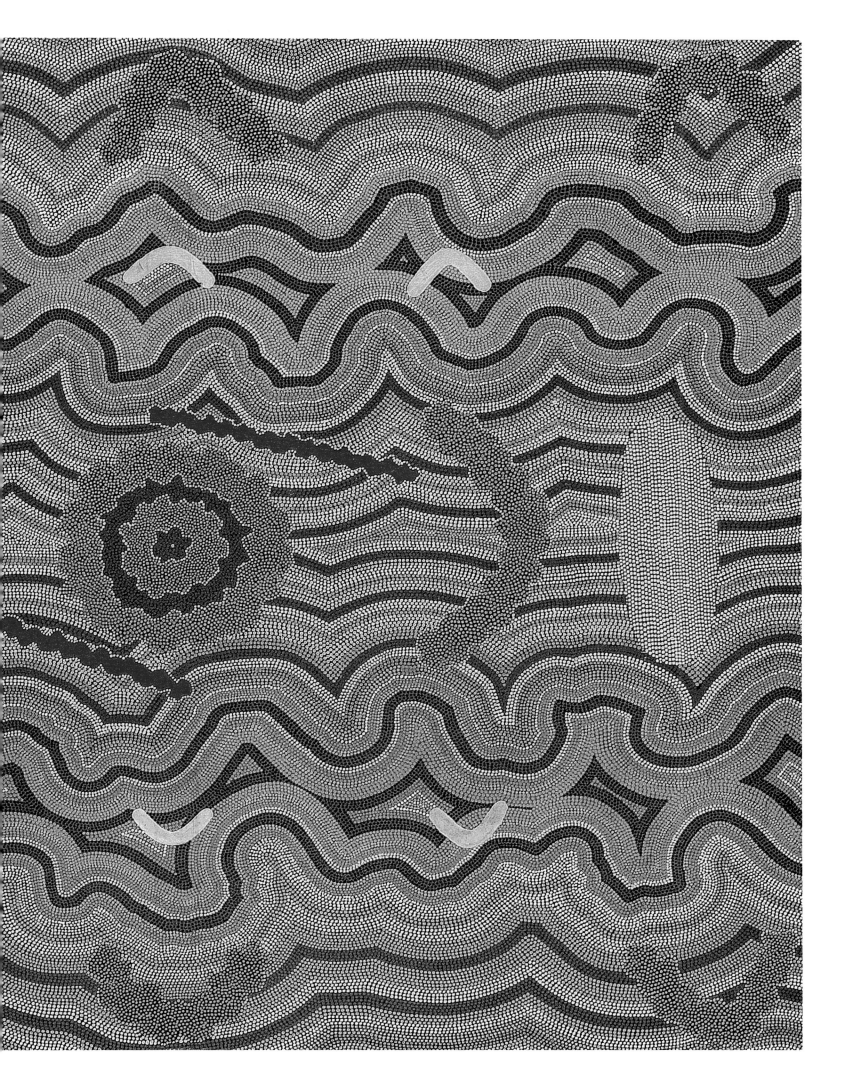

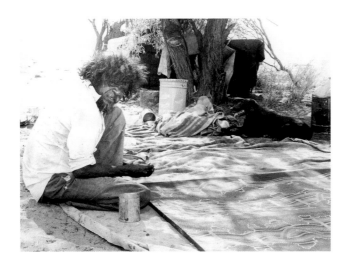

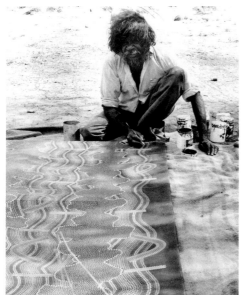

above: Clifford Possum working on *Water Dreaming at Napperby*, Mbunghara, 1983. Photos: Dave Richards, Courtesy *The Centralian Advocate*

Water Dreaming at Napperby, 1983, synthetic polymer paint on canvas, 183.0 x 152.0 cm; Flinders University Art Museum, Adelaide

enthusiasts included Ron Radford of the Art Gallery of South Australia, who added *Old Man Dreaming at Yumari* and a large Paddy Carroll canvas to his earlier purchase of Clifford Possum's *Man's Love Story*, 1978. Four other large canvases (including another of Clifford Possum's) were bought by the Queensland Art Gallery and the new Parliament House Committee – indicative of growing institutional recognition and support of the Papunya artists. The painting which the artist had saved from destruction at Mbunghara, *Water Dreaming at Napperby*, 1983 (p. 147), was purchased by the Flinders University Art Museum. Its design of bands of grey and yellow ochre cloud superimposed over the flowing rain and water, in which are inserted the dotted arcs of the ceremonial participants, is an elegant fusion of background and design which prefigures much later developments in the artist's style.[23] *Fire Dreaming*, 1983 (p. 149) was one of several smaller works in the exhibition sold to private buyers. Exemplifying the minimalism of means which was becoming a key feature of Clifford Possum's work, the painting's visual impact relies on the flawless precision of the dotting.

Like many of the pioneers of the art movement who sharpened their dotting technique over two decades, Clifford Possum Tjapaltjarri had refined his

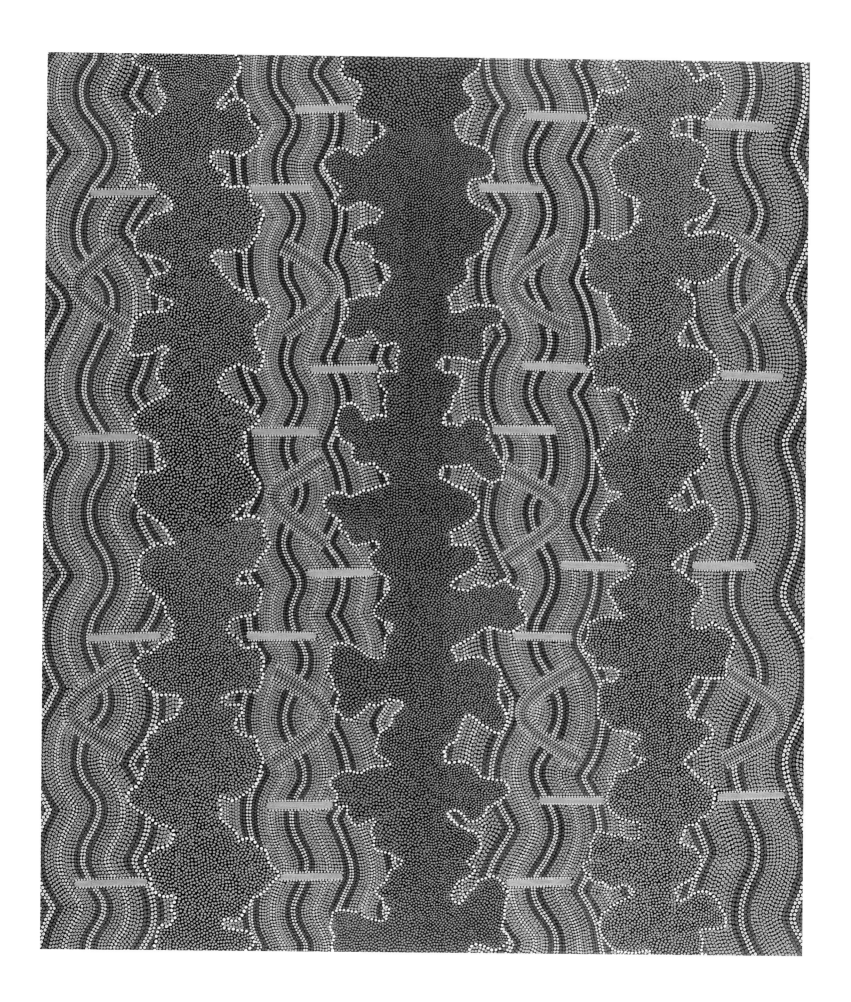

to a distinctive personal style readily recognisable to any serious student of his paintings. The most distinctive feature of Clifford Possum's mature dotting style is its extraordinary evenness. It is not a question of mechanical regularity – the many slight irregularities unpredictably distributed across the surface provide a constant delight for the contemplative gaze. But whether the dots are large or small, whether randomly distributed, in lines, in interlocking beehive-like patterns, or in concentric circles as unmarked sites embedded in the background, whether painted with brushes, or the cut-off end of a brush, or the traditional implement of a stick with the end chewed to soften the fibres, or even the cotton buds which were briefly tried by Andrew Crocker at the start of the 1980s – whatever the process, the dotting technique is always totally consistent. The dots rarely touch, and though they spread out and close up, it is always within parameters that maintain the overall look of uncanny exactitude in the spacing. Even going from one colour to another across a background of patches of different colours, there is no disturbance of the rhythm of the dotting through the colour changes. The whole background (or each layer of it) is knitted together like a seamless web. There is more than evenness to this perfection. The heart, not the brain, was the motor that drove the art of Clifford Possum Tjapaltjarri. He was passionately involved with the act of painting itself, as an expression of his subject matter. His passion was not expressed in gestural paintwork, but in the intense concentration required to achieve these technical effects.

The success of *Painters of the Western Desert* was a vindication of the departure from Papunya Tula's customary approach which it represented. All previous exhibitions mounted by the company had been surveys, with the artists' individual identities submerged in the collective artistic identity of 'Papunya Tula Artists'. The Adelaide Festival exhibition featured a group of three, albeit representative of the three major tribal groupings amongst the artists: Anmatyerre, Warlpiri and Pintupi. By the mere fact of their selection for the exhibition, these three painters had been given the mantle of the company's most outstanding artists at that time. The complications engendered by such distinctions amongst the painters had in the past been a powerful disincentive for Papunya Tula to single out any individuals. In the event, Charlie Tarawa Tjungurrayi simply refused to be left out and had accompanied the other three artists to Adelaide at his own expense, singing lustily on stage on the opening night while Clifford Possum seemed overcome with shyness. Nevertheless, individuation – at least in the sphere of consumption – now seemed vital to the artists and their company continuing to make inroads into contemporary Australian art.

To judge from the reviewers' comments, such a move did not mean dilution of the paintings' cultural authority or political potency. On the contrary, for at least one reviewer, *Painters of the Western Desert*, by adopting (like this monograph) a narrower but deeper focus on individuals, had made possible a clearer insight into the reality of land ownership in the Western Desert:

Fire Dreaming, 1983, synthetic polymer paint on canvas, 120.0 x 152.5 cm; Private collection

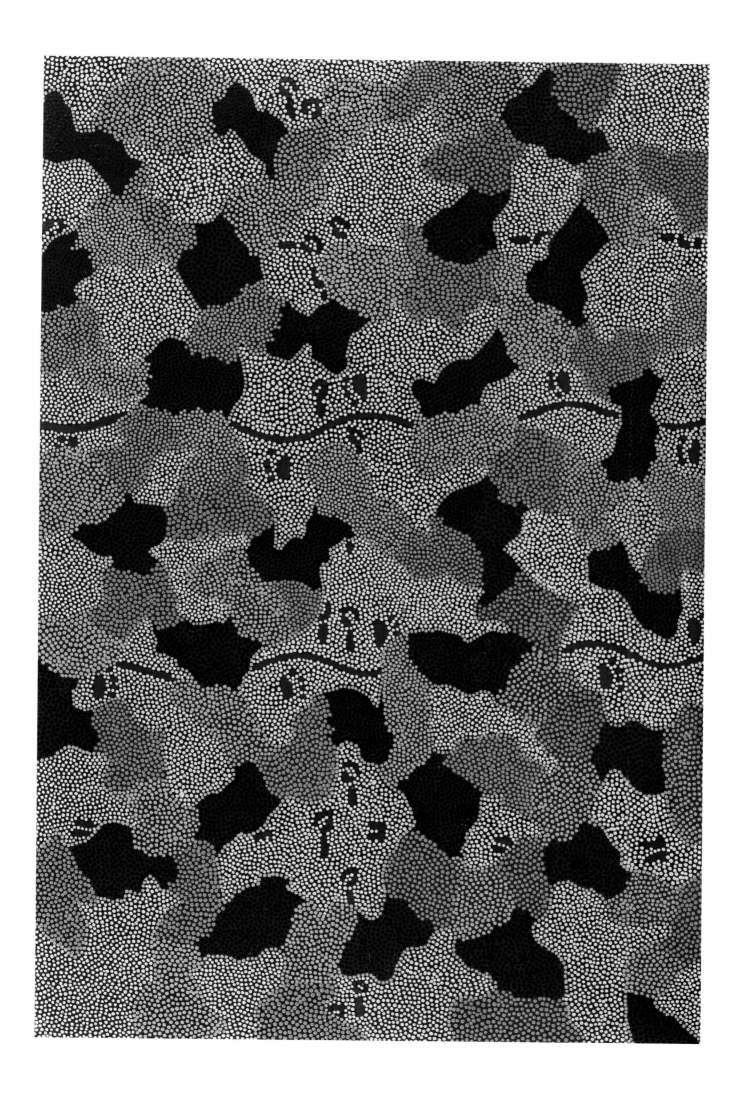

> By focusing on the representation of the sacred sites and Dreamtime
> journeyings of their totemic ancestors, there is a clearly stated reference to
> Aboriginal custodianship of particular territories and the primeval basis for
> these [Land Rights] claims. It is to be hoped that the prestigious art
> institutions of Australia, by purchasing these works, are indicating general
> acceptance of the justice of these claims and our preparedness to meet them
> with the dignity and honour they deserve.[24]

During their stay in Adelaide, Daphne Williams took the artists to visit the
Art Gallery of South Australia, where Clifford Possum saw his *Man's Love Story*,
1978 displayed in the modern Australian painting section alongside his non-
Aboriginal contemporaries. Daphne Williams noticed, with some foreboding as
to the possible effects on his work, how he spent hours studying the other works
in the section. But the most memorable image of the artist from their trip to
Adelaide was when the four painters were taken out to see the sea. Clifford
Possum stood a long time on the jetty looking – not out at the waves as one
might expect, but down, at the pattern made in the sand by the motion of the
water on the shoreline.[25]

Before returning to Alice Springs, Clifford Possum and Paddy Carroll flew
on to Canberra to view the site of the new Parliament House on Capitol Hill.
Aldo Giurgola, the American architect of the project, had invited Papunya Tula
Artists to commission designs from five of its leading artists for a mosaic to be
situated in the main forecourt of the building. Both artists submitted designs,
though it was Michael Jagamara Nelson, a new and relatively unknown artist at
that time, whose work was finally chosen. The two men then flew home, where
bad news awaited Clifford Possum. After an illness of several years, Tim Leura
Tjapaltjarri was fading fast. In the last months of his life, Tim Leura used to speak
with a kind of desperate bravado about going to America to seek his fortune. It
was like an antidote for the frustration of his artistic ambitions over the past
fifteen years: the recognition beginning to build up for the art movement came
just too late for him. By mid-year he was gone, and like others who had known
him, Clifford Possum was deeply affected by the tragic manner of his brother's
death. Slowly and carefully he finished Tim Leura's last painting for Papunya Tula
Artists, which he had been too sick to work on in the end: *Dancing Men*, 1984
(p. 151), whose vivid dancers focused all the intensity of Tim Leura's suffering.
The brothers' artistic partnership, which over the years had borne such brilliant
fruit and been briefly revived by the painting of *Napperby Death Spirit Dreaming*,
was now only a memory.

Clifford Possum continued his journey alone, as he had for several years
now, with close ties only to his immediate family. Holding the group together
in the face of challenges posed by his children's induction to western culture
through the education system would become an ever more taxing task as his
other children prepared to join their sister at school in Alice Springs. But
Clifford Possum had experienced the disadvantages of illiteracy and innumeracy
in his own dealings with the 'whitefella' world and was determined they should
have an education. An invitation in late 1984 from the recently opened Araluen
Arts and Entertainment Centre in Alice Springs to paint the design for a mural

Tim Leura Tjapaltjarri, completed by
Clifford Possum Tjapaltjarri, *Dancing
Men*, 1984, synthetic polymer paint on
linen, 101.0 x 91.0 cm;
Private collection

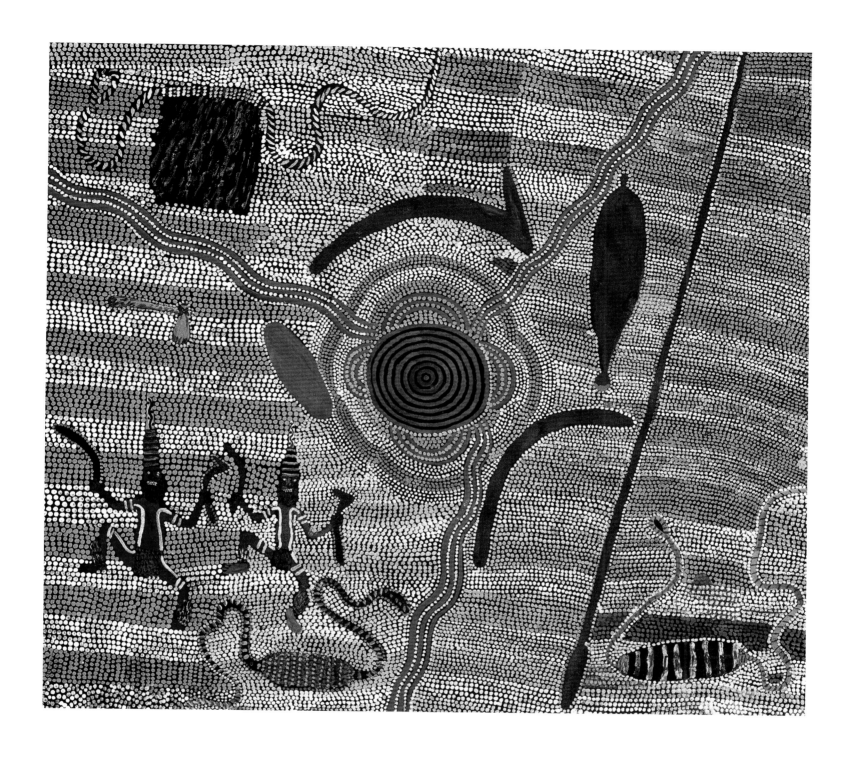

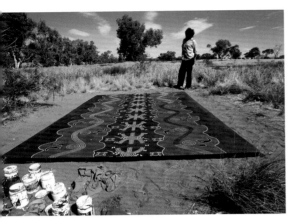

to adorn the twenty-five metre external wall of the new gallery would soon require his own presence in town. Before leaving Mbunghara, he painted one more vast canvas for Papunya, *Hare Wallaby and Possum Dreaming* (p. 153) or, according to the Papunya Tula annotation *A Constellation of Ceremonies at Yakuti*. Nine years later, when my earlier book on Clifford Possum was being put together, this annotation was not available to the writer, and the artist was asked to provide the story of the painting. According to his 1992 version of the story illustrated by this image, the site depicted in the painting was not Yakuti but another to which he also had close ancestral connections: Lawunga soakage, or Centipede Dam, a few miles east of Mount Allan Station, where Clifford Possum remembered catching kangaroo and 'having a feed at Lawunga Soakage' when he had worked across this area as a stockman. Here, old men of the Tjungurrayi and Tjapaltjarri skin subsections (shown by the pairs of U-shapes on either side of the four small roundels down each side of the painting) were sitting talking, deciding amongst themselves what ceremony they would perform that day. They made a sand drawing on the ground: the wavy lines with concentric circles between them running down the inside of the old men's camps. The black markings beside the circles on either side of the sand drawing are the segments of their pubic belts or 'tjilpitjilpi', the long irregularly edged black lines representing kangaroo sinews used in the belts. A euro or Rringalingtiju approaches the soakage from Mbatji and they decide to perform the euro ceremony. The central panel represents the sand painting which the old men made for the ceremony. The small brown circles along the edges show the whiskers of the euro, and their white tracks traverse the area of the ground painting (and indicate the paths of the dancers in the euro ceremony). The discrepancies between this account of the painting's symbolism, and the annotation prepared for the painting in 1984 based on what the artist had told the Papunya Tula art advisor, provide a remarkable insight into the way Western Desert artists 'read' their own paintings.[26]

Alice Springs style

The term 'town painting' originated well before the 1980s and before there was any significant community of Western Desert-style painters working out of Alice Springs. It was applied to the work of established Papunya Tula artists with the implication that the painting was a rush job done for some extra cash while they were in Alice Springs. Believing that this haste and the distracting conditions of the fringe camps in which these paintings were generally produced showed in their rougher workmanship compared to paintings produced by the same artists back on the remote settlements, Papunya Tula for a long time tried to discourage its artists from painting in town. However, the artists persisted – some, like Tim Leura, taking pride in their ability to obtain the canvas and materials from art supply shops in town like the Arunta bookstore and produce work independently of the painting company. Like all the artists, Tim Leura always offered the paintings to Papunya Tula Artists first, before approaching other shops and galleries in Alice Springs catering to the developing trade in cultural tourism.

Clifford Possum at Mbunghara with *Hare Wallaby and Possum Dreaming*, 1984. Photo: John Corker

Hare Wallaby and Possum Dreaming, 1984, synthetic polymer paint on canvas, 365.8 x 243.0 cm; Purchased with the assistance of the Visual Arts Board, Australia Council 1985. Ballarat Fine Art Gallery, Ballarat

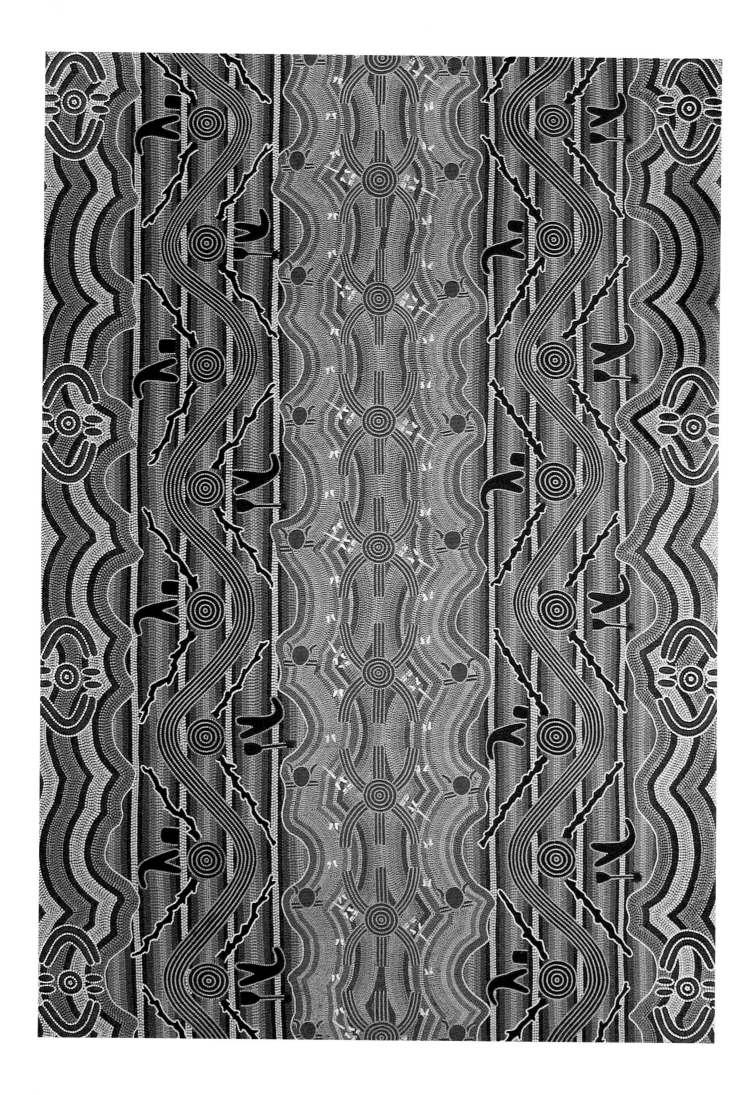

A major commission from Araluen to produce an image which could be realised successfully on the 25 x 2.8 metre east wall of the new Arts Centre placed Clifford Possum's mural study well outside this somewhat derogatory category. However, as a sketch or working drawing to be enlarged 4.6 times to fill this vast area, the mural study possessed many of the typical features of a 'town painting'. The work presented a series of five panels, in no particular geographical sequence, depicting men and women's ground and body designs for a series of Dreaming sites around Mount Allan and Mount Wedge. The designs are very basic, mainly U-shapes, concentric circles and straight lines – not in this instance to cut corners for quick cash, but because of the difficulty more complex designs would have presented for the muralists. The backgrounds offer a startling contrast to the complexity of a work like *Water Dreaming at Napperby* painted less than a year earlier. Simple blocks of colour were laid one against the other without any of the intricate interlocking of flagged shapes usual in Clifford Possum's use of this infilling device. The artist had experimented with the obvious presence of assistants on the background dotting, possibly to test out the image's capacity to survive the scaling-up process at others' hands.

The design was to be applied to the wall by two local muralists, Kaye and Bob Kessing, assisted by students from Yirara College. Delayed by the easterly aspect of the wall which prevented work starting till the afternoon because of the glare, the task was completed in eighteen days in early 1985. At the time, there was some criticism of the muralists by people who thought they should not be painting an 'Aboriginal' painting, but the artist himself expressed no

top: Muralists execute Clifford Possum's design for the east wall of the Araluen Centre, Alice Springs 1985–86. Photo Kay Hartley, Courtesy *The Centralian Advocate*

bottom left: The completed mural 1985–86. Photo: Tim Johnson

right: The nearly obscured mural in 2003. Photo: Vivien Johnson

Fish Dreaming, 1986, synthetic polymer paint on canvas, 91.5 x 121.5 cm; Private collection

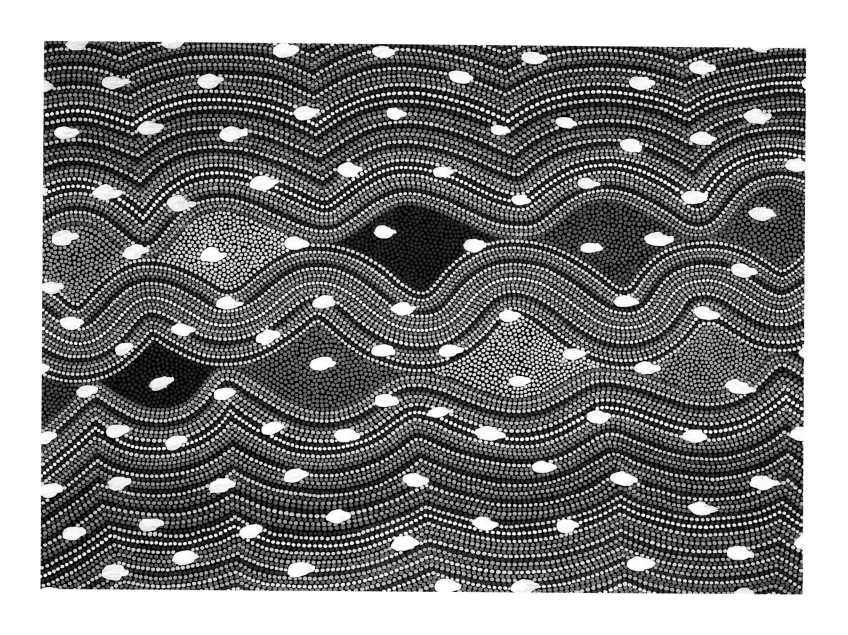

dissatisfaction with the arrangement. He had taught his eldest daughters to paint by allowing them to assist with the background dotting of his paintings, a practice which was already widespread in Western Desert art (see p. 143). He had no problem with collaborating on this particular project with fellow artists skilled in mural painting. In March 1985, the *Centralian Advocate* announced the mural's completion,[27] with a period of about eight years in the Kessings' professional opinion before fading of the colours in the harsh Centralian sunlight became apparent. Eighteen years later, the line of trees planted alongside the wall to create shade almost obscures the work from view.

In September 1985, *Face of the Centre: Papunya Tula Paintings 1971–84*, opened at the National Gallery of Victoria, that gallery's first excursion into the field of Western Desert art. It was a landmark show for the artists and their company: a major retrospective, thirty-two paintings, including *Warlugulong*, 1976, *Anardeli Kangaroo Dreaming*, 1980 and *Water Dreaming at Napperby*, 1983 by Clifford Possum, at one of the major public galleries in the country, opened by Prime Minister Bob Hawke himself. The catalogue essay placed the Papunya artists alongside Fred Williams in the great tradition of Australian landscape painting.[28] The 'impossible dream' of becoming professional artists now seemed close to a reality for the original 'painting men', and the ensuing explosion of painting across the length and breadth of the Western Desert was already building in the wings.

The effect of this publicity was soon felt at Charles Creek, one of the town camps on the northern fringes of Alice Springs, where by the middle of 1986 Clifford Possum was living with his family. He was still painting for Papunya Tula Artists, producing smaller works and major canvases for their exhibitions. One of these was *Fish Dreaming* (p. 155), which was included in Papunya Tula Artists' 1987 group exhibition at Gallery Gabrielle Pizzi in Melbourne. No painting more perfectly illustrates Clifford Possum's superlative skill in dotting *through* rather than *around* the design elements in his paintings. It is hard to believe that the white shapes of the 'fish' from Bean tree or Ngapatuka waterhole north of Napperby Station[29] were not painted after the running water and higher ground on which they appear to be superimposed, because they do not in any way disturb the flow of the dots. The effect – of bringing the designs forward visually – reverses the perception of the order in which things have actually been painted. *Untitled (Lungkata's Two Sons)* (p. 197) from the same period has the same sophisticated trompe l'oeile effects. These highly integrated surfaces hold up a mirror to their conceptual integration – to a point where the very distinction between design and background dotting on the level of both visual and narrative significance, breaks down.

The market in Papunya paintings was expanding rapidly. The entry of one of Australia's wealthiest men as a major player into the market for Papunya paintings sustained and increased this momentum. Not long after *Face of the Centre*, Robert Holmes á Court had recruited its curator, Annemarie Brody, to build him an Aboriginal art collection of unrivalled size – and value. The Holmes á Court Foundation had begun collecting Papunya paintings in the

Ringalintjita Worm Dreaming, 1986, synthetic polymer paint on linen, 122.0 x 76.0 cm; Acquired from the 1986 Caltex/NT Art Award by the Central Australian Art Society. The Araluen Centre, Alice Springs

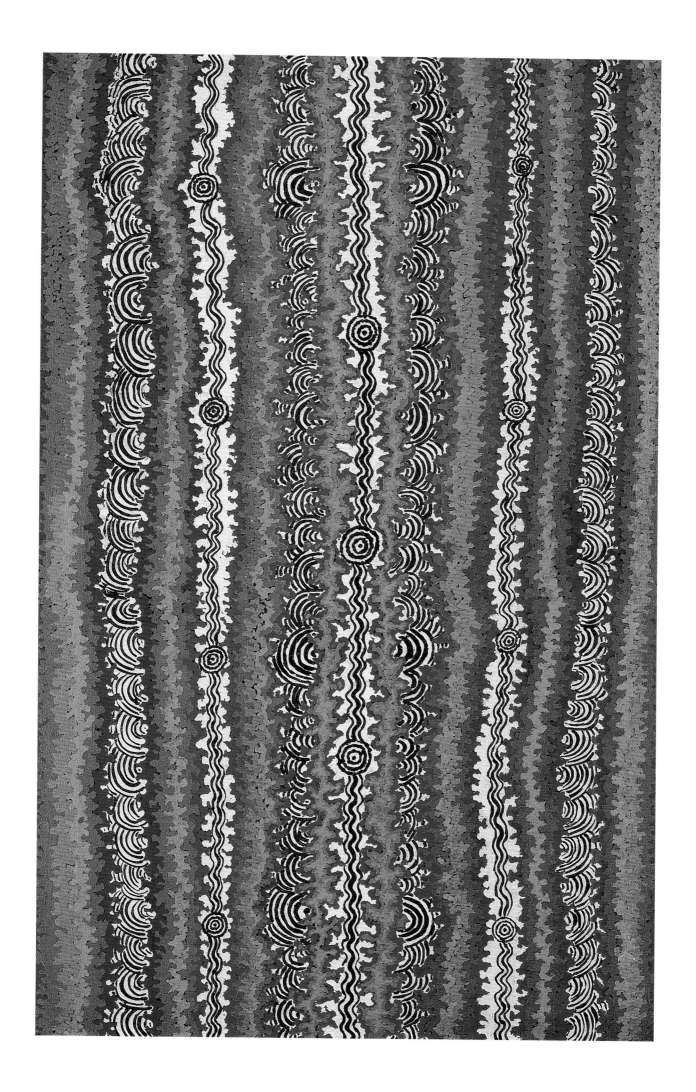

early 1980s, with the purchase of the entire *Mr Sandman* exhibition before it was sent to America. Papunya painting was the area in which expansion of the existing collection was initially proposed. Papunya Tula Artists' sales were already benefiting from the recognition which most of the key public galleries in Australia had by then accorded the art movement by including the works of Papunya Tula artists in their permanent collections.

In 1986 the Holmes á Court collection acquired two Clifford Possum Worm Dreamings, in which the progressive refinement and simplification of the artist's technique appeared to stunning effect. Though painted sequentially, the paintings look dramatically different. In *Dingo Dam Worm Dreaming* (p. 159), the trails left by the worms as they burrow underground are set against a background of blocks of colour. The irregular patches of the worms' washed out burrows, outlined in white, stand out beneath the worms' path. In *Narripi Worm Dreaming* (p. 161), the unbroken line of travel of the Worm Ancestor is skilfully interwoven into an all-over patterned surface, in a bold but technically flawless early example of the 'linked dotting' technique which, in the following decade, would become a common element of so many Western Desert artists' styles. The colours: the same grey, greeny-yellow ochre, red ochre, white, and a brighter yellow which is the colour of the worm, are the only clues to their identical subject matter.

These two paintings of the Worm Dreaming, and a third, *Ringalintjita Worm Dreaming* (p. 157), painted just before them, exemplify Clifford Possum's approach to his subject matter at this time. He would take a Dreaming, or a site and its Dreamings – in this case, the three adjacent but geographically distinct sites of Narripi, Dingo Dam and Ringalintjita on Mount Allan Station – and paint several versions of it, experimenting with new ideas for depicting this particular story or new techniques for backgrounds or compositions. He might work in this way on a couple of different Dreamings at the same time, the two sequences cross-fertilising each other. After completing a series on a particular Dreaming, he would move on to another subject, and might not paint that Dreaming again for many years, or depict it in a visually similar way when he did. Clifford Possum had always worked like this, but had never had a solo exhibition of a continuous body of his work in which his seemingly inexhaustible inventiveness could be demonstrated in a group of paintings illustrating a specific sequence of Dreaming subjects.

Clifford Possum's name was associated with two exhibitions in 1987, one in Melbourne and another in Brisbane, but neither attempted anything as difficult as obtaining a chronological sequence of the artist's work, or a series on a particular Dreaming subject. The Melbourne exhibition, *Paintings of Clifford Possum Tjapaltjarri*, at Avant Galleries, was the first time the artist had been featured individually in this way, though it is doubtful whether he even knew of the exhibition's existence. To that point anyway, he had always sold his paintings as he finished them, one by one – which is how Avant Galleries would have acquired the paintings in this exhibition – either directly from the artist or through later re-sale. The exhibition was testimony to Clifford Possum's growing

Dingo Dam Worm Dreaming, 1986, synthetic polymer paint on linen, 180.0 x 120.0 cm; Holmes á Court Collection

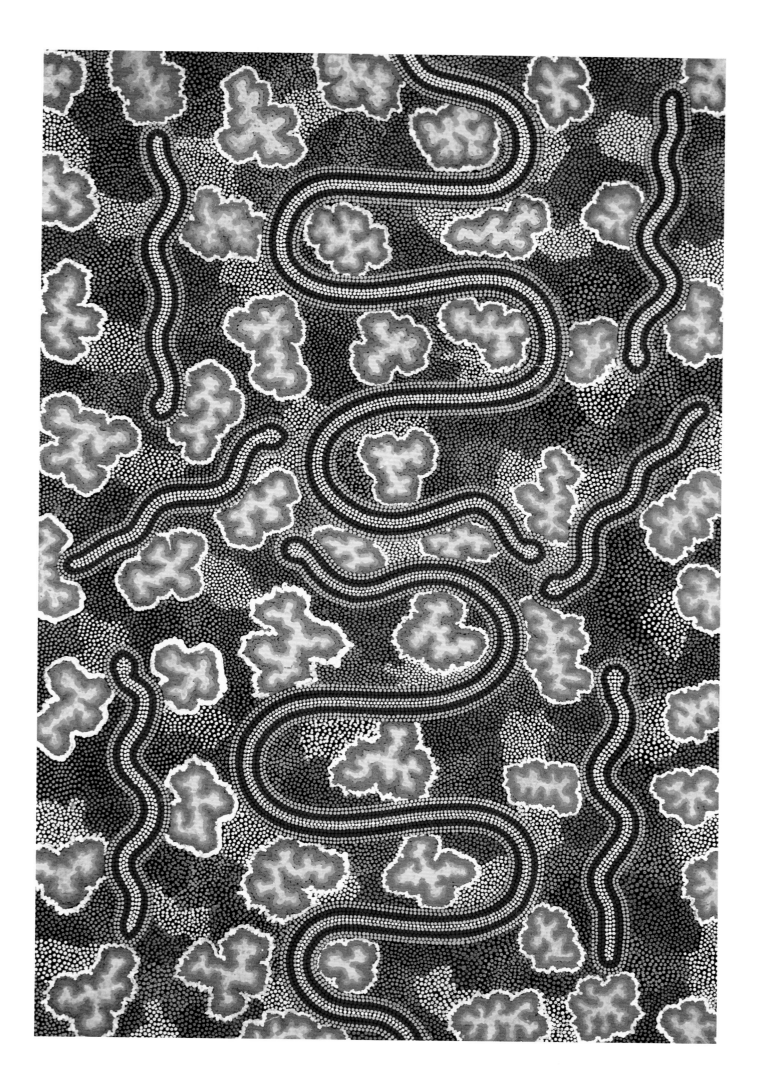

recognition and marketability amongst Avant's art world clientele, but the event itself was outside of the artist's agency or control.

The second exhibition, at a Community Arts Centre in suburban Brisbane later in the year, was advertised as *Art from the Central Desert and Northern Arnhemland, featuring the work of Clifford Possum Tjapaltjarri and members of his family*. The exhibition was organised by a private entrepreneur – the first of so many – who decided to move into marketing Aboriginal art after getting to know the Possum family on a visit to Alice Springs. His use of the name Clifford Possum as a draw card seems hardly justified by the number of Clifford Possum – or Clifford Possum-assisted – paintings in the exhibition. There were also works by Gabriella Possum, her younger sister Michelle Possum and Michelle's young husband Heath Ramjan Tjangala, a former sign-writer who had been having painting lessons from his new father-in-law. Gabrielle Possum travelled to Brisbane for the exhibition, reflecting the family's active involvement. Teaching his children to paint was a way of imparting to them an Anmatyerre education alongside their western one, but the artist was equally intent on imparting a skill which would help them to survive in the new and different world they were growing up in. The inclusion of his daughters in the exhibition was high on Clifford Possum's personal agenda in the Brisbane exercise – as a step on the way to their following in his footsteps.

For Papunya Tula Artists, further differentiation of their more established painters by individual shows of their work had been the obvious next step after the Adelaide group show of 1984. In mid-August 1988, the first of a series of solo exhibitions by Papunya Tula artists opened at the Gallery Gabrielle Pizzi in Melbourne. It featured the work of Joseph Jurra Tjapaltjarri, one of the new group of young Pintupi painters beginning to emerge from Kintore now that the settlement was firmly established. The work had been collected over many months of careful preparation. Daphne Williams had worked closely with the artist, explaining the context in which his work would be exhibited and sold. Clifford Possum would have been an ideal subject for this kind of well-planned solo exhibition. He had long understood the importance of variety in marketing a body of work. His artistic profile was high enough to make exercises like the Melbourne and Brisbane exhibitions worth their promoters' while – but they were precisely the problem for Papunya Tula and its Melbourne agent Gallery Gabrielle Pizzi. Not only had Clifford Possum's work already been exhibited in Melbourne by another gallery, the artist himself was actively lending his name to shows like the Brisbane one, over which Papunya Tula Artists had no control. In a later notorious example of territoriality over an Aboriginal painter's work, access to the artist Emily Kngwarreye was at least limited to two main sources by her residence on a remote outstation. In Clifford Possum's case, living in town and accessible to all comers for the cost of a $30 taxi fare (or so rumour had it in Alice Springs in early 1988), there seemed no way any limit on commerce in the artist's work could be set – and certainly the artist himself was brooking none. The traffic to Charles Creek was getting heavier with each passing day.

Narripi Worm Dreaming, 1986, synthetic polymer paint on linen, 121.5 x 91.5 cm; Holmes á Court Collection

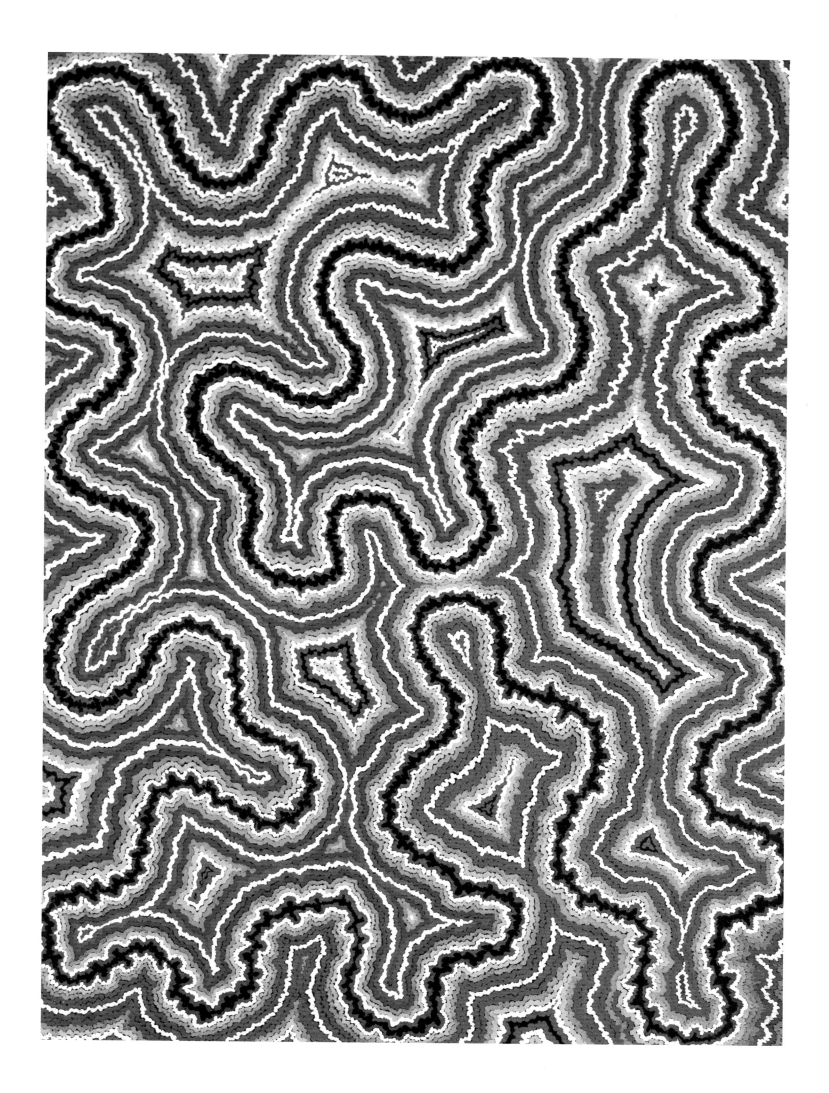

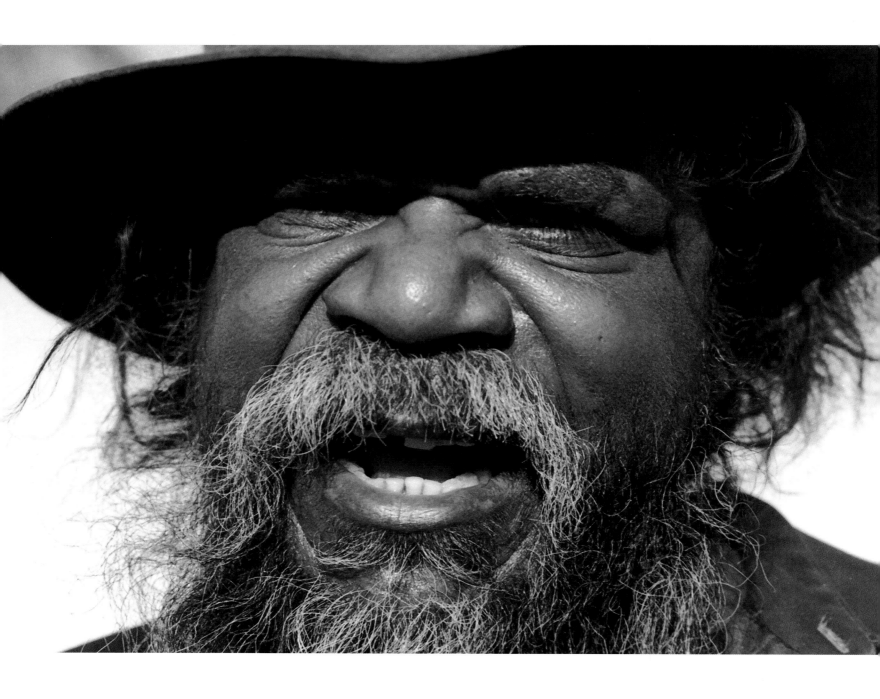

My private canvas

If a solo retrospective is 'the touchstone of being considered a Fine Artist in European circles'[1] then *Clifford Possum Tjapaltjarri: Paintings 1973–86* which opened at the Institute of Contemporary Art in London on 7 April 1988, marked Clifford Possum's attainment of this status. Like the Flying Snakes of Altjupa he had soared, straight from the marginal status signified by the two 1987 exhibitions in Melbourne and Brisbane to international recognition, bypassing the long hard climb of solo exhibitions through which most artists attain this peak experience of their careers. Curator and ICA Director Iwona Blazwick announced the show as 'the first solo exhibition of his work in this country',[2] but if we discount Avant Gallery's re-sale without the artist's knowledge, it was the first real solo exhibition Clifford Possum had ever had in a painting career spanning, by then, almost two decades.

Clifford Possum Tjapaltjarri: Paintings 1973–86 was also the first solo exhibition by an Aboriginal artist ever seen in London. A retrospective of one of the pioneer painters of Papunya Tula Artists was a radical move in terms of the London audience's previously minimal exposure to Western Desert art. The idea arose from Iwona Blazwick's research trip to Australia in early 1988. After a decade of intense debate, Australian art audiences were finally receptive to Aboriginal artists having solo exhibitions like their contemporaries. Applying the ICA's policy of giving rising artists their first major showing in a public gallery, Blazwick decided that Clifford Possum Tjapaltjarri was the obvious candidate for the ICA's exhibition to mark the 1988 Australian Bicentenary.

Critical reaction to the retrospective was entirely positive, one reviewer calling it an 'overwhelmingly beautiful one-man show'.[3] The *City Limits* reviewer waxed lyrical over:

> Spots of paint ... bunched together like the filaments of the head of flowers or intricate beadwork, and what close-up can be seen as poor quality acrylic paint is given a stunning intensity of colour. At times the effect is of fantastic luminosity, at others a hallucinatory confusion of scale and depth.

But he also grasped the cultural and political import of the paintings, describing them as:

> ... narratives of religious and mystical importance and also topographical depictions establishing Aboriginal land rights, recognised as such by Australian state authorities.[4]

Clifford Possum, Alice Springs, March 1989. Photo: John Corker

More establishment critics avoided the political overtones and framed their comments in terms of the time-worn 'art or ethnography?' dichotomy. In language reminiscent of Andrew Crocker's 1980 statement on ethnographic documentation, *The Times*' reviewer proposed:

> Certainly it is interesting to know the precise explanations of his abstract-seeming imagery, but his paintings have a sheer power of design and a subtle harmony of colour which seem to be quite personal and certainly obviate the necessity for literal interpretations. [5]

The individuality of Clifford Possum's paintings was a constant theme of the extensive media coverage which the show received. Although put together over just a few months, [6] the group of about a dozen paintings was strong enough to sustain the exhibition's unfamiliarity as a perspective on 'Fourth World' art. The London audience's response to the absent Clifford Possum as a romantic post-colonial outsider figure was expressed in a series of performances at the ICA titled *The Subtle Divide – Songs for Clifford Possum Tjapaltjarri*, featuring musicians from the United Kingdom, Africa, America and Europe. The ICA invited eight composer–performers to respond to the 'visual language' of the paintings 'through their own musical language' over two nights. The enthusiastic response of the general art public can be gauged from the show's unusually strong attendance figures and the record sales of the catalogue: at the time, *Clifford Possum Tjapaltjarri* was said to be the fastest selling catalogue the ICA had ever published. [7]

Clifford Possum had been interviewed for the catalogue essay, so he knew there was to be an exhibition of his paintings in London. But he had no knowledge of the contemporary international art scene on which to base an assessment of the potential significance of a retrospective at the Institute of Contemporary Art for his artistic career. He was in any case preoccupied with the ever-increasing pressure from local and interstate traders in the booming Alice Springs market in 'dot' paintings. Many of these people knew little more about Western Desert art than that they could always sell a Clifford Possum for a profit. This situation was attracting ever-increasing numbers of hangers-on, whom kinship ties obliged the artist to support. The envy of non-artists and less successful ones in the large camp at Charles Creek also had to be contended with: on a visit I paid him there in early 1988, resting against the wall of the hut where he and Heath Ramjan, painted were several primed white canvases which had been splattered with paint and kicked in. 'Jealous ones', he said quietly.

For a time, the Possum family moved further out of town with a few close relatives to a place known as 'Eight Mile' for its approximate distance from the centre of town. For a while, they found some respite there from the continual harassment. Clifford Possum had struck up a connection with the Central Australian Aboriginal Media Association, whose newly established retail outlet in Alice Springs for Aboriginal music tapes was rapidly expanding into a full scale art-marketing operation. Initially, CAAMA concentrated on the town-based artists pressing at its door: the news that a shop operated by an Aboriginal organisation had opened up to sell their paintings spread rapidly among the local

painters. Clifford Possum's participation was welcomed by CAAMA: his name lent credibility to the fledgling enterprise. Several of his paintings had been included in CAAMA's inaugural show at Sylvester Studios in Redfern Sydney in December 1987. For Clifford Possum, CAAMA's involvement offered a return to a more stable working situation, in which he could begin to see past finishing the next canvas.

The artist's intermittent experiments with more technically sophisticated backgrounds than the standard 'town style' flagged dotting were encouraged by CAAMA's manager Rodney Gooch, who had asked him for a 'big mob' of 'flash ones' for an upcoming exhibition at the Austral Gallery in St Louis featuring Clifford Possum. The St Louis show was timed to coincide with *Dreamings: Art of Aboriginal Australia*, the exhibition which launched Western Desert painting in America. The *Dreamings* exhibition opened at the Asia Society Galleries in New York in October, 1988 to record-breaking attendances and extensive media coverage. It presented anyone engaged in marketing this art with a golden opportunity to break into the United States market. The large number of works on canvas from Papunya Tula and the newly established Warlukurlangu Artists company at neighbouring Yuendumu, catered so perfectly to New Yorkers' craving for the new, that they were bound to produce a sensation.

This was the atmosphere to which Clifford Possum was exposed when he arrived in New York in November 1988 for a brief visit. It was his first trip outside Australia. He had accompanied Rodney Gooch to the opening of the CAAMA show in St Louis, then flown to New York, staying in a hotel where their rooms overlooked the Manhattan skyline. The artist insisted on being photographed against it, holding rather nervously onto the balcony railing, to show his family back in Alice Springs. Christopher Hodges, CAAMA's Sydney agent who was living in New York at the time, took the artist to the largest art supply shop in the city so he could see the full range of paints available to local painters. Clifford Possum selected a box of iridescent paints, some silver and some gold – and reputedly produced a sensation after he returned to Alice Springs by finishing his next painting with them. They also went to see the *Dreamings* exhibition, in which five of the artist's paintings (six, if *Napperby Death Spirit Dreaming,* a collaborative work, is counted) were on display, making him the most highly represented artist in the show.[8]

On sheer size, *Napperby Death Spirit Dreaming* was the focal point of the *Dreamings* exhibition. How Clifford Possum might have felt at seeing this painting hanging in pride of place in the opulent Asia Society Galleries, surrounded by the admiring crowds which Tim Leura had envisioned in his dying days, is probably inexpressible in words. His only recorded response to the American trip was a comment he made to a visitor to his campsite on the afternoon of his return to Alice Springs in late November:

> We talked for a while and I recall asking him about New York. He laughed and looked at me saying 'too many black fellas, too many white fellas, too many cars and ground too dry, no trees growin' there'.[9]

Those who had seen Clifford Possum before he left for America were

Clifford Possum in New York,
November 1988. Photo Chris Hodges

'astounded' by his 'renewed vigour, enthusiasm and healthiness' on his return to
Alice Springs. But he soon resumed his former stressful lifestyle, painting
constantly to meet the incessant demands of relatives and art dealers. His special
relationship with CAAMA did not long survive the flurry of new interest
produced by the American venture. It did last long enough for Gooch to arrange
for Clifford Possum's inclusion in *Papunya Tula: Contemporary Paintings from
Australia's Western Desert* in May–June 1989 at the John Weber Gallery, one of
New York's most prestigious contemporary art galleries. Regrettably, Weber's
association with Papunya Tula, which had the potential to launch Western
Desert art in the New York art scene, was short-lived. It was undermined by the
activities of the fastbuck merchants who had descended on New York hoping
to cash in on the publicity for the *Dreamings* exhibition. Back in Alice Springs
however, these same elements were driving the trade in Western Desert
paintings to fever pitch.

The Chairman of the Review Committee on the Aboriginal Arts and
Crafts Industry, Jon Altman, was also in town asking a lot of questions. In May
1988, as part of the flood of 'Aboriginal stories' inspired by Australia's
Bicentenary, Clifford Possum's picture had appeared with a page one Exclusive
in *The Weekend Australian* under the headline: 'Tradition Trampled in Rush for
Riches'. The caption read: 'Clifford Possum, a leading tula [*sic*] artist, painting a
work for which he expects to receive $500. When it reaches the cities, it should

fetch five times that amount'. The article claimed to have uncovered 'a mire of exploitation', citing transactions witnessed at Clifford Possum's camp to illustrate the point.[10] The story, pandering to the assumption that Aboriginal artists were 'primitives' being taken for a ride by unscrupulous dealers, had all the makings of a moral panic, and was quickly taken up by the other media.

Towards the end of 1988, the federal government bowed to the media pressure and announced a formal review of 'the Aboriginal arts and crafts industry', the first official recognition of the economic significance of what had previously been perceived as primarily a welfare enterprise. The review committee's terms of reference included a brief to investigate issues of 'cultural integrity' in Aboriginal art arising from this new status. The committee had ready access to the government-funded organisations and to legitimate operators in whose interest it was to be vindicated by the review's findings on the conduct of the industry. The committee found no significant evidence of malpractice. This was a reasoned assessment of the evidence available from their sources. However, the small independent operators at the bottom end of the Aboriginal art market, whose activities had been the original cause of concern, were not accountable to the review committee. The persistent claims of astronomical mark-ups were dismissed in their report as isolated examples. In economic terms, the risks involved for retailers obliged to buy up Aboriginal artists' work for up-front cash with no guarantee of re-sale, justified profit taken on more saleable items. The critical need from a policy-making point of view was for a comprehensive general profile of an industry for which, at the time, no reliable statistics were available. Gathering industry-wide data took precedence over consideration of the special case of artists like Clifford Possum, to whose situation their argument about retailer overheads did not apply – because the dealers could always be certain of re-selling his works for a profit sooner or later. Ironically, it was his situation, as reflected in the scenes witnessed at Charles Creek by *The Australian*'s reporter, which had sparked the call for a government inquiry in the first place.

To many of the Aboriginal artists themselves (and they were not alone in this perception), the review was seen as the prelude to an attempted government take-over of the Aboriginal arts industry. Clifford Possum was amongst those disturbed by the prospect of a government monopoly. When Jon Altman met with representatives of various government-funded organisations involved in marketing Aboriginal art, Clifford Possum was upset at what he perceived as his exclusion from the discussions. He had wanted an opportunity to voice his opposition to government regulation of the Aboriginal art industry, which he believed would infringe upon his right as an artist to sell his work to whomever he wanted for whatever price he wanted to put on it. An audience with Jon Altman was arranged by one of the local gallery operators who dealt in Clifford Possum's paintings at the time, at which the artist, in the end, spoke little.[11] Altman remembered suggesting he could always go back to Papunya Tula if he felt he was being exploited by the private dealers. But, as the situation had been thirty years before when the painting movement began at Papunya in defiance of government controls over the painters' lives, so it was now for Clifford

Possum. He would not permit any interference, however well-meaning, in what he considered to be his private business. When questioned about his conversation with Altman later that year, he gave this account of what he had wanted to say:

> Papunya Tula give me canvas, or might be from Dreamtime or Stuart Arms Gallery: You do me this one. All right, yeah. I'll cost it up when done, all the stories. But they asking me first, How much it gonna cost me for that canvas? I'll give you that much price. All right? That's true! That's the Alice Springs way. Not allowed to get my price. I'll pay you that much. No! you wait for me. I'll give you price when I know what stories – might be five stories, might be six. They won't just wait for me if they want this Clifford Possum. So now, might be my property, my private canvas.

These attitudes would cost him dearly in the end, but Clifford Possum wanted to be his own man, not a 'company man'. Freedom to be exploited by corrupt dealers may not sound much like freedom, but to those who knew his proud independence nothing seemed more unlikely than that Clifford Possum would ever compromise it in any way.

Just before Christmas 1989, Clifford Possum made a trip to Sydney on 'painting business' accompanied by his older daughter Gabriella and an Alice Springs dealer in his work. For a week, he and Gabriella were encamped painting in the front room of a Paddington gallery as part of an exhibition of their paintings. He wanted to trade face-to-face with the Sydney market for his work, rather than accepting the often doubtful services of the small army of middlemen who frequented his camp in Alice Springs. An article on his visit in the *Sydney Morning Herald* in December 1989, under the heading 'Possum Comes to Town', [12] was devoted almost entirely to discussing the disparity between the prices allegedly being fetched by his paintings and the amounts he had been paid for them. The extended family of 'twenty-seven' back in Alice Springs which he was supporting with his art, was also on the artist's mind in the interview. They made some money to take home for Christmas, but the experiment cannot have been entirely successful, for on returning to Central Australia, the artist moved in the opposite direction. He was spending more and more time at Napperby Station, trying to get away from the pressures of Alice Springs. By 1989, a painting enterprise was well-established at Napperby, run by Janet Chisolm, the station owner's wife. Over twenty painters, including Clifford Possum's older brother Cassidy Tjapaltjarri, were working for exhibitions in the eastern states, which began to include Clifford Possum's paintings. But there was no escaping his determined pursuers from the town:

> When I say, 'Without everybody' – you know, go bush, these people still look around. 'Where? Which one?' they asking Papunya Tula or might be someone else. You know soakage water, way out from station. If they come, get a Toyota, have to ask station owner. And station owner tell him, 'Just go and see camp mob – might be Cassidy's mob'. They find me, 'Got canvas in car. You paint for me?'

Around this time, a man named John O'Loughlin found his way to the Possum family's camp and offered the artist something more than the usual

cheap canvas with a fixed buy-back price. Instead, he offered him a solo selling exhibition at the Rebecca Hossack Gallery in London. O'Loughlin would later say that Clifford Possum had befriended him, taken him hunting and in a ceremony involving kangaroo blood, had declared him to be his 'cousin'.[13] This seems doubtful,[14] but Clifford Possum was sufficiently impressed by his offer to abandon the negotiations which had begun with the owners of Napperby Station to grant him an excision from their lease of some of his ancestral lands if he would come and paint full-time for them again. Instead the artist and his family accompanied Hossack's intermediary back into town to a house obtained for them and he began work on a series of paintings for the exhibition. This time, Clifford Possum's presence as well as his paintings was required in London. An invitation had been issued for the artist to attend a garden party at Buckingham Palace. Being presented to the Queen is a status symbol in Central Australia, particularly amongst the older artists, because it signals acceptance by the highest levels of European society. It meant far more to Clifford Possum than the chance to put his art career on the road to international stardom. In Alice Springs, it was the talk of the town and the local dealers were fighting over who should have the privilege of accompanying him.

Tjapaltjarri Dreaming

In July 1990 Clifford Possum flew out of Alice Springs bound for London, accompanied by a roll of paintings – and John O'Loughlin. The exhibition opened at the Rebecca Hossack Gallery in London's high summer, under the title *Clifford Possum and Papunya Tula Artists: Songlines IV*. The Summer edition of the British art magazine *Artline* featured a cover photo of the artist and included the catalogue for the exhibition as a lift-out colour supplement. There were fourteen canvases attributed to Clifford Possum, ranging in size from the largest, at 305.0 x 137.0 cm, to a set of circular ones 137.0 cm in diameter. Most were in the familiar Clifford Possum 'town' style, with simple design work in red ochre outlined in white on backgrounds of flagged shapes in the artist's usual colour range. Only one of the larger canvases attempted the intricate composite background style with which the artist had experimented occasionally during the previous two years. The assistance of family members and possibly others too was evident on many of the paintings, identifying them as early examples of the genre of Clifford Possum 'family paintings' which would prove so contentious over the next decade.

Rebecca Hossack's *Songlines* theme, implicitly instating Bruce Chatwin's novel of Central Australia[15] as an authoritative source on the paintings' significance, typifies the romantic ethnography approach favoured by many of the European entrepreneurs who had begun to deal in Western Desert art. Nothing more completely embodied the British version of this attitude than Clifford Possum's visit to Buckingham Palace to meet the Queen.[16] It was a classic setting: the Annual Royal Garden Party, at which most of the eight thousand guests enjoy only the privilege of consuming their afternoon tea in Her Majesty's vicinity. However, Clifford Possum, resplendent in a hired grey

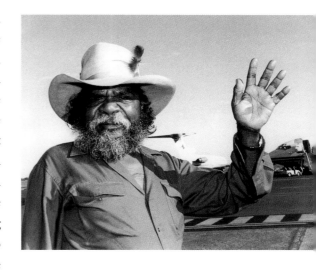

Clifford Possum, Alice Springs airport, August 1990.
Photo: Courtesy Carmel Sears

morning suit, top hat and white sneakers painted with dot and circle designs, was placed first in the line by the Queen's private secretary in the queue of guests to be presented to Her Majesty. This had been pre-arranged by Lord Harwood, the Queen's cousin. The artist's attempt to acknowledge his sense of the honour being bestowed on him by the gift of a small painting he called *Tjapaltjarri Dreaming* had attracted the attention of the security men, who stepped in to prevent the breach of protocol involved if the artist had simply handed it to her. Clifford Possum later received a note from her private secretary, written at the Queen's command, thanking him for his 'kind gift' in these words:

> It is appropriate that such a splendid example of the work done by Aborigines in Central Australia should find a place in the Royal Collection.

> The Queen was glad to have the chance of meeting you and talking with you at her garden party last week. She would be grateful if you would take her greetings to all your people at home in Australia.[17]

ART LINE INTERNATIONAL ART NEWS

Vol 5 N°2 SUMMER 1990 £2.20

ON SALE IN: NETHERLANDS FRANCE AUSTRIA GERMANY BELGIUM SWITZERLAND ITALY
ICELAND PORTUGAL MEXICO USA JAPAN SINGAPORE HONG KONG AUSTRALIA

FEATURED

VAN GOGH IN AMSTERDAM

RUSSIANS INVADE NEW YORK

HAYWARD BRITISH ART SHOW CONTROVERSY

FRIEDRICH AT NATIONAL

CLASSIC GROUND AT THE TATE

BIENNALE PHOTO-FILE REPORT

ARTWORLD NEWS
FROM THE NOSE CAPTION COMPETITION

INTERNATIONAL REPORTS
NANTES VENICE

CLIFFORD POSSUM
AND PAPUNYA TULA ARTISTS
DOCUMENTARY EXHIBITION AT REBECCA HOSSACK

'Another one like that'

Queen like me to stay in England. I was thinking, because my missus were there in Alice Springs. Thing is, she passed away. I shipped out. This time I can go anywhere.

Within weeks of Clifford Possum's return from London, disaster had struck. His gentle 'missus' Emily Nakamarra, mother of his four children, was dead, a casualty of the destructive lifestyle of the Alice Springs town camps. A few weeks later, Clifford Possum awoke one morning in the Todd River bed to find his older son Daniel lying dead beside him.[18] Mother and son were buried at Larumba, where the local Anmatyerre people had been granted an excision from the Napperby lease. It was the hardest of times for Clifford Possum personally. His work offered little solace. Despite the London exhibition, things

Warlugulong, 1991, synthetic polymer paint on canvas, 183.0 x 450.0 cm; Courtesy of the Strehlow Research Centre

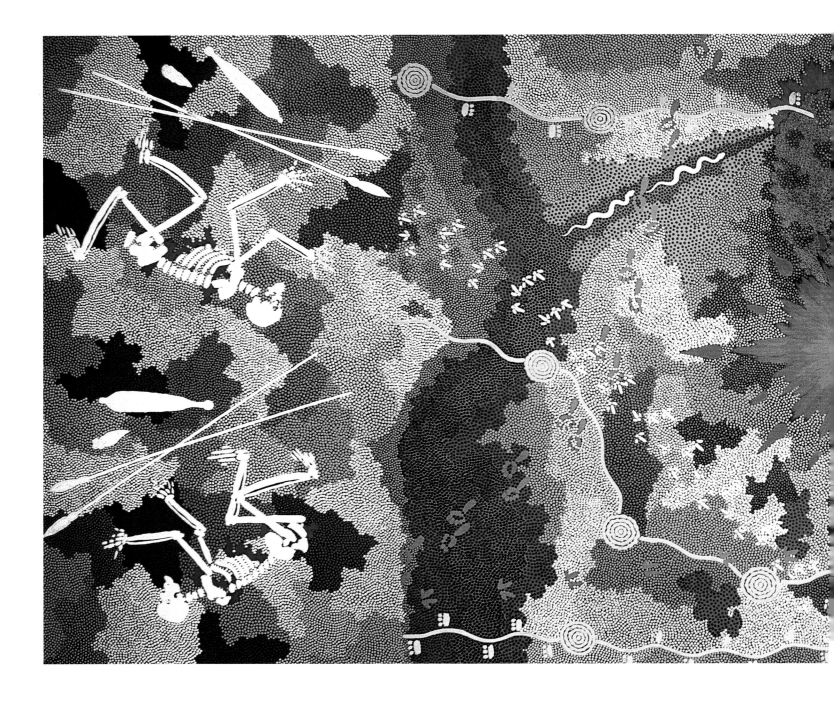

were not going well for the artist professionally either. Since the collapse of his relationship with CAAMA, he had been drifting towards the lower end of the Alice Springs art market. CAAMA had turned its attention to building the career of Emily Kngwarreye, an eighty-year-old Eastern Anmatyerre woman from the Utopia lands, who was by 1990 well on her way to becoming Aboriginal art's first 'superstar'. Clifford Possum could still sell anything he put his name to, but better connected artists like Kngwarreye were making significant inroads into the upper reaches of the Australian art world, while he painted merely to survive.

Although he now had few dealings with the painting company he had helped to found, Clifford Possum's name was still closely associated with Papunya Tula Artists. He had been one of the seven artists featured in *East to West: Land in Papunya Tula Painting* at the Tandanya Aboriginal Cultural Institute

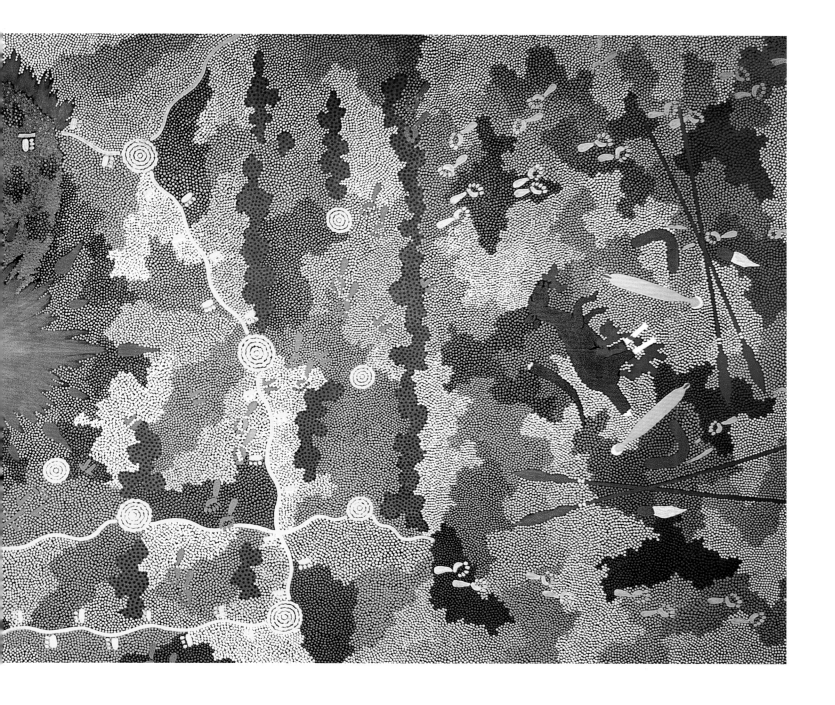

during the 1990 Adelaide Festival.[19] The exhibition was conceived and realised by John Kean whose curatorial project drew inspiration from Clifford Possum's breathtaking explorations of Dreaming cartography during the late 1970s when Kean managed Papunya Tula Artists. *East to West* was the first exhibition to attempt systematic exploration and presentation of Western Desert paintings as 'maps of country'.[20] Kean drew on his detailed knowledge of the artist's output and its often obscure destinations, for such highlights of the display as the first public showings of *Mt Denison Country* and *Two Men Fighting* twelve years after they were painted. It was also Papunya Tula Artists whom the Strehlow Research Centre approached towards the end of 1990 for assistance in obtaining a major painting from Clifford Possum for their new building, under

Fire Dreaming, 1991, synthetic polymer paint on canvas, 451.0 x 197.0 cm; Federal Airports Corporation

construction alongside the Araluen Arts Centre in Alice Springs. The commission, signalling to the artist his enduring place in the history of Central Australian Aboriginal art, may have saved him from despair.

The work was painted on the floor of a new gallery for Aboriginal art established just off Todd Street in Alice Springs. Its proprietors were Frank Mosmeri and Milanka Sullivan, two travellers from Melbourne who were not the first or the last to come to Alice Springs for a week and stay for a year. Both were practising artists who admired Clifford Possum's work in reproduction. When the artist himself walked into their gallery, they eagerly showed him pictures of his paintings in books, wishing aloud that he would paint them 'another one like that'. Sullivan recalled the artist's amazement at how many of

his paintings had been reproduced – apparently he had never seen most of the books they showed him.[21] This exposure may explain why, more than thirteen years since the last great map painting, Clifford Possum decided to paint a third version of *Warlugulong* (pp. 172–73) on the 183 x 450 cm stretcher with which Papunya Tula Artists had supplied him for the commission. These dimensions were designed to accommodate the vast main wall opposite the entrance of the Strehlow Research Centre for which the painting was destined. Mosmeri and Sullivan's gallery enterprise was short-lived, but it provided the artist with a quiet place to work away from the camps. Each dot was placed carefully in its appointed place with the fine brushes which he had not used for backgrounds since the 1970s. Three months of painstaking toil were devoted to the painting's immaculate execution. While work was proceeding on the Strehlow commission, Papunya Tula Artists received another important request for one of Clifford Possum's paintings. The Federal Airports Corporation wanted a large work by the artist for the main passenger lounge of the new Alice Springs Airport. He painted another Bushfire Dreaming for the occasion, but eschewed the labour-intensive detail of the Strehlow piece in favour of a bold representation of the two brothers' skeletons.

To anyone familiar with Clifford Possum's works in reproduction to that point, the most striking thing about these two paintings was their marked visual resemblance to works from earlier periods in the artist's development. The Strehlow Research Centre's *Warlugulong* was a re-painting of the first *Warlugulong* from 1976, although the artist had extended the imagery of the original to enrich the larger surface on which he had made his own 'reproduction'. The central bushfire motif no longer exploded across the whole surface, but was integrated into a larger landscape covered in a delicate tracery of tracks and sites, set between the skeletons of the dead brothers at one end and the sacred kangaroo they had greedily cooked and eaten for themselves, at the other. In the case of *Fire Dreaming*, 1991 (pp. 174–75) for the Alice Springs Airport, Clifford Possum was explicitly commissioned to produce a 197 x 451 cm version of the 1982 *Bushfire Dreaming* in the collection of the Art Gallery of South Australia (p. 139), which had been reproduced in the catalogue of the *Dreamings* exhibition. The Federal Airports Corporation representative actually showed the artist a postcard of the painting and asked him to paint them one like that.[22] The possible negative impact of the death imagery on intending travellers seems not to have occurred to the commissioning body until after they saw the painting completed. At their earnest insistence, Clifford Possum reluctantly added a few more red dots around the figures to tone down the effect.

This new element of image replication in Clifford Possum's art may be read as a response to the availability of his work in reproduction. Obviously, there is the factor of consumer demand for images which have been sighted in books: both of these paintings were produced in response to requests that the artist paint 'another one like this!'. This was nothing new: the first large *Warlugulong* from 1976 had also been the outcome of explicit suggestions to the artist about

what he should paint. The difference now was the exponential increase in these kinds of demands on the artist which mass circulation of his work in reproduction had generated. As more of his work became known through the publication of the first edition of this book in 1994, these pressures became even stronger. Had people realised, from studying his oeuvre, the greater wisdom of the artist's advice to 'just wait for me if they want this Clifford Possum', it might have had the reverse effect. But it was easier to learn such wisdom, when requests for 'another one like this' were futile since the commissioned work never looked anything like the original. For Clifford Possum to begin recycling his own imagery in this way was a complete departure from his previous method of working.[23] But its significance cannot necessarily be reduced to the demands of the market, which he had never had to bow to in any case. Reproductions in books put Western Desert artists like Clifford Possum in touch with their own past images, which, in earlier times, were never seen again once the paintings were finished. Why should Clifford Possum, any more than the rest of us, have been immune to the fascination of his own images?

'Shipping out'

As soon as *Fire Dreaming* was finished, Clifford Possum flew out of Alice Springs to stay with the family of his younger daughter Michelle in Adelaide. He returned to Alice Springs in December 1991 to be present at the official opening of the new airport terminal building, when his painting and another of the same size by Eunice Napangati were unveiled. But then he 'shipped out', embracing the freedom conferred by his wife's death to 'go anywhere'. For the next ten years he would pursue an itinerant lifestyle, like his ancestral namesake Upambura who wandered 'everywhere' across Anmatyerre country and well beyond its borders, searching for food – and love. During the painting of the Strehlow commission in Alice Springs, Clifford Possum had formed a relationship with Milanka Sullivan which continued for another five years and drew him away from Central Australia. Clifford Possum's sundrenched studio in their house at Warrandyte on the outskirts of Melbourne overlooked a tree-lined river. In summer the smell of the dense onion weed lining the roads hung in the air like the scent of Kerrinyarra, the love song mountain, remembered from his boyhood. During the next few years, Clifford Possum divided his time between the cities of Adelaide and Melbourne, where his two daughters and growing numbers of grandchildren lived, working constantly on the paintings which helped to support them. He also returned to Alice Springs at regular intervals to check up on his younger son Lionel and paint for an assortment of local dealers and interstate traders. His continuing involvement with these people was a source of friction with Sullivan, who considered some of his associates nothing short of disreputable. In response, he curbed his other dealings, but never desisted from them entirely. The path of the free agent which he had chosen for his art 'business' demanded an endless search for new buyers. Increasingly, this required his presence in the cities, where he could also concentrate on his art.

New directions were emerging in his work. His experiments in the late 1980s with composite backgrounds integrating different styles of dotting came together in the complex multi-layered and interlocking surfaces of works like *Carpet Snake Dreaming*, c.1991–92 (p. 179) and *Larumba*, c.1992–94 (p. 181). His over-painting of the designs onto these backgrounds reversed the usual order of events in Western Desert painting – including his own. The double and triple superimpositions create illusions of depth, as layer upon layer of the Dreaming mantle is exposed. The significance of these visually stunning works is not adequately encompassed by reference to their obvious marketability, or to the artist's display of virtuosity in the face of his legions of imitators, though both these factors clearly played some part. Their other side was the intensity of concentration required of the artist in producing them, born of their significance to Clifford Possum's emotional life. As twenty years earlier, the Papunya painters had found in painting a way of externalising their longings for country, so Clifford Possum now kept contact through his art with that part of himself which still lived in Anmatyerre country.

The same mindset is apparent in the direction which his ongoing experimentation with colour now took. Abandoning the exploration of abstract colour effects evident in the unusual pale blue, mauve and grey tones of the Alice Springs airport's *Fire Dreaming*, he turned back to his own culture for inspiration. In 1990, he told me that the background colours of one of his latest canvases were the colours to be found in the rocks at the place depicted in the painting, which were also the colours applied to the participants' bodies in the Dreaming ceremonies for that site. This could be seen as a refinement of the idea of the schematised but chromatically accurate aerial landscape observed in the backgrounds of his late-1970s large map series, but with a more closely observed – ground-level – point of view on the place being represented. More significant for the artist however, was the way this approach took up the symbolic priorities of Anmatyerre culture by introducing criteria of colour selection based on the traditional utilisation of local colour in ceremonial contexts.

The actual pigments used in ceremonies are not site-specific in the way this might suggest. They come from particular ochre pits within that area of country, access to which is strictly controlled by the laws of the Dreaming. As Clifford Possum explained:

> C.P.: You know what this is? [pointing to one of the tins of paint he was using to dot the background]. It's because red ochre rock – that's for Tjungurrayi and Tjapaltjarri.
>
> *V.J.: Is that the one from the ochre mine near Mungapunju?*
>
> C.P.: Yes. That is Yakuti. Nothing to do for Tjupurrula and Tjakamarra and Tjangala and Tjampitjinpa. They gotta use'm pink. That's Karrku. You know that place Karrku? Rain Dreaming – big storm come through this place from west into my country. Karrku mostly pink. Not red one, not black one, just pink only. Yellow ochre and light yellow ochre, that's for us too. This is from Yaramayi area – this light one.

Clifford Possum painting one of his Snake Dreamings, 1997.
Photo: Adam Knight

Carpet Snake Dreaming, c.1991–92, synthetic polymer paint on canvas, 210.0 x 127.0 cm; Peter Los Collection

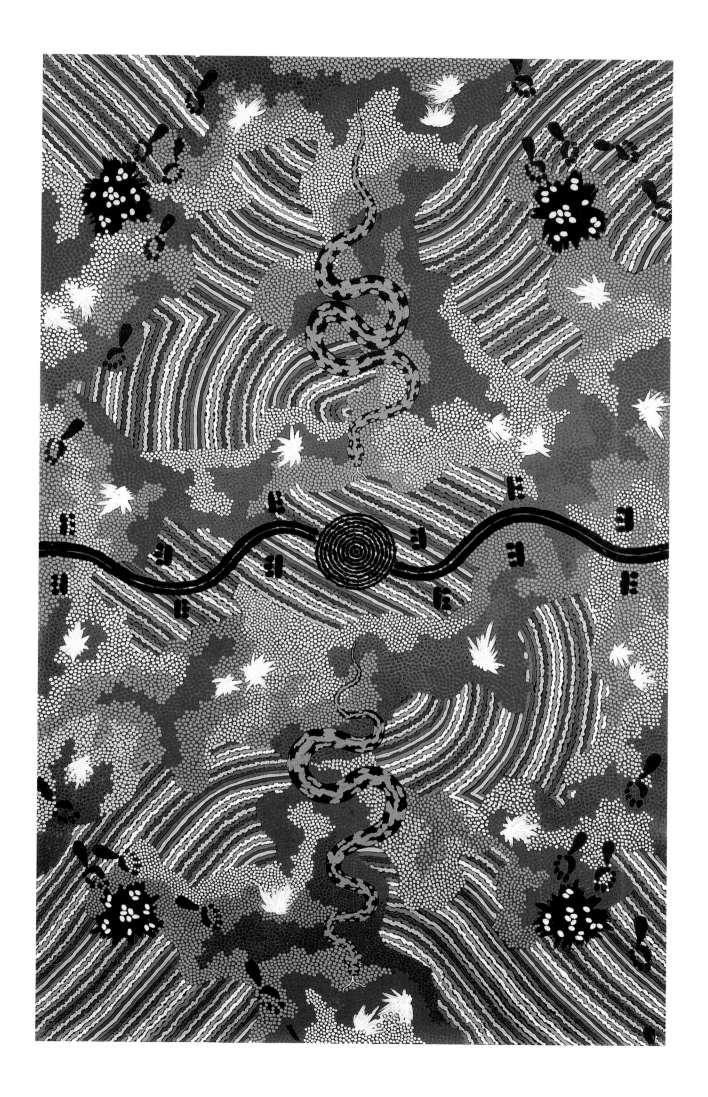

V.J.: So you mix the colour of the different ochres?

C.P.: That's it! Ochre, and this one [pointing to black] I use'm from spinifex grass, make'm black. Not charcoal, from spinifex grass. We found it.

V.J.: What about white?

C.P.: Nguntju nguntju mean this one – pale yellow. Kaltji is white. That is whole lot – see?

Everyone would have had access to the black produced from spinifex resin, but only certain people are entitled to use the ochre from particular sites in their ceremonial art. Accusations of unauthorised access to others' ochres might have had dire consequences in the ceremonial context. This could be the cultural basis for the reluctance on the part of most desert artists to mix pigments, which makes Clifford Possum's continuous experimentation with this aspect of his art so unique.

This idea of mixing from the introduced European pigments the colours of the palette available to a Tjapaltjarri from his part of the country under the strict rules of access laid down in the Dreaming, perfectly exemplifies the combination of traditionalism and innovation which Andrew Crocker had observed in his work a decade earlier. It was not about the 'traditional palette' in the sense of an idea held by the Europeans supplying the paints (or their attempt to anticipate the market's idea) of what an 'authentic' Aboriginal colour sense is. Clifford Possum had gone well beyond the market's expectations of authenticity, returning to an acrylic simulation of the palette traditionally assigned to him under the laws of the Dreaming. From this palette, the artist also mixed new colour combinations, which in the early stages of the development of this idea, apparently echoed variations in the colour of the rocks at different sites of ceremonial performance. In those ceremonies, according to the artist, the participants also mixed, from their ochre palettes, the specific colours of that Dreaming place to apply to their bodies. Thus Clifford Possum extended the basic idea of Western Desert art of 'painting your own Dreamings' into the area of coloration, developing a colour theory which could be applied throughout the entire spectrum of contemporary Western Desert art,[24] and expounded it masterfully in his own work. The tonal consistency within and between his paintings, which had long been one of the hallmarks of his style, could thus be maintained within a project of constant change:

I gotta change'm see? Make'm nice colours. Nobody try to mob me on this, because colours – I gotta change'm. I tell'm everyone, soon as I saw my canvas, I gotta be changing colours. Not only this same one, same one – colours, I change'm all the way along. Gotta be different.

As this suggests, the focus on colour was also a response to seeing his work in reproduction, and his determination that if he must repaint his earlier works to order, he would continue pushing his art into new areas by altering the colours of the original.

Nor would this be the last word on colour from the mind that could cut through the morass of the authenticity debate to (re-)create the 'Anmatyerre'

Larumba, *c.*1992–94, synthetic polymer paint on canvas, 180.0 x 127.5 cm; Yolette Sullivan Collection

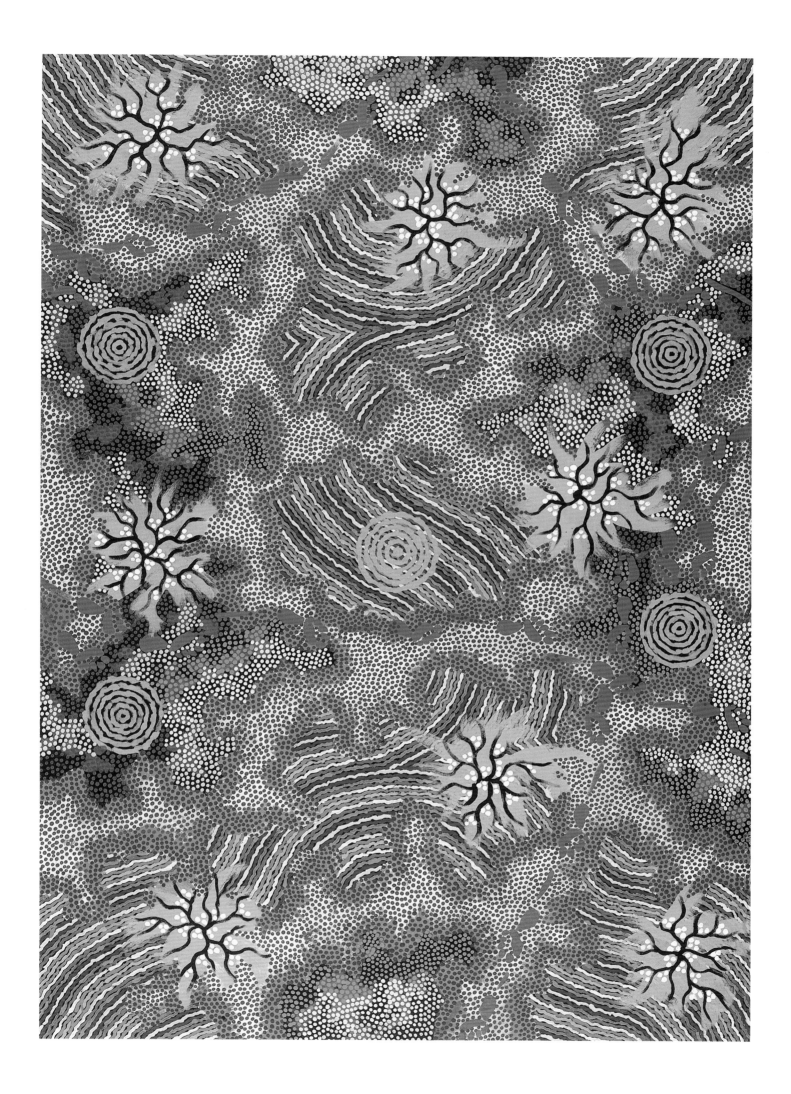

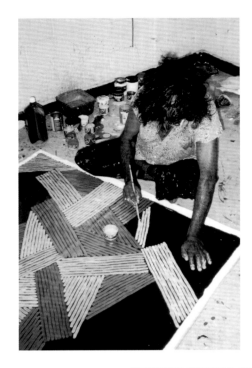

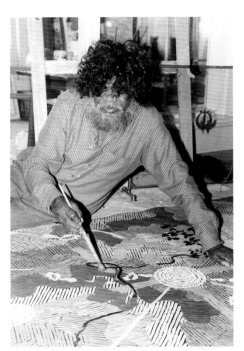

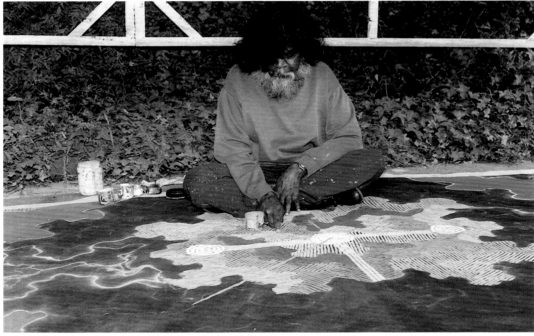

left top: Clifford Possum painting the background of one of his Love Story paintings before adding the design motifs.

right top: Clifford Possum painting *Man's Love Story (Ngarlu)*, Warrandyte, 1993. Photo: Milanka Sullivan

bottom: Clifford Possum painting *Man's Love Story*, 1993–94, (see pp. 186–87), Warrandyte. The chalk drawing is clearly visible. Photo: Frank Mosmeri

Man's Love Story (Ngarlu), 1993, synthetic polymer paint on canvas, 125.0 x 181.0 cm; F. Mosmeri and M. J. Sullivan Collection

palette. The kind of openness to ideas and experience which such creativity involves, also meant that Clifford Possum broke his own rules all the time. The 'look of blueness', which some see as a characteristic of his 1970s oeuvre,[25] is a complete wild card in this account. Colours lying quite outside the 'Anmatyerre palette' could occur at any time in the sequence of his paintings. In 1993 he embarked on a series of paintings featuring the colour orange, including a series of Possum Dreamings in which old Upambura's tracks in luminous orange meander across the swirling arabesques of the artist's distinctive linework. Using this palette he painted *Man's Love Story (Ngarlu)*, 1993 (p. 183), a resplendent and meticulously rendered version of the Ngarlu Love Story motif for his Melbourne 'kungka', Milanka Sullivan.

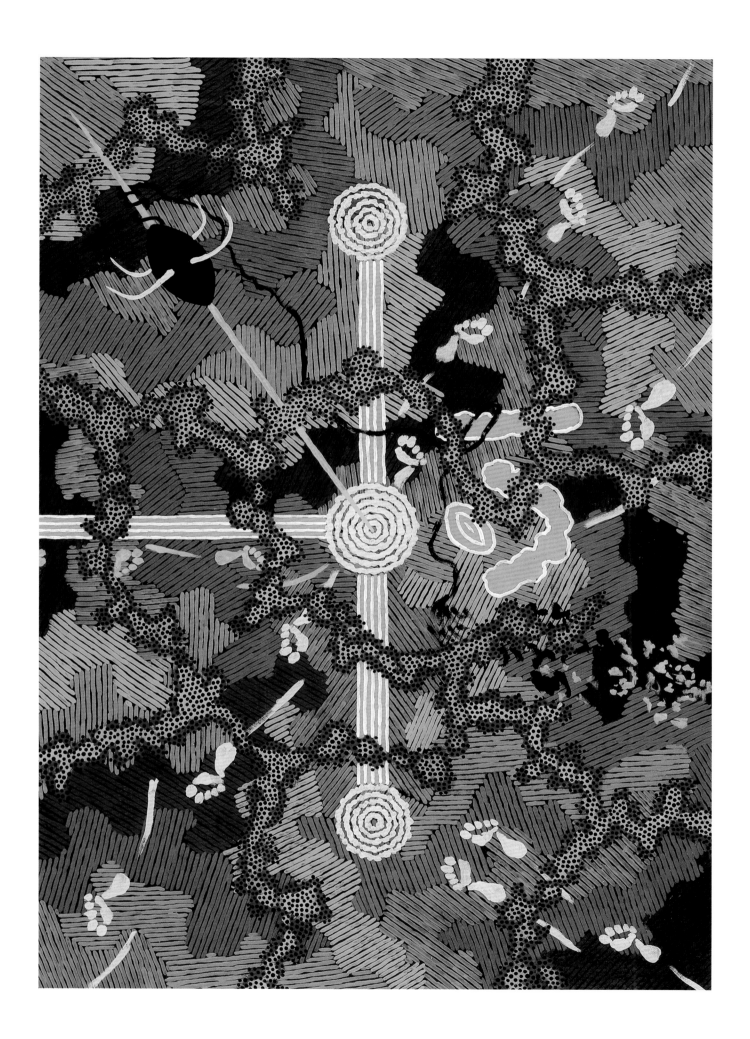

During the Warrandyte years, the artist developed a pattern of working in which he would produce minor works in a single session for day-to-day income while he laboured at a more measured pace on a large commissioned canvas. Using Alice Springs parlance, he would refer to these smaller works as 'tucker paintings', to signify that his creative energies were focused on the major works. As soon as one of these was completed and paid for, he would go to Alice Springs for a 'holiday'. After weeks or months of high living and occasional painting in the town camps he would return to Melbourne and the cycle would begin again. The very substantial payments he received for the large canvases were important to maintaining this lifestyle, but their increasingly extragavant complexity revealed also his desire to show in them what Clifford Possum was still capable of. He was well aware of the art world's fascination with the minimalist tendencies in Western Desert art exemplified by Emily Kngwarreye. In conversation during a 1992 visit he quizzed me about Kngwarreye's work: 'What story this one?', 'Where the designs?' He was genuinely perplexed by both her work and its popularity with Aboriginal art buyers. The aesthetic appeal of what contemporary art audiences call 'painterliness' was to him inexplicable: a messiness he had never allowed to enter his own work. For each painting, especially the larger ones, there was an essential final phase which he

Clifford Possum's quick sketch parodying the styles of leading Aboriginal artists Rover Thomas (top left), Emily Kngwarreye (top right) and Ronnie Tjampitjinpa (bottom left). His own style, still featuring traditional Western Desert iconography, is also illustrated. Image courtesy Adam Knight.

called 'cutting it' in which he would carefully paint out any smears or drips from the surface to 'make'm flash'.

But such meticulousness no longer added value in Aboriginal art. The painting language of Western Desert art which he had helped to invent no longer defined the fashionable 'look of Aboriginality'. Names like Emily Kngwarreye, Rover Thomas and Ronnie Tjampitjinpa were on the art world's lips, not his. Rather than changing to accommodate the tastes of the market, Clifford Possum painted his heart out in the old way on large commissions for those who did want his work. What they wanted more often than not was 'another one like that'. During the week of my 1992 visit, Clifford Possum could be found every day sitting on the floor of his Warrandyte studio with the carefully mixed colours of his Anmatyerre palette arranged neatly beside him, working on another huge version of *Warlugulong* on commission for a private buyer. Unrolled, the canvas covered the entire floor area of the space in which he worked. He showed me a battered reproduction from the back cover of a booklet put out by an Aboriginal organisation which was his point of reference. On the smooth black ground he painted in his trademark areas of textural brushwork, layering the design between them, with the whole canvas spread out before him. Except when painting the background, only the section of the painting he was actually working on was unrolled. The intricate design of the background unfurled off the roll like a fabric of lines and dots, as the artist moved systematically through the different styles of infilling, mapping out the surface as he went. I was startled with the realisation, confirmed by a question to the artist, who looked up from his work only after a long pause, that he already saw what the completed painting would look like in his mind's eye, or as he put it, 'Soon as I pick up my brushes, I got'm in my head'. What an amazing brain he must have, I exclaimed, to be able to conceive such a complex image in advance of its creation. He gently corrected me. 'Not brain, Nakamarra', he said to me, 'Not brain – heart'.

Back in Alice Springs with another pocketful of money to share with relatives and hangers-on, Clifford Possum ran into some major trouble. His celebrity status in the town afforded him no protection from its violent ways – on the contrary, it made him the target of a vicious white drunk who punched him in his good eye during a barroom brawl. The artist was flown to Adelaide for expert assessment and told he could lose the sight of this eye if they did not operate. Even if they did, there was a fifty-fifty chance the operation would not work. Deeply troubled, he returned to Warrandyte to ponder his future. It may have been then, to assist his blurred vision, or at some earlier stage, that Clifford Possum began to use chalk as a means of refining the draftsmanship of his paintings. Mosmeri recalled having suggested it when he saw the artist folding the canvases diagonally to find the exact centre and marking designs into the background with the pressure of the wrong end of his brush. Clifford Possum had used these sorts of preparatory techniques in his work to achieve symmetry and precision since at least the early 1980s. But with the introduction of chalk, the pre-painting phase became much more elaborate and extended, in a way

that distinguishes his later works from those of all other desert painters, who universally paint their designs straight on to the plain dark backgrounds.

Clifford Possum now began to draw up every element of the design first in chalk. He would rub out and correct endlessly until he achieved the exact line he was looking for, and only then pick up his brush to paint. After the painting was completed, he would meticulously remove the evidence of his preparatory work. The first time I became aware of the artist's extensive use of chalk in the drafting phase of his paintings was on another visit to Warrandyte in late 1993. On a vast canvas, unrolled across the living room floor, was an extraordinarily detailed and beautiful chalk drawing. At its centre, occupying the same space in the composition as the rocky outcrop with its Nangala sentinels on *Yuutjutiyungu*, was an enlarged version of the Love Story motif. But apart from that, and the whole drawing's echoes of the structure of the 'diamond of the

Man's Love Story, 1993–94, synthetic polymer paint on canvas, 184.0 x 457.0 cm; Collection of Jim and Elaine Mead

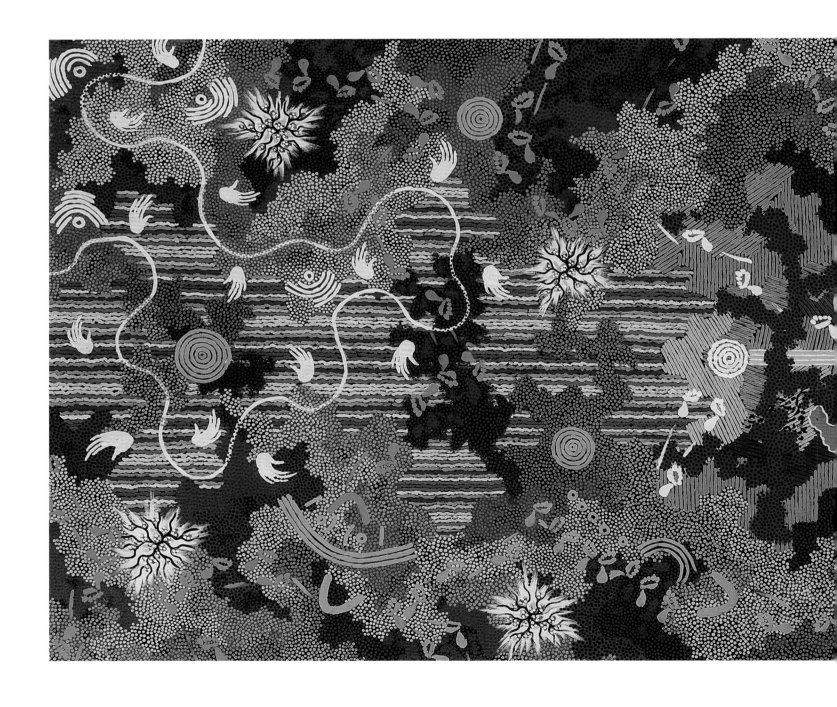

movement', this was not recognisably a redrafting of a previous work. It might be his last painting, I was informed, if the surgery he was facing on his eye did not succeed, and it would be something quite out of the ordinary.

As with the prototypical *Man's Love Story*, 1973, the purchaser of this painting gave a rather different account of how *Man's Love Story*, 1993–94 (below) – this was the canvas I had seen at the chalk drawing stage – came to be painted. Mrs Elaine Mead met Clifford Possum in Melbourne through a display of emu egg painting at Williamstown Town Hall at which he was present. Carving was their point of connection. Elaine offered the artist a basket of ostrich eggs from her son's ostrich farm for him to carve. Subsequently Clifford Possum came to tea at Jim and Elaine Mead's. During the conversation, Elaine remembers asking the artist for a small Love Story painting for their forty-fifth wedding anniversary. At the end of the visit, she presented him with a fine

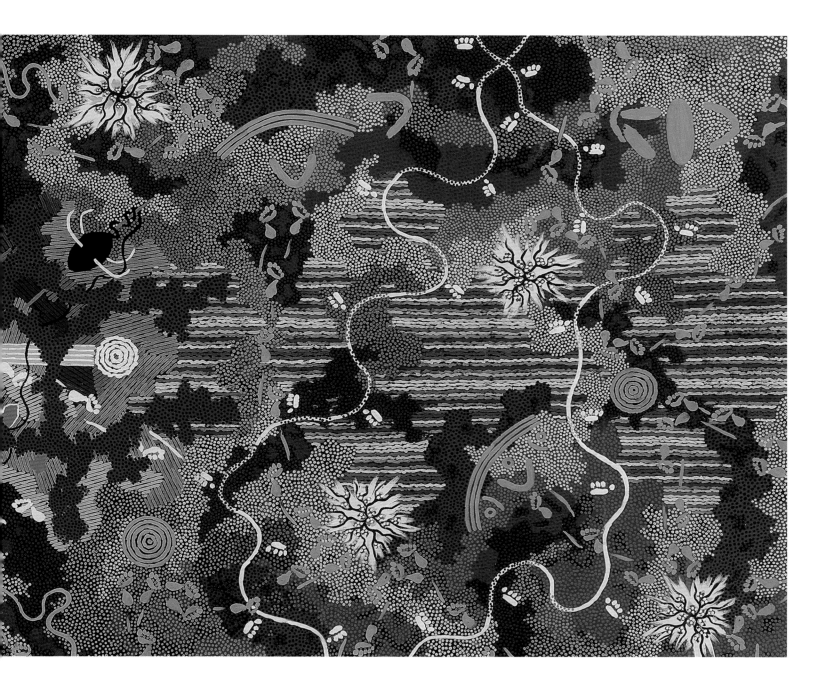

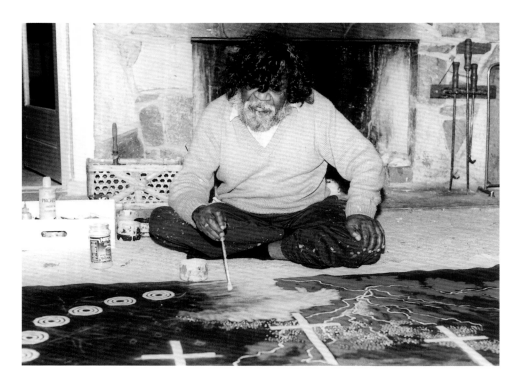

Clifford Possum painting *Good Friday*, Warrandyte, 1994. Photo: Milanka Sullivan

Good Friday, 1994, synthetic polymer paint on linen, 116.0 x 154.0 cm; Collection of Jim and Elaine Mead

leather stockwhip from her personal collection in memory of his days as a stockman. He was delighted with the gift and said to her as he was leaving, 'I like you. I paint you something really special'. Months later, he returned with the large *Man's Love Story*, 1993–94 and the Mead collection of Clifford Possum paintings acquired its centrepiece.

The notes which Milanka Sullivan was commissioned by the purchaser to write about the painting enable the two halves of this story to be pieced together. Of the period 1993–94 when *Man's Love Story* was created, she wrote:

> The artist was preparing himself for a necessary eye operation, which had the potential of leaving Clifford Possum permanently blind. Rather than complete this major work before placing himself in the hands of his surgeon, the artist left this painting unfinished. The idea of completing what might be his last work left the artist feeling jinxed. So Clifford Possum Tjapaltjarri challenged 'fate' by leaving his masterwork waiting for his full recovery – which came to be in 1994.[26]

At the end of my 1993 visit, Clifford Possum, still in dread of his eye surgery, had told me that he would be 'in God's hands' on the operating table. When the operation was successful, he must have felt blessed, and wanted only a suitable buyer on whom to bestow the work before embarking on the massive labour of completing the canvas he had already drawn up. The Meads offered, and one of the most exceptional paintings of his later years was the result.

Within a year, every available wall space in the Mead home was hung with Clifford Possum paintings, plus several by his daughters, and a large collaborative work by all three. To walk in the Mead's front door was like entering a Clifford Possum Museum, whose caretakers are getting on with the rest of their lives surrounded by its treasures. One painting particularly attracted my attention, because it was unlike any other Clifford Possum I had seen. It was called *Good Friday* (p. 189). Three crosses like a crucifixion scene stood out in the

composition, with a set of Clifford Possum's realistic human footprints leading up to them. A fiery bolt of lightning was set into a cosmic background which included seven circles representing the Seven Sisters constellation, which the artist's daughter Gabriella Possum subsequently made into one of *her* signature motifs. Milanka Sullivan, who initially saw herself as Clifford Possum's collaborator in the work, acknowledged in the notes she had prepared for the buyer, that the painting 'ended up being chiefly conceived and painted by Clifford Possum Tjapaltjarri'. She was responsible for the crown of thorns, the nails, and 'the orange dotted version of the Milky Way'. The lightning, Sullivan wrote, 'shows "God's" anger' at the death of His Son. It was 'inspired by Easter'. The artist evidently subscribed to the hellfire-and-brimstone version of Christianity in which the Hermannsburg missionaries had originally instructed him. The painting stands alone in the artist's work, not only as a statement of what Sullivan termed 'a unique expression of the artist's Christian ideology', but also of his unexplored potential in the 'landscape' genre he had long ago forsworn. [27]

'A jewel in the crown'

In the publicity build-up that preceded Sotheby's first *Contemporary and Aboriginal Art* sale at their Melbourne headquarters in June 1995, the company's representative was featured holding up a painting which he proclaimed a 'jewel in the crown' of Aboriginal art. It was Clifford Possum Tjapaltjarri's first version of the Ngarlu motif, *Love Story,* 1972, one of his earliest paintings. For six years, it had been hanging in the Art Gallery of Western Australia on indefinite loan, before its 1994 publication in *The Art of Clifford Possum Tjapaltjarri* revealed to a wider public its existence and significance in the artist's oeuvre. Until the mid-1990s, the secondary market in Aboriginal art was practically non-existent. However, it was only a matter of time before someone in the art auction business recognised what the commercial gallery dealers had known for years: that Aboriginal art's status as contemporary art in Australia presented a unique marketing opportunity. It was Sotheby's Australia who seized the moment. Abandoning the North American and European model of auctioning 'tribal art' and 'contemporary fine art' separately, they combined them in the one auction. *Love Story,* 1972 was an appropriate choice to spearhead this new sales initiative. Clifford Possum's *Man's Love Story,* 1978 had been the first work by a Western Desert artist to be given a place within contemporary Australian art. [28] The auction house confidently predicted *Love Story,* 1972 would break the record of $22,000 (set in 1989 by another Clifford Possum work) when it was auctioned off on 30 June 1995, along with some 400 items of 'the nation's most important Aboriginal art'. The outcome far exceeded these expectations. On auction night, *Love Story,* 1972 went under the hammer at $57,500, prompting the first in a string of exultant 'world auction record for Aboriginal art' announcements by Sotheby's.

The news quickly reached Alice Springs and Clifford Possum himself. Recalling that he had originally sold *Love Story* [29] to a 'sheep farmer' for $60,

Clifford Possum told a reporter from the *Sunday Territorian*:

> They should give me the painting back or pay me half. They should have told me they were selling it. I'm still working now and sometimes I can get $1,000, sometimes $2,000, for a painting. It is my work and they should pay me properly.[30]

The 'leveller' principle that everyone should share equally in such good fortune is little understood outside Aboriginal culture. Clifford Possum's ideas on *droit de suite* were dismissed as 'ridiculous' with the comment that 'the estate of van Gogh would receive $25 million every time one of his paintings was sold'.[31] But Clifford Possum was still alive when his painting was auctioned off for nine hundred and fifty times what he had been paid for it – and thirty times what his current work was fetching on the markets to which he had access.

Opponents of re-sale royalties would argue that these record-breaking transactions indirectly benefit the artists' primary markets. This was doubtful in Clifford Possum's case. Within a week the *Alice Springs News* had run a feature article headlined 'Possum art: Sotherby's [*sic*] to bottle shop', whose portrayal of the artist working in a camp full of drunks can hardly have improved his sales prospects.[32] The rest of the article focused on the large sums which an Alice Springs art dealer claimed to be paying Clifford Possum for his work. The dealer in question offered illustrations of the artist's indifference to material possessions which would have ended most readers' sympathy for his plight,[33] concluding with the reassuring notion that:

> Money to them really doesn't mean anything. It's survival from morning to evening. The next day they start again.[34]

That struggle for the cash sufficient to each passing day is precisely what places Aboriginal artists like Clifford Possum at the mercy of the business end of town.

Proper really man and painter

The final chapter of my 1994 book about the artist began with the prophetic words: 'If there were such a thing as a "typical" Clifford Possum, it would probably be a forgery'.[1] In retrospect, the naivete of this comment is almost embarrassing. I recognised then that its 'distinctiveness is what makes Clifford Possum's style so attractive to plagiarists', but argued that 'such appropriations are usually piecemeal and could not withstand closer scrutiny over a range of aspects'. Maybe so, but who was really looking in 1992? It still goes without saying that 'the painterly inventiveness of Clifford Possum's art is not reducible to some repertoire of pictorial means'. In his hands, every stage of the simple three-part process of ground, designwork, and background infilling, which generates the 'typical' Western Desert painting, had received new twists, creating tantalising riddles for both the eye and the brain. However, towards the end of his life, Clifford Possum was no longer concerned with keeping one step ahead of his imitators through the continual addition of new stylistic elements into his paintings. One of the characteristics that distinguishes the majority of Clifford Possum's own work of this period from his imitators' is precisely the forgers' less-than-successful attempts to mimic his inventiveness — at a time when the artist himself was engaged in a resolute reduction of his style to the point where finally only the 'hand of the master' would identify the painting as his. How ironic that, a decade after this statement was made, it seems almost more apposite to comment on the features of a typical Clifford Possum forgery than to offer a summary of the artist's own style. In this book rather than making it easy for potential copyists by offering them a checklist of distinctive features of Clifford Possum's work, I have made it more difficult, by embedding this kind of stylistic analysis at appropriate points throughout the text.

At the beginning of this account of the life and work of Clifford Possum Tjapaltjarri, I commented that the entire history of Aboriginal art-making in Central Australia would seem to be reflected in the events of Clifford Possum's life. This next episode is more like history repeating itself, so eerily similar is the Clifford Possum forgeries affair to a 'scandal' in the affairs of Albert Namatjira in the early 1950s. The headlines called it 'THE CASE OF THE FORGED PAINTINGS'. Namatjira was the unhappy subject of nationwide publicity after dissociating himself from both paintings and signatures falsely attributed to him in the booming market for his works. At first Namatjira had dismissed the faked

Untitled (Lungkata's Two Sons), (detail), 1986, synthetic polymer paint on canvas, 174.4 x 243.0 cm; Courtesy Gabrielle Pizzi Collection, Melbourne

paintings scandal with the observation that 'I can paint plenty more pictures'.[2]
Clifford Possum had been similarly philosophical when I first raised with him
in 1992, the increased scope for copying his work which a book of his best
paintings would provide for plagiarists. They are doing it already, he had said. At
least people will now know the source of their ideas. Clifford Possum could not
read, but he understood the promotional function of art books, and enough of
their art-historical purpose to stipulate that the paintings it reproduced should
be 'all my work'.[3] What neither of us realised at the time was that the book
could also be a primer for forgers.

How was this possible? The federally funded network of art centres and art
advisors established on remote communities across the Centre during the 1970s
and 1980s was designed to prevent the sort of rampant commercial exploitation
to which Namatjira and his generation of successful Aboriginal artists had been
exposed. The art centres' role was to maintain quality at the production end and
maximise returns to the artists and their communities from the proceeds of their
art-making. The system had been working well in the late 1980s when the
Review of the Aboriginal Arts and Crafts Industry conducted its inquiry. But in
the early 1990s the market for Western Desert art exploded. The architects of
this infrastructure had not anticipated such a sudden and massive demand for
'dot style' paintings, which far outstripped the capacity of the community art
centres to supply it. Outside interests had been able to establish a foothold in
Central Australia, just as they had in Namatjira's day, by picking up the slack of
overproduction by name artists oblivious to the damage that could be done by
flooding the market with inferior examples of their work. Artists like Clifford
Possum, with no art centre in the background to keep a watching brief over
their careers and pricing structure, were especially vulnerable to these pressures.

Just as Namatjira and his followers had walked the streets with their
paintings, selling them to passers-by for a fraction of their real worth, so Clifford
Possum was rarely seen after the mid-1990s without a rolled-up painting under
his arm, ready to unroll it for anyone who might ask him and do a deal on the
spot. However, it must be acknowledged that his sales technique, drawing on his
remarkable personal magnetism, was almost irresistible and that, true to One
Pound Jim's memory, he drove a much harder bargain than his predecessors.
One night in 1996 I had the privilege of watching him in action in my living
room. He had been staying with his younger daughter Michelle and her family
on the New South Wales North Coast. He rang to say that he was in Sydney
overnight and had a painting for a friend who had previously acquired one of
his works. Although it was late, I dutifully contacted the friend, who came
straight over at the prospect of meeting the artist himself. Half an hour later
Clifford Possum came down the hallway with the canvas under his arm, and at
our invitation *Two Tjangalas,* 1996 (p.195) was unfurled. The hair rose on the
back of my neck: it was the first time I had seen one of the large skeleton
paintings which he would go on to paint so many times more.

The skeletons was the only one of the 'set pieces' in Clifford Possum's 1990s
repertoire for which he never used chalk. He had memorised the structure of

Two Tjangalas, 1996, synthetic polymer
paint on canvas, 171.0 x 121.0 cm;
GRANTPIRRIE Collection

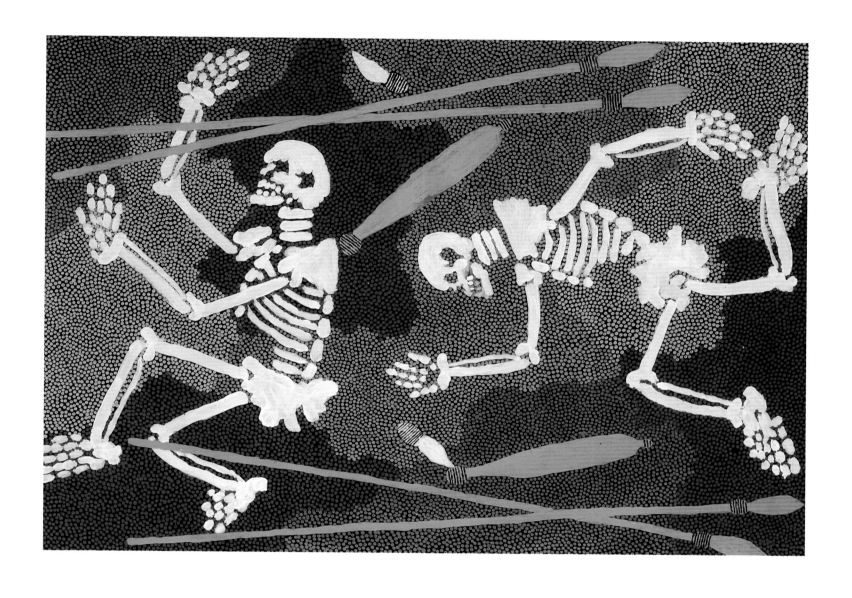

the human skeleton and would paint it out bone by bone to this formula. As time went on, the large skeletal figures became more and more stylised, but in this *Two Tjangalas* the figures were startling in their realism. They were the two brothers who had perished in the Warlugulong fire. They had already appeared in this form in several earlier paintings by the artist, but never so starkly. In *Lungkata's Two Sons at Warlugulong*, 1976 (p. 87), they stride across the fire-ravaged country like figures in a European landscape. In *Warlugulong*, 1977 (pp. 94–95) they lay like piles of bones delicately arranged at the edge of the painting where the brothers met their death. In *Bushfire Dreaming*, 1982 (p. 139) and its re-painting for the Alice Springs airport, they are submerged in the background dotting. Even in the 1986 prototype for the skeletons series, *Untitled (Lungkata's Two Sons)* (p. 197), the white figures are suspended over a complex background representing the passage of the fire. But in *Two Tjangalas* (p. 195) the background has faded into insignificance, leaving the powerful image of the skeletons – not dancing, but running.

Why skeletons? Not for the market, since even his most faithful buyers were somewhat reluctant to take them home, and no public collection, apart from the unconventional Queensland Art Gallery, saw fit to add one to its collection. A partial explanation may again be lie in the availability of the prototype in reproduction. The front cover of the catalogue of the 1988 Institute of Contemporary Art retrospective had featured an image of *Untitled (Lungkata's Two Sons)*. Did this image carry some special significance for the artist as a reminder of one of the high points in his career? A more profound explanation for the use of this image can be found by reflecting on Jack Cooke's comment all those years ago in Papunya on Clifford Possum's elaborate wood carvings of snakes draped around the branches of trees. Cooke applied the word 'gruesome' to describe the products of Clifford Possum's imagination. This is a predictable response, given western culture's dominant view of snakes as dangerous and frightening creatures, bolstered by the Christian view of the serpent as the root of all evil. To the artist however, snakes could be dangerous but they were not objects of fear or loathing. Snakes could make a tasty meal and also, importantly, they were the descendants and incarnations of ancestral beings, bound just as he was, by the Laws of the Dreaming. He did not set out to alarm or disgust the viewer by his lifelike representations of them. Similarly, although death may be considered a macabre subject by western audiences, for a man of Clifford Possum's cultural background, it was simply a fact of life: 'We cry and then we go'. There is also an undeniable beauty in these skeletal symbols of human mortality which are animated by the skill and fluidity of the painter's technique.

The prospective buyer was still hestitating. The artist then drew his attention to a smaller canvas previously rolled up inside the larger work. It was an equally graphic depiction of the charred body of the sacred kangaroo which the two brothers had killed and eaten, framed by their crossed spears. The buyer was clearly not tempted by this piece, but the pressure was on for him to buy something, and the skeletons were at least spine-chilling. So he back-tracked, indicating his preparedness to negotiate a price for the skeletons. Clifford

Untitled (Lungkata's Two Sons), 1986, synthetic polymer paint on canvas, 174.4 x 243.0 cm; Courtesy Gabrielle Pizzi Collection, Melbourne

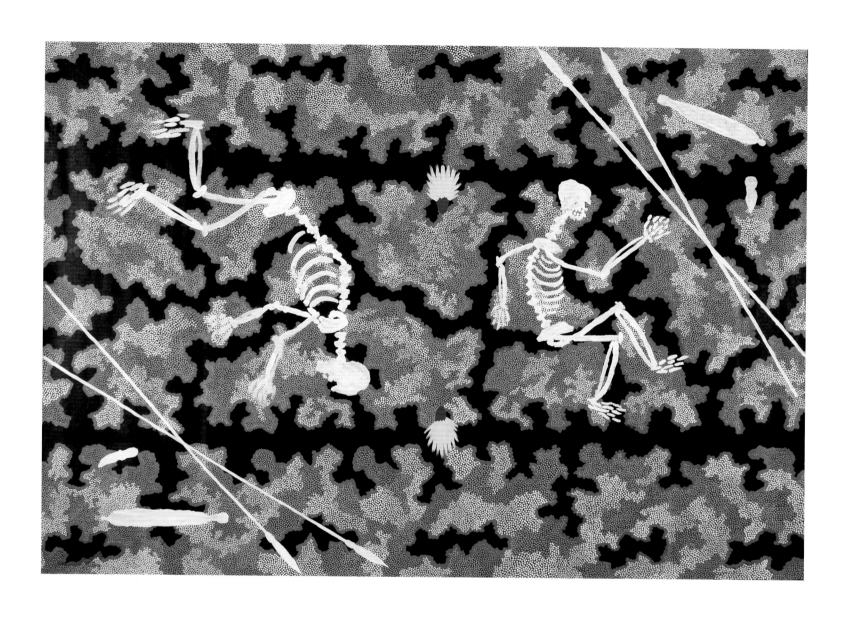

Possum then insisted that the two paintings were a pair – which in terms of their Dreaming subjects, they obviously were – and must be sold together. He named his asking price for both, which was no trifling sum, and would not be persuaded from it or the package deal. While the buyer considered his position, Clifford Possum took a tobacco tin from his shirt pocket and made himself a wad from the contents. After chewing it for a moment, he began to 'sing' the paintings, explaining as he did so that this meant they were now 'alive'. This was not mere show: it was important to him that every element of his paintings was an integral part of the story, depicting not only the physical terrain on which the Dreaming events took place, but also the types of edible plants, insects, birds, reptiles and animals to be found there and their interdependence with one another and with the Dreaming protagonists. It made him angry when he saw paintings by others which omitted the food supplies of the ancestral beings they depicted. 'Where food for this one?' he would ask. 'Dead ones', he called these paintings. As he painted he habitually sang the songs of the Dreamings he was depicting to ensure that his paintings were 'alive'. The buyer was captivated by his performance and soon parted with the cash he had withdrawn from an ATM on his way over as a down payment. The deal was completed the next morning in time for Clifford Possum to make his flight to the next stopover on his neverending journey.

That same year, Clifford Possum's painting *Yuelamu (Honey Ant Dreaming)* 1980 was included in *Rings: Five Passions in World Art*, the cultural centrepiece of the Atlanta Olympics. The exhibition comprised 125 paintings, sculptures and ceramics drawn from every major world culture from ancient Egypt onwards, and was based around the 'interconnecting human emotions' of Love, Anguish, Awe, Triumph and Joy. *Yuelamu* was placed by the exhibition organisers in the category of Awe, a response which its creator might have experienced himself at being placed in such company. However, he was probably unaware of the accolade his painting had received. 'CV' was not a word in Clifford Possum's vocabulary. No records were kept of the many journeys he made to North America and Europe in the mid to late 1990s, always with one of his dealers in attendance and the ubiquitous roll of canvases under his arm.

Clifford Possum embraced wholeheartedly the role of a roving national and international ambassador for Central Australian Aboriginal art which fate had assigned him. In his travelling years, Clifford Possum met so many people and taught them, through personal contact as well as through his paintings, more about the culture in which he had been raised and the values by which he lived his entire life, than any book or exhibition could ever hope to. But the journeys that meant most to Clifford Possum were those he made back to his Anmatyerre homelands, to visit the sites he had been celebrating in his paintings for a quarter of a century. There were several joyous trips in the early and late 1990s to his key sites in the Mount Allan/Napperby area.[4] He also went back to the Mount Allan community which had been established on part of his ancestral lands, where his older brother Immanuel had lived for many years, and his brother, Cassidy Tjapaltjarri, now resided, having moved across from Napperby. On these

occasions, Clifford Possum reportedly came away 'happy' from his private meetings with the local lawmen and returned invigorated to Alice Springs.

In June 1997, the world record price for Clifford Possum's *Love Story, 1972* was totally eclipsed by Johnny Warangkula's *Water Dreaming at Kalipinypa, 1972,* which sold for an unheard of $206,000 at Sotheby's first 'Important Aboriginal Art' auction. It was Clifford Possum who gently explained to the excited old man that, in the white man's world, he was entitled to none of this money. The *droite de suite* issue which Clifford Possum had attempted to raise in 1995, did get a brief run this time, mainly because Johnny Warangkula was the perfect media image of the starving artist, who had sold his masterpiece for a pittance and now stood to gain nothing from the fabulous sums by which it was enriching others. After years of being considered by most people around Alice Springs too old and blind to paint any more, Johnny Warangkula found that he too could earn $1,000 a painting from the opportunistic private dealers who soon beat a path to his door.

For Clifford Possum, the Sotheby's effect had been less tangible. The publicity surrounding the sale of *Love Story, 1972* had produced a run of requests for Love Story paintings, but this was already one of his set pieces. To streamline production, he applied the principle of overpainting to the symbols of Liltipilinti's love magic, placing them on top of backgrounds derived from the complicated cross-hatched patchwork of his 1973 depiction of the Ngarlu story, with which he had been experimenting since the early 1990s (see p. 182). Legend has it that the purchaser of *Love Story, 1972* from the 1995 auction was also the first to request of Clifford Possum that he paint another one like his 1986 *Narripi Worm Dreaming* (p. 161).[5] This became the favourite set piece in the artist's mid-to-late 1990s repertoire – except when the skeletons mood came upon him. The 1986 prototype had been widely circulated in reproduction, and a detail of the painting had figured on the front of the catalogue of a travelling exhibition of the Holmes á Court Collection. At the time it was painted, *Narripi Worm Dreaming, 1986* had been one of the first works by the Papunya Tula artists to dispense with the traditional iconography and simply show the marks of ancestral passage in the landscape. By the late 1990s, the 'striped style' so dominant in the work of leading Papunya Tula artists like Mick Namarari Tjapaltjarri, Turkey Tolson Tjupurrula and Ronnie Tjampitjinpa was becoming what the language of dot and circle had once been: the lingua franca of Western Desert painting. The linked dotting linework of Clifford Possum's Narripi Worm Dreamings became a point of connection for the artist to the style of the moment.

The artist's fortunes took a positive turn in 1997 with an invitation from the Rebecca Hossack Gallery to return to London for a second solo exhibition. Another house in Alice Springs was rented for Clifford Possum's use and the artist was absent for many weeks from his usual haunts while he concentrated on producing enough paintings to take to England for the exhibition. British Airways had approached Hossack about using one of Clifford Possum's designs on the tailpieces of their aircraft. Hossack, who was less taken with the aesthetics

Clifford Possum Tjapaltjarri and his son Lionel Possum Tjungurrayi with one of the artist's 1990s series of Worm Dreamings, Alice Springs, 1996. Photo: Adam Knight

of the artist's more recent work, had selected for this purpose the one work remaining from his previous exhibition in 1990, and a lucrative bargain was sealed between artist and airline.

The British Airways deal was the highlight of the trip. The critics who had been so excited by his work a decade before, were apparently unmoved by his latest direction. There was no royal garden party, although Germaine Greer had opened the exhibition. Her ill-judged comments on the evils of Aboriginal art, soon to be published in a syndicated article entitled 'Selling Off the Dreaming',[6] would hardly have helped his sales, although she may not have expressed such views in his hearing. Rumours were subsequently circulated by the British tabloids that Greer had received a proposal of marriage from the artist. If all the liaisons attributed to Clifford Possum over the years had actually occurred, then he certainly lived up to the reputation of his amorous ancestral namesake old 'lover boy', Upambura. But there is unlikely to have been much truth in this rumour, because Clifford Possum already had a wife waiting for him back in Alice Springs. In about 1994, towards the end of his relationship with Milanka Sullivan, Clifford Possum had painted a strange series of realistic torsos of women, and sometimes men too, in ceremonial body paint, intimating perhaps, that next time he would find himself a 'kungka' from his own culture. By 1997 he was happily married to Nora Nakamarra, a strong and loving woman who became his constant companion in Alice Springs. There were other 'girlfriends' of whom he was fond, but Nora's death a few years later was a profound loss to the artist.

Clifford Possum was not only the most widely travelled Aboriginal artist of his generation, he was also the most self-reliant. Always self-funded, he moved freely between the various private dealers to whom he sold his work, answerable only to himself. The status of 'money man' which he had acquired due to his generosity within his own circle was not desired for its own sake. He took pride in his ability to deliver the financial rewards of this lifestyle to his family and others to whom he had obligations. He was also proud of his ability to survive in the white man's world on his terms. He appeared to be in such determined control of his own destiny, that at times he seemed in more danger of becoming a player in the art dealers' games than their helpless victim. The reality was however, that he and his fellow artists were facing ever more sinister forms of victimisation. An unintended effect of the six-figure sums being realised for the early works of the 'old masters' of desert painting at auction was the arrival in Central Australia of a new wave of art profiteers, more ruthless in their methods than their predecessors, and with the surviving founders of Papunya Tula Artists firmly in their sights. The modus operandi of the original 'carpetbaggers' was to fly or drive into Alice Springs with plenty of cash, buy all the available paintings as cheaply as they could from the Aboriginal camps and on the streets, then head out of town with a big roll of canvases to re-sell at a profit in the cities. But this new breed of 'backyarders' operated on a completely different scale. Behind high fences on the outskirts of town they set up their own painting workshops and 'picked up' the artists they wanted to come and work for them exclusively.

Man's Love Story, 1997, synthetic polymer paint on canvas, 120.0 x 89. 0 cm; Santos Fund for Aboriginal Art 1997. Art Gallery of South Australia, Adelaide

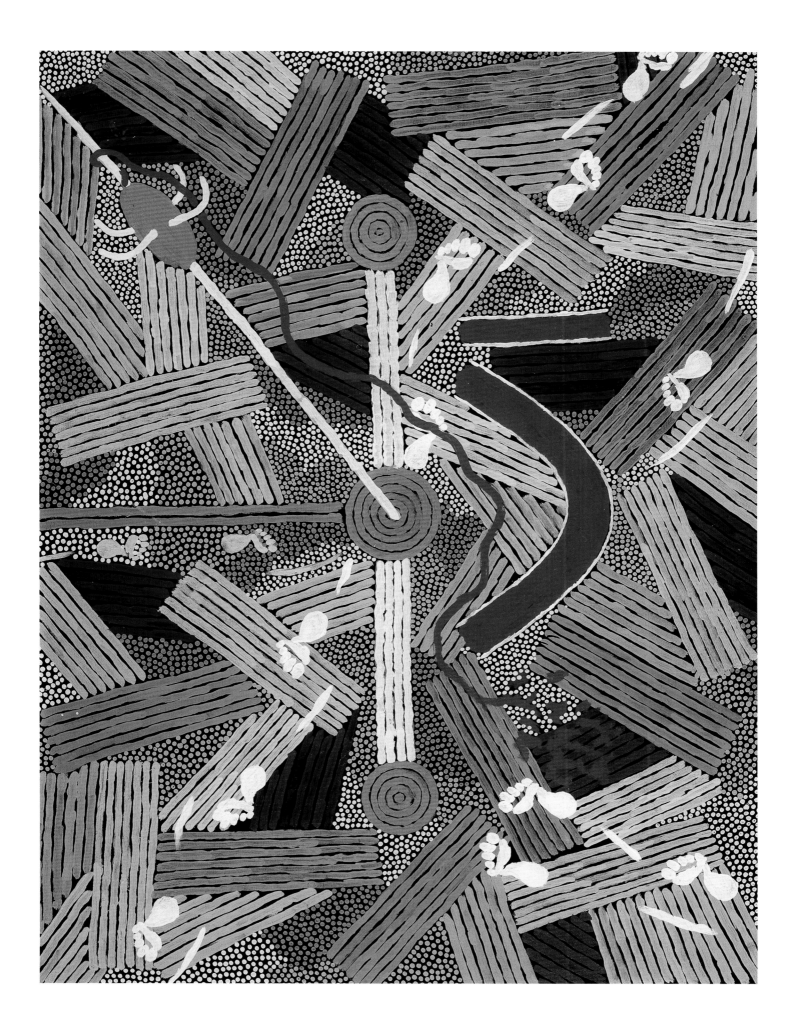

Johnny Warangkula immediately became the target of their attentions. Clifford Possum also found it convenient to paint for them off and on when he was in Alice Springs. It saved him the trouble of finding buyers for his work, although he was far too much his own man to be indentured by the lure of unlimited 'tucker money' which the situation offered.[7]

As well as securing exclusive control of an artist's output, the new backyard workshops offered a further advantage to the dealers. They could keep the progress of individual paintings under constant surveillance, and thus be certain that they were all the artist's own work. As demonstrated by Clifford Possum's *Honey Ant Story,* 1972, where a red washover transformed a Clifford Possum into a Tim Leura, authorship had been a fluid concept in Western Desert art since its inception. The collaborative painting practices exemplified in *Warlugulong,* 1976, where several painters worked together on the same painting, were sanctioned and even encouraged by Papunya Tula's art advisors. They were less enthusiastic about older artists enlisting their wives and other female relatives to help with the painting labour of background dotting, a practice which began with Kaapa Tjampitjinpa in the early 1980s. However, it was also clearly within the painters' rights under their own laws to engage such ritually appropriate assistance. These practices also served as an important training ground for new painters. As Andrew Crocker was wont to remark, Michelangelo had not painted the Sistine Chapel unaided, so why should the Papunya painters not engage assistants?

However, as the secondary market in desert paintings expanded, catering to the obsession of western art collector–investors for works by the 'hand of the master', collaboration began to emerge as a controversial issue in Aboriginal art. In the closing months of 1997, *The Australian* newspaper ran the first of its 'Black Art Scandals' series. Under a page one banner headline, it reported the claims of a Welsh immigrant named Ray Beamish to primary authorship of certain works by well-known Utopia artist Kathleen Petyarre, including the work which had won her the 1996 Telstra 13th National Aboriginal & Torres Strait Islander Art Award. The art world sprang to Petyarre's defense, claiming that any knowledgeable person would be aware that such collaborative practices as Beamish alleged were in any case an intrinsic part of art-making in the ceremonial context and should in no way impugn the legitimacy of the ritually senior artist's claims to authorship of her work. The Museum and Art Gallery of the Northern Territory, which sponsored the art award, agreed after a lengthy inquiry into the affair. Their report concluded that authorship of collaborative works could legitimately be assigned to the senior artist or Dreaming custodian, irrespective of whose hand had held the brush. But for the collectors, this was still the burning question.

Clifford Possum, who still loved to paint 'more better than everything', rarely engaged assistants on his works. Sometimes members of his immediate family, whom he had trained to dot in a style intentionally indistinguishable from his own, would work alongside him on larger canvases. But what could he do if others to whom he had social and cultural obligations painted their shared Dreamings in a style that the uneducated eye might mistake for an 'Alice

Springs' Clifford Possum? Criticise his own countrymen for flouting the conventions of the 'whitefella' trade in his work, which his Sotheby's experience had taught him gave nothing back to the artist? If he allowed others to write his name, or even if he wrote it himself, on paintings largely or even wholly executed by other members of his Alice Springs entourage, it was because the dealers would pay so much more for them if he did. In earlier times Clifford Possum's paintings were never signed.[8] Signatures (always on the back of the canvases) began to appear in Western Desert art around the same time as the private dealers, who found them an effective marketing tool with buyers whose expectations of art had been formed in the individualistic world of contemporary fine art. In the 'tribal art' market, a signature would have been an impediment to the anonymity and timelessness required for ethnographic authenticity. But in the new market for desert paintings, signatures were becoming almost obligatory – so Clifford Possum obliged. Signing his name on what were termed in the trade 'family paintings' was a logical extension of his rights and obligations within his own culture: 'My Dreaming. My painting'.

After the Petyarre–Beamish controversy, no one on the other side of the cultural frontier was prepared to condemn such 'collaborative practices'. The situation was ripe for exploitation by unscrupulous individuals outside the circle of Clifford Possum's family and kin whose business contacts with the artist at his camp made them aware of these practices. Precisely when the 'school of Clifford Possum' began to develop into something quite outside the artist's culture and knowledge may never be fully discovered. Clifford Possum may have suspected for some time that paintings were being marketed which bore his name and to which he had no connection. Out of a sense of obligation to the relatives and kin whom he believed were responsible for them, he may have adopted a *laissez-faire* approach. However, when the exact nature of the problem became apparent, he initiated a police investigation in a determined effort to 'clear my name', and like Namatjira before him, reaped the bitter fruits of his honesty in collateral damage to his primary sales.

In late February 1999 Clifford Possum stepped bravely into the media spotlight and declared to the New South Wales commercial crime squad, that over twenty paintings in an exhibition purporting to be a 'retrospective' of his work were, in his own words, 'Not mine'. In his written statement to the police he explained:

> I am a custodian for the Anmatyerre people of the Dreamings that I paint. These stories have been given to me by my daddies and my granddaddies to be passed on to the next custodians: Tjungurrayis, my sons.
>
> When somebody says these paintings have been painted by me it brings me shame, that I am not the custodian of the Dreamings that they paint, and the paintings are not the Dreamings of my people.
>
> I want these people who say these paintings were made by me to stop. Let them paint their own Dreamings.[9]

Involving the police in his affairs was an act of unusual courage from a man whose family members had been murdered or narrowly escaped slaughter by a

police posse in the 1928 Coniston Massacre.[10] The landmark legal victories which Aboriginal artists had won in the earlier part of the decade against copyright infringers[11] may have influenced the artist's faith in the legal system to deliver justice to Aboriginal artists in the face of unscrupulous business interests. Perhaps he was simply a pawn in the games of the private dealers, whose internecine rivalry had become intense with the inroads Sotheby's and the other auction houses were making into the Aboriginal art market. Ironically, the main beneficiaries of the authenticity scandals that rocked Western Desert art in the late 1990s were the auction houses, with their secure provenances and money-back guarantees for fakes. Buyers also turned to the art centres in their search for credibility.

In late November 1999, after nine months of dogged investigation behind the scenes, the detectives assigned to the Clifford Possum case charged John O'Loughlin, the Adelaide art dealer who had been the principal supplier of the fakes identified by the artist, with numerous fraud offences involving paintings knowingly misattributed to Clifford Possum Tjapaltjarri.[12] Clifford Possum admitted to the police that he had signed one or two of the works from whose authorship he now so firmly disassociated himself. He said he had been drunk and frightened of the men who asked him to do this. More far-reaching in their implications were the artist's claims that not only the paintings, but also many of the signatures were 'Not mine'.[13] After a lengthy committal hearing,[14] O'Loughlin entered a guilty plea,[15] becoming the first person ever to be convicted of a criminal offence involving art fraud in Australian legal history. Clifford Possum had been vindicated, and some twenty of the unknown number of paintings falsely attributed to him over the years by O'Loughlin and others were removed from circulation. O'Loughlin's penalty was a three year good behaviour bond.

Coming on top of Nora Nakamarra's death, the court proceedings took a heavy toll on the artist's once robust health. At one point in O'Loughlin's week long committal hearing, Clifford Possum jabbed his finger at his cross-examiner and shouted across the startled courtroom, 'You calling me liar? I don't tell lies. *You* are the liar!' Then came the media reports, with headlines like 'BLACK ART SIGNATURES NOT RIGHT'.[16] Clifford Possum's response to what he experienced as public 'shaming' was, like Namatjira before him, to retreat from the world which had, for the best part of the past decade, been his stage. He rarely travelled outside Alice Springs and seemed to have turned his back on the white art world. He made a brief appearance at the Art Gallery of New South Wales on the day before the grand opening of *The Papunya Tula: Genesis and Genius* retrospective which the gallery staged for the 2000 Sydney Olympics. He was shown over the exhibition, which contained five of his paintings, and shared a cup of coffee with the three Pintupi artists whom Papunya Tula had flown down from Alice Springs for the occasion. The timing of his visit, intentionally or not, was a statement about his connection to the company, which had been an important part of Papunya Tula's history and his own. Little remained of the role which he and other members of the school of Kaapa had played in the first

two decades. He was the outsider, turning up unannounced with the inevitable roll of canvas under his arm, his marginality to the worlds in which Papunya Tula was now moving all too plain.

A young French art dealer by the name of Arnaud Serval saw an opportunity presented by the artist's declining sales to establish the kind of business partnership with Clifford Possum which so many before him had dreamed of. Like other enthusiastic young men who had come into his life since his older son's death, Serval became a kind of surrogate son to the artist. Serval raised his hopes of renewed sales opportunities from their more or less exclusive association. At a time when few people wanted his paintings, or were prepared to pay what he considered them worth, the 'mad Frenchman' as he was known around Alice Springs, treated the artist like royalty. Serval had the financial backing to meet Clifford Possum's daily needs and keep him supplied with the large quantities of paint and canvas required to realise his vision for the artist's work. Unlike many before him who had wanted more of the same, Serval wanted the artist to try something completely different. There were to be no more dots – just the stories, on plain dark backgrounds reminiscent of the school of Kaapa (although only the artist would have known this).

The Dreaming stories are the subsoil of Western Desert art. They remain forever, like the Dreaming itself, whatever changes might occur in their manner of representation. In his weakened state, Clifford Possum knew his old style was too exhausting to be executed without assistants. Accepting the necessity of working solo, he began to work in the way Serval had suggested. His new style also borrowed from the artistic discoveries of the late Emily Kngwarreye, whose meteoric rise and absence of iconographic references had always perplexed him. He began to paint huge line drawings: the fluid curves of his Worm Dreaming or simple stripes of rough patchy lines across vast canvases. In other works, the familiar design elements were scaled up as never before on plain dark grounds. The Goanna brothers, who had fought in the artist's country around Aralukaja west of Mount Allan until the older split the younger's head open with a stone axe and killed him, figure large in these paintings. From the explanations Clifford Possum had been supplying for several years now with his trademark skeleton paintings,[17] it seems the Warlugulong narrative which the scene had originally represented had metamorphosed in the artist's imagination into the death scene from the Aralukaja story. In these last paintings the Goanna brothers emerge from their accustomed combative poses to engage in face-to-face conversation (*Dead Spirit at Napperby,* 2001 [p. 207]) or fuse in a Janus-faced dance of death (*Two Goanna Men,* 2001 [p. 209]).

In late 2001, Serval hired a gallery space in Sydney and mounted an exhibition he called *Carry On Clifford Possum* which included some of these works, whose visual impact was almost as overwhelming as their asking prices. The exhibition was opened by the French Consul-General, who remarked on the irony of an outsider like Serval appreciating this great artist more than his fellow Australians. For the first time Clifford Possum looked like an old man, with his long white beard and slow weary gait. He showed a little of his old fire

when he responded to the Consul-General's remark with a quip about Captain Cook beating the French to Australia! Then he sang his songs to the near-empty gallery, hung with what would be his last paintings. Although the artist and his dealer maintained a daily vigil over the exhibition, only one red sticker was in evidence when the paintings were taken down a fortnight later and shipped out to Paris. The artist's dream of establishing a home for himself and a Clifford Possum cultural centre for the world on the outskirts of Alice Springs with the proceeds was never realised.

It was Serval who called the ambulance on the day in late January 2002 when Clifford Possum almost died. As he was being flown to the Royal Adelaide Hospital in a coma, a rumour was circulating among the dealer fraternity in Alice Springs that he had already died. The night after his emergency surgery to remove a build-up of blood on his brain, he began to move his legs and by the next morning he was awake and talking. His doctors were astounded by the speed of his recovery and the almost superhuman strength he exhibited after three days in a coma. When he first regained consciousness in a strange hospital bed he fought like a tiger, demanding to see his family and the woman he had married after the death of Nora: Eileen Nakamarra from the Pitjantjatjara lands. He had followed in the steps of the ancestral Upambura even in this detail. No one could ever say that Clifford Possum's was a life half-lived.

★ ★ ★

21 June 2002. For Clifford Possum, it would be the shortest day of his life – and the last. If I were Shakespeare, I could express the celestial significance of an artist who used 'the incandescence of the sun as a metaphor for love'[18] dying on the day of the winter solstice. It was supposed to be an auspicious occasion for Clifford Possum. His investiture as an Officer of the Order of Australia in the General Division for 'service as a contributor to and pioneer of the development of the Western Desert art movement and to the Indigenous community through interpretation of ancient traditions and cultural values', had been organised for 12 noon at the Alice Springs Council Chambers. Gough Whitlam himself had telephoned to congratulate the artist and say, 'Welcome to our Order'. Clifford Possum was indeed 'thrilled' to receive such an honour from Australian society. His greatest joy would have been for all eleven of his grandchildren to have witnessed their grandfather accepting his gold medal. He had come in from Mount Allan, where he had been staying with his niece Isobel Hagan and her family, a week before the presentation ceremony so as to be fully recovered from the long drive into town. He was very ill from the cancers devouring his body, but his mind and his irrepressible sense of humour were as strong as ever. Only the day before, he had been in high spirits on a bus trip with his older brother, Billy Stockman Tjapaltjarri, and other long-term residents of the Hetti Perkins Nursing Home, joking with Billy about making their escape and going down to the creek for a couple of beers for old times' sake. But the next morning he could not be woken. The hour of noon passed and at two o'clock the Administrator of the Northern Territory, who was to have presented the medal,

Dead Spirit at Napperby, 2001, synthetic polymer paint on canvas, 152.0 x 121.0 cm; Arnaud Serval, France

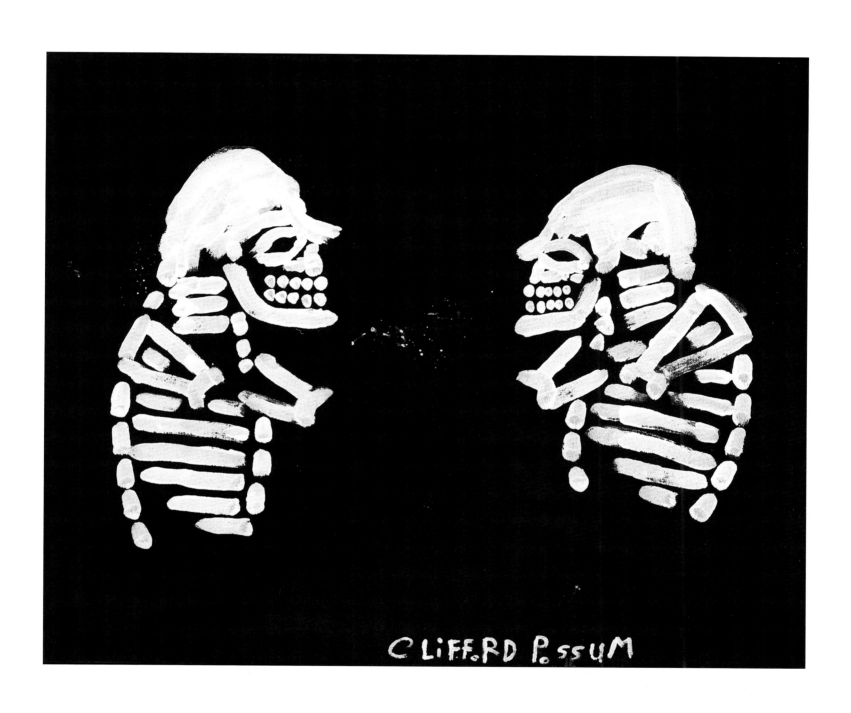

announced he would visit the artist. Satisfied that he was too ill to accept the medal that day, the official party left, still hoping that a more suitable occasion would soon present itself. The ministrations of his wife Eileen had calmed him, and as the sun, now low in the sky, lay full across his bed and his last visitors departed, he slipped into a tranquil sleep, from which I like to believe he never awoke.

A great silence should rightfully descend over the death of any man to enable those who loved him and were close to him to recover their lives. But Clifford Possum's passing was headline news the very day he died. The ABC broadcast included archival footage of him at work on a painting, followed by a statement that the national broadcaster had observed Aboriginal protocol by asking the artist's family for permission to release his name and image in the report. 'He was too big a man not to' according to their unnamed contacts within the family. It was a simple statement of fact, for the media had been poised to run the story of his medal presentation, and they were not to be denied this even bigger story.[19] A few months before he died, Clifford Possum himself had authorised the use of his name and image in materials connected with his forthcoming retrospective. We must go ahead, he said, 'whatever happen'. But just as in his paintings Clifford Possum often drew a veil over the designs which spelled out the Dreaming narrative, so it should have been in the matter of his last wishes for his funeral and burial site. While in Adelaide for treatment a few months before his death, Clifford Possum took the unusual step for a man from his cultural background of writing a will. He made provision for his estate to be distributed among his descendants and requested burial alongside his wife Emily and their son at Larumba on Napperby Station. This was not to be. After a bitter battle played out in public through the media and the courts, he was finally buried in the cemetery at Mount Allan community beside his brother Immanuel. He may have wanted it otherwise, but it must be hoped that Clifford Possum's spirit took some comfort in the fierceness of his surviving family's determination to lay his body to rest at Mount Allan, within his fathers' and grandfathers' heritage country. He is now free to wander all of his beloved corroboree country forever.

It is said that it does an artist no good to hear himself described as a genius. That consideration need no longer deter his biographer, but the inappropriateness of describing Clifford Possum in terms presumed to lie outside his own cultural frame of reference remains. In the end, the artist's own words are a more fitting epitaph than all the superlatives which art historians might apply:

> You know what? I like so people can understand. Might be all the young ones, they can understand. Because they gotta carry on. They can grow up and say, 'This man, he was proper really man and painter'.

Two Goanna Men, 2001, synthetic polymer paint on canvas, 92.0 x 121.0 cm; Arnaud Serval, France

p. 211: *Anardeli Kangaroo Story*, (detail), 1980, synthetic polymer paint on canvas, 122.5 x 76.0 cm; Holmes á Court Collection

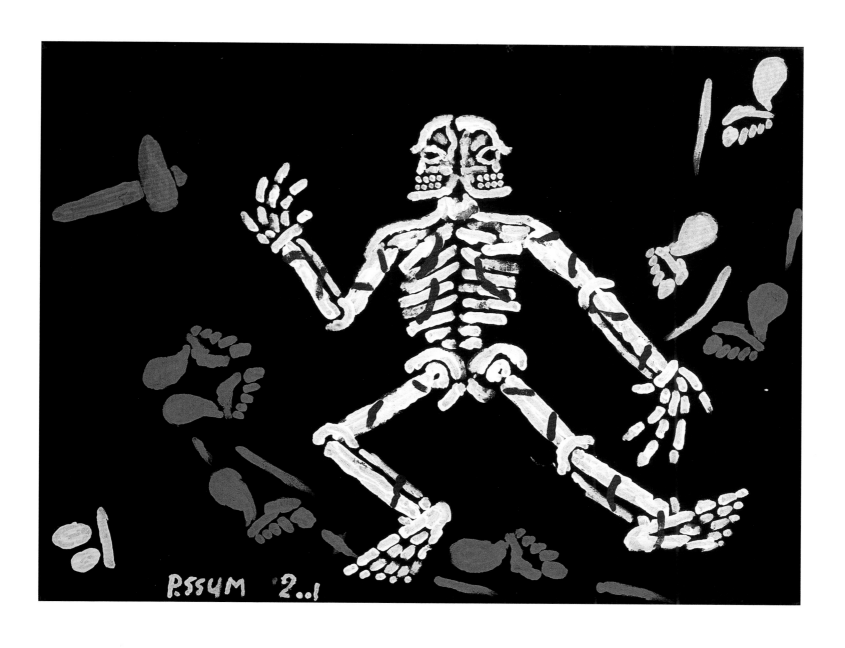

End notes

Introduction

1 'As an anthropological designation, the term "Western Desert" refers to a cultural/linguistic demarcation, rather than a strictly geographical one. The concept is based on particular religious or ritual manifestations which give an image of homogeneity across the very broad area encompassed by what Aboriginal linguists call the Wati group of languages (i.e. all those languages or dialects in which "Wati" is the word for "man")'. V. Johnson, *Aboriginal Artists of the Western Desert: A Biographical Dictionary*, Craftsman House, Australia, 1994, p. 11.

2 While the terms 'European' and 'whitefella' are still used by Aboriginal people of the region to describe non-Indigenous Australians, in this text the preferred terminology is 'settler' culture, which encompasses both the ethnic complexity of the non-Indigenous population and its immigrant status in Indigenous eyes.

3 'Two Ways', that is, biculturally.

Chapter 1 Corroboree country

1 According to Norman B. Tindale's *Tribal Boundaries in Aboriginal Australia*, Coniston and Napperby are firmly within Anmatyerre territory. Mount Denison straddles the border of Anmatyerre and Ngalia (Southern Warlpiri) country and Mount Wedge and (old) Mount Allan lay just across the border from Anmatyerre lands.

2 All unfootnoted quotations are taken from a series of interviews with Clifford Possum Tjapaltjarri conducted by the writer during the second half of 1992 and early 1993 in Melbourne and Alice Springs.

3 Western Desert English for paternal forebears.

4 Soakages are wet areas within the mainly dry creekbeds, from which drinking water could be obtained by digging down. Clifford Possum also applied the term to native wells, soakages which had been dug out below the usual water line and were maintained in that state by their custodians.

5 Tempe Downs, Hamilton Downs and Glen Helen were other early stations.

6 'Warringi' means 'grandfather' in Anmatyerre. (Paddy Stewart Tjapaltjarri interviewed by Vivien Johnson, Yuendumu, 2003).

7 ibid.

8 The Register of Wards' estimate was 1934 for 'Clifford Ara Pultara' (Pultara corresponds in the Arrente system of skin names to Tjapaltjarri [with thanks to Jeremy Long]).

9 Clifford Possum Tjapaltjarri interviewed by John Kean, Alice Springs, 1987. (See *Clifford Possum Tjapaltjarri: Paintings 1973–86*, ICA, London, 1988, pp. 4–6).

10 His older brother Immanuel who was Long Rose and Jajirdi's oldest child.

11 During which time I had interviewed him repeatedly and written a book about his life and art.

12 According to the Register of Wards, Tim Ura-ura (Leura) Pultara – which corresponds in the Arrente Kinship system to the skin name Tjapaltjarri – was born in 1934, the same year as Clifford

Possum). The Register also recorded a Barney Kanei-wau Warai (Tjungurrayi) born 1895 and a Maggie Wadiana Ngala (Nangala) born 1903, both living at Narwietooma at the time the census was taken. (With thanks to Jeremy Long for this information).

13 Two of Clifford Possum's surviving 'brothers', Paddy Stewart Tjapaltjarri the son of Jajirdi's older brother Jimmy, and Samson Tjapaltjarri, son of Jajirdi's second wife Ruby Nangala, confirmed this account of Clifford Possum's parentage when I sought them out at Yuendumu in February 2003.

14 Police and missionaries had originally introduced the dingo bounty.

15 Clifford Possum Tjapaltjarri interviewed by John Kean, Alice Springs 1987 (see *Clifford Possum Tjapaltjarri: Paintings 1973–86*, ICA, London, 1988).

16 Moses, on behalf of the Jay Creek Aboriginal Community, 1940 (from a letter to the Director of Native Affairs), cited in A. Markus, *Governing Savages*, Allen & Unwin, Sydney, 1990, p. 20.

17 Hélène Burns interviewed by Vivien Johnson, Adelaide 1992.

18 Jeremy Long, personal communication 2003. Hélène Burns's recollection in 2003 when the location of the photograph was pointed out, was that the photograph had been taken by Dr Charles Duguid on an expedition by camel with her father Pastor Albrecht, made some time before Haasts Bluff was opened as a ration depot by the missionaries in 1941. However, the child Dr Duguid photographed on that occasion was not Clifford Possum, who would have been perhaps two and no more than six years old in 1936 when Dr Duguid made his trip to Haasts Bluff with Pastor Albrecht. Duguid befriended and photographed 'an outstanding Pintupi boy of about eleven years' who was Charlie Tjararu Tjungurrayi. They also took a very sick twenty-four-year old man back to Hermannsburg with them and gave *him* a course of injections (*No Dying Race*, Rigby, Australia, 1963, pp. 40–1). Duguid's photograph of Charlie Tjararu appears in *Doctor Goes Walkabout* (Rigby, Australia, 1972). Its subject has a different head shape and severe burns to the chest which are not evident in the boy who appears in the photograph Hélène Burns gave me.

19 Her connection with Clifford Possum continued right up to his death: Hélène Burns, who now lives and works in Adelaide, witnessed Clifford Possum Tjapaltjarri's will in 2003 at the Royal Adelaide Hospital.

20 F. W. Albrecht, 1977 'Hermannsburg from 1926 to 1962' in E. Leske, *Hermannsburg: A Vision and a Mission*, Lutheran Publishing House, Adelaide, 1977.

21 *Walkabout*, vol. 16, 1 September 1950, no. 9, p. 9.

22 ibid.

23 According to *The Australasian Stamp Catalogue*, 24th edition, 1989, Seven Seas Stamps, Dubbo, New South Wales, p. 11, One Pound Jim was so named because when asked how much he charged to perform a task, he invariably answered, 'One pound, Boss'.

24 Clifford Possum Tjapaltjarri interviewed by John Kean, 1987.

25 ibid.

26 Clifford Possum spoke Anmatyerre (first language), Luritja, Pintupi, Warlpiri, Arrente, Pitjantjatjara, and 'a little bit' of English.

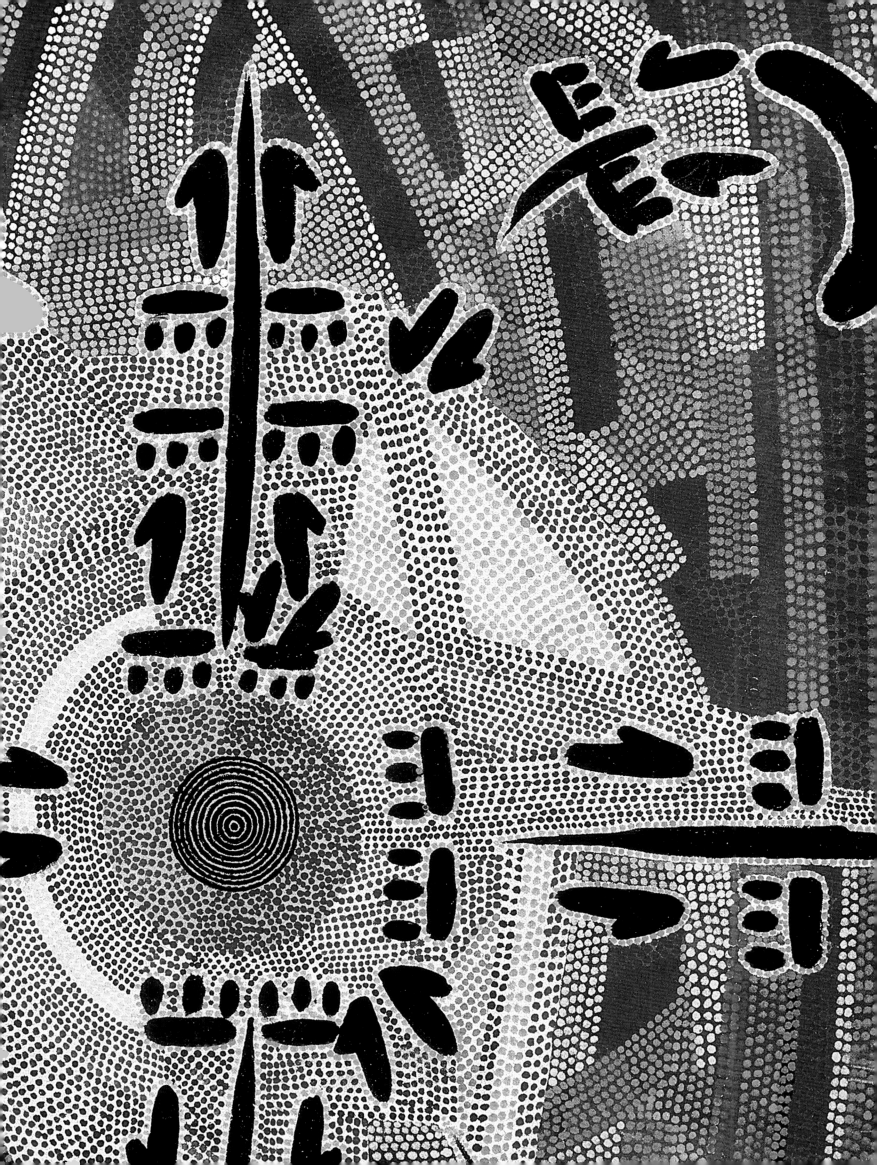

27 Dick Kimber wrote in the annotation of *Warlugulong* 1976. 'Such a fight may well reflect that a battle did take place in the area long long ago. Certainly it is an interesting fact that the Pitjantjatjara people, far to the south in the vicinity of the South Australia and Northern Territory border, did not traditionally make boomerangs'.

28 Possums, one of the artist's perennial subjects, are also associated with a number of sites to the north and west of Napperby Station as far as Limestone Bore, including Quartz Hill Dam (Irriltja), Mica Dam, Sugarbag Bore – 'all that one – they looking around for fruit and flowers'. In the area south of Napperby, Upambura is principally associated with Gidyea Creek (or Possum Creek as the artist called it), particularly Corroboree Bore, where he is often shown in Clifford Possum's paintings searching for food. It was from Gidyea Bore that he set out on the journey to Uluru.

29 Clifford Possum, personal communication 1993.

Chapter 2 Start from carving

1 Clifford Possum Tjapaltjarri interviewed by John Kean, 1987.

2 Clifford Possum, personal communication 1992.

3 Dick Lechleitner Tjapanangka interviewed by Vivien Johnson, Papunya, 1986.

4 Immanuel Rutjinanama used to say that he was the one who had introduced Clifford Possum to painting, with the watercolours which he gave him when he was staying at Napperby. He quickly abandoned landscape, deciding 'No, he wanted his traditional designs'. Hélène Burns interviewed by Vivien Johnson, Adelaide, 1992.

5 Central Australian Aboriginal Media Association.

6 Albert Namatjira was born at Hermannsburg Mission on 28 July 1902.

7 For example, Hélène Burns interviewed by Vivien Johnson, Adelaide, 1992.

8 Clifford Possum is recorded in the Register of Wards as 'Clifford Ara Pultara' born *c.*1934 – 'Pultara' corresponding to Tjapaltjarri in the Arrente skin name system. Namatjira was an Kngwarreye man from his father's side, which corresponds in the Western Desert system of skin names to Tjungurrayi.

9 For example, in Geoffrey Bardon, *Aboriginal Art of the Western Desert,* Rigby, Australia, 1979, p. 56.

10 Rex Batterbee, *Modern Australian Aboriginal Art,* Angus & Robertson, London, 1951, p. 54.

11 See B. Henson, *A Straight Out Man: F. W. Albrecht and Central Australian Aborigines,* Melbourne University Press, 1992.

12 Interests in and responsibilities for the places that compose an estate are of two principal kinds: [those] inherited from the father and those inherited from the mother. Those whose responsibilities are patrilineally inherited are referred to as kirda. Their spiritual responsibility is to re-enact the founding drama associated with particular places on their estate to sustain the supply of life force which maintains the fertility of people and natural species. In carrying out these rites the assistance of those who have inherited interests and responsibilities for these places through their mother is essential. These people are known as kurdungurlu. The kurdungurlu prepare for the rites, ensure they are correctly performed, protect the sacred places and look after the sacred objects. Without their participation and cooperation the rites could not be efficacious. Kirda and kurtungulu thus have common spiritual responsibilities and affiliation to particular places that are completely complementary. 'Land Claim to Mount Allan Pastoral Lease', Nicolas Peterson and Elspeth Young, prepared at the instructions of the Central Land Council on behalf of the claimants, 1981, p. 12.

13 *Walkabout,* September 1950, p. 11.

14 *The Centralian Advocate,* 29 April 1965, p. 1.

15 Stamp no. 67, *The Australasian Stamp Catalogue,* Seven Seas Stamps, Dubbo, New South Wales, 24th edition, 1989, p. 11.

16 *Walkabout,* December 1951, p. 9.

17 According to the Register of Wards, One Pound Jimmy (Gwoja) Tjungurrayi was born in 1895. (With thanks to Jeremy Long for this information.)

18 *Walkabout,* December 1951, p. 9.

19 R.G. Kimber interviewed by Vivien Johnson, Alice Springs, 1992.

20 *Australasian Stamp Catalogue*, 24th edition, p. 11.

21 *The Centralian Advocate,* 29 April 1965, p. 1.

22 ibid.

23 Unless they had seen it mentioned in Dick Kimber's excellent essay in *Wildbird Dreaming,* N. Amadio & R. G. Kimber, Greenhouse, Melbourne, 1989.

24 Inyamari Napanangka was the sister of Gladys Napanangka, another of Tjanatji's wives, who later took Johnny Warangkula Tjupurrula as her second husband (with thanks to Gabriella Possum Nungurrayi and Jeremy Long for this information).

25 Jeremy Long personal communication 2002.

26 Fred R. Myers, 'Truth, Beauty and Pintupi Painting', *Visual Anthropology,* vol. 2, 1989, p. 166 and subsequently in Bardon, 1991.

27 Like Billy Stockman Tjapaltjarri and Long Jack Phillipus Tjakamarra.

28 For example in neighbouring Yuendumu, where watercolour was tried in the early 1970s.

29 Richard Kelton personal communication 2003.

30 See *Cheeky Snake carving,* 1973 (cat. no. 55).

31 Jack Cooke personal communication 2001.

32 R. G. Kimber 'Papunya Tula Art: Some Recollections' August 1971–October 1972', in *Dot and Circle,* ed. J. Maughan and J. Zimmer, RMIT, Melbourne, 1986, p. 43.

33 Vivien Johnson, *The Early Papunya Boards*, in preparation.

Chapter 3 School their eyes

1 According to the records of the Stuart Art Centre, which was the main outlet for the work of the Papunya painters during Bardon's time at Papunya and beyond, Tim Leura often brought his paintings into the Stuart Art Centre himself in those early years. Until the old Papunya Town Hall space was acquired for the painters, the artists continued to work in separate areas around the settlement, including the old settlement office (see Bardon 1991).

2 G. Bardon, *Papunya Tula: Art of the Western Desert,* McPhee Gribble, Melbourne, 1991, p. 31.

3 ibid. p. 113.

4 ibid. p. 108.

5 Failed projects at Papunya to 1977 included a vegetable garden, piggery, orchards (citrus, carob, olive), flower gardens, rose gardens, post and rail cutting from desert oak and mulga, quarrying, dam construction, brick making, mohair goat husbandry, re-afforrestation, date palms, prospecting, fencing, road clearing, camel catching, bread baking, small goods manufacture, an apiary, lucerne fodder crops and poultry. See K. Davis, J. Hunter and D. H. Penny, *Papunya: History and Future Prospects*. A report prepared for the Ministers for Aboriginal Affairs and Education, Canberra, 1977, p. 45.

6 Bardon 1991, p. 115.

7 Paddy Stewart Tjapaltjarri is a senior man in the Yuendumu community and one of the principal artists involved with the Yuendumu Doors project which started the Warlukurlangu painting enterprise more than a decade after these events. That he was also involved in the painting of the 1971 Papunya school murals makes him a key figure in the dissemination of the painting enterprise to other settlements.

8 Bardon 1991, p. 113.

9 Geoffrey Bardon interviewed by Ulli Beier in *Long Water: Aboriginal Art and Literature*, eds U. Beier and C. Johnson, Aboriginal Artists Agency, Sydney, 1988.

10 *The Centralian Advocate*, 2 September 1971, p. 31.

11 G. Bardon interviewed by Ulli Beier, op. cit., p. 92.

12 Bardon 1991, p. 115.

13 Bardon 1979, p. 20.

14 ibid. p. 16.

15 Bardon 1991, p. 23.

16 Bardon 1979, p. 68.

17 Bardon interviewed by Ulli Beier, op. cit., pp. 90–92.

18 *Centralian Advocate*, 4 January 1990, p. 3.

19 Much Anmatyerre land also lay on Napperby station, whose owner was antagonistic to anthropologists. The view of adjacent tribes that the Anmatyerre were part of their tribe, may have also influenced subsequent anthropologists not to make the Anmatyerre the subject of a separate study. Anmatyerre country borders in the south on the territory of the Northern Arrente, who (like the territorially ambitious Warlpiri on their north-west) have historically regarded its occupants as a sub-group of their respective tribes. The Anmatyerre themselves firmly deny these claims, though Clifford Possum has affirmed that he is 'little bit Northern Arrente', so long as Northern Arrente is understood to be radically distinct from Arrente itself.

20 R.G. Kimber interviewed by Vivien Johnson, Alice Springs, 1992.

21 ibid.

22 In *Papunya Tula: Art of the Western Desert* he noted its deliberate omission from the publication on these grounds.

23 The image of the painting that appeared in *The Art of Clifford Possum Tjapaltjarri*, 1994 was from a slide Geoffrey Bardon had taken in 1972 for his own records.

24 See chapter 4 for discussion of the emu tracks in *Warlugulong*, 1976.

25 See *Emu Corroboree Man*, cat. no. 1 for an account by its American owner of the painting's acquisition in Papunya all those years ago.

26 'The inseminating powers of the ancestors are like the soil or like the fluff shaken from the decorations of the ancestors as they danced at their own sites; but for the most part men do not conceive of them in any specific likeness. They are simply a "strength" which infuses the soil'. Nancy Munn 'Totemic Designs and Group Continuity' in *Aborigines Now* ed. M. Reay, Angus and Robertson, Sydney, 1964, p. 86.
There have been numerous accounts of the origin of the dots which characterise Western Desert art. Nancy Munn's has the merit of anticipating the painting movement and the advent of the dots, by nearly a decade. It is also one of the most poetic: the idea being that the dots signify the power of the ancestors returning to the earth in the ceremonies as the balls of fluff on the dancers' bodies fall to the ground. There are many other possible sources for dotting both inside and outside Western Desert culture. In *Papunya Tula: Art of the Western Desert*, Geoffrey Bardon attributes the original discovery of dotted infilling to Johnny Warangkula Tjupurrula, but the idea has many resonances also in traditional culture – and is it only coincidence that television, whose images are also composed of dots, came to Papunya in 1971?

27 In the late 1980s this effect in the first works of Emily Kngwarreye produced a rapturous response from contemporary art audiences as a brilliant visual metaphor for the practices of concealment surrounding ceremonial life.

28 Bardon 1991, p. 114.

29 ibid., p. 116.

30 See *Bushfire II*, cat. no. 7.

31 Bardon 1991, p. 115.

32 Some Anmatyerre painters from Napperby have begun treating Clifford Possum's design in *Man's Love Story* as if it were a traditional iconograph in their own paintings of the Ngarlu story – influenced in this by a visit from Geoffrey Bardon in 1991 when he showed them the painting in his newly published book.

Chapter 4 Mapping the Dreaming

1 Clifford Possum interviewed by John Kean, 1987.

2 See *Kerrinyarra* cat. no. 19 for an account of the traditional ground paintings.

3 W. E. H. Stanner quoted in D. Lewis, 'Observations on Route Finding and Spatial Orientation among Aboriginal Peoples of the Western Desert Region of Central Australia', *Oceania*, June 1976, p. 271.

4 ibid.

5 Tim Leura's *Anmatyerre Dreamings* from 1974 on 90 x 120 cm composition board, now in the Holmes á Court collection is an extraordinarily detailed mapping out of ancestral trails and sites. (See A. Brody, *Contemporary Aboriginal Art from the Holmes á Court Collection*, Heytesbury Holdings, Perth, p. 11).

6 Tim Leura Tjapaltjarri personal communication, 1984.

7 The use of quote marks indicates artist's own terminology.

8 Peter Fannin interviewed by Vivien Johnson, Uluru, 1991.

9 R. G. Kimber, in *Australian Perspecta '81: A biennial survey of contemporary Australian art*, Art Gallery of New South Wales, 1981, p. 136.

10 See *Warlugulong*, 1976 cat. no. 17.

11 In the analysis, when the viewer is said to be facing north-south-east or west across the painting, this refers to the canvas as if it were laid out on the ground, rather than hung vertically on the wall.

12 See *Warlugulong*, 1976 cat. no. 17.

13 A point of intersection in these shifting spatial alignments in the painting seems to occur towards the middle of the right side of the painting at a site identified in the diagram as Wakulpa, a blue hill to the north of Yuendumu where the wedge-tailed eagles hunt for prey. The annotation tells of a euro browsing on grass in the Aileron area far to the east of Wakulpa, who suddenly becomes aware of the eagle overhead and flees through a line of sites shown up the right-hand side of the painting. Unusually, the tracks of the terrified euro are not shown, presumably for compositional considerations on an already laden surface. Finally the bird swooped on its prey, grabbing the euro at the site where its huge talons are shown touching the earth. The annotation for Warlugulong states that the euro was killed at Wakulpa. However, if I understood him correctly, Clifford Possum pointed out a site along the eastern boundary of his heritage country close by to Mount Boothby on the topographic map of the area, as the place where the euro was taken. The site of Wakulpa, on the western boundary of Anmatyerre country far to the north of Kerrinyarra, he nominated as the place where the eagle returned to hunt again. There are two Eagle Dreaming sites in this story, one in the north-west, and the other on the far eastern side, of Anmatyerre territory. Either could be the place where the eagle's talons are marked, depending whether the top of the painting is taken to be north (for Mount Boothby) or west (for Wakulpa). The oscillation of spatial orientations between these two Eagle Dreaming sites seems appropriate to the wheeling, swooping pattern of flight of these magnificent birds.

14 For instance, the track of the 'boss' emu, who travelled into Warlpiri territory and brought back a large group of emus to Napperby, runs in a broad band across the top of the second painting alongside the multiple tracks of the larger group returning. Above the path of the emus are the footprints of a group of dancing women from Aileron who also appeared in the first painting. The same Rock Wallaby Dreaming that belonged to Clifford Possum's father is again shown, with the mala slowing down to drink at various soakages and rockholes on their way through Anmatyerre territory to the 'Top End'.

15 Parallel to Upambura's track under the path of the fire is another set of footprints belonging to a family group of a father, son and mother. Their journey leads from Winpar'ku to the Ngama cave site, the same journey undertaken by the Great Snake Yarapiri in *Warlugulong*, 1976.

16 These include the distinctive tracks (with the padded foot and four toes) of the old dingo who travelled east to Arrangi then north with his mate, crossing the artist's country on the way to the Warlpiri settlement of Warrabri. The Tjungurrayi man from Kunatjarrayi who is shown trying to steal sacred objects from a number of sites on the painting is the same kataitja man who appeared in the 1973 painting of a group of sites in the same region – around Yuendumu, Mount Denison, Mount Allan and Brogas (Brookes) Flat. The 'perentie' (goanna) trail marked in the 1973 painting is also presumably connected to the episode marked on the left-hand side of the diagram for *Warlugulong*, 1977 as The Camp and Chase of the Goanna Men, beginning at Yarumayi (Aralukaja) east of Yuendumu and ending at Warri Warri (Mount Allan).

17 See *Warlugulong*, 1977 cat. no. 18.

18 Dick Kimber interviewed by Vivien Johnson, Alice Springs, 1992.

19 ibid.

20 Graham Sturgeon, quoted in an Aboriginal Arts and Crafts News Release advertising a show of Papunya paintings at the Collectors Gallery in Sydney, 1978.

21 John Kean personal communication 1986.

22 On 13 August 1994, the Los Angeles Times art critic William Wilson (reviewing *The Evolving Dreamtime*) had this to say about *Yuutjutiyungu*: 'It's a large composition by Clifford Possum Tjapaltjarri. As dark and sumptuous as an imperial Chinese court painting, it is also as unexpected as an Abstract Expressionist masterpiece. Its title, *Yuutjutiyungu: Ancestral Tales of Mt Allan Sites*, is mysterious and stately. It's easy to imagine artists like Richard Pousette-Dart or Lee Mullican or for that matter Jean Dubuffet admiring it and seeing something of themselves in it too. From here on in, there is no question this is an art exhibition'.

23 Curiously, the annotation prepared for *Yuutjutiyungu* by John Kean has Yirrinytarrakuku coming from the east, having already stolen the Alyawerre's tjurungas, sneaking past Yuutjutiyungu and after an unsuccessful attempt to steal the Anmatyerre's tjurungas, proceeding west to Kunatjarrayi, where he hid his Alyawerre booty. Then he returned past Yuutjutiyungu, attempting again to steal the Anmatyerre sacred boards and being foiled in the same manner by the watchful Nangalas. Finally, he returned to Alyawerre country empty-handed. It is impossible to tell from his tracks, which run vertically on either side of the Yuutjutiyungu outcrop, which account of these events is represented on the painting. Perhaps it does not greatly matter, but it may explain why the diagram of the painting was placed *upside down* with respect to the original Papunya Tula annotation, which specifies that the women digging for honey ants are located to the *right* of the centre of the painting and the possum tracks to the *left*.

24 Not as 'huge storm', as the Papunya Tula annotation of the painting contends.

25 Papunya Tula Artists' asking price for *Yuutjutiyungu* when it was consigned to the Aboriginal Arts Board in August 1979 was $1425 (from copy of invoice in Papunya Tula's file on the artist's paintings).

26 Peter Fannin, annotation of Papunya Tula Artists, stock no. CP73098.

27 Many of the Dreamings involved were so extensive – sometimes over thousands of kilometres – and communications and mobility between remote Aboriginal settlements were so limited in those days, that seeking all the relevant permissions was a practical impossibility anyway. However, major progress towards resolving these issues was made during Dick Kimber's time in the Papunya manager position.

Chapter 5 More better than everything

1 As David Corby's elected Deputy, Clifford Possum was appointed to replace him, and then re-elected to the position of Chairman for the next four years by his fellow artists. He was succeeded in 1985 by Turkey Tolson Tjupurrula, also one of the youngest of the original group of painters.

2 'I think *Yuutjutiyungu* is the most complex and ambitious Papunya Tula painting; it calls on the full range of dimensions – space, time, depth and description of the surface of the earth – that can be expressed in the medium and resolves them with encyclopedic authority'. John Kean personal communication 2003.

3 For example, *Contemporary Art of the Western Desert*, Orange City Art Gallery, 1981.

4 A. Crocker, Fieldnotes for Papunya Tula Artists, Stock no. 800229.

5 See notes on *Napperby Death Spirit Dreaming*, cat. no. 27.

6 Reproduced in J. Isaacs, *Australian Aboriginal Paintings,* Weldon, Australia, 1989, p. 23; V. Johnson, *The Painted Dream,* Auckland City Art Gallery, 1991, p. 19; H. Finke and H. Perkins, *Papunya Tula: Genesis and Genius,* Art Gallery of New South Wales, Sydney, 2000, p. 79.

7 Other influences on the artist's development of striped backgrounds during this period may have included the Pintupi painter Limpi Tjapangati from Haasts Bluff, who was one of the first artists in the Papunya group to perfect a personal style of striped infilling on his paintings. The group of Warlpiri artists around Paddy Carroll Tjungurrayi, including Don Tjungurrayi and Two Bob Tjungurrayi, also experimented with compositions based on stripes in the early 1980s.

8 There were also isolated precedents in the artist's more recent work like *Two Fighting Men*, 1978, (p. 119) where he had used double lines of dots on the infilling of the figures.

9 Bardon 1979, pp. 22–23.

10 Others have read the same doom-laden messages into Clifford Possum's own work at the end of his life, see *Dead Spirit at Napperby*, 2001 p. 207.

11 *Warlugulong*, 1976 was purchased after the exhibition for the Gallery's permanent collection.

12 T. Maloon, *Sydney Morning Herald,* 9 January 1982.

13 A number of exhibitions organised by the Aboriginal Arts Board had travelled overseas in the 1970s which contained the work of Papunya Tula artists (Peter Stuyvesant Collection; US Bicentennial exhibition), though none included Clifford Possum's work.

14 Tim Johnson interviewed by Richard McMillan in V. Johnson, *The Painted Dream,* Auckland City Art Gallery, 1991.

15 Clifford Possum interviewed by John Kean 1987.

16 Peter Fannin interviewed by Vivien Johnson, Uluru 1991.

17 However, it must be emphasised that there was no hard and fast rule – artists could request colours which deviated from this norm, and would be supplied with them.

18 Betty Churcher personal communication 2002.

19 When presented with this garment, Clifford Possum insisted on wearing it for the back cover shot (with the author) of *The Art of Clifford Possum Tjapaltjarri*, 1994. He also insisted that the jumper belonged to him: 'My Dreaming. My painting. My jumper'.

20 The Caltex Art Award which Kaapa Tjampitjinpa had shared in 1971 at the very beginning of the art movement has now been amalgamated with the Alice Springs Art Award, but at that time they were separate events.

21 Dave Richards, *Centralian Advocate,* 9 November 1983.

22 ibid.

23 see chapter 6, p. 178.

24 Barry Craig, 'Non-Violent Land Claims from the Centre', *Artlink,* vol. 4, nos 2&3, 1984.

25 Daphne Williams personal communication 1984.

26 V. Johnson, *Michael Jagamara Nelson,* Craftsman House, 1997, pp. 134–142 for a detailed study of the 'variously readable iconicity' of Michael Nelson's *Five Stories*, 1984.

27 *Centralian Advocate*, 27 March 1985, p. 20.

28 '... certain aspects of Williams's transformation of the [mainstream tradition of landscape painting] coincides [*sic*] with some of the conceptual and pictorial approaches of central Australian Aboriginal artists.' A. Brody, *Face of the Centre: Papunya Tula Paintings, 1971–1984,* National Gallery Victoria, 1985, p. 7.

29 See chapter 1 p. 26 [with reference to Jajirdi's connections to Napperby].

Chapter 6 My private canvas

1 As Andrew Crocker observed in his introductory essay for *Charlie Tjaruru Tjungurrayi: A Retrospective 1970–86,* Orange Regional Gallery, Orange City Council, New South Wales, 1987, p. 10.

2 I. Blazwick, *Clifford Possum Tjapaltjarri: Paintings 1973–86*, ICA, London, p. 3.

3 M. Field, 'Dreaming in London', *The Bulletin,* 1 August 1989, p. 20.

4 'M.C', *City Limits,* 21 April 1988.

5 J. R. Taylor, *The Times,* April 1988.

6 The ICA's prestige and Australia's Bicentenary year helped to speed up arrangements, but it was far too short a time-span to arrange loans from public institutions. The exhibition's reliance on the cooperation of private lenders attracted this comment from one reviewer: 'Outside influences impinge, not only in the form of realistic skeletons or in the use of acrylics, but in demand. The best pictures in the show belong to Robert Holmes á Court and Alistair McAlpine'. (W. Feaver, *The Observer,* April 1988).

7 Iwona Blazwick, personal communication 1988.

8 The five paintings were *Aralukaja* and *Five Dreamings* from 1976 (pp. 84, 85), the small *Love Story* from 1981 (p. 137), the 1982 *Bushfire Dreaming* from the Art Gallery of South Australia (p. 139), and *Water Dreaming at Napperby* purchased by Flinders University Art Museum from the 1984 Adelaide exhibition (p. 147).

9 From an anonymous note supplied with the painting *Wildflower Dreaming*, 1988 (plate 63 *The Art of Clifford Possum Tjapaltjarri,* 1994) to the Holmes á Court Collection.

10 *The Weekend Australian,* 21–22 May 1988, p. 1.

11 Jon Altman, personal communication 1992. See also *The Aboriginal Arts and Crafts Industry.* Report of the Review Committee, Department of Aboriginal Affairs, Canberra, 1989.

12 *The Sydney Morning Herald,* 19 December 1989.

13 During his sentencing hearing in February 2001 for offences

relating to his fraudulent dealings in works falsely attributed to the artist. See chapter 7.

14 However, the skin name 'Tjaparulli' (Tjupurrula) which Clifford Possum allegedly bestowed on him would make him Clifford Possum's father-in-law, not his cousin. The ceremonial drinking of blood which O'Loughlin alleged took place at the time may be an overdramatisation of traditional Aboriginal cooking techniques in the Western Desert, which do tend to the raw side of 'rare'. The piece of kangaroo meat he was offered after the successful hunt may well have dripped blood.

15 Bruce Chatwin, *Songlines,* Jonathan Cape, London, 1987.

16 Described in one of the television late news bulletins seen in Australia as 'the first meeting between the British monarch and an Australian Aborigine actually at the Palace'.

17 Quoted in the *Centralian Advocate,* 3 August 1990.

18 Iris Harvey, personal communication 2002.

19 The other six artists in the show were Maxie Tjampitjinpa, Johnny Warangkula Tjupurrula, Mick Namarari Tjapaltjarri, Turkey Tolson Tjupurrula, Uta Uta Tjangala and Anatjari Tjakamarra.

20 Each artist's paintings were hung according to the location of their Dreamings on an east-to-west axis. End to end, the exhibition mapped out a series of major sites across a broad stretch of country from about 200 kilometres west of Alice Springs through Anmatyerre, Luritja, Warlpiri and Pintupi territory across the Western Australian border.

21 Milanka Sullivan, personal communication 1992.

22 Milanka Sullivan, personal communication 1992.

23 Some large private commissions tentatively dated from the mid-1980s appear to be repaintings of earlier works that had recently become available in reproduction. For example, *Kangaroo Story, c.*1986 bears a striking resemblance to the middle section of *Kangaroo Story (Mt Denison)* 1980–81 (see *The Art of Clifford Possum Tjapaltjarri,* 1994, p. 169, notes on plate 56). These may be the first examples of image recycling in Clifford Possum's work.

24 And beyond, as Rover Thomas and other Kimberley painters, working on canvas with their own ochres, were then in the process of discovering, and have since been discovered for, by the Australian art world.

25 John Kean, *East to West: Land In Papunya Tula Paintings,* Tandanya, Adelaide, 1990.

26 Milanka Sullivan notes on *Man's Love Story* (unpublished).

27 See chapter 2.

28 By the Art Gallery of South Australia in 1980. See chapter 4.

29 Or *Red Hill* as he called the painting – after the European name of the site of Ngarlu which it depicts.

30 *Sunday Territorian,* 25 June 1995.

31 ibid.

32 He was also described as 'about forty-five', which would have made him twenty-one years old when he painted *Love Story*; astonishing that no one appears to have noticed such extreme youth amid the old men of the painting room, but also indicative of the boundless energy of the man, which could outlast most younger men, let alone his contemporaries.

33 'He will go out and buy himself a leather jacket or a good suit for $2,000. The same evening he will sleep in the Todd River and next morning it will look like it's ten year's old', op.cit., *Sunday Territorian,* 25 June 1995, p. 6.

34 ibid. p. 6.

Chapter 7 Proper really man and painter

1 Vivien Johnson, *The Art of Clifford Possum Tjapaltjarri*, Craftsman House & G+B International, Sydney, 1994 p.135.

2 Joyce Batty, *Namatjira: Wanderer Between Worlds*, Hodder and Stoughton, Melbourne, 1963, reprinted Rigby, Adelaide, 1977, p. 70.

3 In the end, a number of works that were 'family assisted' did find their way into the (artist approved) selection but this was Clifford Possum's starting point, which has been more strictly observed in this book.

4 Des Rogers, Len and Adam Knight and Mem Aziz personal communications 2003.

5 In the course of that conversation, the artist also explained why the worm's tail is so often represented in these works as a loop: the bird can sense the worm's movements under the ground but not detect the location of its head or tail. (H. Ebes, personal communication 1993).

6 For example, seen in Australia in *The Sydney Morning Herald,* 6 December 1977.

7 This did not prevent one of the backyarders from producing tasteless cloth wall hangings and baseball caps of his Narripi Worm Dreaming in lurid colours – which were at least useful to the art centres for showing other artists the perils of becoming involved with such establishments.

8 And to this day, paintings sold by Papunya Tula Artists and most other community art centres are not signed by the artists.

9 Clifford Possum Tjapaltjarri: excerpt from his first statement to the police in February 1999, translated by Janet Long Nakamarra, videoed by Simone Deeb.

10 See chapter 1.

11 See Vivien Johnson, *Copyrites: Aboriginal Art in the Age of Reproductive Technologies*, National Indigenous Arts Advocacy Association and Macquarie Universities, Sydney, 1996.

12 On 11 October 1999, Mr O'Loughlin was arrested by South Australian Fraud Squad officers and extradited back to New South Wales. He was charged with twenty counts of Obtain Benefit by Deception and two counts of Using a False Instrument. (Paul Baker, former New South Wales Commercial Crime Squad detective who headed the investigation, 2003).

13 On 26 February 1999, during a video-taped police interview at the Mascot warehouse where the paintings from the 'retrospective' were stored, Clifford Possum was questioned about what purported to be his signature on the back of one of the paintings from whose authorship he had dissociated himself. Clifford Possum's response was 'Not my work. Someone put my name, but not my work'. And 'Put my name on it. Not mine'.

14 Between 11 and 14 July 2000, a full committal hearing was heard at the Downing Centre Local Court. The Magistrate considered the evidence strong enough to commit O'Loughlin for trial to the Sydney District Court to have the matter heard by a Judge and

jury. (Paul Baker, former New South Wales Commercial Crime Squad detective who headed the investigation, 2003).

15 After some negotiation between the DPP and the defence, on 23 February 2001, Mr O'Loughlin pleaded guilty at the Penrith District Court to ten charges of Obtain Benefit by Deception (five of which were considered on a schedule). (The term 'considered on a schedule' means that O'Loughlin had these matters considered by the Judge when sentenced, even though he was not actually sentenced on them. It really means that Mr O'Loughlin faced five charges with five others in the background. It is designed to streamline criminal trials where offenders face a multitude of offences and it is too cumbersome for the court to hear each individual matter. The other advantage is that the accused person thinks they are really only being dealt with on a lesser number of charges, even though their criminal record will record all matters against them.) (Paul Baker, former New South Wales Commercial Crime Squad detective who headed the investigation, 2003).

16 *The Weekend Australian*, 24–25 February 2001, p. 5.

17 The bundles of sticks the brothers used to try to beat out the flames had been omitted for compositional reasons.

18 Bardon 1991, p. 116.

19 Five days later, on 26 June 2002, the Australian Senate, in a motion put by Senator Ridgeway, noted: 'with sadness, the passing of one of the grand masters of Aboriginal art in Australia, Mr Clifford Possum Tjapaltjarri'. The motion thanked 'the Tjapaltjarri family for their permission to refer to him by name in recognition of his importance and standing as an artist', and also paid tribute 'to Mr Tjapaltjarri's outstanding life's work, which brought him and his community national and international acclaim and now constitutes an invaluable part of the nation's cultural heritage'. Hansard Australian Senate, Wednesday 26 June 2002, p. 2688.

Catalogue of works of art

'The painting is the story, not the design' – Clifford Possum Tjapaltjarri

The works of art are listed chronologically. Works that display an asterix★ after the catalogue number are included in the 2003 retrospective exhibition.

For the preparation of these notes, Papunya Tula Artists made available to the writer its Clifford Possum file, containing records of 150 of the artist's paintings over the period 1973–1991. These records, which the company keeps of all its artists' work, were accumulated over the years by a succession of painting company coordinators and company field officers. Since the time of Geoffrey Bardon, every Papunya Tula painting has gone into the world accompanied by its annotation, which identifies the artist and tribe, the story of the painting and usually the precise date of production. Many have copied this format, but none have matched Papunya Tula for accuracy and detail.

The historical importance of this material cannot be overstated. In particular, the annotations which Dick Kimber, Janet Holt nee Wilson and John Kean prepared for *Warlugulong*, 1976, *Warlugulong*, 1977, *Kerrinyarra*, *Man's Love Story*, 1978, *Mt Denison Country* and *Yuutjutiyungu*, 1979 are so detailed and so informative that most art historians would argue against making any changes to them – even minor corrections in the light of the artist's later comments. However, Clifford Possum's individual and cultural authority to pronounce on the meaning of his work should, in the writer's view, be allowed to override such considerations. The historical authority of Papunya Tula's annotations is acknowledged by transcribing them in full wherever they were available, with corrections fully acknowledged and only to points which conflict with the artist's account.

However, the records from the early 1970s are sketchier. Only one painting, *Honey Ant Ceremony*, 1972 has a Stuart Art Centre stock number which gives any precise indication as to its date of production. A few others have high numbers in the voluminous nineteenth Consignment, in which many of the paintings were those left undocumented from the Bardon times, which were later annotated by Peter Fannin. Most of Clifford Possum's paintings after 1990 were not handled through Papunya Tula or even regular commercial outlets. Precise dating is often difficult. Where paintings were obtained directly from the artist, the notes provided usually extrapolate from his explanations of the symbolism to the purchasers.

1★ **Emu Corroboree Man**
1972
synthetic polymer paint on composition board
45.8 x 61.5 cm
Collection of Larry and Susan May

The site depicted in this painting is Ngalikulong, a waterhole north of Yuendumu settlement, beyond the blue mountain known as Wakulpa. Ngalikulong is an Emu Dreaming site, to which the artist is connected through his Tjapaltjarri grandfather. Tjapaltjarris are 'policemen' or kurtungurlu for this ceremony. Tjampitjinpas and Tjangalas are owner–keepers of the site.

The painting shows an Emu Corroboree Man dancing in full ceremonial regalia. He wears a pubic belt and the body paint for the Emu corroboree. Behind him he holds a shield bearing the emu design, including emu footprints. His headdress or 'kutarri' (Anmatyerre) is adorned with emu feathers. Two large sacred boards or tjurungas, also decorated with emu designs, are attached to his back and four larger ones bearing the same designs are shown below and on either side of the dancer.

The smaller tjurungas around the edge of the painting decorated with similar designs are traditionally inserted in the headdress. The two long shapes at the bottom of the painting decorated with paintwork that looks like carved incisions on wood and white tassels are also part of the kutarri. The six smaller circles surrounded by small emu footprints down the sides of the painting are body paint worn in the ceremony. Two ceremonial poles or 'atarra' (Anmatyerre) topped with emu feathers and flanked by realistic emus in silhouette are shown on either side of the Corroboree Man.

(These notes were based on information supplied to the writer by Clifford Possum in 1993.)

This is the first painting Clifford Possum did for Geoffrey Bardon in the painting

room at Papunya, in February 1972. A few months later it was sold to an American traveller who was in a Papunya by a remarkable combination of circumstances.

The Fate of *Emu Corroboree Man*

In May–June of 1972, my good friend Harold T. Coss and I were traveling in the outback by way of a Land Rover we had rented in Alice Springs. We had traveled out of Alice Springs to the Amadeus Trough area, then to Ayers Rock and out to Mount Olga. From there we went through Docker River then north up the 'Gun Barrel' highway to Sandy Blight Junction. Our intent had been to head out to Lake Mackay and the Canning Stock Route but we had vehicle problems, so prudently turned towards Papunya via the Kintore Range and Liebig Bore to see if we could arrange for repairs. Near Liebig Bore we encountered a jeep loaded with Aboriginal men and children out hunting kangaroos with the driver, Mr Peter Fannin, of the Papunya Native Settlement. They had been drawn towards us by the sounds of our straining vehicle approaching out of the west, an extremely rare occurrence in those days. After meeting everyone in the jeep and making inquiries about the availability of fuel and spare parts in Papunya, the two parties separated. The Aboriginal group continued on their hunt, while we gingerly nursed our rental Land Rover with substantial transmission problems on toward Papunya.

That night, still about twenty miles west of the Aborigine community, Mr Coss and I set up camp and prepared a late evening meal. While cooking, Fannin's jeep and the successful hunters came along and stopped by our camp. We invited them all to share what we had, providing them with about a week's supply of our canned goods and bread, and also sharing the meat from a small kangaroo that the hunters had taken earlier in the day. After a congenial meal, Fannin invited us to look him up in Papunya, piled his mob back into the heavily laden jeep, and jounced east into the late desert night toward home.

The next morning, we broke camp and drove toward the bright sun as it broke over the horizon. Several miles from the settlement, we encountered a spry, elderly man named 'Nosepeg', ambling toward Papunya and picked him up. During the ride Nosepeg gave directions to reach the store and 'in proper Queen's English', guided us by the school where Peter Fannin worked as a teacher. After a windshield tour of the settlement and picking up some powdered milk for his family, we drove Nosepeg back to his camp, met his shy family, and then returned

to Papunya. As school was finishing for the day, we approached the school and saw Fannin, who invited us to stay over at the house where Peter and his roommate, Geoff Bardon, were living.

The warm invitation was accepted, and that evening we met Geoff and received introductions to the Aborigine men who were on the Papunya Village Council (PVC) at a social 'Workman's Night' gathering. There, we first met many of the artists whose 'dot paintings' and creativity would later mushroom into a significant international art movement. As the evening conversations with the PVC men expanded, Mr Coss and I became more and more intrigued, and extended our stay in the Papunya area. While there we accepted invitations to 'go for a walkabout' for a few days to the north and west of Papunya with Bill Stockman and Jim Tjangala, and afterwards to camp with the 'single men' of the settlement.

Between wanderings, we visited the shop area where the artists were working. The enthusiastic Bardon showed us numerous paintings, helped with more introductions that led to permission for us to photograph some of the artists at work, and explained how this new (to Westerners) developing art form evolved from making ephemeral 'sand-speak' drawings scratched on smoothed out, sandy ground. Geoff also voiced how it was hoped that the sale of their paintings might offer a way for the men to develop an economic base and inform people of Australia of the needs of the Aborigines, and their wishes for preservation and appreciation of their culture.

That evening, our last in Papunya before heading back to Alice Springs to have our vehicle repaired, Geoff showed us even more paintings with a nod that they too could be purchased if we wished. After I bought the *Emu Corroboree Man* painting by Clifford Possum and two other paintings, and Mr Coss bought a painting and a carved, painted carpet snake signed by Bill Stockman. Geoff prepared sketches interpreting the icons and symbols that were depicted in the artwork. He also suggested that Clifford Possum's painting of Emu Dreaming with the prominent and detailed likeness was a bit controversial because some Aborigines felt it might compromise their prohibition of sacred and secret images that might have a ceremonial context and that should not be viewed by someone who was not 'initiated'. All the paintings were bought because they evoked unique and fond recollections of our time and adventures in the desert outback.

(This story is cited here with the kind permission of Mr Larry May)

In 2003, contact was made with

Mr Larry May, the owner of *Emu Dreaming*, as the painting was originally titled on the annotated sketch which Geoffrey Bardon hurriedly prepared at the time of its purchase. The site is identified on this sketch as 'Ngalicolong' (Ngalikulong) and the explanations of the various elements are very much as Clifford Possum gave them twenty-one years later. The two long shapes at the bottom of the painting decorated with white tassels were identified in the diagram as a 'special corroboree strip worn around the waist, made of human hair with cotton plant tassles' rather than parts of the headdress as in Clifford Possum's later account. The six circles down the sides surrounded by Emu tracks were identified in the diagram only as 'special emu good places'; the background dots as 'all emu tucker'; and the white cross-hatching as 'body paint'. Geoffrey Bardon also noted the 'likely European influence' in the proportions of the figure.

Illus. *The Art of Clifford Possum Tjapaltjarri*, V. Johnson, Craftsman House G+B International, Sydney, 1994.

2★ **Love Story**
1972
synthetic polymer paint on composition board
45.5 x 61.0 cm
Ebes Collection

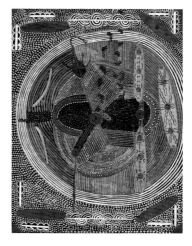

This is the second painting Clifford Possum did for Geoffrey Bardon in the painting room at Papunya, and his first version of the Love Story at Ngarlu. (see chapter 3) for a detailed account of this Dreaming, and notes on *Man's Love Story*, 1978 cat. no. 20 for more detail on the Love Story motif depicting Liltipililti Tjungurrayi's activities). All the basic

design components are already included in this painting: the spindle on which Liltipililti spins hairstring to entice the Napangati woman to his campsite 'talking with his thoughts on the wind', is shown beside the large U-shape. His footprints traverse the left-hand side of the painting. The brown concentric circles joined by straight lines represent body paint for the Ngarlu ceremony. The bunches of hair blown away by the wind as Liltipililti becomes distracted by the woman's approach are also visible against the brown flecked ceremonial ground at the centre of the painting.

The pink boards at the base of the painting and the smaller brown ones at each corner are 'ukurrukurru' (Anmatyerre) or dancing boards, used in the Ngarlu ceremony by Napaltjarri women, Liltipililti's 'daughters'. The white designs around the outside are the Napaltjarri women's sand paintings. The boomerang-like shapes at the top centre of the painting are 'tjipwala' (Anmatyerre) or 'winpi' (Luritja), the special curved sticks used for digging out honey ants.

The white circles, around the area where Liltipililti is sitting spinning hairstring with a spindle to draw the Napangati woman to his campsite, represent the mirages or 'mirrawarri' (Anmatyerre) associated with this love magic. The background infilling inside this circle denotes the topography of Ngarlu or Red Hill – 'really beautiful country'.

(Information supplied by Clifford Possum, 1993)

Illus. *The Art of Clifford Possum Tjapaltjarri,* V. Johnson, Craftsman House G+B International, Sydney, 1994

Nangara: The Australian Aboriginal Art exhibition from the Ebes Collection (2 volume exhibition catalogue), Aboriginal Gallery of Dreamings, Melbourne, 1996.

The Australian Aboriginal Art exhibition catalogue, sponsored by Yomiuri Shinbun 2001.

Contemporary Aboriginal Art, S. McCulloch, Allen & Unwin, Sydney, 1999.

Exh. *Nangara: the Australian Aboriginal Art exhibition from the Ebes Collection,* Stitching St Jan Brugge Belgium, 1996.

The Australian Aboriginal Art Exhibition, Asahikawa, Utsunomiya, Iwaki, Shimonoseki, Japan, 2001.

3★ **Honey Ant Ceremony**
1972
powder paint on composition board, 100.0 x 78.0 cm
Elder Wing Centenary Gift of The Foundation 2001.
Art Gallery of South Australia, Adelaide
Stuart Art Centre no: 16001

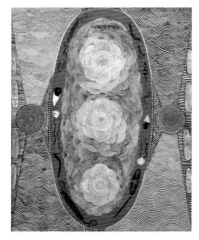

Concentric circles with eight underlying whorls overlapping each other are associated in the artist's work with Honey Ant Dreaming, notably the site of Yuulkuru (see *Yuutjutiyungu,* 1979, cat. no. 23). The three in red down the centre of the painting are a depiction of the underground nests of the Honey Ants as excavated by an ancestral woman. Her pubic belt and digging stick appear in miniature around the red rim of the large oval shape of the shield, symbolising a significant gathering of people for ceremonial purposes. Also shown here are items associated with men: boomerangs, stone knives and axes, hair string belts and sacred boards or tjurungas – larger versions of which are placed down either side of the painting. Traditional Anmatyerre symmetry is also evident in the dotted concentric circles flanking the oval, which represent ground paintings. The site depicted may be Yuulkuru, or more likely Yinyalingi, where in mythological times, groups of Honey Ant people gathered for men's and women's ceremonies (see *Yinyalingi (Honey Ant Dreaming Story,* cat. no. 32). According to the diagram, the whorled patterning represents 'growth' – perhaps of the roots of the mulga trees amongst which the Honey Ants live and whose flowers' nectar the worker ants gather to fill the abdomens of the 'storehouse' ants, a highly prized delicacy among the desert peoples.

After a long period of seclusion in a private collection in South Australia, *Honey Ant Ceremony* was advertised in the Sotheby's *Aboriginal Art,* July 2001 sales catalogue (lot 47), where it was claimed to be the artist's 'first recorded work, and … possibly his first painting'. While *Honey Ant Ceremony* is the first work of Clifford Possum's from the Stuart Art Centre consignment lists to be accounted for, there are works still unaccounted for, that were assigned to 'Clifford' in earlier consignments. *Honey Ant Ceremony* was sold before the auction to the Art Gallery of South Australia.

4★ **Honey Ant Dreaming**
1972
synthetic polymer paint on composition board
65.5 x 48.0 cm
Australian Museum, Sydney
Papunya Tula stock no: 20057

Although this painting bears the stock number 20057 on the reverse, indicating that it was painted in the last half of 1972 or even early 1973, Clifford Possum's contribution to it would appear to have been painted during Geoffrey Bardon's time in Papunya i.e. before his departure at the end of July 1972. Underneath the red wash which now covers its surface, is the painting reproduced on p. 114 of Geoffrey Bardon's second book about the early years of the painting movement, *Papunya Tula: Art of the Western Desert* (1991), and also on the back cover of his first book *Aboriginal Art of the Western Desert* (1979) as *Honey Ant Dreaming* by Clifford Possum Tjapaltjarri. The work was acquired in its present condition by the Australian Museum in 1983 as part of the Papunya Permanent Collection. It has been attributed to 'Timmy' (i.e. Tim

Leura Tjapaltjarri) on verso, no doubt because such wash-overs were one of the most distinctive features of Tim Leura's early style. However, it seems that Tim Leura added the wash later, after Bardon's departure, and submitted it to Peter Fannin as his painting.

According to the annotation Bardon wrote for the underlying painting by Clifford Possum (Bardon 1991, p. 114):

Location: Long way east of Yuendumu into the sunrise

Custodian: Tjapaltjarri-Tjungurrayi (the artist's grandfathers and fathers)

The straight lines through the centre of the painting are the journey lines of the Honey Ants travelling east through Yuendumu. The concentric circles are their camping places and the wavy radiating lines show the Honey Ant men going about looking for honey bag. The background is dotted in black over a field of yellow, white and red patches. The 'nebulous yellow shapes' are the honey bags, and the red is the earth. Bardon commented: 'Intense dotting unifies the patchy effect caused by the irregular shapes and gives the painting an impressive decorative splendour'.

Illus. *Aboriginal Art of the Western Desert*, Geoffrey Bardon, Rigby, 1979.

Papunya Tula: Art of the Western Desert, Geoffrey Bardon, McPhee Gribble, 1991.

5★ **Love (Sun) Dreaming**
1972
synthetic polymer paint on composition board
61.0 x 46.0 cm
Private collection

According to (Bardon 1991, p. 116), 'This painting describes the passion of physical love whereby an old man captures the girl of his song. Here, Clifford paints in exultation and happiness, using the incandescence of the sun as a metaphor for love. The painting gives a visual image of sunlight, clouds, shadow and earth'.

According to Bardon's diagram, the large U-shape is the sun, the long shape on the left is his digging stick, and the oval shape his shield. The cloud shapes which partly obscure the underlying designs are described as 'atmosphere'.

Like *Honey Ant Dreaming*, this work is a very early example of the artist's innovative technique of 'masking' the designs with a dotted patchwork of colours. It depicts the Ngarlu Love Story, though without the spindle with which it is usually associated in the artist's work (including the earlier *Love Story*, 1972 cat. no. 2)

Location: Arrangi, east of Mount Allan and north of Papunya

Custodian: Tjapaltjarri-Tjungurrayi

Illus. *Papunya Tula: Art of the Western Desert*, Geoffrey Bardon, McPhee Gribble, 1991.

6★ **Bushfire I**
1972
synthetic polymer paint on composition board
62.0 x 46.2 cm
Purchased 1994
National Gallery of Australia, Canberra
Papunya Tula stock no: 19361

Place: fifteen kilometres south-west of Yuendumu [Warlugulong – spelt 'Walukuklangu' in the original annotation]

Ownership: Tjampitjinpa

The bushfire started here, and swept over a vast area to the west and south. [see notes on *Bushfire II*, cat. no. 7]. The barely discernible lines are not, as I first thought, burned out people and camps, but merely a tangle of fallen wood and trees covered with charcoal and ashes. The realism of these two paintings is unusual.

© Papunya Tula Artists

The painting was acquired by its first owner from the first exhibition of Papunya paintings organised by Aboriginal Arts and Crafts P/L (the government-sponsored marketing outlet) in Sydney in 1973. According to the reverse side of the painting it was catalogued by Papunya Tula Artists in November 1972.

Illus. *The Art of Clifford Possum Tjapaltjarri*, V. Johnson, Craftsman House G+B International, Sydney, 1994.

Papunya Tula: Genesis and Genius, H. Fink and H. Perkins (eds), Art Gallery of New South Wales, Sydney, 2000.

Exh: *Papunya Tula: Genesis and Genius*, Art Gallery of New South Wales, Sydney, 2000.

7★ **Bushfire II**
1972
synthetic polymer paint on
composition board
61.0 x 43.0 cm
Purchased 1994
National Gallery of Australia,
Canberra
Papunya Tula stock no.: CL20106

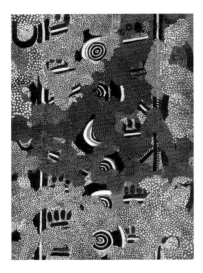

Place: On main road to Yuendumu
(Northern Territory)
Ownership: Tjampitjinpa

The dreamtime bushfire started near
Yuendumu and swept over a vast area
west and south. Many paintings of people
from widely separated areas record its
devastation. In this spectacular view we
see possum prints and tracks covered by
ashes and charcoal. No lives were lost
here. There were casualties elsewhere.

© Papunya Tula Artists

The 'CL' of the Papunya Tula stock
number stands for Clifford Leura.
Annotations from this period regularly
cite the artist as Clifford Leura (Possum)
Tjapaltjarri, presumably because he had
been introduced to the annotator as Tim
Leura's younger brother. In this very early
example of the superimposition and
overlaying of Dreaming landscapes which
remained one of the distinctive features of
the artist's work, burnt-out camps can be
seen at the centre of the painting and
possum prints, also partially obliterated by
the passage of the fire. The large dark
areas of dotting signify burnt-out country,
and the lighter areas, ash. Whoever wrote
the annotation was evidently impressed
by the painting, whose reverse side is
inscribed with the words 'Am giving this

an extraordinary $12 a square foot
[illegible] 35'.

Illus. *The Art of Clifford Possum Tjapaltjarri,*
V. Johnson, Craftsman House G+B
International, Sydney, 1994.
Papunya Tula: Genesis and Genius,
H. Fink and H. Perkins (eds),
Art Gallery of New South Wales,
Sydney, 2000.

Exh: *Papunya Tula: Genesis and Genius,* Art
Gallery of New South Wales,
Sydney, 2000.

8★ **Bushfire at Irpulku**
1973
synthetic polymer paint on
composition board
77.4 x 59.8 cm
Holmes á Court Collection
Papunya Tula stock no.: CP730935

This painting shows the country referred
to in the title as 'Irpulku', north-east of
Mount Wedge after the passage of the
great bushfire started in the Dreaming by
the old Tjangala man to destroy two
enemies, who are identified in later
accounts of this story in the artist's work
as his sons. The old Tjangala man in
question is Lungkata, the Blue Tongue
Lizard man of the Warlugulong story. (see
Warlugulong, 1976, cat. no. 17 for a
detailed account of this Dreaming).
According to the Papunya Tula
annotation, the Possum travelled through
here and to Mungapuntju (Mungapunju
– ten miles east of Yuendumu). The same
Possum was way out west at
Ngamurranya, near Sandy Blight. The
characteristic paw marks and dragging tail
of the old Upambura Possum man

travelling can be seen traversing the
painting, broken up where the path of the
fire has crossed them. According to the
Papunya Tula diagram from 1973, the
lighter set of possum prints and tail marks
through the centre indicate that there was
no water in this area, although twenty
years later the artist would interpret these
elements in accordance with the
symbolism of paintings like *Possum
Dreaming at Napperby*, 1979 (cat. no. 24) as
indicating that the Possum man travelled
by both day (light tracks) and night
(darker tracks). The country through
which he passed was growing back after
the fire. The darker areas of dotting are
charcoal from the fire, the white is ash,
the darker yellow areas are unburnt
spinifex grass, and the brighter yellow
patches, a type of yellow daisy known as
'wantjarri' (Anmatyerre) used in body
decoration and sand painting.

(These notes are based on information
supplied to the writer by Clifford Possum
Tjapaltjarri in 1993 and the Papunya Tula
Annotation for this painting prepared by
Peter Fannin in 1973.)

Illus. *The Art of Clifford Possum Tjapaltjarri,*
V. Johnson, Craftsman House G+B
International, Sydney, 1994.

9★ **Man's Love Story**
1973
synthetic polymer paint on
composition board
58.0 x 43.0 cm
Private collection

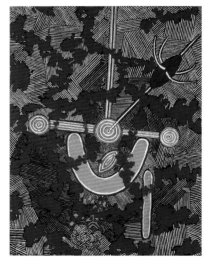

Clifford Possum's best-known version of
the Love Story motif introduced in cat.
no. 2. A detailed account of the Ngarlu
Love Story is given in the annotation of

cat. no. 20. The painting was called *Love Story at Napperby Station* in Geoffrey Bardon's original diagram annotating the work. Ngarlu is now on Mount Allan Station, but at the time the painting was created, the Mount Allan Land Claim was not yet in progress. The eastern part of what is now Mount Allan Station was once part of the Napperby lease.

Illus. *Aboriginal Art of the Western Desert*, G. Bardon, Rigby, Adelaide, 1979.

Papunya Tula: Art of the Western Desert, G. Bardon, McPhee Gribble, Sydney, 1991.

The Art of Clifford Possum Tjapaltjarri, V. Johnson, Craftsman House G+B International, Sydney, 1994.

Fieldwork: Australian Art 1968–2002, J. Smith and C. Green (eds), National Gallery of Victoria, Melbourne, 2002.

Papunya Tula: Genesis and Genius, H. Fink and H. Perkins (eds), Art Gallery of New South Wales, Sydney, 2000.

Exh. *Fieldwork: Australian Art 1968–2002*, National Gallery of Victoria, 2003.

Mythscapes: Aboriginal Art of the Desert, National Gallery of Victoria, 1989.

Papunya Tula: Genesis and Genius, Art Gallery of New South Wales, 2000.

10★ **Dreaming Story at Warlugulong**

1976
synthetic polymer paint on canvas board
50.0 x 40.0 cm
National Museum of Australia
Papunya Tula stock no.: CP76928

The site of Warlugulong, approximately 300 kilometres north-west of Alice Springs, inspired this painting. It is owned by men of the Tjangala and Tjampitjinpa sub-sections of the Warlpiri tribe, but the Anmatyerre have strong links.

In the Tjukurrpa – the Dreaming, a Tjangala travelled through the country carrying a fire stick. Actually, he was a man. His two sons followed behind and, although they had enjoyed a meal of kangaroo the previous day, they were now hungry again.

Lungkata decided to light a fire. He touched the fire-stick to a bush and it exploded into flame. The flames licked out, flicking as the tongue of the Blue-Tongue, and indeed of all lizards and snakes, still does today, and soon clumps of grass and bushes were ablaze in every direction. The two sons broke branches from trees and beat at the flames, but the tongues of fire flicked past them. Still the sons fought on, giving ground, beating away at the Bushfire, and then being forced to retreat again.

The fire licked through the grass, exploded from bush to bush in crown fire, and drove them further and further south. Eventually the exhausted sons, having been pushed some 150 kilometres to the south, saw the fire lose its explosive nature, and die.

Lungkata still resides at the place where the fire began (the concentric circles). The movement of red indicates the explosive nature of the fire, and the charcoal areas indicate the burnt out country, the white dots being ash.

In some way the story has a double lesson: one must be careful with the use of fire, and one must also be careful with lizards and snakes – their tongues 'come from nowhere', and are indicative of their striking ability.

© Papunya Tula Artists

Note: This is Clifford Possum's first painting of the bushfire motif, which inspired his selection to paint a larger version for the BBC film crew (*Warlugulong*, 1976 cat. no. 17). Though this annotation repeats parts of the more detailed account of the Warlugulong story given in the notes for cat. nos 17 & 18, it has been included here for purposes of comparison, which disclose the significant omissions (e.g. the death of Lungkata's two sons in the fire) in the earlier version.

Painted at Alice Springs, September 1976.

Illus. *The Art of Clifford Possum Tjapaltjarri*, V. Johnson, Craftsman House G+B International, Sydney, 1994.

11★ **Aralukaja**

1976
synthetic polymer paint on canvas board, 50.5 x 40.3 cm
South Australian Museum, Adelaide
Papunya Tula stock no.: CP 76952

Aralukaja (or Yarumayi, as the artist usually refers to the site now★) is a large soakage site near Boundary Bore, about twenty kilometres east of Yuendumu on the Tanami Road. Tjapaltjarri and Tjungurrayi (the artist and his father) are custodians for this site. Here, two men sat down (horse-shoe shapes) and set up camp (concentric circles). They were skin brothers who had just been through ceremonies together at a place to the North, near Mount Allan:

> Might be two Tjungurrayi, might be two Tjapaltjarri: two sons. That is the trouble. Those two should be friends.

When they had made camp, the older man said to the younger, 'We ought to go hunting for food' but the other man replied 'No! I'm too tired'. The man who wanted to hunt stood up and went off to hunt making no further comment.

The original Papunya Tula annotation says here that he returned later, laid down his catch and then – inexplicably – began to threaten his brother with his stone axe or 'mardapa' (Anmatyerre). However, as Clifford Possum himself told the story, the older man returned from hunting alone empty-handed, blaming the younger man that he had caught nothing, 'because he was proper really thinking long – really worried for his brother'. But now he was 'proper really hungry' and angered by the other's lack of cooperation.

With his stone axe he made threatening gestures, and soon was chasing the man who had refused to hunt between and around trees. At each tree he attempted to

strike down his companion, but did not succeed. The concentric circle and U-shaped forms above and below it represent the men's camp while the surrounding footprints depict the chase. Their tracks going off at the right-hand side of the painting lead onto *Five Dreamings,* cat. no. 12 where the final outcome is viewed.

★ The reason for the alternation between the names Aralukaja and Yarumayi for this story may be explained (like the similar alternation between Yakuti and Mungapunju for the Possum Dreaming at Ten Mile), by Yarumayi being the name for the whole area, as well as the name of the ochre pits nearby whose pale yellow pigment is used in certain ceremonies for this region. See notes on *Yuutjutiyungu* cat. no. 23 for another account of the Aralukaja story.]

These notes are based on information supplied to the writer by Clifford Possum Tjapaltjarri in 1993 and the Papunya Tula Annotation for this painting prepared by Janet Holt nee Wilson in 1976.

Illus. *Dreamings: Art of Aboriginal Australia,* P. Sutton, Viking, New York, 1988.

The Art of Clifford Possum Tjapaltjarri, V. Johnson, Craftsman House G+B International, Sydney, 1994.

Exh. *Dreamings: Art of Aboriginal Australia,* Sydney, 1988–89.

12★ Five Dreamings

1976
synthetic polymer paint on canvas board
50.5 x 40.3 cm
South Australian Museum, Adelaide
Papunya Tula stock no.: CP76953

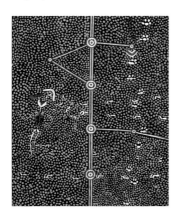

Five mythological stories are depicted in this painting. The double white foot tracks represent two men – one pursuing the other because he refused to hunt. They had come from the site called Aralukaja, the top track representing the pursuer, the lower the pursued. The pursued man was finally caught and dragged to the ground by his hair. His pursuer killed him with his stone axe by splitting his head open (as shown on the painting) and sat down exhausted to contemplate his action (horseshoe shape). [See cat. no. 11 for Part 1 of the Yaramayi Goanna Brothers story, possibly the artist's first depiction of it. Peter Sutton wanted to call this painting *Two Men Fighting* in *Dreamings: Art of Aboriginal Australia,* after the figure of the younger brother as a skeleton with his head split open which dominates the painting.]

The central series of concentric circles linked by straight lines represent part of the mythological route of the Honey Ant people who travelled extensively throughout Anmatyerre tribal country. The Honey Ant sites represented by the circles are from the top – Yabbierangu, Yuelamu, Yuutjutiyungu and Yuendumu.

The track with the padded foot and four toes is that of the 'Papa' or Dingo mythology that travelled from Western Australia past Arrangi (Dingo Downs Station) from Pikilyi (Vaughan Springs Station), 'Little Papunya' near Mount Allan (lower concentric circle) and east into Alyawerre tribal country. This Dingo was an old man of the Tjungurrayi sub-section. Where his tracks are accompanied by human foot tracks, a common characteristic of mythologies is viewed: that the mythological being alternates the features and activities of a man or animal.

Transverse to the Honey Ant and Dingo routes, from left to right, is the Mala (Wallaby) People's tracks travelling east from Warlugulong (approx. 300 kilometres north-west of Alice Springs) where Lungkata (Blue Tongue Lizard) started a raging bushfire that dispersed many people in its path. The Mala's travels are extensive, looping out from Napperby Creek to the Tanami Desert, far to the north-west of Alice Springs.

The lowest transverse mythological route is that of a woman (of the Nungurrayi subsection) who travelled from far in the South in Pitjatjantjara country almost due north to Punarakumba in the vicinity of Hooker Creek (now Lajamanu, 1000 kilometres

north-west of Alice Springs).

© Papunya Tula Artists

Illus. *Dreamings: Art of Aboriginal Australia,* P. Sutton, Viking, New York, 1988.

The Art of Clifford Possum Tjapaltjarri, V. Johnson, Craftsman House G+B International, Sydney, 1994.

Exh. *Dreamings: Art of Aboriginal Australia,* 1988–89.

East to West: Land in Papunya Tula Painting, Tandanya Aboriginal Cultural Institute, Adelaide, 1990.

13★ Possum Country

1976
synthetic polymer paint on canvas board
50.5 x 40.3 cm
South Australian Museum, Adelaide
Papunya Tula stock no.: CP76954

Mungapunju is a site located close to Yuendumu Settlement approximately 300 kilometres north-west of Alice Springs. Associated with it is the Possum mythology – of Wyuta ['Upambura' in Anmatyerre], an old man Possum of the Tjangala sub-section who in this instance is travelling east from Mungapuntju towards Altjupa.

Wyuta searched for food to eat, often spending all night looking for a good feed. His tracks indicate this activity, the wavy lines being his tail, the white foot tracks depicting where he travelled in the day time, and the red foot tracks depicting where he travelled in the night.

The Possum's foot is shown clearly, indicating its claw-like shape which enables it to move with agility in trees and on the ground. The coil-like concentric circle represents the Possum's home, and being derived from the common symbol of the concentric circle

representing in general, a 'meeting place' or 'home', the nature of the Possum tail 'tracking in' to one central point.

Painted in Alice Springs, September 1976.

© Papunya Tula Artists

Illus. *The Art of Clifford Possum Tjapaltjarri*, V. Johnson, Craftsman House G+B International, Sydney, 1994.

Exh. *East to West: Land in Papunya Tula Painting*, Tandanya Aboriginal Cultural Institute, Adelaide, 1990.

14★ Possum and Rainbow Snake

1976
synthetic polymer paint on canvas board
50.5 x 40.3 cm
South Australian Museum, Adelaide

Papunya Tula stock no.: CP761024

Two different mythological stories are involved in this painting. The track of Wyuta the Possum ['Upambura' in Anmatyerre], an old man of the Tjangala sub-section who fled west of Napperby Station and Mungapunju to escape the tremendous fire started by Lungkata (Blue Tongue Lizard) at Warlugulong. Wyuta's foot print is quite distinctive, showing the claw-like nature of his foot that enables versatile movement both on the ground and in the trees.

Travelling transverse to Wyuta's path is the Rainbow Snake called Nyatingajarra whose mythological trail was made before Wyuta's. Nyatingajarra had travelled south from Hooker Creek (now Lajamanu) to Altjupa (the artist's father's site on the West boundary of Napperby Station), and along Bullocky Creek. This snake formed a water course as it moved over the country. This was achieved by blowing through his nose.

The site of Altjupa is represented by the central set of concentric circles. In terms of the ceremony enacting Nyatingajarra's activities, this site is a 'business camp' – where sacred knowledge is imparted of a 'high school' level; that is, knowledge imparted only to men in the post-initiatory stage of learning. The arcs constituting the central design element represent the snake's ribs, while the motif extending from this is the air from the snake's nose. The large arc around the central site is a rainbow, this probably being connected with the forming of a water-course.

Painted at Mbunghara Camp, October 1976.

© Papunya Tula Artists

Illus. *The Art of Clifford Possum Tjapaltjarri*, V. Johnson, Craftsman House G+B International, Sydney, 1994.

15★ Rock Wallaby Story

1976
synthetic polymer paint on canvas board, 61.0 x 45.5 cm
National Museum of Australia, Canberra

Papunya Tula stock no.: CP(76)1026

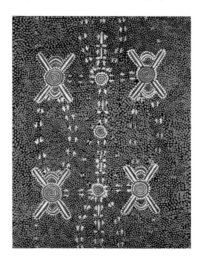

Approximately 280 kilometres north-west of Alice Springs, and west of Mount Wedge, is the site of Marru(nga), (sometimes called Waite Creek). From this site, the Mala or Rock Wallaby ['Tjilpa' in Anmatyerre] travelled south-west past Ayers Rock into Pitjatjantjara country.

The central series of concentric circles is the central camp at this site. The other concentric circles are related, and those accompanied by the horse-shoe shape and the four extended lines are the camps made by two old men wallabies. The

horse-shoe shape represents one of the old men seated, and the extended lines represent his whiskers and indicate his age.

These two old wallaby men were of the Tjangala sub-section group, and whilst at this site they led young initiates through part of their instruction in Aboriginal law and ritual. The tracks show the movement of the men's travels in the area. Such excursions into the bush were fundamental to the younger men's instruction, and often they were compelled to 'stay bush' for up to two years.

Painted Mbunghara Camp, October 1976.

© Papunya Tula Artists

Illus. *The Art of Clifford Possum Tjapaltjarri*, V. Johnson, Craftsman House G+B International, Sydney, 1994.

16★ Lungkata's Two Sons at Warlugulong

1976
synthetic polymer paint on canvas board
70.5 x 55.0 cm
Mollie Gowing Acquisition Fund for Contemporary Aboriginal Art 1996
Art Gallery of New South Wales, Sydney

Papunya Tula stock no. CP76969

There are three Dreamings depicted in this work which are visible by the tracks. The pair of white tracks represent those of the two young sons who had not shared meat with their father, Lungkata. Lungkata started a great bushfire at Warlugulong. The two sons died in this fire at a site called Jambijimba-Jarra. The white dots represent the ash.

An old man's tracks lower than and traversing the two sons' trail are those of Upambura. He is searching for food.

The third set of tracks are those of a father, mother and son who are travelling to Ngama. This work predates Clifford's *Warlugulong*, 1976 by one month.

© Papunya Tula Artists

Exh. *Copyrites: Aboriginal Art in the Age of Reproductive Technologies*, Art Gallery of New South Wales, 1996.

Gamarada, Art Gallery of New South Wales 1996.

Australian Collection Focus: 'Warlugulong', 1976, Art Gallery of New South Wales, 1999.

17★ **Warlugulong**
1976
synthetic polymer paint on canvas
168.5 x 170.5 cm
Purchased 1981
Art Gallery of New South Wales, Sydney

1 Sandhill lined claypan-lake country, home of a Great Snake
2 Lungkata's sons forced back by the fire
3 Travelling route of Yarapiri, the Great Snake from Winparku
4 Dancing Women from Pikilyi
5 Upambura, old Possum man travels back home to Napperby
6 Kerrinyarra
7 Two Carpet Snakes travel north-easterly from the claypan lake
8 Takarilla-Buntja
9 Pair of Carpet Snakes travel the country, holding ceremonies
10 Mala Hare Wallaby men, travel in a fighting group armed with spears
11 Emu from Yaliyumu travelling to Warlpiri country
12 Storm from Kalipinpa which formed the Rain Dreaming
13 Wedge-tailed Eagle kills Euro at Wakulpa
14 Women travelling from Aileron area for ceremonies
15 Warlugulong
16 Mala Hare Wallaby men and Possum men have a big fight, the northern Possum men having a great advantage because they possess boomerangs (as well as spears)

17 Kutupa
18 Aruakuna
19 Arangkia
20 Euro begins frantic attempt to escape attacking Wedge-tailed Eagle
21 Takara

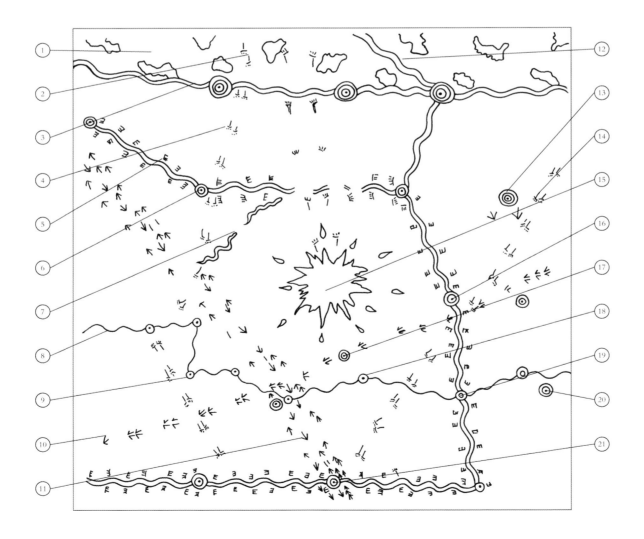

This painting is the most complex ever created by any of the Papunya Tula artists. Both Clifford Possum Tjapaltjarri and his brother, Tim Leura, are very good artists, and in this work they have combined their talents.

Traditionally – and to this day – similar ground mosaics are created by Central Australian tribes. They are secret–sacred, and belong to the men's religious world. In their creation an area of ground is cleared, moistened and then decorated in symbols which tell of mythological ancestors: native daisies are chopped and pounded to make a plant down, this is mixed with various combinations of black, white, red and yellow colouring, and the design is structured from this. Upwards of twenty men may be involved in the labour over a period of perhaps ten hours, songs being chanted for much of the time. The final magnificent work may then almost instantaneously be destroyed in its ceremonial use, and is always totally destroyed at the completion of the ceremonies.

The canvas gives details of several legends, the most, in fact, ever presented on one of these adapted works of art which, as with actual ground paintings, is intended for plan viewing. In its creation the bushfire was centrally placed to give artistic balance, certain of the mythological routes were slightly altered to maintain this balance, and minor imperfections were purposefully made to allow secular viewing. Added to this, only a secular description of events, rather than a secret–sacred, has been given to ensure that offence is not given to other Aboriginal men. This is common to virtually all paintings, the artists having, in general, come to grips with an acceptable way of presenting their art to an audience they recognise as being largely non-Aboriginal.

The following notes give some idea of the mythology of the area, for the canvas is, in effect, a map of a section of country centred approximately 200 kilometres north-west of Alice Springs, and with a radius of about 100 kilometres. These events all took place in the Tjukurrpa, the Dreamtime creative period.

WARLUGULONG is the site where the great fire began.

Lungkata, the Blue-Tongue Lizard man, had rested at this site. His two sons, following behind, speared a kangaroo, cooked it, and then greedily ate it all. The father, wondering why his sons were so long, suddenly sensed what had happened. Determined to punish them, he blew on a fire-stick until it glowed, then touched it to a bush. The bush exploded into flame (as the painting illustrates), then burnt everything in its path. Tongues of flame flicked out, as do all lizards' and snakes' tongues to the present day, and soon the two brothers were fighting the flames. They broke branches and beat at the fire, but always the front leapt beyond them, forcing them back, as the tracks indicate. Far to the south they perished, going into the ground as the bushfire lost its fury and died.

Lungkata and his two sons reside at the site where the fire began, nearly 300 kilometres north-west of Alice Springs.

All mythological events are 'larger-than-life' – more intense, more devastating, more uplifting, more heroic – and yet are related to it. Just as the bushfire was so devastating, so the Dreamtime storms were all derived from a 'storm to end all storms'. The trail which begins on the uppermost edge of the painting shows how the Rain Dreaming came from Kalipinypa, far to the west. Here the wind blew, the dust clouds scurried and billowed, and then the Lightning Man, 'boss' of the storm, struck. He lashed the storm into a furious deluge. The rain poured down, running over the ground, filling the rock-holes, flowing out until it formed a creek and a sheet flow over the earth. And then the storm travelled easterly, creating more claypans and rock-holes on its way.

Near Kerrinyarra, a large mountain 240 kilometres north-west of Alice Springs, a long line of claypans, fringed by tea-tree scrub and sandy country, runs. This country, home of an enormous snake, is depicted on the left-hand side of the painting. When the great rains come these claypans fill, and form an almost unbroken line nearly twenty kilometres long: the mythological Snake is believed to have stirred, and may lurk in waters ready to attack those who do not respect his power.

Two carpet snakes are depicted as travelling northerly from this 'lake', and yet another pair of Carpet-Snake men travelled on the lower route which traverses the entire painting. Coming from the vicinity of Hooker Creek [Lajamanu], some 1000 or so kilometres north-west of Alice Springs, they travelled the country, calling people together at various places to instruct them in the performance of ceremonies. Each small set of concentric circles marks a place where the ceremonies were held, an identifiable location to the present day as with all such sites depicted in the painting – Nyamala-ungar-angutja, Yunkurru, Takarilla-buntja, Arrunga-puta, Takara, Aruakuna, Arrangi; the place names run from the north to the south over a vast stretch of country.

Similarly, the uppermost transverse route is that of Yarapiri, an enormous snake who, travelling from Winbar'ku (a sacred mountain over 300 road kilometres to the west of Alice Springs), made many features of the present landscape as he travelled north into the Tanami Desert, far to the north-west of Alice Springs. The white blotches near the edge of the painting indicate that he passed through limestone country.

Mythological storms such as that which began at Kalipinypa are usually associated with subsequent events – the appearance of waterbirds at the claypan 'lakes' and rock-holes, regrowth of plants and therefore of vegetable foods, and activity by mythological people and animals. Thus two women of the Napanangka sub-section (each indicated by one footprint) are indicated as travelling from Pikilyi (approximately 380 kilometres north-west of Alice Springs) in a southerly direction; these women were dancing, celebrating the prolific fruit and vegetable foods, and from far in the east, in the vicinity of Aileron (near Alice Springs) other women came. The sets of footprints are shown to the left-hand and right-hand sides of the painting, their moves towards convergence showing that later they met and held Women's ceremonies which were very happy ones.

The availability of grass and plant foods is implicit in at least two other aspects of the painting:

The line of sites on the right-hand side of the painting (unlike most, they are not depicted as linked) shows the route of a terrified Euro (hill-dwelling 'cousin' of the kangaroo) as he was chased by a Wedge-tailed Eagle. The Euro, browsing on grass in the Aileron area, suddenly became aware of a great Eagle. He fled from hill to hill, seeking sanctuary among the rocks, but the huge Wedge-tailed bird was relentless in pursuit. Eventually, at

Wakulpa – where a set of talons is depicted in the painting – the Eagle swept down. His talons struck and the great beak tore, and the Euro was killed. After he had fed, the Eagle flew on to the West, forever ready to sweep down and to rend and tear.

Conversely, the long set of Emu tracks indicates a friendlier relationship. Here is indicated the travelling of an Emu ancestor from Yali-Yumu, a site in the heart of Anmatyerre country where soakage waters and food are readily available. He travelled westerly into Warlpiri tribal territory, there meeting a large group of other Emus. These he invited and encouraged back to the Yali-Yumu area, thus establishing the good emu country that exists to the present day.

Interestingly enough, this is the one element of the painting over which the two Tjapaltjarri artist brothers have no direct authority. However, perceiving a need for some further mythological element to give even greater balance to the canvas, they asked permission of two Tjampitjinpa sub-section brothers to depict part of a mythological trail over which they had ownership rights. The Tjampitjinpa men agreed, and so a further travelling route was added.

Finally, one has the mythological trails of the Possum men – a large route somewhat like a U resting on its side – and the Mala (Hare Wallaby) men. The Mala Hare-Wallaby men came from far in the South, from sandy spinifex country. Travelling through Kambakapiti, a gap in a range some 200 kilometres north-west of Alice Springs, they came to Kutupa, a small black hill; here they drank at a large rock-hole. Passing on they came to Yakuti, where they suddenly came face to face with the Possum men. Here they had a big fight, the northern Possum men using Karli (boomerangs) with devastating effect, while the Mala only had Kulata (spears).

Such a fight may well reflect that a battle did take place in the area long, long ago. Certainly it is an interesting fact that the Pitjantjatjara people, far to the south in the vicinity of the South Australia – Northern Territory border, did not traditionally make boomerangs.

The above completes a brief summation of the basic mythological events depicted in this very complex painting. As can be seen, not only are

natural features of the landscape explained, but the stories tell of natural phenomena such as storms and bushfires; may well have a moral base; indicate social relationships, and so on. Furthermore, although derived from the men's secret–sacred religious world, the painting is an adaption from this realm, deliberately manipulated to allow for general viewing whilst also maintaining faith with tribal law.

© Papunya Tula Artists

Illus. *Australian Perspecta '81*, Bernice Murphy, Art Gallery of New South Wales, 1981.

Patrick White's Choice, cover, Art Gallery of New South Wales, 1981.

Ten Masterpieces of Australian Painting, Art Gallery of New South Wales, 1993.

The Art of Clifford Possum Tjapaltjarri, V. Johnson, Craftsman House G+B International, Sydney, 1994.

Yiribana, M. Neale, Art Gallery of New South Wales, 1994.

The Art Gallery of New South Wales Collections, E. McDonald, Art Gallery of New South Wales, 1994.

Australian Collection Focus: 'Warlugulong' 1976, Art Gallery of New South Wales, 1999.

Papunya Tula: Genesis and Genius, H. Fink and H. Perkins (eds), Art Gallery of New South Wales, Sydney, 2000.

Exh. *Australian Perspecta '81*, Art Gallery of New South Wales, 1981.

Patrick White's Choice 1981, Art Gallery of New South Wales, 1981.

Project 41: 'The mosaic The grid, Art Gallery of New South Wales, 1983.

Art Treasures of Olympic Cities, Lausanne Olympic Museum, 1993.

Copyrites: Aboriginal Art in the Age of Reproductive Technologies, Art Gallery of New South Wales, 1996.

Australian Collection Focus: 'Warlugulong' 1976, Art Gallery of New South Wales, 1999.

Papunya Tula: Genesis and Genius, Art Gallery of New South Wales, 2000.

Postmark Post Mabo June–September 2002, Post Master Gallery, National Philatelic Centre, Melbourne.

18★ **Warlugulong**
1977
synthetic polymer paint on canvas
201.5 x 338.0 cm
Ebes Collection
Papunya Tula stock no.: CP77624

[**N**ote: The first two paragraphs of the annotation for *Warlugulong*, 1977, dealing with ceremonial ground paintings and their relationship to the painting, have been omitted here because they repeat the second and third paragraphs of the annotation for *Warlugulong*, 1976 (cat. no. 17). The story of Lungkata and his two sons who perished in the terrible bushfire is as it appears in the annotation of the first *Warlugulong*. The reader should refer to the diagram of *Warlugulong*, 1976 and to the annotation for cat. no. 17. The original Papunya Tula annotation for this painting then continues … .]

A family group can be seen crossing through the bushfire area from south to north. The three sets of footprints are those of a father, son and mother, of the Tjupurrula, Tjakamarra and Napanangka subsections respectively. They are travelling from Winpar'ku, a mountain south of Haasts Bluff (approximately 250 kilometres west of Alice Springs), to Ngama, a cave near the Yuendumu settlement.

The long set of Emu tracks, above the path of the bushfire, indicates the travels of a 'boss emu' of the Tjampitjinpa sub-section. [See the notes on *Warlugulong*, 1976 for the rest of the Emu story. The Papunya Tula annotations for *Warlugulong*, 1977 add only that the 'boss emu' found the group of emus at the site of Walwalpa.]

One of the more sinister legends presented in this painting is that of a Tjungurrayi man. He is represented sneaking up to ceremonial areas with the intention of stealing sacred objects. This Tjungurrayi is foiled at Yuelamu (Mount Allan), Kalpirrijarra (Brogus Flat), Yuendumu, and Yalang-imi, but eventually succeeds in Alyawerre country to the North-East of Alice Springs. He then returns to Kunatjarrayi, from whence he came. [See notes for *Yuutjutiyungu*, 1979 cat. no. 23 for a fuller account of the Tjungurrayi's activities.]

To the south of the Emu path are the tracks of a group of women from the Aileron area who travel through the area

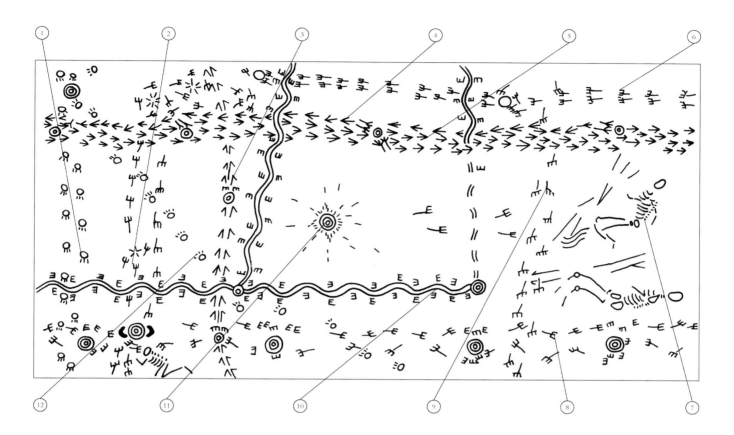

1. Tjangala and Nungurrayi Dingoes to Warrabri
2. The Camp and Chase of the Goanna men
3. Rock Wallabies from Port Augusta
4. Boss Emu
5. Large group of Emus returning to Napperby
6. Dancing women from Aileron
7. Lungkata's Two Sons (Tjampitjinpas)
8. Tjungurrayi man sneaking up to Sacred Sites in order to steal Sacred Objects
9. Travelling Family (Tjupurrula, Napanangka, Tjakamarra) to Ngama
10. Trail of the Possum men
11. Warlugulong
12. Tjangala Dingo from Ngama

covered by the painting, and on to the east arriving at a lake site Molla-warra. As they travel they hold joyous ceremonies, marked as blank circles along their path.

Emerging from the south is the track of the Mala or the Hare Wallaby. This is an extensive line of travel. It starts around Port Augusta and eventually reaches the 'Top End' after passing through the artist's country. The wallaby can be seen slowing down and drinking at soakages and rockholes along his path.

The track with the padded foot and four toes is that of the 'Papa' or Dingo mythology that travelled from Western Australia to Arrangi (Dingo Downs Station). This old Dingo of the Tjangala sub-section there meets a female Dingo

of the Nungurrayi sub-section, and they travel north together to Warrabri.

Two goanna men are represented sitting down at the site called Aralukaja (Yarumayi – horse-shoe shapes at concentric circles). [See notes for cat. nos 11 & 12, for fuller accounts of The Camp and Chase of the Goanna Men.]

Finally, one has the mythological trails of the possum men – a large U-like route. (The Papunya Tula annotation of *Warlugulong*, 1977 here recounts the story of the encounter of the northern possum men and the southern hare or rock wallaby men at Yakuti. In fact, since the Possum men involved in this incident were already at Mungapunju performing ceremonies and stayed there after the

fight and the subsequent ceremony, these must be the tracks of Wyuta [or in Anmatyerre 'Upambura'] the old Tjangala possum man of *Possum Country*, 1976, cat. no. 13 and also many of Clifford Possum's other paintings.

Illus. *The Art of Clifford Possum Tjapaltjarri*, V. Johnson, Craftsman House G+B International, Sydney, 1994.

Exh. *The World Over, Under Capricorn: Art in the Age of Globalization*, Wellington Art Gallery, Wellington, New Zealand, 1996.

Australian Collection Focus, Art Gallery of New South Wales, 1999.

19★ **Kerrinyarra**
1977
synthetic polymer paint on
canvas
238.0 x 365.5 cm
Westpac Corporate Art
Collection
Papunya Tula stock no.: CP771039

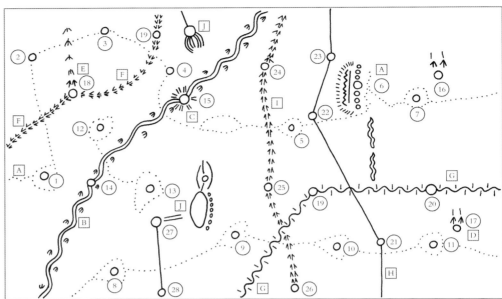

Tjapaltjarri is one of the youngest artists working at Papunya and has been the most willing to experiment with the traditional iconography of his group. He has perceived the parallels between the ceremonial ground mosaics of the Anmatyerre and Western style maps. Ground mosaics are made by many of the Central Australian Aboriginal tribes. [See notes for *Warlugulong*, 1976 cat. no. 17 for a description of the preparation and use of ground mosaics.] These mosaics are then used as part of the ceremonial celebration of the associated mythology. They form a plan on which the ceremonial activities are held. This ceremonial ground plan relates to the geographical locality at which the mythology is believed to have occurred. It is from this point that Tjapaltjarri has expanded the culture's traditional form. He has combined many mythologies on the one surface, in geographical relationship to one another. Each of these mythologies were traditionally celebrated by a ceremony and therefore a related ground mosaic.

On this occasion Tjapaltjarri has chosen to depict the mythologies around Kerrinyarra (Mount Wedge) of which he is Keeper–owner. Members of the Tjungurrayi, Tjapanangka, Tjapangati and Tjapaltjarri kinship subsections have jurisdiction over these sites. The sites (concentric circles) at which these mythological events occurred are set out in approximate relationship to each other, while travels of the 'Tjukurrpa' (Dreamtime) beings are represented as the lines of tracks that join these sites.

There follows a brief description of the mythological trails depicted and a list of the names of the sites at which important mythological events occurred.

A. The extensive travels of a group of women of the Napaltjarri and Napanangka kinship subsections are represented by the human footprints that cover much of the country depicted. The women were said to have danced for

much of the way, and held many ceremonies (at the sites at which multiple footprints are depicted), the most important of which was held at Kerrinyarra, the ground plan of which is detailed on this canvas. This mythology is of a light-hearted secular nature as when I was collecting the notes the men were keen to show any passing children the places at which the 'Kungkas' (young women) stopped to dance.

The sites at which the women stopped were

1. Nykyapini
2. Naakuuku
3. Intillpi
4. Myawakayra
5. Yaknykitjitji
6. Kerrinyarra
7. Puntja Warrmulla
8. Rrunta
9. Walyara
10. Paawintjuk
11. Narpulararrata
12. Tantaga Ngamana
13. Manyama

B. Another very important mythological trail celebrated in this depiction is that of Untanya (ie Wyuta) the Possum. Untanya was said to have travelled up and down this route in search of a possum woman. The sinuous line represents his dragging tail while his footprints are described at either side of this line. He visited
14. Allarrti
15. Alkuta Allantya.

C. At Alkuta Allantya a great and dangerous water serpent 'Wanampi' [This is the Warlpiri name, the Anmatyerre name is 'Koolia'] is believed to live.

D. 'Nguuri' the Tawny Frogmouth (night bird) ancestor landed twice within the area depicted. First at (16) Multju and then at (17) Turru Turru.

E. (18) Mutjuku is an 'Allukuppurra' (a

small predatory bird, possibly a brown hawk or a kestrel) Dreaming site. The footprints of the bird, depicted above Mutjuku, represent the bird swooping on its prey.

F. In the top left-hand side of the canvas, part of the great Tirra (kangaroo) and Rringa (euro) line of travel is depicted. Double tracks are represented, the footprints separating as the mythological creatures slowed down to drink at the water places (18) Mutjuku and (19) Utjurru.

F★. Two snake ancestors can be seen travelling south west to the right of the painting. They are 'Antatjarrka', described by Tjapaltjarri as a small grey snake.

G. A section of the 'Kuatja' or Water Dreaming mythology is represented in the bottom right-hand corner. This Dreaming line connects with important rockhole sites in Pintupi tribal territory. The sinuous lines represent the lightning while the small parallel bars represent the rainclouds associated with a great storm that passed through this area. This storm is now particularly remembered at the water places (19) Yarrukunu [Aruakuna] and (20) Uuntatji.

H. The 'Kanparrka' or Centipede Dreaming mythology cuts right across the painting from bottom to top (i.e. north-north-west to south-south-east). This trail is marked by three sites of mythological importance, (21) Kanparrka (22) Anytaltyi and (23) Palka Kerrinyarra. The centipede eventually travelled to a site near Haasts Bluff where he entered the ground.

I. Travelling from south to north, Tjillpa (a left-handed rock wallaby ancestor) progressed right across Anmatjera (Anmatyerre) tribal territory. Here he is depicted slowing down to drink at (24) Ulliturki (25) Yatitjyatitji and (26) Yarulu.

J. The last and perhaps the most significant depiction on this canvas is that of the 'Malliera' or post-initiatory instruction of the young men in tribal law. No details were given of the ceremonies or of the related mythologies, as they belong to the secret–sacred world of the men.

However, an explicit ground plan of one of the main ceremonies held at (27) Yunkurru is presented in the centre of the canvas. The other site involved is (28) Luukululku. The figure at the top of the painting related to the ceremonies held at Yunkurru.

Tjapaltjarri, who has worked over this area as a stockman as well as visiting it ritually in the role of a Keeper–owner, spoke of drinking or camping at many of the sites depicted. The names of some of the sites were given only after discussion with a group of countrymen.

He has, as well as representing the country's mythological significance, described the actual physical makeup of the area, with the use of different coloured background dots. The areas of dots describe the limits of various environments such as: grey dots – saltpans, yellow dots – desert, and pink dots – mulga tree stands.

Painted at Papunya, during October 1977.

© Papunya Tula Artists

Illus. *The Art of Clifford Possum Tjapaltjarri*, V. Johnson, Craftsman House G+B International, Sydney, 1994.

20★ **Man's Love Story**
1978
synthetic polymer paint on canvas, 214.5 x 257.0 cm
Visual Arts Board, Australian Contemporary Art Acquisitions Program 1980
Art Gallery of South Australia, Adelaide
Papunya Tula stock no.: CP7811

Clifford Possum is one of most creative of all the artists working in the vicinity of Papunya and its outstations. His ability as a carver is unsurpassed as is the strong yet subtle way he combines the depictions of many mythologies on the one canvas. In this case he has depicted three separate mythologies. The painting can be placed on the ground with the tracks of the mythological ancestors in geographical relationship to each other.

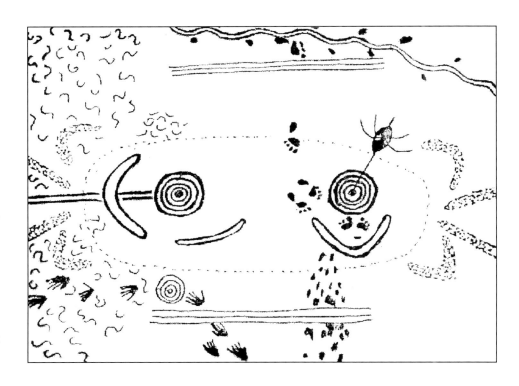

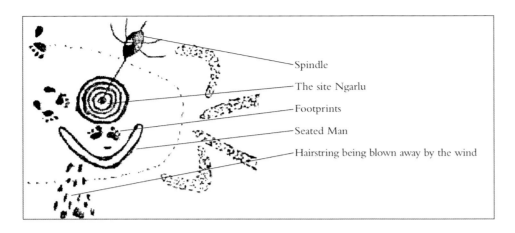

Spindle

The site Ngarlu

Footprints

Seated Man

Hairstring being blown away by the wind

The principal mythology here tells of a man and a woman of the Tjungurrayi/ Nungurrayi sub-section group. The woman came from Yuelamu in the west to Yinyalingi where she found the white sugary substance 'Lurrka' on leaves at the foot of a mulga stand. Lurrka indicates the presence of Tjala or Honey Ants, for which the woman was searching. The predominant iconograph to the left of the painting describes this action.

The iconograph to the right symbolises the activities of the Tjungurrayi man at Ngarlu, a close by but geographically distinct site from Yinyalingi. The Tjungurrayi came to this site and sat down and proceeded to spin hairstring on a simple cross spindle known as 'Wirrakurru'. Clifford said that Tjungurrayi sent a 'Telegram' to a Napangati woman whom he desired but who was the wrong kinship subsection group for marriage to Tjungurrayis. The woman was drawn to his campsite by his singing. The Tjungurrayi was so distracted by her approach that he lost concentration on his spinning and his hairstring was blown away by the wind.

The principal elements in this section of the mythology are indicated below.

During the night four Nungurrayi (kinship classification) women approached and sat in darkness around the lovers' camp. The four Nungurrayi are depicted as the dotted U-shapes at the right and left of the painting. They are accompanied rather threateningly by their digging sticks.

The large area of black symbolises 'Kanala', the area in which the post-initiate young men or 'Punyunyu' are taught this mythology, and the associated 'Law' in ceremonies known as 'Malliera'.

The long bars at the top and bottom of the Kanala were said to be 'Mirrawarri' or mirages, but the artist did not describe the part they played in the associated narrative. He also omitted to describe the meaning of the wriggly shapes to the left of the painting other than to say that they were Kapatadi, an edible green caterpillar.

The footprints at the bottom left of the painting are those of 'Arrumai' the goanna man who passed through the area in this depiction in mythological times. He was chasing a Kungka (woman) whom he eventually caught and decapitated. The principal site associated with this mythology is Yarumayi indicated by the set of concentric circles. [See notes on cat. nos 11 & 12 describing the Camp and Chase of the Goanna Men – of which this appears to be a distorted version.]

The path of another small goanna ancestor Kulluntjirri is depicted in the top right of the painting. Kulluntjirri eventually went to the lake site Mutjuku.

The coloured background dots symbolise Mulga and Witchetty seed, which was traditionally collected, ground and used in the preparation of a nutritious damper.

Painted at Mbunghara, during October 1978.

© Papunya Tula Artists, corrected by Clifford Possum 1993

Illus. *Creating Australia: 200 Years of Art 1788–1988,* D. Thomas (ed), ICCA in association with the Art Gallery Board of South Australia, Adelaide, 1988.

Art Gallery of South Australia: Selected Works, Art Gallery of South Australia, Adelaide, 1991.

Australian Colonial Art, J. Hylton and R. Radford, Art Gallery of South Australia, Adelaide, 1995.

Art history, M. Stokstad, Abrams, New York, 1995.

Dreamings of the Desert: Aboriginal 'dot' paintings of the Western Desert, V. Johnson, Art Gallery of South Australia, Adelaide, 1996.

Papunya Tula: Genesis and Genius, H. Fink and H. Perkins (eds), Art Gallery of New South Wales, Sydney, 2000.

Exh. *Recent Australian Painting 1970–83,* Art Gallery of South Australia, Adelaide, 1983

The Great Australian Art Exhibition 1788–1988, Australian national tour, 1988–89.

East to West: Land in Papunya Tula Painting, Tandanya Aboriginal Cultural Institute, Adelaide, 1990.

Aratjara: Art of the First Australians' Nordrhein-Westfalen, Kunstammlung, Germany, 1993–94.

Dreamings of the Desert, Art Gallery of South Australia, Adelaide, 1996.

Papunya Tula: Genesis and Genius, Art Gallery of New South Wales, Sydney, 2000.

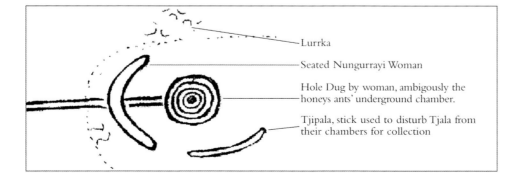

Lurrka

Seated Nungurrayi Woman

Hole Dug by woman, ambigously the honey ants' underground chamber.

Tjipala, stick used to disturb Tjala from their chambers for collection

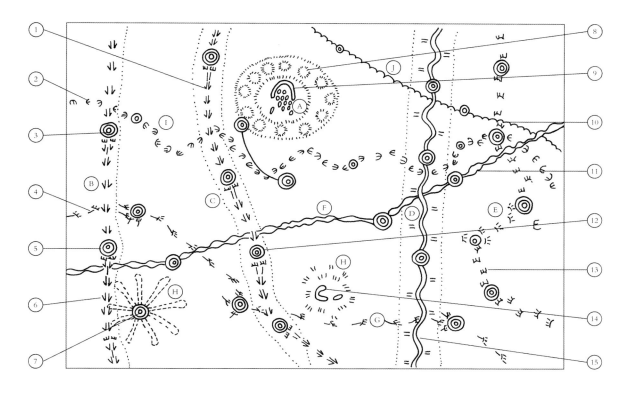

21★ Mt Denison Country

1978
synthetic polymer paint on linen
200.0 x 170.0 cm
The Kelton Foundation

1. Old Tjungurrayi Wallaby man
2. Track of Echnida man "old Backwards Foot'
3. Mutju Mutju
4. Old Tjungurrayi man 'Lover Boy'
5. Wakatjirri
6. Blue Kangaroo with joey travelling to Mount Denison
7. Tjanpapakanu Mulga Seed Dreaming
8. Camps of the Soldier Ants
9. Unprata, where an Emu (Unkarra) sat on its eggs
10. Path of Rrinpa Rrinpa Legless Lizard Dreaming
11. Path of Latji, Wild Carrot Dreaming
12. Marbo
13. Track of Old Dingo man
14. Woman grinding Mulga Seed on her oval topstone
15. Lightning Dreaming associated with Kalipinpa storm front

This painting is one a series of large canvases from the late 1970s in which Tjapaltjarri mapped much of western Anmatyerre land. In this series the intersecting trails of a constellation of ancestral heroes are depicted as they traverse the mulga plains, rocky outcrops, creekbeds and occasional sand dunes of Anmatyerre country.

The series is remarkable for several reasons. Firstly, by representing the trails of many ancestral heroes on the one canvas, the totemic landscape as a whole is highlighted, rather than the ceremonial context of a particular event or series of events, as is usual in Papunya Tula Art. In revealing the spatial aspects of the totemic landscape, non-Aboriginals are given a clear insight into a central feature of Australian desert culture – the 'mental map' whereby sites of spiritual significance are conceptualised in their geographic relationship to each other. These configurations form the basis of route finding and orientation in everyday life. Finally, these paintings are maps in a more conventional sense as the vegetation, geology and topography of the area is represented by the arrangements of background dots.

Tjapaltjarri painted the first of this series with his brother Tim Leura

Tjapaltjarri and there is no doubt that the inspiration for depicting many Dreamings on one canvas stems from this remarkable collaboration. Tjapaltjarri painted five canvases of this type, of which this painting is the fourth. The series culminated in a 7'7" x 12' depiction which featured the interconnecting underground chambers of the Yarrampi (Honey Ant) Ancestors as well as many trails on the surface of the earth [*Yuutjutiyungu*, 1979, see cat. no. 23]. Eventually these map paintings gave way to the more decorative and iconographic paintings that are characteristic of Tjapaltjarri's work in the 1980s.

Mt Denison Country depicts twelve ancestral trails as they criss-cross the mulga (*Acacia aneura*) woodland on what is now Mount Denison Station. There follows a brief description of the travels of each of these ancestral heroes. Sites at which key events occurred will be highlighted. Each of these sites is represented on the canvas by a set of concentric circles. The presence of the ancestors themselves can be envisaged by their tracks which link the sites. So as to best mirror the artist's intention, sections of the painting will be referred to in terms of compass direction.

a) The dark circular configuration is exceptional in the painting as it depicts a night scene. During the 'Creative Era' a group of ants travelled from Kakatu to

Unprata where they saw an Emu (Unkarra) sitting on its eggs. The ants surrounded the Emu's camp and (in the artist's words) 'mustered him up' then lit a circle of fires to pen in the bird. As morning dawned the ants closed in on the Emu devouring it together with the eggs.

b) The westernmost trail is the path of a Blue Kangaroo who was travelling along a sand dune with her joey from Kirrantja to Mount Denison. Key sites visited on her journey from south to north were Wakantji and Mutju Mutju.

c) Parallel to the trail of the Blue Kangaroo runs the line of travel of an Old Wallaby Man of the Tjungurrayi kinship subsection. Key sites visited from south to north were Tjatiti Wakatjirri, Marrtunkata, Upantja and Marrala.

d) The path of the Rain (Storm) ancestors is depicted to the east of centre on the top of a sand dune. This section of the story is a mere segment of a much larger mythology in which a great storm emerged at Kalipinypa far to the west and travelled east to Mikanji where a great battle erupted with another storm that had come from the east. Eventually the storms joined together and travelled through this area, far to the north. The sites depicted are Arrulyukuatja, Multju and Pingari. The storm is envisaged as having human characteristics and is associated with many other ancestral heroes during the epic journey.

e) At the extreme east of the painting the trail of a lone Dingo Man can be seen. The old Dingo Man was also travelling north and at the second site his tracks can be seen turning around as he looked back over the country from where he had come. This place is called Mintjinpullarra meaning 'looked back' in Anmatyerre. The sites are Ngulya, Mintjinpullarra, Ngarri-ulangu and Ngalinka.

f) Plant ancestors in desert mythology are embued with many human characteristics. A major feature of this painting is the route of Latji, a Wild Carrot ancestor that travelled across the area from the north-east to the south-west. The Latji ancestor travelled through Yalatjikulong, Ngalatji and Wapiti en route to ceremonies in the west.

g) The human footprints are a section of the trail of an old man of the Tjungurrayi kinship group who had previously come

from neighbouring Alyawerre country. This old man is referred to as a 'lover boy' and while in this area he had been sending telepathic 'telegrams' to women of the Napangati subsection. The sites along his trail are Rrintjirritjirri and Yurrupulku. [Possibly a reference to the Ngarlu Love Story Dreaming which is the subject of cat. nos 2, 5, 9, 20, 30, 47 & 48].

h) Mulga Seed formed a key item in the diet of the Anmatyerre and this painting reflects its economic importance. The grey patches superimposed with small black dots throughout the canvas are mulga seed supplies. These contemporary mulga stands emanate from an 'increase centre' in the south-west corner of the canvas. The expansion of trees from Tjanypapakanu is literally expressed by the explosive motif that surrounds the site. At another site in the central south of the area, a woman is depicted grinding mulga seed. Her topstone can still be seen at this place. Mulga seeds are ground with a little water and eaten as a paste or cooked briefly in ashes as a damper.

i) Old Backwards Foot, an Echidna Man is going from east to west. He was on his way to ceremonies. The sites depicted on the travels of this well-liked ancestor were Talyi Talyi, Multju and Nyinga.

j) The north-east corner of the painting is bisected by the underground travels of the Legless Lizard Rrinpa Rrinpa, so called because of the curiously loud sound made by the small reptile.

These notes were compiled by John Kean for *East to West: Land in Papunya Tula Painting* at the Tandanya Centre, Adelaide after conversations with the artist in 1978 and 1984.

Illus. *East to West: Land in Papunya Tula Painting,* J. Kean, Tandanya Aboriginal Cultural Institute, Adelaide, 1990.

The Art of Clifford Possum Tjapaltjarri, V. Johnson, Craftsman House G+B International, Sydney, 1994.

Exh. *East to West: Land in Papunya Tula Painting,* Tandanya Aboriginal Cultural Institute, Adelaide, 1990.

Canvas and Bark, South Australian Museum, Adelaide, 1991.

Crossroads: Towards a New Reality: Aboriginal Art from Australia National Museums of Australia, Kyoto and Tokyo, 1992.

The Evolving Dreamtime, Pacific Asia Museum, August 1994 – January 1995

The World Over, Under Capricorn: Art in the Age of Globalization, Stedelijk Museum, Amsterdam, 1996.

22★ **Two Men Fighting**
1978
synthetic polymer paint on canvas
170.0 x 200.0 cm
Private collection

This painting depicts a soakage known as Leura Leura (also called Warri Warri) at the present site of Mount Allan Station. According to Clifford Possum, 'Leura Leura' means lake and blue saltbush country (similar to the area around Napperby Lakes), represented in the painting by dotted areas infilled with parallel bands of dotting. There is still rainwater in these soakages today, and the ceremonies there are 'for all the family: Tjungurrayi, Nungurrayi, Tjapaltjarri and Napaltjarri'.

These areas are also the giant figures of two men fighting with boomerang and stone knife (right) and shield and wadi (left). They are the same two brothers in the Aralukaja story of the Camp and Chase of the Goanna Men [see notes for cat. nos 11, 12 & 18]. In this version of the story, the younger brother fights back, trying to defend himself from the older brother's blows.

Information supplied by Clifford Possum, 1993.

Illus. *The Art of Clifford Possum Tjapaltjarri,* V. Johnson, Craftsman House G+B International, Sydney, 1994.

Exh. *East to West: Land in Papunya Tula Painting,* Tandanya Aboriginal Cultural Centre, Adelaide, 1990.

1979
synthetic polymer paint on
canvas
231.0 x 365.5 cm
The Kelton Foundation
Papunya Tula stock no.: CP79708

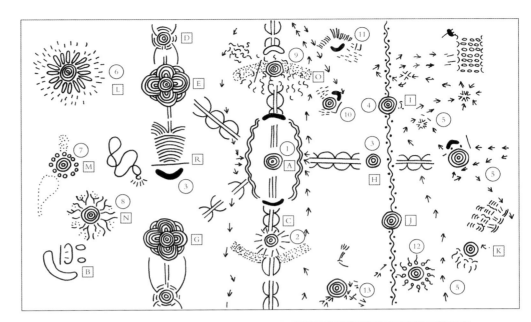

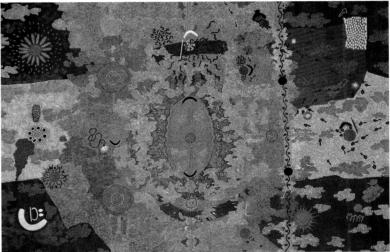

This painting depicts some of the ancestral trails that pass over a large area of Mount Allan Station (to the north-west of Alice Springs). The painting was said to cover an area of about 40 x 30 miles, on which there are many mulga stands –though there are also small rocky outcrops, low lying swampy areas, open grassy areas and creekbeds with associated scrubby plains.

The artist has selected symbolic elements from the ceremonial ground paintings associated with the area depicted and has placed them on the canvas in geographic relationship to each other, to form a mythological 'map' of the area.

Aboriginals conceive their Ancestral Heroes as emerging from the earth and travelling across the country creating landforms, occasionally meeting other ancestors and establishing the ceremonial cycles that are still performed to celebrate their Dreamtime journeys. Thus Aboriginal people have a mental map of their country through the knowledge of the paths and intersection of the lines of travel of the various ancestral beings they are associated with. Clifford Possum is the artist who has expressed this world view most clearly and each of his large canvases indicates the complexity and intimacy with which Aboriginal men relate to their country.

There follows a brief description of each of the narratives depicted. The numbers correspond to the number on the attached diagram.

1. During the distant past, Yirrinytarrakuku who was Kataitja or ritual assassin tried to sneak up on Two Nangala women seated on the top of a large round rock outcrop known as Yuutjutiyungu. Yirrinytarrakuku had come from the east, in Alyawerre tribal territory where he had stolen a group of sacred boards/totem. The Old Kataitja had come to Yuutjutiyungu with the intention of again stealing the totems owned by the two Nangala women (a

kinship classification term). However, the two Nangala who had a wide view of the surrounding country had seen the Kataitja sneaking up on them and guessed what he was up to and so hid the boards in a cave in the side of the hill. Disappointed at not being able to steal the sacred boards the Kataitja turned to the west and walked out far through the sandhill country until he reached Kunatjarrayi, a site just east of the Northern Territory–Western Australia border. Here he hid the sacred boards, that he had carried from Alyawerre country and turned around to travel back to Yuutjutiyungu. Again he attempted to sneak up on the women, but was once more thwarted by them and forced to return to the east empty- handed.

2. These symbols tell the story of a lone man who had travelled from Tjunykurra to Ngarritjaliti where he saw a huge storm approaching and in haste he started

to build a Purri (wet weather shelter). However, before he had completed the shelter the storm arrived and he was struck by lightning. In the artist's words, the lightning blew him up 'just like a bomb'. The bits and pieces of the poor man were scattered far and wide over the country and his remains can still be seen in a number of places, metamorphosed into rock.

3. Much of the country in this depiction is associated with the travels of the Irranpa or Honey Ant people. As their ancestors do to this day, the Honey Ant people lived in large colonies deep underground in mulga country.

The life of the Honey Ant is complex, however briefly, Worker Ants collect the nectar from flowering Mulga Trees and carry it to underground chambers where the abdomens of the 'storehouse' ants are gradually filled with the nectar. The ants

can be dug up and collected and as such are a highly prized food of desert dwelling Aborigines.

Irranpa ancestors are conceived as having lived in a similar way and many of the rocky outcrops on Mount Allan station are thought to mark the sites of huge underground chambers inhabited by the Irranpa. Many of the symbolic elements in this painting refer to these unseen chambers. The large circular patterns of background dots indicate significant Honey Ant Dreaming sites, however, the actual symbolic elements at these sites have been omitted to avoid cluttering the pictorial space of the canvas. All these chambers are thought to be linked by underground tunnels, the travelling routes of the Irranpa ancestors.

The pictorial elements to the left of the centre of this painting refer to a narrative that tells of a woman who came to Yuulrrku to dig for Irranpa. The woman is represented as seated (i) with her digging stick (ii). The marks left as she scraped the ground, looking for the hole that marks the entrance to the underground chamber are also depicted (iii). The woman then followed the hole (iv) down to the homes of the honey ants. The woman then dug herself a large hole to sit in (v) from where she excavated the Irranpa homes (vi) collecting all the honey ants ready for eating. (vii) represents further unexcavated honey ant chambers, (viii) represents Wirripunkanu, the hairstring belt worn by the mythological woman.

The underground tunnels that link the various sites associated with the honey ant ancestors are symbolised by

4. Much of the country of Mount Allan and especially Napperby Station to its immediate south, is associated with the travels of the Tjukunypa or Possum people. One of their mythological trails is depicted as it passes through the country in this painting. A representation of the tracks of a possum marks the travelling route of the possum people. The sinuous line indicates the possum dragging its tail while his paw prints are clearly evident. The principal sites envisaged in this depiction are Kaarkuatja and Yuulu, where a possum ancestor looked into a rockhole and saw his own reflection.

5. Two Goanna brothers known to the Anmatjera (Anmatyerre) as 'Wanyaritji' came into the area of this depiction from the north. They were said to be 'funny buggers' as they had previously made jokes in a 'malliera' or post-initiatory ceremony. [Clifford Possum elaborated :

> Yeah, really funny buggers, and everybody laugh in the corroboree camp, malliera camp. People laughing. Everybody happy – laugh, laugh, laugh. Oh yes.]

The Wanyaritji had travelled a long way (actually, only from Mount Allan), and when the younger brother sat down exhausted from their trek, the older brother who had a little more energy decided to go off hunting (his trail leads out of the area of this depiction). The older brother re-entered the area in this depiction without meat but for an unexplained reason with a will to catch and fight his brother. A long chase ensued as the older goanna tried to strike his young brother with a stone axe. The chase led the Wanyaritji ancestors past a number of soakage sites and terminated only when both the Goanna men entered a low lying rock outcrop near Mount Allan known as Warri Warri. The Goanna ancestors' eggs can be seen lying on top of this outcrop, metaphorsed into large round rocks and are depicted in this painting. The older brother's discarded axe is also shown.

+++ is a ceremonial area known as 'Ngaalala' associated with this mythology.

6. The site of Yungilytji is an increase centre for the bush potato of the same name. The Yungilytji plant forms an edible tuber and grows in creekbeds around the area of this depiction. The set of concentric circles represents the centre, or point of growth of the plant, while the long oval shapes are its leaves, the surrounding large dots are the flower heads. As with many bush tucker increase centres, it is believed that the correct maintenance and ceremonial celebration of various sites associated with the plants will ensure good supplies of the related foods throughout the area.

7. Uulytanypa is a site where the native honey bees or 'sugar bag' ancestors established a home. This site is now marked by a large rock. There are still many 'sugar bag' homes in the River Gums that line the creekbeds of this area.

'Kuna' Excretia — Sugar bag home — The Sugar bag mother

8. Wakuti is an increase centre for the seeds of a native grass which was traditionally ground to produce a flour which was then mixed with water to make a nutritious damper.

9. Kapatala (Kapatadi) is both the name of a site and the Anmatjera (Anmatyerre) word for an edible green caterpillar that can be found in the area after heavy rains. During the Dreaming an old man of the Tjapangati subsection collected a mass of Kapatala (Kapatadi) and cooked them in the ashes of a small fire at this site.

10. The path of another old man of the Tjapangati subsection can be seen leading to where he found and ate the bush fruit Yakatji. The man's 'Pinatjarra' or hooked boomerang is also depicted.

11. Here yet another Tjapangati came and found, dug up and ate, the root food Unkuli.

12. Marks an increase site for the bush fruit Ulyquata, which was said to be something like a cucumber.

13. The path of the 'Kuninka' or marsupial mouse (possibly bandicoot) ancestors as they entered the area of this depiction on their epic travels from Port

Augusta (on the south coast of Australia) can be seen slightly to the right of the centre at the top of this painting. The Kunika ancestors had earlier done battle with the possum people (out of the area covered in this painting). Like the possum ancestors, the path of the Kuninka are marked by characteristic foot and tail print. [Note: The tracks here appear to be those of the rock wallabies which Clifford Possum usually identified as the makers of this ancestral journey.]

The site names given for the places in this depiction are as follows:

a. Yuutjutiyungu
b. Tjunykurra
c. Ngarriljaliti
d. Atkjirra
e. Yulimu
f. Yuulrrku
g. Tjilyipyilyut
h. Pupunya – a site with the same name as the settlement
i. Yuula
j. Kaarakuatja
k. Ngaalala
l. Yungilyitji
m. Uulytanypa
n. Wakati
o. Tunykurra
p. Kapatata (Kapatadi)

© Papunya Tula Artists

Illus. *Contemporary Australian Aborigine Art*, Pacific Asia Museum, Los Angeles, 1980.

The Art of Clifford Possum Tjapaltjarri, V. Johnson, Craftsman House G+B International, Sydney, 1994.

Exh. *Past and Present Art of the Australian Aborigines*, Pacific Asia Museum, Los Angeles September 1980 – June 1981.

Dreamtime: Art of the Australian Aborigines, California State University, Northridge, 1988.

Awake to the Dreamtime, San Diego Museum of Man, 1993.

The Evolving Dreamtime: Contemporary Art by Indigenous Australians from the Kelton Family Foundations Collection, Pacific Asia Museum, August 1994 – January 1995.

The World Over, Under Capricorn: Art in the Age of Globalization, Stedelijk Museum, Amsterdam, 1996.

24★ **Possum Dreaming at Napperby**
1979
synthetic polymer paint on canvas
154.0 x 186.0 cm
Private collection
Papunya Tula stock no.: CP791224

Depicted here are the travels of a possum ancestor in and about the area known as Tjuirri (also called Irriltja), about two miles north of Gidyea Bore on Napperby Station, approximately 250 kilometres north-west of Alice Springs.

Much of the area at Napperby Station is associated with the Tjukunypa or possum ancestors, and there are many traditional trails of the possum people there. Some of the trails are of travelling ceremonial groups while others relate to the movements of families as they foraged. In the story shown here, the ancestral hero stayed in a limited area round Tjuirri while his companions travelled to the south-west. The Tjukunypa ancestor is said to have travelled both on top of and beneath the surface of the ground. His underground path is shown partially covered (central set of tracks). The trails on the surface are shown uninterrupted. The undulating lines are the tracks of the possums' tails and are flanked by his distinctive paw marks. The background dots represent the contours and vegetation in the vicinity of Tjuirri. The areas outlined in pink represent dry bushes characteristic of the country around Tjiurri. The sets of concentric circles are sites of special import in relation to the possum, including the spots where he emerged from and eventually re-entered the ground.

© Papunya Tula Artists

Note: This was Clifford Possum's next painting after *Yuutjutiyungu* cat. no. 23.

Illus. *The Painted Dream*, V. Johnson, Auckland City Art Gallery, Auskland, New Zealand, 1991.

Exh. *The Painted Dream*, Auckland and Wellington New Zealand, 1991.

25★ **Dreamings of Napperby Station**
1980
synthetic polymer paint on canvas
182.0 x 182.0 cm
Holmes á Court Collection

This painting shows Plum and Women's Dreamings for the area around Napperby station (Larumba). Along the top and bottom of the painting women are shown beside their oval coolamons filled with bush plums or pulapa. Inside this, the yellow circles with U-shapes show women engaged in a women's ceremony or 'walya' for the Plum Dreaming. The background stripes of the painting indicate sandpaintings which the women make for this ceremony.

This painting may have been the first of several which Clifford Possum painted for the owners of Napperby Station in the period 1980–81.

Information supplied by Clifford Possum 1993.

Illus. *The Art of Clifford Possum Tjapaltjarri*, V. Johnson, Craftsman House G+B International, Sydney, 1994.

26★ **Anardeli Kangaroo Story**
1980
synthetic polymer paint on canvas
122.5 x 76.0 cm
Holmes á Court Collection

This painting shows a Kangaroo Dreaming site called Anardeli, the main soakage site for Kangaroo at Mount Denison [also known to the Anmatyerre as Atjumpi].

The central roundel is the waterhole, located in a creekbed whose different coloured stripes of sand are shown in the background of the painting. The artist has shown the tracks of the kangaroo as it approaches a waterhole to drink. The kangaroo then moves away and lies down. The curved black shape shows the animal lying down.

© Papunya Tula Artists

Illus. *Mr Sandman bring me a Dream*,
 A. Crocker, Papunya Tula Artists and Aboriginal Arts Agency, Sydney, 1981.

 The Face of the Centre: Papunya Tula Paintings 1971–1984, A. Brody, National Gallery of Victoria, Melbourne, 1984.

 The Art of Clifford Possum Tjapaltjarri, V. Johnson, Craftsman House G+B International, Sydney, 1994.

Exh. *Mr Sandman Bring Me a Dream*, United States of America, 1981.

 The Face of the Centre: Papunya Tula Paintings 1971–1984, National Gallery of Victoria, Melbourne, 1984.

 Clifford Possum Tjapaltjarri, ICA, London, 1988.

Tim Leura Tjapaltjarri assisted by Clifford Possum Tjapaltjarri

27 **Napperby Death Spirit Dreaming**
1980
synthetic polymer paint on cotton duck
213.0 x 701.0 cm
National Gallery of Victoria, Melbourne

The painting was first exhibited in *Australian Perspecta '81* at the Art Gallery of New South Wales under the title of *Anamatjerra Aranda Territorial Possum Spirit Dreaming* which Geoffrey Bardon originally gave it. This was shortened to *Possum Spirit Dreaming* in the catalogue of *Dreamings: Art of Aboriginal Australia*, the exhibition organised by the Asia Society and the South Australian Museum, which toured North America in 1988–89. The work was acquired in 1988 by the National Gallery of Victoria, which permits its reproduction only under Geoffrey Bardon's second title of *Napperby Death Spirit Dreaming* and with the attribution cited above. As could only be expected of a monumental work of such breathtaking originality, the meaning of this painting escapes the simple translations of Dreaming iconography conventionally provided by 'annotations' in Western Desert art.

The painting was a private commission from Bardon – not for Tim Leura Tjapaltjarri as is commonly reported, but originally for Clifford Possum. Tim Leura took over the commission after Bardon rejected Clifford Possum's first offering (the 1980 *Bush Tucker Dreaming* first publicly exhibited at the ICA show in London in 1988). However, it was Clifford Possum Tjapaltjarri who painted the innovative 'distorted bulls eye' (Bardon 1981) version of the Possum ceremonial body paint design along the middle of the canvas, which the *Dreamings*' annotator (and the painting's

original title) declared to be the 'integrating theme' of the painting. The diagram which appeared beneath the painting in the text of *Dreamings*, showed clearly the structure of the Possum's journey line through six sites with a repeating pattern of windbreaks above and below each site. The sets of wavy lines above and below this, also the work of Clifford Possum, were identified as running water, although Clifford Possum himself would later insist that they were mirages.

Over his brother's strictly symmetrical base composition, Tim Leura placed various elements asymmetrically around the painting: the skeleton and its weapons in the lower right-hand corner, the camps, spears and windbreak of a group of male hunters, and the coolamon, digging stick and curved digging stick of a woman. He also added 'quotations' of three of his works which were painted during Geoffrey Bardon's time at Papunya in the early 1970s: *Old Man's Dreaming*, *Yam Dreaming*, and *Sun and Moon Dreaming*. These last two works were reproduced in Bardon's first book on the art movement, *Aboriginal Art of the Western Desert*, published by Rigby in 1979, just before *Napperby Death Spirit* was painted.

Neither Bardon's original discussion of the painting in the *Perspecta* catalogue nor its annotation in the *Dreamings* catalogue invested any transcendent significance in Tim Leura's contributions to the painting. In the *Perspecta* catalogue, Bardon had ascribed the work to both artists equally. However, in 1989, Bardon, who was deeply affected by the tragic manner of Tim Leura's death in 1984, offered a startlingly different interpretation of the painting. He wrote an essay which he called 'The Great Painting: *Napperby Death Spirit Dreaming*, by Tim Leurah Tjapaltjarri' for the catalogue of *Mythscapes: Aboriginal art of the desert* at the National Gallery of Victoria. (see Ryan 1989 pp. 46-7) The opening sentence of this essay reads:

The culmination of Tim Leurah Tjapaltjarri's painting life was probably his *Napperby Death Spirit Dreaming*, completed in 1980. It is an extraordinary work because it is the first painting in which a Western Desert artist stands aside from his tribal context and comments, quite self-consciously, on his art, his Dreamings, and himself.)

The only mention of Clifford Possum's participation in the *Mythscapes* essay was an acknowledgment that he had 'completed some of the structure of the journey line, windows and windbreaks, because he shared the Dreaming stories which the painting depicts'. The painting which Bardon had described in the *Perspecta* catalogue as a 'vast odyssey-like adventure of the Possum Spirit Being from the Dreamtime and his mischievous exploits' (Bardon 1981) was now presented as a 'savage and brooding repudiation' by Tim Leura of his 'white masters'.

> He apparently felt that his life's journey, shown in the huge sinuous line holding the Dreaming 'windows' in equipoise, was a rejection of the white man's pretensions. The death figure in the painting is Tim's perception of himself in his own social context.

Bardon's re-interpretation profoundly influenced subsequent readings of the painting's meaning, from which any reference to the Possum Dreaming has been eliminated (see for example Ryan 1989 p. 47). In his 1991 *Papunya Tula: Aboriginal Art of the Western Desert*, Bardon asserted that in this work Tim Leura had 'turned ostensibly Aboriginal icons into personal and deeply felt representations of his soul's journey'. The painting was 'a masterful statement of a life dismayed by the brutality and indifference of the Europeans to what Tim believed were his own lands' (Bardon 1991, p. 122). If this was Tim Leura's intention, his startling transformative imagery is nevertheless an overlay on the Dreaming significance of Clifford Possum's scaled-up design work indicating the presence of Upambura, the old Possum man of Napperby who appeared in so many of both Tjapaltjarri brothers' paintings. On Clifford Possum's personal reading, the skeletal figure was his paternal grandfather, also identified with his namesake, the ancestral Upambura.

Illus. *Australian Perspecta '81*, Bernice Murphy, Art Gallery of New South Wales, 1981.

Field to Figuration: Australian Art 1960–1986, R. Lindsay

Advance Australian Painting, A. Bogle, Auckland City Art Gallery, 1988.

Dreamings: Art of Aboriginal Australia, P. Sutton, Viking, New York, 1988.

Mythscapes: Aboriginal art of the desert from the National Gallery of Victoria, J. Ryan, National Gallery of Victoria, 1989.

Papunya Tula: Art of the Western Desert, G. Bardon, McPhee Gribble, Sydney, 1991.

Australian Aboriginal Art, W. Caruana, Thames and Hudson, 1993.

The Art of Clifford Possum Tjapaltjarri, V. Johnson, Craftsman House G+B International, Sydney, 1994.

Songlines and Dreamings: Contemporary Australian Aboriginal Paintings, P. Corbally Stourton, Lund Humphries Publishers Ltd, London, 1996.

Peintres Aborigénes d'Australie: le Rêve de la Fourmi à Miel, Parc de la Villette, S. Crossman & J. P. Barou, Paris, 1997.

Fieldwork: Australian Art 1968–2002, J. Smith and C. Green (eds), National Gallery of Victoria, Melbourne, 2002.

Exh. *Australian Perspecta '81*, Art Gallery of New South Wales, 1981.

Field to Figuration: Australian Art 1960–1986, National Gallery of Victoria, 1986.

Circle Path Meander: Central Australian Paintings from the Carnegie Collection, National Gallery of Victoria, December 1987 – March 1988.

Advance Australian Painting, Auckland City Art Gallery, 1988.

Dreamings: The Art of Aboriginal Australia, Asia Society Galleries, New York, David Smart Gallery, Chicago, Natural History Museum, Los Angeles, Museum of Victoria, Melbourne, 1988–89.

Power of the Land: Masterpieces of Aboriginal Art, National Gallery of Victoria, 1994.

Peintres Aborigénes d'Australie: le Rêve de la Fourmi à Miel, Parc de la Villette, Paris, 1997-98

Fieldwork: Australian Art 1968–2002, The Ian Potter Centre: National Gallery of Victoria, Melbourne, 2002–03.

28★ **Yuelamu (Honey Ant Dreaming)**
1980
synthetic polymer paint on canvas
360.0 x 227.0 cm
South Australian Government Grant 1980
Art Gallery of South Australia, Adelaide
Papunya Tula stock no.: CP800624

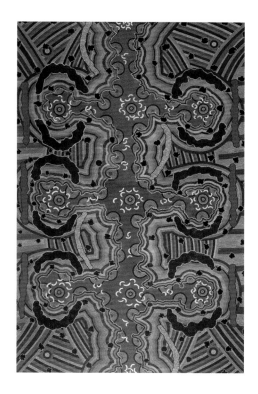

This exceptional painting relates to a detail of a particular Honey Ant 'Dreaming'. The place where the detail occurs is called Yuelamu on Mount Allan Station, north-west of Alice Springs. This Honey Ant Dreaming runs from Yuendumu, through Mount Allan, through Pine Hill Station to a place called Nkwalanema in Alyawerre country. What happened was that large rains came and washed away the top of the chamber of the ants' nest thereby exposing what was going on inside.

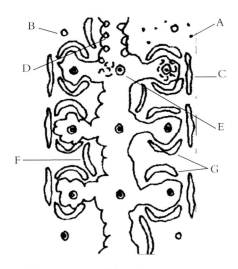

A: Stones exposed by rain
B: Background lines = floodwaters
C: Firesticks which are not burning
D: Abdomens of Ants clinging to the sides of the nest
E: Centre of the nest, nakala, containing grubs, lurrka
F: Winpi, sticks used for probing ants
G: The shapes are the people sitting at the ants nest; they are also the nest's Dreaming custodians – Tjapaltjarri, Tjungurrayi, Tjapangati and Tjapanangka subsections.

© Papunya Tula Artists

Illus. *Clifford Possum Tjapaltjarri,* ICA, London, 1988.

 The Art of Clifford Possum Tjapaltjarri, V. Johnson, Craftsman House G+B International, Sydney, 1994.

 RINGS: Five Passions in World Art, J.C. Brown, Abrams in association with High Museum of Art, New York, 1996.

 Dreamings of the Desert: Aboriginal 'dot' paintings of the Western Desert, V. Johnson, Art Gallery of South Australia, Adelaide, 1996.

 Treasures from the Art Gallery of South Australia, Art Gallery of South Australia, Adelaide, 1998.

Exh. *Clifford Possum Tjapaltjarri,* ICA London, 1988.

 East to West: Land in Papunya Tula Painting, Tandanya Aboriginal Cultural Institute, Adelaide, 1990.

 Windows of the Future, Department for the Arts and Cultural Heritage, Adelaide, 1993.

 Dreamings of the Desert, Art Gallery of South Australia, Adelaide, 1996–97.

 RINGS: Five Passions in World Art, High Museum of Art, Atlanta, 1996.

29★ **Kangaroo Story (Mt Denison)**
1980–81
synthetic polymer paint on canvas
122.3 cm diameter
Holmes á Court Collection

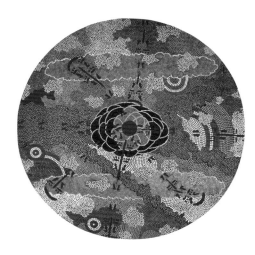

This painting depicts the main Kangaroo Dreaming site for Mount Denison. Tracks show the kangaroo approaching a waterhole and then moving off to lie down. The central black and light brown whorls are the kangaroo's entrails, and the large yellow shapes above and below are its backbone and tailbone. The blue area is the bed of the Anardeli river. A number of other soakage sites are indicated by concentric circles set into the background dotting, as on *Yuutjutiyungu* cat. no. 23. The more prominent striped roundels, some partially concealed by the other elements on the canvas are the old camps of the kangaroo men. The pink areas represent the grass known as ulkwatukwatu favoured by kangaroos.

© Papunya Tula Artists

Illus. *Mr Sandman Bring Me a Dream,* A. Crocker, Papunya Tula Artists and Aboriginal Arts Agency, Sydney, 1981.

 Clifford Possum Tjapaltjarri, ICA, London, 1988.

 The Art of Clifford Possum Tjapaltjarri, V. Johnson, Craftsman House G+B International, Sydney, 1994.

Exh. *Mr Sandman Bring Me a Dream,* United States of America, 1981.

 Clifford Possum Tjapaltjarri, ICA, London, 1988.

30★ **Love Story**
1981
synthetic polymer paint on linen
51.3 x 41.5 cm
Private collection

See notes for cat. nos 2, 5, 20, and also chapter 3 pp. 66 for detailed account of the Ngarlu Love Story and discussion of the spindle motif.

Tim Johnson commissioned this painting from the artist when he was company supervisor for Papunya Tula in July 1981. See chapter 5 p. 136 for an account of the circumstances.

Illus. *Dreamings: Art of Aboriginal Australia,* P. Sutton, Viking, New York, 1988.

 The Painted Dream, V. Johnson, Auckland City Art Gallery, Auckland, 1991.

 The Art of Clifford Possum Tjapaltjarri, V. Johnson, Craftsman House G+B International, Sydney, 1994.

Exh. *Dreamings: The Art of Aboriginal Australia,* Asia Society Galleries, New York, David Smart Gallery, Chicago, Natural History Museum, Los Angeles, Museum of Victoria, Melbourne, 1988–89.

 The Painted Dream, Auckland, Wellington, New Zealand, 1991.

31★ Bushfire Dreaming

1982
synthetic polymer paint on canvas
81.0 x 100.8 cm
Elder Bequest Fund 1984
Art Gallery of South Australia, Adelaide
Papunya Tula stock no.: CP820731

This painting shows the death of two young men of the Tjampitjinpa kinship subsection. Their father, Lungkata (Blue Tongue Lizard) started a huge bushfire at Warlugulong because his sons had not shared meat with him. They tried unsuccessfully to extinguish the flames but were forced backwards and eventually perished at a site called Tjampitjinpa-Jarra [also Ramarakujunu 'red bones', five miles to the south of Yuendumu].

In the painting, the artist has shown the remains of the two young men with their hunting weapons. He has also shown the bundles of brush with which they attempted to extinguish the flames. The red patches in the background show the flames of the fire, while the grey is the smoke. The wavy lines passing through the central section show the smoke being carried through the air by the wind.

© Papunya Tula Artists

This is the first painting of Clifford Possum's in Papunya Tula's records in which the two skeletons that became one of the artist's signature motifs are the dominant feature.

Illus. *Dreamings: Art of Aboriginal Australia*, P. Sutton, Viking, New York, 1988.

Exh. Art Gallery of South Australia 1984, 1986.

Dreamings: The Art of Aboriginal Australia, Asia Society Galleries, New York, David Smart Gallery, Chicago, Natural History Museum, Los Angeles, Museum of Victoria, Melbourne, 1988–89.

32★ Yinyalingi (Honey Ant Dreaming Story)

1983
synthetic polymer paint on canvas
244.0 x 366.0 cm
Purchased from National Gallery admission charges 1984
National Gallery of Australia, Canberra
Papunya Tula stock no.: CP830520

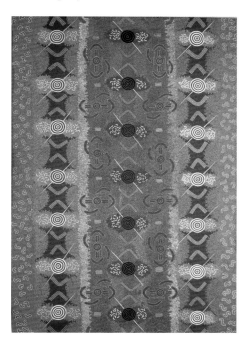

In this painting, the artist has shown the body and ground designs used in both men's and women's ceremonies for the Honey Ant Dreaming at Yinyalingi.

In mythological times, groups of Honey Ant people, or Tjala, came to this site to meet and hold ceremonies. During the daylight hours the appropriate men prepared the elaborate ground design. The ceremonies started at dusk and continued through the night and were completed at first light.

The centre panel shows the designs used by the women in these ceremonies, the circles, bars and arcs being applied to their faces, breasts, shoulders and upper arm, and backs. The straight bars depict digging sticks which are used to dig up the Honey Ants. The white shapes are the young ants.

The design on either side of the central panel shows the seating arrangements for the men participating in the ceremonies. The roundels are the camps and the arcs are men of the Tjungurrayi and Tjapaltjarri subsections. Tjungurrayi is father for the artist.

The white sections extending the full length of the painting on either side show the fog which forms on the hills in very cold weather.

The two outside panels of grey lozenge shapes show a caterpillar-type grub which comes out from the ground after the summer rains when everything is green. In early days the Aborigines ate these grubs. Now they provide plentiful food for goannas which abound at this time and therefore the goannas caught for food at this time are nice and fat. The artist has suggested the 'good bush tucker' nature of the area in addition to its mythological and ritual significance.

© Papunya Tula Artists

Illus. *Australian Aboriginal Art: A Souvenir Book of Aboriginal Art in the Australian National Gallery*, W. Caruana, Australian National Gallery, Canberra, 1987.

Windows on the Dreaming: Aboriginal paintings in the Australian National Gallery, W. Caruana, Australian National Gallery and Ellsyd Press, Sydney, 1989.

Aboriginal Art, W. Caruana, Thames and Hudson, London, 1993.

The Art of Clifford Possum Tjapaltjarri, V. Johnson, Craftsman House G+B International, Sydney, 1994.

Papunya Tula: Genesis and Genius, H. Fink and H. Perkins (eds), Art Gallery of New South Wales, Sydney 2000.

Exh. *XVIIth Bienal de Sao Paulo*: Australia, Parque Ibirapuero Sao Paolo Brazil, 1983.

Papunya Tula: Genesis and Genius, Art Gallery of New South Wales, Sydney, 2000.

33★ Mulga Seed Dreaming

1983
synthetic polymer paint on
linen
152.5 x 182.5 cm
Acquired by the Alice Springs
Art Foundation as winner of
the Alice Prize 1983
The Araluen Centre, Alice
Springs
Papunya Tula stock no.: CP831014

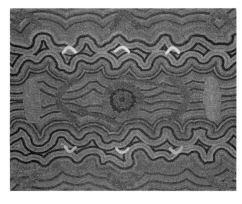

This painting depicts designs associated with the Mulga Seed Dreaming at a claypan site near Tilmouth Well [known as Yikapingya].

The roundel is the camp site of two men who are represented by the arcs. The oblong shapes are their shields and the straight bars are fighting clubs.

The small arcs are also men who are participating in the ceremonies, while the larger arcs at top and bottom of the work represent the very senior men.

Mulga Seed Dreaming won the artist the 1983 Alice Springs Art Prize.

© Papunya Tula Artists

Illus. *Wildbird Dreaming*, N. Amadio &
 R. G. Kimber, Greenhouse,
 Melbourne, 1987.

 The Art of Clifford Possum Tjapaltjarri,
 V. Johnson, Craftsman House G+B
 International, Sydney, 1994.

34★ Water Dreaming at Napperby

1983
synthetic polymer paint on
canvas
183.0 x 152.0 cm
Flinders University Art
Museum, Adelaide
Papunya Tula stock no.: CP831108

This painting shows designs used in Malliera ceremonies associated with a site called Yantantji, a soakage site near Central Mount Wedge.

The particular designs here show a Water Dreaming. The areas of blue and brown show patches of dark and light clouds. The wavy lines show water, both in the sky and on the ground. The short bars depict the lightning – and body paint of the ceremonial participants.

As the Malliera ceremonies are of a secret–sacred nature, no further details were given.

© Papunya Tula Artists

Note: Shortly after the Flinders University Art Museum acquired the painting from *Painters of the Western Desert* at the 1984 Adelaide Festival, Clifford Possum explained to Professor Vincent Megaw that the painting showed the designs used in the Malliera ceremonies associated with a site called Yantantji (Napperby Lakes). Hence the painting's original title *Water Dreaming at Napperby*. The Napperby Lakes area is a long line of claypans stretching out from east of Kerrinyarra beyond Tilmouth Well and up towards Napperby Station. The artist's key Water Dreaming sites were located in the area of Mount Wedge, including those related to the handover of the Altjupa Flying Snake Dreaming at Yunkurru, and Watulpunyu. It seems most likely that the soakage site of Yantantji depicted in this painting is in the Napperby Lakes area at the Kerrinyarra (Mount Wedge) end, and that a more correct title for the painting would be *Water Dreaming at Napperby Lakes*. See *Larumba*, c.1992–93 (cat. no. 46) and *Carpet Snake Dreaming*, c.1991–92 (cat. no. 45) for later depictions of Napperby Lakes by the artist, in which the water is again shown running underneath the surface of the ground. Though the artist's rendering of the same Dreaming story a decade later is distinctively different from his 1983 depiction, there are also very strong continuities between them.

Illus. *The Face of the Centre: Papunya Tula
 Paintings 1971–1984*, A. Brody,
 National Gallery of Victoria,
 Melbourne, 1984.

 *Dot and Circle: A Retrospective Survey
 of the Aboriginal Acrylic Paintings of
 Central Australia*, J. Maughan and J.
 Zimmer (eds), Royal Melbourne
 Institute of Technology, 1986.

 *Australian Government Information
 Service Calendar*, 1986.

 *The Dreamtime Today: A Survey of
 Contemporary Aboriginal Arts and
 Crafts*, J. Maughan, Kintore Gallery,
 Adelaide, 1986.

 Dreamings: Art of Aboriginal Australia,
 P. Sutton, Viking, New York, 1988.

 Australia Post stamp issue (first day
 cover) 1988.

 The Art of Clifford Possum Tjapaltjarri,
 V. Johnson, Craftsman House G+B
 International, Sydney, 1994.

Exh. *Painters of the Western Desert: Uta Uta
 Tjangala, Clifford Possum Tjapaltjarri
 and Paddy Carroll Tjungurrayi*, Royal
 South Australian Society of Arts,
 Adelaide 1984.

 Face of the Centre, National Gallery
 of Victoria, 1985.

 Dot and Circle, Royal Melbourne
 Institute of Technology Gallery
 1985.

 *The Dreamtime Today: a Survey of
 Contemporary Aboriginal Arts and
 Crafts*, Kintore Gallery Adelaide
 1986.

 Dreamings: Art of Aboriginal Australia,
 United States of America, 1988–89.

East to West: Land in Papunya Tula Painting, Tandanya Cultural Centre, Adelaide 1990

Twenty-Five Years and beyond: Papunya Tula painting, Flinders University Art Museum, Adelaide, 1999.

35★ Fire Dreaming
1983
synthetic polymer paint on canvas
120.0 x 152.5 cm
Private collection
Papunya Tula stock no.: CP831210

The designs in this painting show an area just to the north-east of Watulpunya, which is west of Central Mount Wedge. In mythological times a bushfire passed through this area travelling from Mount Liebig. The black areas in the painting show the country after the fire had passed through. The artist has shown the tracks of a Possum ancestor of the Tjangala kinship subsection who had passed through this site before the bushfire. The wavy lines are the marks made by his tail. Also depicted on one side of the painting are the tracks of a Wallaby ancestor who also passed through before the fire.

Exh. *Painters of the Western Desert: Uta Uta Tjangala, Clifford Possum Tjapaltjarri and Paddy Carroll Tjungurrayi*, Royal South Australian Society of Arts, Adelaide, 1984.

Tim Leura Tjapaltjarri, completed by Clifford Possum Tjapaltjarri

36 Dancing Men
1984
synthetic polymer paint on linen, 101.0 x 91.0 cm
Private collection

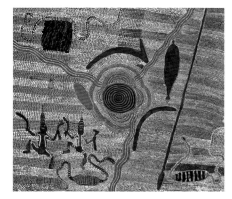

This painting is the Tjapaltjarri brothers' last collaboration. It was the last canvas Tim Leura painted for Papunya Tula Artists. Before it was completed, he was taken to hospital for an operation from which he never really recovered. His brother Clifford Possum finished it for him, and their different styles – Tim Leura's delicate dots on the right-hand side and Clifford Possum's bold precise ones on the left – are clearly discernible.

According to Clifford Possum, the concentric circles at the centre of the painting indicate the site of Ngarritjaliti near Kadaitcha Dam east of Mount Allan Station, where a Tjungurrayi man was struck by lightning from a mysterious cloud which had travelled all the way from Lajamanu [see notes for cat. no. 23] The same Tjungurrayi is shown twice, dancing a ceremony. The designs on the small sacred boards or 'kutarri' (Anmatyerre) inserted in his headdress appear related to the Lightning Dreaming, but Clifford Possum said that it was a 'women's' ceremony in which the men dance. The women are seated around the central concentric circle, 'singing for the man'.

The Tjungurrayi carries 'number 7' or 'killer' hooked boomerangs as well as the more familiar returning boomerangs. His body is painted with other designs and he wears a pubic belt and leg decorations of leaves. A number of objects used in the Dreaming ceremony are shown around the site: a hairstring pubic belt, two headbands, boomerangs, a spear, a spear thrower, a shield, and a stone axe.

Illus. *The Art of Clifford Possum Tjapaltjarri*, V. Johnson, Craftsman House G+B International, Sydney, 1994.

Exh. *Stories of Australian Art*, Commonwealth Institute, London, 1988.

The Painted Dream, Auckland City Art Gallery, 1991. *Painted Dreams*, Art Gallery of New South Wales, 1995.

Photographer: Elaine Kitchener

37★ Hare Wallaby and Possum Dreaming
1984
synthetic polymer paint on canvas
243.0 x 365.8 cm
Purchased with the assistance of the Visual Arts Board, Australia Council 1985
Ballarat Fine Art Gallery, Ballarat
Papunya Tula stock no.: CP840661

A Constellation of Ceremonies at Yakuti

Tjapaltjarri here depicts three separate ceremonies that occurred at Yakuti during the 'Creative Era'. These ceremonies of instruction are performed to this day to educate the young men and women in traditional law. The artist makes no separation between the depiction of these two time scales.

All three ancestral groups travelled to Yakuti. A site to the east of Yuendumu, approximately 250 kilometres north-west of Alice Springs. The ceremonies of the 'Mala' Hare Wallabies are depicted on the central panel, while those of 'Wyuta' Possum Ancestors are on either side. Clifford is also custodian of many more Possum Dreaming sites that lie on Napperby Station to the east of Yakuti and it is through these associations that he gets his name. On the top and bottom panels of the canvas the ceremonies of the women are depicted.

Tjapaltjarri told of the journey of a large group of Mala:

> They come up from Port Augusta, this mob, right through Mereenie, Town Bore, and that Papunya rumpa gate, through that watercross, long way, right across the desert to Ulyitjirrki, they go right up to Yakuti.

At every main place along this Dreaming trail, the Mala ancestors performed ceremonies of instruction for the post-initiate novices with whom they were travelling. Both ceremonies and novices are referred to as Malliera. At Yakuti the Mala ancestors met the Wyuta ancestors coming in from the east. Immediately a fight broke out between the two travelling bands. Through the fight they reconciled their antagonism and became friends. The Mala mob then performed their ceremonies of instruction for the Possum people showing them the sacred designs associated with their travels. Then the Possums reciprocated, showing the Mala the sweeping tail marks and small paw prints left by the performers of their ceremonies:

> schoolim one another after fight, and after that they bin still travelling, long way – they finish up in the marble stones [Devil's Marbles near Tennant Creek].

The white tracks in the painting are the marks left by the Mala in their ceremonies. The concentric circles are the main ceremonial areas at Ulyitjirrki. The bands of dots are Wumulu, the body decoration of the participants. The face of the Mala ancestors is evoked by the image. It refers to their eyes, nose and moustache.

The long curvy lines that cross the canvas are the marks of the Possums' tails as they were dragged through the sand. They are interspersed with large dots

which represent their paw prints. The short corroboree hats are worn by the Kiita (owners) of the ceremony and the long hats, topped with a bunch of emu feathers are worn by the Kutungula (policeman/workers).

The Tjakuti ceremonial sticks which the performers held in their hands are the antler-like shapes. This shape is the body paint of both the Kiita and the Kutungula.

While the men of the Mala and Wyuta groups held their ceremonies ('Malierra'), the women performed 'Yawulyu' ceremonies of instruction for the young women with whom they were travelling. These ceremonies were performed some distance away from the men and have their own unique form and imagery. Tjapaltjarri evokes the ceremonies by representations of Tjipitj, the designs painted on the bodies of the dancers with ochres and fat.

© Papunya Tula Artists

See also chapter 5 p. 152 for comment on the explanation of the symbols provided by the artist to the writer in 1992 for *The Art of Clifford Possum Tjapaltjarri*, V. Johnson (Craftsman House G+B International, Sydney, 1994) in the absence of the above information.

Illus. *The Art of Clifford Possum Tjapaltjarri*, V. Johnson, Craftsman House G+B International, Sydney, 1994.

38★ Fish Dreaming

1986
synthetic polymer paint on canvas, 91.5 x 121.5 cm
Private collection
Papunya Tula stock no.: CP860586

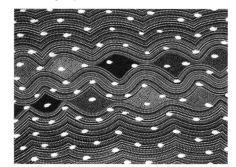

The Fish Dreaming site of Ngapatuka north of Napperby Station is depicted in this work. The Fish Dreaming travelled south from this site through Amburla Station to the Fink River.

The sinuous lines of dots show the flood waters flowing across the land. The central areas are the higher ground in the river bed. The white shapes are the fish.

© Papunya Tula Artists

See chapter 1 p. 26 for a fuller account of the Napperby Fish Dreaming.

Illus. *Clifford Possum Tjapaltjarri: Paintings 1973–1986*, Institute of Contemporary Art, 1988.

Exh. *Clifford Possum Tjapaltjarri*, ICA, London, 1988.

39★ Ringalintjita Worm Dreaming

1986
synthetic polymer paint on linen, 122.0 x 76.0 cm
Acquired from the 1986 Caltex/NT Art Award by the Central Australian Art Society
The Araluen Centre, Alice Springs
Papunya Tula stock no.: CP860589

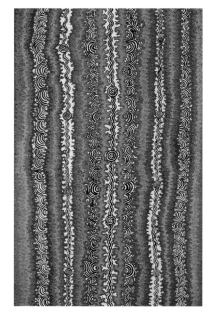

The artist has, in this painting, depicted the travels of Ancestor Worm-men as they move across the earth. The U-shapes depict the ancestors, whilst the painting is a celebration of their association with the site of Ringalintjita on Mount Allan Station.

Some sections of the design in this painting are worn on the bodies of women during ceremonies at the site.

© Papunya Tula Artists

40★ Dingo Dam Worm Dreaming
1986
synthetic polymer paint on linen
180.0 x 120.0 cm
Holmes á Court Collection
Papunya Tula stock no.: CP8606102

Clifford Possum has shown in this painting the sort of trail that a little yellow worm leaves as it burrows underground. The wiggly lines depict the ridges left by the Ancestor Worm-men as they moved across the earth in mythological times.

The Worm Dreaming is the artist's Dreaming and belongs particularly to a site, Narripi, 100 kilometres east of Mount Allan. The patches in the background show the holes left in the ground after the rain has washed through the ridges.

© Papunya Tula Artists

(Though it says Narripi in the original annotation, Clifford Possum corrected this in 1993 to 'Dingo Dam', which he said was another site close by.)

41★ Narripi Worm Dreaming
1986
synthetic polymer paint on linen, 121.5 x 91.5 cm
Holmes á Court Collection
Papunya Tula stock no.: CP860724

Clifford Possum has shown in this painting the sort of trail that a little yellow worm leaves as it burrows under the ground. The ridges in the earth are depicted by wiggly lines.

The Worm Dreaming is the artist's Dreaming and belongs to a site, Narripi, 100 kilometres east of Mount Allan. There are many Dreamings associated with this area.

The wiggly lines are also a depiction of the Ancestor Worm-men as they moved across the area in mythological times.

© Papunya Tula Artists

42★ Untitled (Lungkata's Two Sons)
1986
synthetic polymer paint on canvas, 174.4 x 243.0 cm
Courtesy Gabrielle Pizzi Collection, Melbourne
Papunya Tula stock no.: CP860760(b)

This painting shows tells the story of Lungkata, the Old Blue Tongue Lizard Ancestor, who started a huge bushfire to punish his two sons. The skeletons of the two Tjampitjinpa brothers who perished in the fire are depicted at the site of Tjampitjinpa-Jarra ('two Tjampitjinpas') or Ramarakujunu ('red bones'), five miles south of Yuendumu, where they died.

© Papunya Tula Artists

See notes for cat. no. 17 for detailed account of the Bushfire Dreaming.

Illus. *Clifford Possum Tjapaltjarri: Paintings 1973–1986*, Institute of Contemporary Art, 1988.

Exh. *Clifford Possum Tjapaltjarri*, ICA, London, 1988.

43 Warlugulong
1991
synthetic polymer paint on canvas, 183.0 x 450.0 cm
Courtesy of the Strehlow Research Centre
Papunya Tula stock no.: CP910305

At a site called Warlugulong ['Warlukurlangu' is the Warlpiri name for the site] south of Yuendumu, the artist in an elaborate array of colour and design depicts his Warlugulong or Fire Dreaming which is symbolised by the red central flame-like motif (the burning countryside) and the emerging grey colour formation which represents smoke as well as the burnt vegetation.

It was during the Dreamtime Era, that a Blue Tongue Lizard Man of the Tjampitjinpa subsection group set fire to the surrounding countryside to pursue and punish his sons, two Tjangala Ancestors, who refused to share a Kangaroo they had killed. On seeing the raging fire, both sons, together with their spears, spearthrowers and stone knives, fled south towards South Australia, but were eventually engulfed in flames, leaving only their skeletal remains.

Not only has the artist captured that tragic moment of death with great visual clarity, but he has also given the viewer an insight into the violation of traditional tribal law.

With the graphic emphasis on the subject of the Fire Dreaming, one is visually enticed to explore several other Dreaming mythologies which surround and intercept the site of Warlukurlangu.

In a complex interweaving of iconic details, such as the sinuous lines, concentric circles, human footprints and bird tracks, the Dreamtime journeys of Women, Emu, Rock Wallaby, Possum, Lizard and Snake Ancestors have been depicted.

Before our eyes, not only do we witness a statement about the artist and his religious affiliations, but we are also made aware of his relationship both in social and pragmatic terms with other people who also have rights along these intercepting Dreaming trails.

© Papunya Tula Artists

All other versions of the Warlugulong story in Papunya Tula's annotations give the skin name of Lungkata the Old Blue Tongue Lizard Man as Tjangala, and his sons as Tjampitjinpas. Perhaps the annotator of this painting was unfamiliar with the skin name system and misunderstood Clifford Possum's meaning. Yet several purchasers of Clifford Possum's late 1990s skeleton paintings independently reported *Two Tjangala's* as the title bestowed on the painting by the artist – as if retribution had moved forward (or back) a generation, with Tjampitjinpas now the avengers.

Illus. *The Art of Clifford Possum Tjapaltjarri*, V. Johnson, Craftsman House G+B International, Sydney, 1994.

44 Fire Dreaming
1991
synthetic polymer paint on canvas
451.0 x 197.0 cm
Federal Airports Corporation
Papunya Tula stock no.: CP910502

This painting is titled Fire Dreaming and relates to the site of Warlukurlangu [Warlugulong] south of Yuendumu. In rather a striking array of colour, design and naturalistic features, the artist tells the Mythological Dreamtime story of a Blue Tongue Lizard Man who set fire to the surrounding countryside to pursue and punish his two sons, who refused to share a kangaroo they had killed. Once the fire was raging the Blue Tongue Lizard Man transformed into the willy-willy ancestor, symbolised by the three dotted white lines which horizontally cross the canvas.

The two sons on seeing the uncontrollable willy-willy and enormous bushfire (depicted in the form of the red dots which surround the central images) gathered their spears, spearthrowers, stone knives as well as their fire beaters (depicted at the top of the two groups of spears) and fled in great haste south from Yuendumu towards the South Australian border, but unfortunately were overcome

and engulfed in flames leaving only their skeletal remains. Not only has the artist captured a tragic moment of death with great visual clarity, but he has also given the viewer an insight into the violation of traditional tribal law.

We are also made aware of the enormous size of his traditional country in the topographical and vegetation senses which were both so profoundly significant in the travels of the mythological ancestors. In the background, yellow tufts scattered throughout the painting depict spinifex, a common plant found in semi arid and arid areas of Central Australia. Rocky outcrops, clay pans, blue bush, tussock grass and sand-dunes are represented by the remaining colours.

© Papunya Tula Artists

Illus. *The Art of Clifford Possum Tjapaltjarri*, V. Johnson, Craftsman House G+B International, Sydney, 1994.

45★ **Carpet Snake Dreaming**
*c.*1991–92
synthetic polymer paint on canvas
210.0 x 127.0 cm
Peter Los Collection

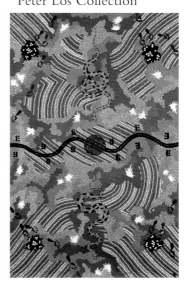

East of Mount Wedge is a long line of claypans which fill in heavy rains and connect up over a distance of almost twenty kilometres, beyond Tilmouth Well. Several mythological snakes are associated this country, known as the Napperby Lakes, including the two Carpet Snakes shown in this painting. The tracks of an old Possum man are also shown crossing the lake. The black shapes with white spots at each corner of the painting are mulga seeds, also associated with this area, for which the Napangati and Napaltjarri women, shown by their footprints, are searching.

Information supplied by Clifford Possum 1992.

The undulating curves of the background stripes of linked dotting represent the Lakes, with the water going underground and then emerging again from the sandhills which are shown by the patched areas of dotting. The artist described how he painted the background first on this canvas: the sandhills, followed by the water, then added the design elements, placing the central concentric circle on at the very end, in an almost complete reversal of the usual Western Desert painting process.

Painted in Adelaide *c*.1991–92

Illus. *The Art of Clifford Possum Tjapaltjarri*, V. Johnson, Craftsman House G+B International, Sydney, 1994.

46★ Larumba

c.1992–4
synthetic polymer paint on
canvas, 180.0 x 127.5 cm
Yolette Sullivan Collection

The area shown in this painting is Napperby Lakes, a long line of claypans stretching out from east of Kerrinyarra beyond Tilmouth Well on Napperby Station. The artist shows the way the water in these claypans flows underground beneath the sandills and then emerges again above ground by the interwoven undulating flow of the linked dotting, broken up by patches of coloured dotting indicating various types of flowers, seeds and other vegetation to be found in the surrounding sandhill country. The overlay of cloudy white dotting represents rising salt.

Painted in Warrandyte, Victoria, *c*.1992–94.

47★ Man's Love Story (Ngarlu)

1993
synthetic polymer paint on
canvas
25.0 x 181.0 cm
F. Mosmeri and M. J. Sullivan
Collection

Clifford Possum was keeper–owner for the site of Ngarlu (Red Hill) on what is now Mount Allan Station, As he used to say, 'Only me! My country, proper really. I got all the songs for this one'. The principal Dreaming that connected him with this site was the story of the 'love magic' which his ancestor Liltipilinti Tjungurrayi worked at Ngarlu to secure the object of his desire. Liltipilinti had been smitten by a Napangati woman while attending ceremonies in Alyawerre country, to the east of his own lands. She was 'wrong skin' for him, his classificatory mother-in-law, and strictly forbidden as a sexual partner under the marriage laws laid down in the Dreaming. The penalty for transgression was death.

The painting depicts the scene at Ngarlu after Liltipilinti returned from the ceremonies. His footprints (in cream) show him searching the area for 'webb' sticks. With these and kangaroo claws he made a spindle or wirrakurru for his 'love magic'. The U-shape shows how he sat down with his fighting stick beside him and created the sand painting that the spell required. Beside the U-shape is the pile of cuttings of his own hair from which Liltipilinti spun hair string as he sang the song that drew the Ngapangati woman to Ngarlu. Her footprints in orange come in at the top of the painting approaching her 'wrong skin' lover's campsite. The cloudy overlay through which these proceedings are glimpsed, was identified by the artist as part of the Dreaming story: the willy willy or small whirlwind which swept through Ngarlu and tried to disrupt Liltipilinti's spell by scattering both hair and sandpainting.

Clifford Possum's first three versions of this subject were *Love Story* 1972, *Man's Love Story* 1973 and *Man's Love Story 1978*, all key paintings in his artistic development. In *Love Story* 1972 he left behind the elements of European realism derived from Kaapa and his followers and took up the visual language of his own culture. A year later, the inspired *Man's Love Story* 1973 brought this direction together with the ability to manipulate three-dimensional space and uncanny precision derived from his decades as a carver in wood. *Man's Love Story,* 1978, the work in which he began scaling up the iconography of his Dreamings, was another decisive step in his development as an artist.

Apart from *Love Story* 1981 and another he painted for the Papunya storekeeper under similar circumstances, Clifford Possum did not revisit the Ngarlu story for over a decade after these seminal pieces were painted. Then in the 1990s Ngarlu re-emerged as one of the artist's core subjects. This work, from his 'orange' period in the early 1990s, is an immaculate example of this late Love Story series that shows off the artist's enduring fascination with colour.

Painted in Warrandyte, Victoria, 1993.

48★ Man's Love Story
1993–4
synthetic polymer paint on
canvas
184.0 x 457.0 cm
Collection of Jim and
Elaine Mead

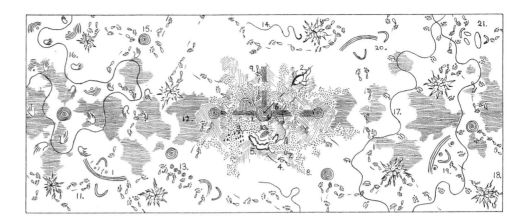

1 Liltipilinti's sandpainting
2 Spindle (wirrakurru)
3 Liltipilinti's unspun hair
4 Liltipilinti's footprints
5 Liltipilinti
6 Design symbolising 'webb' sticks resting
 beneath Liltipilinti's sandpainting
7 Liltipilinti's nulla nulla (fighting stick)
8 Willy willy
9 Tracks of Napangati woman
10 Sacred rock at Ngarlu representing
 Napangati woman
11 Tracks of Liltipilinti's descendants
12 Ceremonial body paint
13 Nungurrayi and Napaltjarri woman
 engaged in ceremony
14 Hairstring belt worn in ceremony
15 Concentric circles represent sandpaintings,
 sites, waterholes and/or soakages
16 Tracks of the Goanna ancestor
17 Tracks of the Possum ancestor
18 Bush food
19 Law men preparing for ceremony
20 Tjapaltjarri and Tjungurrayi Law men and
 their body paint designs
21 Malliera 'business' camp

Diagram drawn by Frank Mosmeri.
Legend by Milanka Sullivan.

The main site depicted here is Red Hill or Ngarlu, although the artist indicated that the whole area covered by the painting included Napperby Station, Brookes Well (Altjupa) on Mount Allan Station, Yuendumu area and Central Mount Wedge Station. According to the artist's account, all of this country is connected to the ancestral exploits of an Anmatyerre man known as Liltipilinti Tjungurrayi. Before the Love Story episode which is the subject of the painting, Liltipilinti was called to attend business (ceremony) by the Alyawerre people, whose lands lie to the east across the Stuart Highway. He did so, and after the ceremonies, returned to Anmatyerre country. He was travelling alone, without his family, through the area of Ngarlu, which the artist described as 'proper really nice country'. Clifford Possum now takes up the story, pointing to the central motif:

This man loved this woman and, Look at that! He ring'm up. He ring'n up for this kungka. I sing'm for you. [*sings*] He wants to ring'm up this kungka, his mother-in-law. Should be her daughter! Everybody know this one. He ring up wrong one, his mother-in-law he was loving. This lady he's in love with, she's Napangati woman.

You know why? Because he walk round for hunting and he standing and thinking, and as soon as he come back, he go and pick'm up as soon as he see'm – mulga webb sticks, spindle and hair string.

Everybody know this one – Red Hill high school, and everybody love him. I love him.

(Clifford Possum Tjapaltjarri 1994)

Liltipilinti's sisters and aunties (Nungurrayis and Napaltjarris) are shown to the lower left conducting ceremonies as they watch over the lovers' campsite. The series of small rings indicate their upright digging sticks implanted in the sand.

By 'Red Hill high school', the artist is referring to Ngarlu as a site of 'malliera' or post-initiatory instruction. The striped linework across the whole length of the painting refers to the body paint worn by the ceremonial participants. The large arc shapes indicate the business camps of the Law men. The 'starbursts' show the growth of bush berries and the patches of background dotting indicate the presence of other types of vegetation in the regions depicted, which the artist likened to a 'supermarket' of bush foods.

The tracks that traverse the right-hand end of the painting are those of the old Possum man Upambura from Napperby Station (Larumba to the Anmatyerre). Upambura travelled from the site known as Twenty Mile in the Napperby Lakes district through Mount Allan area to the totemic Possum site of Yakuti, ten miles east of Yuendumu, before returning to Larumba.

On the left-hand side are the distinctive tracks of the ancestral goanna known as 'No Tail' who walked around the area of Limestone Bore or Yaramayi west of Mount Allan Station.

Painted at Warrandyte, Victoria, 1993–94.

49★ Good Friday

1994
synthetic polymer paint on
linen
116.0 x 154.0 cm
Collection of Jim and
Elaine Mead

This arresting crucifixion scene was
painted over Easter 1994. Clifford
Possum's Christian faith, originally
inculcated by the Hermannsburg
missionaries in his boyhood, was
resurgent following the success of a risky
operation that had saved his eyesight.
Though the work apparently began as
collaboration with his then partner
Milanka Sullivan, as she relates the story, it
was in the end 'chiefly conceived and
painted by Clifford Possum'. The crown
of thorns, the nails and the orange Milky
Way were Sullivan's contribution.

Clifford Possum's trademark footprints
in white here indicate the progress of
Jesus towards the central cross. The three
crucifixes are arranged to suggest a
hillside, around which swirls a dark and
brooding atmosphere, reminiscent of
Warlugulong 1976 or 1977. According to
Sullivan, the river of lightning across the
right-hand side of the painting signified
to the artist the anger of God at the death
of his son. If these were Clifford Possum's
thoughts as he painted the work, then it
may also be charged with his anger and
grief at the loss of his own son. The scene
is watched over by the Seven Sisters of
the Pleiades constellation, shown as seven
concentric circles across the left-hand side
of the painting. Painted at Warrandyte,
Victoria, Easter 1994.

50★ Two Tjangalas

1996
synthetic polymer paint on
canvas
171.0 x 121.0 cm
GRANTPIRRIE Collection

This painting depicts the deaths of two
sons who had angered their father, the
old Blue Tongue Lizard Man, Lungkata,
by killing a kangaroo which was sacred to
him and then eating it in secret without
sharing any with him. Enraged by his
sons' actions, Lungkata started a great
bushfire at Warlugulong which pursued
his sons and eventually burnt them to
death.

Painted at Kempsey in northern New
South Wales 1996.

51★ Man's Love Story

1997
synthetic polymer paint on
canvas
120.0 x 89.0 cm
Santos Fund for Aboriginal Art
1997
Art Gallery of South Australia,
Adelaide

52★ Dead Spirit at Napperby

2001
synthetic polymer paint on
canvas
152.0 x 121.0 cm
Arnaud Serval, France

Exh. *Carry on Clifford Possum,* Sydney,
2001

53★ Two Goanna Men

2001
synthetic polymer paint on
canvas
92.0 x 121.0 cm
Arnaud Serval, France

Exh. *Carry on Clifford Possum,* Sydney,
2001

Carvings

54★ **Cheeky Snake**
1973
carved bean wood and synthetic
polymer paint
62.8 x 27.0 x 22.0 cm (irreg.)
Jinta Desert Art Gallery, Sydney

55★ **Snake Carving**
*c.*1975
carved bean wood and
watercolour paint
68.5 x 40.0 cm
The Kelton Foundation

'**W**e got a lot of different snakes in Australia. This one red and black – really red, and some brown and white – he got white [markings]. This snake he start sixteen mile from Alice Springs up north this time that snake. He stop there and after that he take off to Napperby Lakes'. (Clifford Possum 1999) The artist also commented that the snake looked 'just like live one' and that it was not a carpet snake but a 'cheeky' (i.e. poisonous) one. The artist recalled that he had carved the work about a year after Geoffrey Bardon's original departure from Papunya in July 1972, making its date of production mid-1973. In the midst of the remarkable development of his painting on flat surfaces over the first two years of working in this medium, Clifford Possum had not lost either his love or skill for carving. His abandonment of the medium soon after this was a practical decision based on the perception that there were too many others competing for the not very lucrative tourist market in carvings and that he would be better off concentrating on his painting.

This expert carving of a snake slithering across a forked branch is a reminder that Clifford Possum was already an experienced artist, skilful in the manipulation of his chosen medium to achieve life-like three-dimensional effects, when he turned his hand to picture-making in the early 1970s. This is one of the very few known examples of Clifford Possum's work in the medium to which he devoted himself during the 1950s and 1960s carving in the stockcamps after 'knock off time'. Extracted from a single piece of soft bean tree wood, the curvature of the snake shows the artist's acute powers of observation and his skill in capturing life-like effects of motion. The same attention to realism is shown in the detailed markings painted onto the snake. For years Clifford Possum honed his skills in brushwork, using watercolour paints on these difficult convoluted surfaces, before he switched to painting on flat ones with the materials provided by Geoffrey Bardon in the early 1970s. The original owner of the piece may have admired it for its technical virtuosity, but is unlikely to have been aware of the significance to the artist of the creature which his hands had created from an inert piece of wood. The markings which the artist has painted on this snake are almost identical to those on the Rainbow Snakes in his paintings (R. Kelton personal communication 2003), where they represent ancestral beings.

Drawings

Map of Anmatyerre Country

1988
pencil on paper
56.0 x 76.0 cm
Private collection

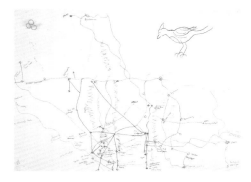

This drawing is a map sketched by Clifford Possum during a late night conversation with Christopher Hodges in New York in November 1988 about the sites and Dreamings depicted in his paintings. According to Hodges, the map began in the dense lower middle section with the artist's principal sites around Mount Wedge, Mount Allan and Yuendumu, then spread out to the north, south, east and west as these Dreaming trails were traced back to their points of origin beyond the artist's family estate. Thus, at the top centre of the map far to the east across the Stuart Highway which bisects the drawing horizontally is the site of 'Aturpa' in Alyawerre territory. From here the Napangati in the Ngarlu Love Story originally came to Red Hill. The map extends north up the Stuart Highway on the left, and south to Uluru in the bottom right-hand corner.

Whereas Clifford Possum marked in all these Dreamings sites and trails slowly and deliberately, the little bird in the top right corner was drawn with a few swift strokes – upside down – to indicate the kind of bird that feeds on the seeds washed down by the flood waters.

The next morning, Hodges sat down and drew his own map of the artist's country based on Clifford Possum's instruction and his memories of the previous night's discussion (see p. 24). This second map covers a more confined area bounded by Napperby in the east (top

centre), Papunya in the south (RHS), Warlugulong in the west (bottom centre), and Mount Denison and Coniston in the north (LHS).

Illus. *The Art of Clifford Possum Tjapaltjarri*, V. Johnson, Craftsman House G+B International, Sydney, 1994.

Mt Wedge and Lake Leura (Napperby Lakes)

1988
pencil on paper
56.0 x 76.0 cm
Private collection

This pencil drawing was done by the artist in a studio/loft in New York in November 1988. It depicts three hills: 'Pulkakarri', 'Kaliyara' and 'Iterinkangu', rising out of the saltbush and mulga country around Lake Leura (across the foreground). The location is marked on Chris Hodges' map by a diagram of the pencil drawing at the site which it depicts, linking it with the women's site indicated in the drawing at the foot of Kerrinyarra.

Illus. *The Art of Clifford Possum Tjapaltjarri*, V. Johnson, Craftsman House G+B International, Sydney, 1994.

Exh. *Reading the Country*, Art Gallery of New South Wales, 1992.

List of exhibitions and publications

Individual exhibitions and awards

1983	Winner, Alice Springs Art Prize
1985	Araluen Centre Mural commission
1987	*Paintings of Clifford Possum Tjapaltjarri*, Avant Galleries, Melbourne
1988	*Clifford Possum Tjapaltjarri: Paintings 1973–1986,* Institute of Contemporary Art, London
1991	Alice Springs Airport commission
1995	*Recent Works,* Fire-Works Gallery, Brisbane
1996	*Recent Works,* Hogarth Galleries, Sydney
1997	Rebecca Hossack Gallery, London
1999	*Linear Works* by Clifford Possum, Fire-Works Gallery, Brisbane
2001	*Carry on Clifford Possum,* Mary Place, Sydney
2002	Queens Birthday Honours List appointed an Officer of the Order of Australia in the General Division (AO)
2003	*Clifford Possum* retrospective, Art Gallery of South Australia, Adelaide, Melbourne, Sydney, Brisbane.

Selected group exhibitions

1977	Realities Gallery, Melbourne
1978	*Art of Man*, Sydney
1980	Randells Mill, Adelaide
1980–81	*The Past and Present Art of the Australian Aborigine,* Pacific and Asia Museum, Pasadena, California
1981	*Mr Sandman Bring Me a Dream*, United States of America, later United Kingdom
	Australian Perspecta 1981, Art Gallery of New South Wales, Sydney
	Patrick White's Choice, Art Gallery of New South Wales, Sydney
1982	Gallery A, Sydney
	Georges Gallery, Melbourne
	The Loft Brisbane (concurrent with Commonwealth Games)
1983	*XVIIth Bienal de Sao Paulo*: Australia, Parque Ibirapuero Sao Paolo Brazil
	Roar Studios, Melbourne
	Gallery A, Sydney
	Art of the Desert stamp issue, *Water Dreaming at Napperby*, 1983 reproduced on cover of commemorative set.
1984	*Painters and the Western Desert: Clifford Possum Tjapaltjarri, Paddy Carroll Tjungurrayi, Uta Uta Tjangala*, Royal South Australian Society of Arts, Adelaide
	Mori Gallery, Sydney
1985	*Dot and Circle: A Retrospective Survey of the Aboriginal Acrylic Paintings of Central Australia*, Royal Melbourne Institute of Technology, Melbourne

1985	*The Face of the Centre: Papunya Tula Paintings 1971–84*, National Gallery of Victoria, Melbourne
1986	Roar Studios, Melbourne
	Galerie Dusseldorf, Perth
	Desert Artists: Paintings from papunya and Craved and Decorated Objects from Uluru, Opera House Exhibition Hall, Sydney
1987	Gallery Gabrielle Pizzi, Melbourne
	Aboriginal Art from the Central Desert and Northern Arnhem Land, featuring the work of Clifford Possum Tjapaltjarri and members of his family, Community Arts Centre, Brisbane
1988	*Advance Australian Painting*, Auckland City Art Gallery, New Zealand
	Creating Australia: 200 Years of Art 1788–1988, Art Gallery of South Australia and all major capitals.
	Time before time: Aboriginal art of Australia, Austral Gallery, St Louis, United States of America
	Tim Johnson and Clifford Possum Tjapaltjarri, Mori Gallery, Sydney
	Dreamtime: Art of the Australian Aborigines, California State University at Northridge, United States of America
1988–89	*Dreamings: Art of Aboriginal Australia*, Asia Society Galleries New York, then Chicago, Los Angeles, Melbourne, Adelaide
1989	*A Myriad of Dreamings*, Victorian Centre for the Performing Arts, Melbourne
	Clifford Possum Tjapaltjarri and Gabriella Possum Nungurrayi, Coo-ee Gallery, Sydney
	Papunya Tula: Contemporary paintings from Australia's Western Desert, John Weber Gallery, New York
1990	*East to West: Land in Papunya Tula Painting*, Tandanya Aboriginal Cultural Institute, Adelaide
	Contemporary Aboriginal Art from the Robert Holmes á Court Collection, Carpenter Centre for the Visual Arts, Harvard University; James Ford Bell Museum, University of Minnesota
	l'ete australien a montpellier, Musee Fabree, Galerie Saint Ravy, France
	Songlines IV: Clifford Possum and Papunya Tula Artists, Rebecca Hossack Gallery, London
1991	*The Painted Dream*, Auckland City Art Gallery, New Zealand
	Canvas and Bark, South Australian Museum, Adelaide
	Aboriginal Art and Spirituality, High Court, Canberra
1992	*Crossroads: Towards a New Reality: Aboriginal Art from Australia*, National Museums of Australia, Kyoto and Tokyo

1993 *Aratjara – Art of the First Australians: Traditional and contemporary works by Aboriginal and Torres Strait Islander artists*, Kunstsammlung Nordrheim-Westfalen, Düsseldorf, Germany; Hayward Gallery, London; Louisiana Museum, Humlebaek, Denmark

Awake to the Dreamtime, San Diego Museum of Man

Art Treasures of Olympic Cities, Lausanne Olympic Museum

Tjukurrpa: Desert Dreamings, Art Gallery of Western Australia, Perth

1994 *Power of the Land: Masterpieces of Aboriginal Art*, National Gallery of Victoria, Melbourne

Tjukurrpa: Aboriginal Art of the Western Desert, The Donald Kahn Collection Museum, Villa Stuck, Munich, Germany

Yirabana Aboriginal and Torres Strait Islander Collection, Art Gallery of New South Wales, Sydney

Faces of Hope, Amnesty International Art Gallery of New South Wales

1994–95 *The Evolving Dreamtime*, Pacific Asia Museum, Los Angeles

1995 *Australian Art 1940–1990*, Museum of Fine Arts, Gifu, Japan

Songs of the Earth, Aboriginal Art of Australia, Susquehanna Art Museum, Harrisburg, Pennsylvania

Droombeelden Tjukurrpa, Groninger Museum, Groninger, The Netherlands

1996 *Dreamings of the Desert: Aboriginal Dot Paintings of the Western Desert*, Art Gallery of South Australia, Adelaide

The World Over, Under Capricorn: Art in the Age of Globalization, Stedelijk Museum, Amsterdam

Copyrites: Aboriginal Art in the Age of Reproductive Technologies, Cairns Regional Gallery, Museums and Art Galleries of the Northern Territory, Darwin; Araluen Centre, Alice Springs, Tandanya, Adelaide, Broken Hill Art Gallery, Art Gallery of New South Wales, Sydney

Nangara: the Australian Aboriginal Art exhibition from the Ebes Collection, Stitching St Jan Brugge, Belgium

1997 *Skin and division ME and Friends*, Brisbane City Gallery, Queensland

1999 *Australian Collection Focus: Warlugulong, 1976*, Art Gallery of New South Wales, Sydney

2000 *Papunya Tula: Genesis and Genius*, Art Gallery of New South Wales, Sydney

Dreamtime to the New Millennium, Penrith Regional Gallery and Macquarie University Gallery

2001 *Dreamtime: The Dark and the Light*, Kunst der Gegenwart Sammlung Essl, Klosternburg, Austria

The Australian Aboriginal Art exhibition, Asahikawa, Utsunomiya, Iwaki, Shimonoseki, Japan

Origins in Contemporary Aboriginal Art – Papunya Tula Artists, Holmes á Court Gallery, Perth

2002 *Postmark Post Mabo*, Post Master Gallery, National Philatelic Centre, Melbourne

Note: Those exhibitions for which no title is given in the list of group exhibitions were Papunya Tula Artists' group shows.

Clifford Possum's usual practice from the mid-1980s onwards was to sell works literally out from under his arm on the streets of Alice Springs and around the world. Needless to say, he kept no records of these transactions and in most cases neither did the other parties. Sometimes these paintings were exhibited and re-sold in private exhibitions, but more often than not they have never been publicly exhibited. Even if it were possible to compile one, a comprehensive list of exhibitions in which the artist was represented would provide little indication of his actual creative output, which was prodigious in his later years. On the other hand, it is important testimony to Clifford Possum's artistic stature, that despite the scurrilous trade in forgeries of his work which accompanied his progress through the world as his own agent, his name nevertheless remained before the art audiences of Australia and the world in major exhibitions with paintings of impeccable provenance, usually dating from earlier in the artist's career. The handful of solo exhibitions with which the artist was directly involved towards the end of his life also show his interest in exhibitions as a means of presenting his work to a wider audience.

Public collections

Araluen Centre, Alice Springs

Art Gallery of South Australia, Adelaide

Art Gallery of Western Australia, Perth

Auckland City Art Gallery, Auckland, New Zealand

Australian National Gallery, Canberra

Ballarat Fine Art Gallery, Ballarat

Broken Hill Art Gallery, Broken Hill

Flinders University Art Museum, Adelaide

National Gallery of Victoria, Melbourne

Parliament House, Canberra

Queensland Art Gallery, Brisbane

South Australian Museum, Adelaide

The Art Gallery of New South Wales, Sydney

University of Western Australia, Perth

Victorian Centre for the Performing Arts, Melbourne

Selected bibliography

AMADIO, N. & KIMBER, R.G., *Wildbird Dreaming,* Melbourne: Greenhouse, 1988

ARTLINE International Art News, vol. 5 no. 2, Summer Supplement: *Clifford Possum and Papunya Tula Artists,* 1990

BARDON, G., *Aboriginal Art of the Western Desert,* Adelaide: Rigby, 1979

BARDON, G., *Papunya Tula: Art of the Western Desert,* Melbourne: McPhee Gribble Penguin, 1991

BBC TV, *Desert Dreamers* Production, G. Dunlop, 50 mins; colour, 1976

BEIER, U., 'Geoff Bardon and the Beginning of the Papunya Tula Art' in *Long Water: Aboriginal Art and Literature,* ed. U. Beier and C. Johnson, pp. 83–100, Sydney: Aboriginal Artists Agency, 1988

BOGLE, A. ed., *Advance Australian Painting,* Auckland, New Zealand: Auckland City Art Gallery, 1988

BRODY, A., *Contemporary Aboriginal Art from The Robert Holmes a Court Collection,* Perth: Heytesbury Holdings, 1990

BRODY, A., *The Face of the Centre: Papunya Tula Paintings 1971–1984,* Melbourne, National Gallery of Victoria, 1985

BROWN J.C. ed., *RINGS: Five Passions in World Art,* Abrams in association with High Museum of Art, 1996

CARUANA, W., *Australian Aboriginal Art: A Souvenir Book of Aboriginal Art in the Australian National Gallery,* Canberra: The Australian National Gallery, 1987

CARUANA, W., *Windows on the Dreaming: Aboriginal paintings in the Australian National Gallery,* Australian National Gallery and Ellsyd Press Sydney, 1989

CARUANA, W., *Aboriginal Art,* London: Thames and Hudson, 1993

COMMONWEALTH OF AUSTRALIA, Parliamentary Debates, Senate, Hansard no. 6, Tuesday 25 June 2002, pp. 2608–9 and Wednesday 26 June 2002, p. 2688

CORBALLY-STOURTON, P., *Songlines and Dreamings: Contemporary Australian Aboriginal Painting,* London: Lund Humphries, 1996

CROCKER, Andrew, *Mr Sandman Bring Me a Dream,* Sydney: Papunya Tula Artists & Aboriginal Artists Agency, 1981

CROSSMAN, S. and BAROU, J.P., *l'ete australien a montpellier* France: Musee Fabree, 1990

CRUMLIN, R., *Aboriginal Art and Spirituality,* Melbourne: Dove, 1991

DIGGINS, L. ed., *A Myriad of Dreamings: Twentieth Century Aboriginal Art,* Melbourne: Malakoff Fine Art Press, 1989

DUERDEN, D., 'Clifford Possum in London', *Art Monthly,* August no. 33, 1990

HOLMES, C.H., *WALKABOUT: The Australian Geographical Magazine,* September, Sydney: Australian National Publicity Association, 1950

HOLMES, C.H., *WALKABOUT: The Australian Geographical Magazine,* December, Sydney: Australian National Publicity Association 1951

HYLTON, J. and RADFORD, R, *Australian Colonial Art,* Adelaide: Art Gallery of South Australia, 1995

INSTITUTE OF CONTEMPORARY ART, *Clifford Possum Tjapaltjarri: Paintings 1973–86,* London: ICA, 1988

ISAACS, J., *Australian Aboriginal Paintings,* Australia: Weldon, 1989

JOHNSON, T., 'The Hypnotist Collector': an interview by Richard McMillan (1990) in *The Painted Dream,* V. Johnson, 1991 pp. 21–37

JOHNSON, V., *The Painted Dream,* Auckland, New Zealand: Auckland City Art Gallery, 1991

JOHNSON, V., *The Art of Clifford Possum Tjapaltjarri,* Sydney, Craftsman House G+B Arts International, 1994

JOHNSON, V., *Aboriginal Artists of the Western Desert: a biographical dictionary,* Sydney: Craftsman House, 1994

JOHNSON, V., *Copyrites: Aboriginal Art in the Age of Reproductive Technologies,* Sydney: National Indigenous Arts Advocacy Association and Macquarie University, 1996

JOHNSON, V., *Dreamings of the Desert: Aboriginal 'Dot' Paintings of the Western Desert,* Adelaide: Art Gallery of South Australia, 1996

JOHNSON, V., *The House of Aboriginality,* CD-ROM, Sydney: Macquarie University, 1988

JOHNSON, V., 'The "Aboriginal Art Scandals" Scandal', *Artlink* Reconciliation? Indigenous art for the 21st century, vol. 20, no. 1, 2000 pp. 32–5

KEAN, J., *East to West: Land in Papunya Tula Painting,* Adelaide: Tandanya Aboriginal Cultural Institute, 1990

LERNER, S., *Contemporary Australian Aborigine Paintings,* Pasadena, California: Pacific Asia Museum, 1980

LOCK-WEIR, T., 'Clifford Possum: the divine navigator' in *Art and Australia,* vol. 40, no. 4, 2003

LOCKWOOD, D., *We, The Aborigines,* Sydney: Walkabout, 'One Pound Jimmy', 1970, pp. 80–3

KLEINERT, S. & NEALE, M., eds, *The Oxford Companion to Aboriginal Art and Culture,* Oxford University Press/Australian National University 2000

LUTHE, B. and LEE G., *Aratjara: Art of the First Australians,* Düsseldorf and Cologne: Kunstsammlung Nordrheim-Westfalen and DuMont Buchverlag, 1993

McCULLOCH, A. and McCULLOCH, S., *The Encyclopedia of Australian Art,* Sydney: Allen and Unwin, 1994

McCULLOCH, S., *Contemporary Aboriginal Art,* Sydney: Allen & Unwin, 1999

MAUGHAN, J. and ZIMMER, J., eds, *Dot and Circle: A Retrospective Survey of the Aboriginal Acrylic Paintings of Central Australia,* Melbourne: Royal Melbourne Institute of Technology, 1985

MORPHY, H., *Aboriginal Art,* London: Phaidon, 1998

MURPHY, B., *Australian Perspecta 1981: A biennial survey of contemporary Australian art,* Sydney: Art Gallery of New South Wales, 1981

MYERS, F., *Painting Culture: The Making of an Aboriginal Fine Art,* United States of America: Duke University Press, 2002

Nangara: The Australian Aboriginal Art exhibition from the Ebes Collection, Melbourne: Aboriginal Gallery of Dreamings, 1996

NEALE, M., *Yirabana,* Sydney: Art Gallery of New South Wales, 1995

NEW SOUTH WALES, DEPARTMENT OF EDUCATION, Board of Studies, 2001, Higher School Certificate Examination, Visual Arts: Art criticism and art history, q. 1(c)

O'FERRALL, M., *Tjukurrpa: Desert Dreamings,* Perth: Art Gallery of Western Australia, 1993

PERKINS, H. and FINK, H. eds, *Papunya Tula: Genesis and Genius* Sydney: Art Gallery of New South Wales and Papunya Tula Artists, 2000

RYAN, J., *Mythscapes: Aboriginal art of the desert from the National Gallery of Victoria,* Melbourne, 1989

SMITH, B. and SMITH, T., *Australian Painting 1788–1990,* 3rd edition, Oxford University Press, 1991

STOKSTAD, M., *Art History,* New York: Abrams, 1995

SUTTON, P. ed., *Dreamings: The Art of Aboriginal Australia,* United States of America: Viking in association with The Asia Society Galleries, 1988

TEK, D., 'Clifford Possum' on *Glass Eye World,* The Golden Breed Career Records, CDS8247, 2003

THOMAS, D. ed, *Creating Australia: 200 Years of Art,* Sydney: International Cultural Corporation of Australia in association with the Art Gallery of South Australia, 1988

Clifford Possum Tjapaltjarri accompanied a touring exhibition of the same title organised by the Art Gallery of South Australia.

Art Gallery of South Australia, Adelaide
31 October 2003 – 26 January 2004

National Gallery of Victoria, Melbourne
24 March – 3 May 2004

Art Gallery of New South Wales, Sydney
14 May – 11 July 2004

Queensland Art Gallery, Brisbane
7 August – 24 October 2004

Written and curated by Dr Vivien Johnson
assisted by Ron Radford and Tracey Lock-Weir

Designed and produced by Antonietta Itropico

Edited by Penelope Curtin
AGSA photography by Clayton Glen
Photography co-ordinated by Georgia Hale
Film separations by van Gastel Graphics Pty Ltd, Adelaide, Australia
Printed on Daltons Ikono Dull 170 gsm
Printed by van Gastel Printing Pty Ltd, Adelaide, Australia

National Library of Australia Cataloguing-in-Publication data

> Johnson, Vivien.
> Clifford Possum Tjapaltjarri.
>
> Bibliography.
> ISBN 0 7308 3053 5.
>
> 1. Tjapaltjarri, Clifford Possum. 2. Arts, Australian –
> Aboriginal artists. 3. Aboriginal Australians – Western
> Australia – Western Desert – Art. 4. Anmatyerre
> (Australian people) – Art. I. Art Gallery of South
> Australia. II. Title.
>
> 759.994

Art Gallery of South Australia

North Terrace, Adelaide, South Australia 5000
telephone: 61 8 8207 7000 facsimile: 61 8 8207 7070 www.artgallery.sa.gov.au

ISBN 0-7308-3053-5

9 780730 830535